ELIE NADELMAN

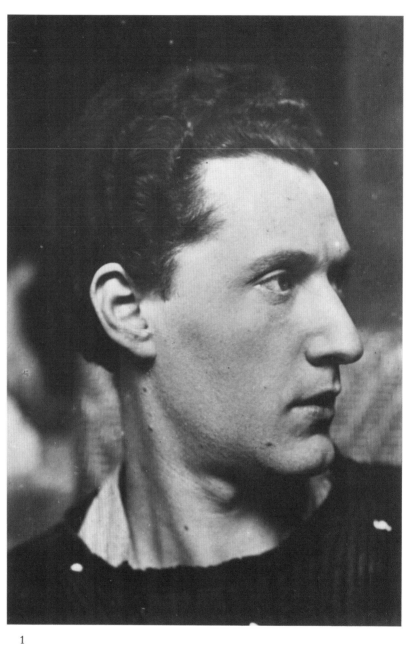

1

2

ELIE
NADELMAN

by

Lincoln Kirstein

THE EAKINS PRESS · NEW YORK

Grateful acknowledgement is made for the following quotations: from "Foot-
steps" and "Sculpture of Tyana" in *The Complete Poems of Cavafy*, translated
by Rae Dalven, Harcourt Brace Jovanovich, Inc., 1961; from "Whispers of
Immortality" in *Collected Poems 1909-1962*, by T. S. Eliot, copyright 1936, by
Harcourt Brace Jovanovich, Inc., copyright 1963, 1964, by T. S. Eliot; from
André Gide, *The Journals of André Gide*, Vol. I, 1889-1913, Alfred A. Knopf,
Inc., 1947; from "Modern Art," by Henry McBride, in *Dial*, Vol. LXXVIII,
January-June, 1925, The Dial Publishing Co.; from Rainer Maria Rilke, *Briefe
aus den Jahren 1907 bis 1914*, Insel Verlag, 1933; from Gertrude Stein, *Portraits
and Prayers*, Random House, 1934.

THE EAKINS PRESS 1973

SBN Number Cloth 0-87130 - 034 - 6
Limited Edition 0-87130 - 035 - 4

Library of Congress Catalogue Number 72 - 85651

for
NELSON ALDRICH ROCKEFELLER:
in memory of
ABBY ALDRICH ROCKEFELLER
patrons: protectors

CONTENTS

FOREWORD
Metaphysic of Style

The principle of all things is the monad, or unit;
arising from this monad the undefined dyad or two serves as
material substratum to the monad, which is cause;
from the monad and undefined dyad spring numbers;
from numbers, points; from points, lines; from lines, plane figures;
from plane figures, solid figures;
from solid figures, sensible bodies,
the elements of which are four, fire, water, earth and air;
these elements interchange and turn into one another completely,
and combine to produce a universe, animate, intelligent, spherical,
with the earth at its centre, the earth itself being, too, spherical.

PYTHAGORAS (DIOGENES LAERTIOS)

VIII: 22-5

"Blessed are all metrical rules that forbid automatic response,
Force us to choose second thoughts, free from the fetters of self."

W. H. AUDEN (1969)

A QUARTER OF A CENTURY has passed since Elie Nadelman died; there have been no books about him for twenty years. In 1948, The Museum of Modern Art, New York, held a retrospective, directed by René d'Harnoncourt, later exhibited in Baltimore and Boston. This was limited in scope; few decorative pieces, no portraits, architectural sculpture or graphics were included. There was restriction in the choice of early marble heads which had been, up to then, his most familiar work. Nadelman was resurrected from two decades of oblivion as a former forefront fighter in the permanent advance-guard. Factors which might have fixed him as traditionalist in the public service of sculpture were slighted. He was presented as an early member of this century's team of elite innovators, although one who, on occasion, lapsed into academic formalism. Such special pleading expressed one museum's policy: legitimization of pioneer orthodoxy. Nadelman's reappearance as "modern" was licensed after vague absence. Neither his complex sources nor considerable influence were elucidated. A blurred impression emerged which has not cleared.

Having posthumously and partially resurfaced past almost total invisibility (determined entirely by himself, since he resisted many efforts to show him), he was presented as a pleasing talent. "Amusing," "delightful" were praise most often repeated, patronizing bewildering labor of forty years. His memorial exhibition was indeed delightfully arranged and amusingly displayed. It had the dubious air of a faintly recent past revived too soon. Bland; nothing dramatically apt focused on so slight a sculptor. Few artists emerge unscathed from retrospectives. Nadelman's was generously intended to put a best foot forward according to obligatory canons admitting him, an unsolved puzzle, to precincts long recognized as anterooms to permanence. So partial an exposure hardly hinted at the whole man. Nor was it designed to do so, nor could it have been so designed. Time was not ripe. Nadelman was not the first to have been, in his early life, chronologically in luck; later, equally unfortunate. Arriving at the right historical or psychological moment, his first novelty coincided with current necessity. He ended, forty years later, firmly against fashion. Popular taste, fostering hunger for new heroes, the more tragic the more attractive, had no testimony to enlist him in the fellowship of saints and martyrs of modernity. More famous images from artists he had powerfully affected blurred any edge in a priority; he endured the hasty discount of one *déjà vu*.

Nadelman was among the last sculptors of quality to provide service on the scale of Renaissance master-craftsmen. Not only did he manage a business-like *atelier* employing skilled roughers-out and finishers as was usual with Giovanni da Bologna,

Houdon or Rodin (with each of whom he has affinities), but he undertook architectural decorations on both domestic and monumental scales, while fulfilling portrait commissions with luxurious refinement. By 1909 he had firmly conceived a method for analyzing and rendering three-dimensional plasticity, one which governed his subsequent practice. His analysis, using as graphic basis intersecting curved lines translated into curvaceous volumes, influenced many more famous French and American artists. This system, particularly in the instigation of the style now known as Art Deco [Plates 43-46], is beginning to be documented.[1] His idiosyncratic grammar of gross blocking by reciprocal curves, plus immense nervous, muscular energy and digital mastery, in a repertory of styles and variety of materials, produced memorable work on deliberate schedule. His formulated program, atypical of almost universal improvisation after 1940, had been normal practice since antiquity. Although first heralded as a revolutionary "abstractionist," Nadelman portrayed only men and animals within a predefined concept of wholeness – in form, scale, surface – which has since become the inverse of permanent "modernism." His work usually seems untouched by human hand, or rather, since it clearly is neither machined nor assembled, appears manually produced by impersonal facture through collective procedures – like votive images, toys, gravestones, cut by nameless craftsmen in undatable decades.

He began by echoing forms appropriate for ancient divinities; he ended by trying to project contemporary idols from dreams or nightmares of adult dolls. His own grammar of style and shape resulted in images which were immediately if deceptively legible. His portraits, however mannered, are specific persons. His wood figures, manikins indeed, are also archetypes. His means now present themselves as one end of an historical process. These attach to tradition even more than to individual talent. In his figures there is nothing fragmentary, improvised, questing, tentative. Now, when improvisation is equated with virtuosity, indeed replaces it, a craftsman as methodical, precise, witty, or elegant as Nadelman balks judgement. His intelligence was tyrannical; he could not scratch on an engagement-pad without producing hints at once exact and, within limits of a sketch, commanding. There were rare differences between first impulse and ultimate definition. Variants for almost every figure exist; many were rejected in favor of final statements, but there is seldom, even in slight studies, correction, erasure, a trace of dubious approach. Procedure held sober order in detached control, cool as the stones he buffed.

Nadelman spoke and wrote fluent Polish, German, Russian, French and English. With equal ease, without grammatical error, and with full information of both vernacular and professional parlance, he communicated through chisel, foundry, clay and kiln. Today this seems unsettling; we prefer rougher method to fit times we are pleased to consider tougher. With him, no ragged edge betrays that agony for which we have been taught to probe in detective stories of secret studios.

This is no biography of Elie Nadelman. Documents exist making one possible. There are few artists in our time about whom we have so much information – yet his personal life involved him little. Details of his days over four decades lie uniquely in week-by-week record of work done. He was devoted to his wife, who bore him a son of whose soldiering he was proud. He enjoyed the esteem of contemporary colleagues. He coöperated in progressive organizations and busy politics of artistic affairs. He had few friends; no close ones. Gertrude Stein, admiring him early and later composing a laudatory prose-portrait (See pp. 274-5), said he was the coldest man she'd ever met. Hawthorne, whose *Marble Faun* can be read as a text on that neo-classic taste which Nadelman shared, noted: "Men of cold passions have quick eyes."[2] Nadelman wrote but few articles (See pp. 265-71), or letters, seldom commenting on his own or others' work.

To a professional biographer, ideally to a comprehensive novelist, Balzac, Proust, or especially Henry James[3] (whose first editions he collected), an enigmatic tension between inner private and public selves might furnish a suggestive pretext. Nadelman's apparent mask was one of conquest rather than conflict. In its intimate center, it remains obscure. On the surface, his tale frames a familiar fable of the brilliant young provincial breaching bastions of Montmartre, Montparnasse, Manhattan, the Pole in exile who became a type of New Yorker, a dandy whose conventional Bohemianism concealed energetic manoeuvre and a high morality. Strolling through sunny days, he distilled well-mannered irony, good humor, discreet disdain. He kept fair opinions of himself; in darker weather he was not past indignation. As far as the world went, self-doubt, identity, money were no problems. He possessed grace of person, suavely accepting princely gifts, rarely puzzled in youth or maturity. Towards the end, he despaired, eyes open, self-aware, silent, stoic, in depths surpassing sureties of earlier optimism.

He was born at a watershed in an old Europe of post-feudal patronage. He came to America at the outbreak of world war, when limitless possibility on this continent promised all Paris or London seemed to have wilfully abandoned. He vanished when forced to judge such opportunity was no longer open. While his marbles appear to embody only aspects of serenity, the deeper meaning of his last plasters embodies other alchemy. In a profound, if admittedly partial, judgement at the time of the memorial retrospective, Professor Meyer Schapiro, medievalist, connoisseur of all art, ancient and modern, wrote:

> He is not an uncommon type of modern artist, although distinct as an individual. The dream of a quintessential or supreme art is a mark of his kind; I feel something narcissistic there and a doom. Such a man can hardly grow and his change must appear to him somehow as compromise and adaptation. He could not utilize in his art the conflict and imperfection in his own contemporaries. The *beautiful* has too great finality. And perhaps

as a kind of penitence for his youthful pride, he became too humble in his later years; but even in this humility there is a compromise, a lack of energy and whole-heartedness, a reliance upon charm . . .

One hardly debates an aesthetic or ethic of agony, physical or metaphysical. Finally, relics in work, cleansed of mortal soilure, offer irreducible testimony for comparison or delight. We may dare decipher a collapse of energy that defeats an artist. With Nadelman, it was a combination of stresses, rarely muscular, for he worked ceaselessly until his death. Facile charm was surely no ensign of his last labor, which indeed has not as yet been shown. His unwillingness or inability to reveal his self resulted in distillation of psychic agonism into lyric or ironic comment. Although his fate was tragic, tragedy was not his genre. Towards the end, attempting to dominate intense physical distress, he spoke of it to his wife as "my *amusing* pain." Marcus Aurelius between battles on the barbarian Danube might have saluted a fellow stoic.

To whatever degree an instigator, Nadelman must be placed rather at the end of his line. However, unlike more vivid melodramas in the martyrology of modernism, his was no catastrophe from delay in recognition. No *poète maudit*, he carved a brooding echo of Baudelaire's face [158-159] and collected Verlaine manuscripts. He did not aspire to Van Gogh's saintliness, nor did he communicate fever-charts of his own anguish. He was no genial monster like Lautrec, nor destroyed by sensual obsession like Pascin, to whom he felt closer than other contemporaries. His own fate was that of a patrician under Nero or Elagabalus. It could be said, without much weight, he suffered more from success than failure. For nearly two decades he lived enthusiastically, an important participant in accepting society, a captain of Manhattan's High Bohemia so dashingly vignetted in the early novels of Carl van Vechten and in the day-glo panoramas of his friend Florine Stettheimer. Magnetized by the heirs of our Hamiltonian plutocracy, he served as a court-artist to our rich, wellborn, able, those American merchant-princes whose mansions imitated the Medicis'. His small bronzes stand proudly in their descent from Riccio, Antico and Vittoria. Conducting himself *en prince*, he adorned his white 93rd Street palace with none of his own work; only shelves of Roman earth-fused rainbow glass; one big lion in Pentelic marble. He quit Europe to become a patriotic American, pioneer collector and propagandist for handicrafts we inherited from medieval folk tradition. A conscientious citizen in his community, he enjoyed everything except just placement, during life and after.

There are few useful studies of American sculpture; its chronicle for our nineteenth century could, if pressed for time or space, be limited (except in quantity) to the tentative if heroic labor of two artists, both painters. William Rimmer and Thomas Eakins forged personal grammars of form, one from dissection and echoes of Michel-

angelo through engravings, the other from analytical anatomy and instantaneous photography. There is, however, one towering exception, recently ignored. Augustus Saint-Gaudens is the single American who stands without apology beside Rude, Barye, Carpeaux; on more than half a dozen occasions, near Rodin himself.[4] He was chief representative of the Franco-American tradition in a generation preceding Nadelman. His reputation has suffered similarly from immediate success and later identification with an epoch which still lacks definition. Like Nadelman's, Saint-Gaudens's importance lay less in innovation than masterwork.

Until now, Nadelman has had no *catalogue raisonné*. His complete graphic work was posthumously published by the late Curt Valentin in 1952 in a handsome, immediately exhausted edition. It is impossible to complete listings since work is widely dispersed, some in French or Polish private collections whose owners maintain anonymity. Pieces from before 1914 still turn up, vaguely recognized despite signature. Many of his polished marble heads until recently graced the world-wide chain of beauty-shops founded by Helena Rubinstein, his first important and most generous patron. Since the auction of her collections in 1966, prices have risen; his work now is more prized than at any time in fifty years.

Why the blur, this lapse of interest? Do not museums of past or modern art, wherever maintained, now at last obviate that time lag which once made a generally informed audience forgetful or ignorant of Terbrugghen, Stubbs, Canova, Gérôme, Klimt or Schiele? The poet-critic Guillaume Apollinaire early in our era described young Nadelman working, *couronné de roses*. Documented heartbreak, public failure, posthumous apotheosis are more exciting than instant triumph, a worldly reputation first crowned with roses, then smothered. Nadelman's obscurity may be blamed on affluence and social assurance, which in the mythology of modernism amounts to the inconsequential. If it was all so quick, methodical, organized, unagonized, how can it be valid? If it is all so pretty, cool, amusing, following neo-classic ideals, palimpsest, or parody of The Beautiful, how can it be Modern? If it isn't Modern, is it anything?

Nadelman aimed at a High Style of bravura elegance and technical virtuosity based on historic absolutes. Our present taste is for low style, repudiating historicity. Pop, op, minimal, mixed-media systematically improvised, obsolescent by policy, the art of today has neither past, future, nor ambition to be compared with other art of long survival. Nadelman's craft was rooted in continuities he wished to extend, adapting rediscovery to new considerations of scale, material and use, suiting his own time, seen not as a fading year, but as one fixed date. First, he set himself an exercise of analyzing origins and succession of Western sculpture deriving from Aegean civilization, from Pheidias through the heirs of Alexander's artisans. In this pursuit he paralleled that of another East European. Igor Stravinsky, early a master of orchestration,

made a vastly influential statement which was at once declaration of independence and manifesto for unlimited extension. Just when the composer of *Le Sacre du Printemps* (1913) seemed to have liberated our century at its outset by a non-Euclidian geometry of unprecedented rhythmic sonority, he proceeded by unfashionable devices to reinvestigate and revitalize the entire sequence of Western music by commentary or projection upon lost masters from Josquin, Lully and Handel through Glinka, Delibes and Tschaikovsky. In this was there "originality," contemporaneity, individuality, personalism? Listen to the scores of seventy years.[5] Stravinsky, the grandest imitator in music, has noted that artists may never be more themselves than when they transform models.

Nadelman seldom vaunted himself as an original, nor was idiosyncrasy attractive until Romanticism. Few Elizabethan or Augustan poets, few baroque or rococo artists saw themselves as originators, yet personality is as apparent in poem or painting as fingerprints. Nadelman had no interest in utilizing subjective striving or neurosis. He struggled; he was no less neurotic than his neighbor, but he always presupposed capacities to do as he pleased. His pleasure was the refinement in terms of plastic form of an ordering historicity, apart from and far beyond his accidental self. If he was "narcissistic" (in Freud's sense), this may be found less self-love than an adoration of tradition and craft with which he identified himself, to whose immutable logic he bore witness.

It is hard to think of Nadelman as a Pole. Rather, he was one of a lively band of East Europeans, Great Russians, Ukrainians, Bulgarians, Rumanians, flowering in the wake of Diaghilev's exportation of Slavic sensibility to the West. Honorary Parisians later, Archipenko, Brancusi, Chagall, Gontcharova, Larionov, Lipchitz, Pascin were formed under the Romanov hegemony in its phosphorescent decline. A note on Winckelmann, most eminent apologist for neo-classicism, applies to such aliens.

> Winckelmann [1717-68], from the Mark Brandenburg [East Prussia], develops the highest enthusiasm for Greek antiquity . . . Innermost longing: the incentive towards a lofty distant ideal. No Italian was so uncompromising a worshipper of the antique as Winckelmann. [G. E.] Lessing [1729-81] also stemmed from an artistically barren northern district, and sought absolute "beauty" in the most distant and most strange. Want of artistic culture was the preliminary condition without which enthusiasm for the antique could not have mounted so high.[6]

Appearing in Paris shortly after the 1905 revolution, these East Europeans brought novel appetite and energy, at first seemingly "barbaric," but which were soon diagnosed more correctly as "Byzantine." To Paris, partially prepared by Gustave Moreau (after Flaubert), *l'art nouveau* and d'Annunzio, the news of the Second Rome – Constantinople – and indeed a Third Rome – Greek-Russian Orthodoxy – forgotten or unsuspected, seemed intoxicatingly exotic. Due to the shock of the first exhibitions,

concerts, opera and ballets presented by Diaghilev, Byzantinism was confused with what late nineteenth century Paris presumed to be *l'âme slave*, a demi-mystical essence of pan-Slavic nationalism. Nadelman carried a Russian passport and wore the Tzar's uniform. Unable to join his regiment at the outbreak of war, he took this as a sign to quit Europe. He was heir to all the cultures, religions and imagery of old Poland – "True Slav," Jewish, Roman, Germanic – but a conformist to none. Born into a climate of intellectual liberalism, he became a citizen of the world. Later, when asked to support ethnic causes, he declined identification with any racial or religious separatism. However, many of his early analytical drawings suggest by their inclination of head, neck, and by massive frontality, Russian Orthodox ikons in the descent from Kiev and Vladimir-Suzdal.

To comprehend Nadelman as a creature in tradition one must link West European cave murals with Alexandrian carving, Byzantine painting with medieval handicraft. His sense of pervasive luxury, his combinings of bronze with marble, his painted brass, tinted wood, colored baked earths, his love of mirror-ivory surfaces and idealized heads, recalls the taste of workers who knew classic Greece through subsequent variants. **[146]** He was not attracted to archaic art; his view of prehistory was archaistic. Later, he preferred the unredundant shapes from international folk-fashioning which, however sophisticated in the true sense, have come to be called "primitive," but which are primal, irreducible, archetypical. His final forms drew on more complex, mature, late or "decadent" forms. His aesthetic derived from Hellas; his metaphysic from Byzantium.

When mosaicists, manuscript-painters, muralists of Constantine's capital depicted incarnations of pure evil, Satan was not manifest (as in the West) by a deformed biped with satyr thighs and cloven hoof, a monstrous bastard man-goat. In the Second Rome, the prince of darkness was a black, not a blond archangel, brother to other fair-haired lieutenants in the holy host, but opaque, dense, separated, damned, removed from that source of light or grace which was Holy Wisdom: *Hagia Sophia*. Concepts of sacred truth as entities are already found in late Judaic philosophy. *Hagia Sophia*, holy wisdom, is arbiter, contiguous to the Godhead Itself. It (or later, She) is mediator of our created world, through whom God intellects mankind. In the Roman Church, She became *Sedes sapientiae*, Wisdom Enthroned, identified with the person of The Blessed Virgin, but not in Eastern Orthodoxy, which inherited Platonic concepts more directly. Plato suggested a pre-existence, or eternal presence of archetypes. Makers, poets, artists work towards rendering legible central ideas upon which our world of appearances depends. The *arche*, source, nature, essence, presupposed flesh and spirit as one. In this divine harmony, there can be no separation or conflict between corrupt body and pure soul.

In Byzantine art, some have felt deprived of what has erroneously come to be called

the "creative" imagination, forgetting that God was once known as unique *Creator*, alone capable of those initial and eternal essences which subsequently decline into idiosyncratic interpretation or dilution. Ikons, ivories, mosaics were not produced by isolated or alienated hands and brains but by sacred craft, a collective residue of traditional procedure, whose process was, in itself, a liturgical act. Ikons, holy images were not considered as work by single talents, but rather exemplars of divine archetypes – epiphanies, revelations, manifestations. A true epiphany is a self-made imprint, a mirror, however blurred by imperfect skill, of Holy Wisdom. It is difficult to think of separate hands chiseling the Parthenon. Manual dexterity, digital mastery were apprenticed to traditional shops or family schools. Individuated talent was presupposed or unquestioned, without the imposition of a single carver's limited capacity or personality. Personifications of concepts were translated into stone or pigment. Jesus supposedly sent the King of Edessa a napkin impregnated with His sweat, imprinting His Face onto its texture; so exact a representation was not delineated by human hands. The nature and service of ikons required that any private distinction between idea and image be absent towards a greater glory in its portrayal, illuminated from its Source, son and sun of Wisdom. Fathers of Greek Orthodoxy said: "We do *not* worship ikons; we know homage to The Image aspires towards The Essence." It is not the stuff crafted, painted, gilded which is venerated, but the embodied Idea, manifesting itself, to whatever degree of energy residual in traditional service, within a current residence or frame.[7]

To Nadelman, self-expression, expressionism, self-pity, inheritances from Provence to the romantic imagination, were alien. He was an image-maker attached to received or preconceived criteria of perfection, adorable ideals which ancient artists worshiped as the concrete innocence of Edenic memory or promise. In certain aspects, he has been denigrated as a neo-classic archeologist, but here method and attitude differ in kind from the pinched formulae of sculptors who did not hold that mastery of modeling or stone-cutting demonstrated even by Canova, Thorvaldsen, Flaxman, Bosio or Hildebrand. These men may have imagined they sedulously followed antique forms; indeed restored or "improved" classic remnants with firm conviction from their contemporary academy and its limited scientific or historical apparatus. In much European neo-classic sculpture presuming to revive the canons of Polykleitos or Lysippos, there is indeed desiccation, a shrunken impoverished correctness lacking vitality – that overflow of plastic generosity apparent even in swollen or wilted versions of Roman statuary, which in itself was Greek sculpture in its imperial recension.

Nadelman did not take as his criterion, as many of his academic contemporaries were prone to do, an inheritance from Canova. He went straight to the fount of classic art. In the descent from archaic to Pheidian modeling or carving, liberating the free-standing biped from its hewn four-square block, there was a dynamism swelling

from elemental simplicity towards increasingly detailed subtlety and asymmetry in connective planes. This progression was additive. Even less than a century (400-325 B. C.) reveals basic differences between primary figures carved by attack on four separate faces of the block, and one imagined as imprisoned within its column, whose ideal rondure pre-exists only waiting skilled release. Method in European neo-classic sculpture was a reverse. Wearied of excessive surface irritation and histrionic redundancy in late baroque or rococo art, reactionaries sheared off detail, reduced tension and torsion, smoothed surfaces while subtracting much physicality and energy in attempts to simplify or essentialize. This purification or deletion intended to heroicize the nude, rendering its clear profiles ethically sincere, but it moved to petrifaction without much diminishing rhetoric.

Nadelman, on the other hand, did not attempt to correct or reconstruct received style, but rather sought first principles applying to a universal plasticity. Neo-classic masters took versions of Graeco-Roman sculpture, or their Italianate imitation, seeking to distil their clarity. Nadelman worked, not on style, but on matter and method. He did not proceed from one chosen epoch which had found its own solution, but rather analyzed a root geometry intrinsic to the fulfillment of forms and volumes deriving from the self-contained primordial ball or egg. [6-7] For him, style – primitive, popular, traditional – was subordinate, a personal frame, useful and exhaustible, in which to set factors of plasticity, stance, and surface in harmonious balance. Echoes of the superficies of precedent, whether antique torso or folk-toy, were only a pair of placements, a metaphorical selection of musical keys for strict solutions, of which there are always as many answers as there are chords, chromatic scales, metres, rhymes, and for which he would demonstrate an anthology of solutions.

Between Canova and Nadelman there was Rodin (and to a different degree von Hildebrand and Medardo Rosso), who found means of suggesting fresh plastic motility by enveloping shapes in a veiled, impressionist urgency without smothering form. And it is not alone an embracement or rejection of monumental scale which links these artists. Rodin acknowledged debts to Clodion as well as to Michelangelo. If Nadelman's most vivid statements are in the metric of dolls rather than demigods, this stems from his historical analysis developed into a private, deeply meditated metaphysic. He broadened strict applications of canonical precedent by wide reference to the wise innocence in residual shapes of folk-fashioning, tempered towards his end by transmuting riper modes. His handling always presupposes strict structure and executive control. His final figurines are not simply the erudite reduction of ancient sources. While he was too modest, or too proud of his diagnosis, to compete often on the heroic scale, even in his last miniatures he never abandoned its lively memories. Rodin in his grandiose "Balzac" managed a monument equal in magnitude to the scope of his stupendous subject, but which, in fact, was a kind of calculated rough

sketch blown up to heroic dimensions. Nadelman's "Baudelaire" (Hirshhorn Collection) [159] achieves a synthesis past graphic likeness, approaching ambiguous but lyric truth, a monumental understanding.

If Nadelman can be placed beside a poet, it is not by Racine, Pushkin, Lermontov, or Baudelaire, whom he loved above others, but near Ezra Pound, whose versions of Propertius, troubadours, Chinese, Théophile Gautier echo ideas of dandyism which Nadelman fixed for an identical era through the lens of Tanagra, the Dordogne caves, Bavarian folk-toys, Guys, Seurat, Pascin. His showgirls, burlesque queens, circus performers, society ladies [123-139] are a light if lodged arraignment of an arena in which individuality has abdicated. His fiercely personal late figures were ordained for a dehumanized planet. People became objects, units, ciphers, bred or breeding not as persons but as spare parts. During his life, these were taken as jokes in poor taste. He sold not one. It was assumed he mocked a society by which he'd been richly rewarded.

The word "witty" applied to Nadelman has long served for his most common dismissal as a "serious" artist. It has confused his position even more than a grudging indulgence of his attachment to Hellenism. Surprise, sparkle, humor, smart facility are no qualities contributing to desiderata in grandeur. Sculpture, being by nature monumental, and, on whatever scale, indicative of the grandiose, is particularly suspect when reduction to a level of "wit" is obvious. "Wit" also means the seat of intellection, cerebration, and conscious analysis in operation, which he possessed to a chilling degree. His insistent reflective judgement seemed to his contemporaries heartless; he didn't wear his heart upon a sleeve, but in his brain.

Social indignation histrionically, passionately, compassionately manifest is licensed. Laughter, or worse, a civil smile, in plastic art is risky. Laughs or grins are ephemeral. The shadow of wit smudges mineral substance; stone and bronze endure. Potential monuments are miniaturized by evanescent shading; it is disquieting to present the preposterous with a straight face. In words, at least, masquerading as sorry jesters, Petronius, Swift, Lewis Carroll, Mark Twain, Orwell, Nabokov invent tutelary monsters. Nadelman was no cartoonist, like Ghezzi, Dantan or Daumier. Dolls are not caricatures; they are domestic idols. Often they look like grown-ups who have lost their "wits." [101]

Also, Nadelman's virtuoso professionalism in treating contemporary subjects added to reluctant acceptance. Together with Saint-Gaudens and Rodin, he would be demoted to the status of a "merely" skilled craftsman, in an age when handcraft is superseded by whim in collecting or arranging trash. [122] Today's taste is for improvisation; metaphorically it legitimizes unlimited luck or possibility. Our forefathers prided themselves on amateur standing. Pioneers improvised with genius, on an uncharted continent, everything from guerilla warfare to split-rail cabins, covered bridges, covered wagons. We have long attached a scent of the effete to any

complete professional – poets or novelists as well as painters. Something furr'n, alien, high-falutin', suspect, opposes elite tradition or method as if European inherited crafts were less wholesome than fortuitous shortcuts, the gift of happy chance, innocent mindlessness, or muscle uncorrupted by intelligence. Nadelman personifies *expertise*, an hereditary aristocracy in plastic achievement. He appeared to have played at sculpture as an elegant game, although elaborate ground rules unfairly cancel aleatory elements. For him, sculpture seemed a moral as well as a physical problem, a metaphysical exercise superior to polo, chess, or fencing. Thomas Mann, five years older, also an artist in exile, explained.

> A hard life? I am an artist. That means a man who wishes to entertain himself – and this isn't a matter to pull a solemn face about . . . In art one is dealing with the Absolute, which is not child's play. But then again, it is after all a form of child's play, and I shall never forget Goethe's impatient dictum: "In the making of art there can be no question of suffering." . . . Anyone who has chosen so essentially amusing a job has no right to play the martyr in the presence of serious people.[8]

There was yet another disquieting element apart from irony – Nadelman's metaphysic of formal plasticity applied to sexuality. In focusing an insistent amplitude in hyper-femininity, Nadelman anticipated Gaston Lachaise.[9]

There has been some speculation as to relations between Nadelman and Lachaise. In the extant history of twentieth century American sculpture, Lachaise appears to hold priority, including even a temporal one. This is incorrect. Nadelman's exhibitions in New York, the first in 1915, preceded Lachaise's first one-man show of 1918, when Lachaise was serving as a stone-cutter to Paul Manship and his personal direction was as yet incompletely defined. While it is on record that the Frenchman esteemed the Pole with little reciprocation, there is a large difference in attitude between two artists whose whole work depended so heavily upon an expression of the eternal feminine. Lachaise's considerable qualities did not embrace either wit, humor, or the dandy's survey of contemporary society. Nadelman played with and on the human body, nude as well as clad. Lachaise worshiped it as the Naked Truth. Nadelman evaded or was amused by sexuality; Lachaise adored and was devoured by it. To Nadelman, life was luxurious if stoic sport; for Lachaise, it was grandeur and crucifixion. Nadelman was an erudite and light manipulator of a stylistic repertory. Lachaise was a mortally serious agonist, increasingly obsessed by devotion to a super-maternal ideal which might be compared in focus and confusion with D. H. Lawrence's psycho-sexual ambiguity. As daily existence conspired to crush him, Lachaise's heart and hand grew heavier in rapt dedication to his mammary and vaginal gospel. As Nadelman withered alone, his fingers grew more full of a delicate finesse until clay they worked was worn to nothing under a desperate exercise. Both careers were the stuff of tragedy, but while

Lachaise proclaimed a sense of tragic existence, Nadelman's purview was lyric and ironic. Lachaise has been granted a niche in museum martyrology, which has legitimized him as serious and worthy, while Nadelman is discounted both for serene perfectionism and the lightness in his smile. Nadelman was a neo-classicist; Lachaise a romantic expressionist. But as Edgar Wind wrote of Expressionism as a whole:

> You can blow the trumpet of the last judgement once; you must not blow it every day. When the peak of excitement is produced with clock-work regularity, it cannot but be slightly strained; and by "strained" I mean a human rather than an aesthetic failing; it entails a lack of balance, a hankering for extremes, and the complete absence of a sense of humor . . . the perpetual fortissimo of Kokoschka and Rouault.

While Lachaise endured his maternal fixation, Nadelman flirted, familiarly if firmly, with bland show-girls and busty burlesque strippers. Lachaise invoked the steatopygous earth-mothers of Lespigue and Willendorf. Nadelman borrowed his bulls and belles from the Font de Gaume caverns in their paradox of massive bodies balanced on brittle heels. Prehistoric bisons floated on smoked ceilings; these he transmuted into three dimensions, airborne, weightless, pricking impalpable earth with stiletto hooves. Lachaise's earnest preoccupation was floridly sober, hence ethically acceptable. Humorless sincerity licensed evangelism. Nadelman's "taste" or integrity was dubious; big bosoms were fertile, not funny; holy, not comfy. When sex was read as comic or satiric, it could only be a poor or dirty joke. T. S. Eliot, daytimes a bank clerk, at night a solemn student of stoic dandies, Baudelaire, Corbière, Mallarmé, produced an analogue to Nadelman's *galvano-plastique* figures of an identical epoch [135]:

> Grishkin is nice: her Russian eye
> Is underlined for emphasis;
> Uncorseted, her friendly bust
> Gives promise of pneumatic bliss.[10]

Nadelman, an emigrant *flâneur*, reaped rich rewards for dreamy busts of society dames; whereupon, insolently prompt, he carved outrageous parodies of the same silly women in wood, an insulting material, less dignified than marble. To him, High Society was circus; in its excluding arena, sex was at most domestic or sportive; infantile not sacerdotal. His goddess was our Big Babe, no tribal matriarch, and never Mom. To New Yorkers in the early 'Twenties, under therapeutic hypnosis of Freud's colonists, sex became a serious and expensive business. However, under Nadelman's apparent raillery, there are, when we arrive at his late, still largely unedited plasters, disarming elements of profound psychic dislocation. His ultimate comment on the flesh neither praised nor blamed. He measured microscopic units of self-love, estrangement, an incapacity to love much if at all, lapse of self-consciousness, lack of

individual or polarized identity. Apathy, iteration without development, self-obsession, *acedia*, he embodied in cult images of coherent anarchy. Among them we discover spoiled, blackmailing Lolitas, twenty-five years *avant la lettre*. Nadelman's farewell images cast sinister shadows. These can be measured by no flashy explosion nor melodramatic crisis, but there are sinister clues. In silence, in secret, he uttered his mortal chamber-music of modeling. In plaster, midgets, humanoids enthrone themselves as lordly cretins; whorish teasers luxuriate in idiotic adornment. [203] They seem incestuous nymphets able to survive insectile holocaust. Dainty anarchs proliferate past threat, fright, hope, desire, thriving on polluted air, echoing shapes of a castrated race whose bankrupt future once spoke limitless promise.

Nadelman was an exemplary victim of his time. Following the boom after the First World War came a stock-market debacle in 1929. His own as well as his wife's fortune gone, he was overnight without studio, helpers, the habitual apparatus of an *atelier* which he'd managed for fifteen years, with small possibility for further patronage. Whereupon he vanished from public view, stubbornly refusing to exhibit, although constantly requested. He worked, harder than ever, to obtain quantity and quality against the day when he might show again. It never came. Shock he sustained from loss of kiln, shop and staff forced him to reconsider his former scale, not alone of living, but of working. There would be no more tycoons to command exquisite marbles of svelte wives or angelic infants [85], few gateposts on Long Island to be topped by heraldic fawns or pheasants.

From the early 'Twenties, the Nadelmans made comprehensive collections of folk-art and craft, ranging from the lace, embroidery, iron, glass of medieval Hungary, Germany, France and Bohemia to the semi-industrialized chalk-ware pottery and *fraktur* calligraphy of German Pennsylvania. Joseph Brummer, an important dealer, once Nadelman's fellow art-student in Paris, repurchased ancient glass and marbles. The Metropolitan Museum (for The Cloisters) and Worcester, Massachusetts, acquired the finest forged iron. [211] Mrs. John D. Rockefeller, Jr., bought the best American paintings for Colonial Williamsburg. The New-York Historical Society took the greater part of European and American dolls and toys.

Nadelman had also collected the anecdotal sculptured groups manufactured for popular consumption by John Rogers in the mid-nineteenth century. From money gained from their sale, and others, he proceeded to try essays in terra cotta, glazed ceramic, papier mâché, and experimental plastics. [171] On the precedent of Tanagra, Myrina, Meissen, Victorian Staffordshire chimney ornaments, he began to produce pilot models adapted to modern apartment-house room units, hopefully to be manufactured cheaply so they might answer some public demand. He delayed exposition until his means and control satisfied him. They never did. In attic, studio, cellar, after his death, were found dozens of completed models. [215] Problems of form or style

never troubled; he reworked his own grammar for a new family of figurines accommodating smaller dimensions and less costly material. In this fevered production, presupposing awesome, even desperate energy, there is finally the ominous presence of psychic disarray. Apart from his technical interest in providing mass-produced statuary of high artistic quality, he consciously or unconsciously reflected the nature of a populace condemned to inhabit more or less hygienic antheap or rabbit-warren, slums for the next decades, whose stunted lives had become, in their own terms, a rat-race. Long before, he had seized as his favorite mask the mirthless grin of shop-window dummies whose neutered souls drape themselves promiscuously in any shift of fashion – passive stand-ins for mindless taste, whores for fads, or vogues of built-in obsolescence. Handlebar moustaches painted on barber-shop wig stands, the wide-eyed, blank, oracular stare of china dolls, the hapless schematic smile on clown or chorine, he had found twenty years before. Now, at his end, everything was reduced to a neat, muted, shyly gorgeous exhibitionism.

Nadelman's ultimate importance is not in how he affected a cluster of better-known contemporaries, but in what he himself began as and subsequently became. First, he analyzed the structure of three-dimensional plasticity as if it were one branch of linguistics. Professor Schapiro has pointed out that when Nadelman was in Munich at the turn of this century, concepts of a pure, absolute, or metrically rational aesthetic were much in the air. Along with Nadelman, many Russian, French, German and Italian artists organized personal research into didactic systems. Some of this preceded the brief but increasingly influential explosion of Cubism. Nadelman's relation to Cubism became, even in his lifetime, something of a *cause célèbre*. (See pp. 183-90) Nadelman had no pupils, but a method and manner from his 1909 exhibition passed rapidly into public domains. His analytical formulae provided labor-saving devices for facile stylization at the hands of designers less strict than he in matters of plasticity or proportion. He presumed to have discovered a universally applicable truth, like others before or since. We may now judge this as commentary on past art, or as personal preference encompassing silhouettes and volumes rather than absolute verity. He claimed, as did several contemporaries, to have uncovered means toward plastic unity and harmony which might be transmitted foolproof, like *materia medica*, counterpoint or solfeggio, or *barre* exercises for the benefit of surgeons, musicians, and ballet dancers. Apart from illusion or delusion, such harmonics and dynamics presuppose manual mastery, intimacy with four thousand years of carving, chasing, casting, hands and eyes supported by underpinnings of brilliant draftsmanship, as well as a cohesive society granting ready patronage. Nadelman devoted his last strength of mind and body to another unifying proposal: mass production of ingeniously sophisticated house-ornaments. [204] Failure was almost implicit in his product. He wished to promulgate idols of adaptable homogenized blandness, composed from

interchangeable parts on the precedent of Tanagra. But these figures were disturbing; were they satirical or sinister? Could they be godlings whose oracle was the radio or television? Were they saleable in a temple whose oracle was mass media?

Inspection of Nadelman's intentions, including his degree of achievement, may place in perspective what passes for progressive sculpture since his death. By its own boast, proliferation is massively ephemeral. As it swells in bulk, its impression is brutally simplistic – grossly, declaredly "minimal." The space today most sculpture is formed to fit is within public or commercial galleries which at best are temporary sites, however well stage-managed for one-man shows. Infrequently, pieces constructed with no preconsidered site in mind are set against buildings as token ornament, unrelated by scale or spirit. A recent exhibition of American Pop art in London led one distinguished critic to announce it as "discursive, anecdotal and biographic," recommending its "movement" for being "uncontaminated by history."[11] Nadelman was saturated in history. Nevertheless, his redeployment of historic styles from pre-history to Staffordshire resulted in making him the single sculptor of his time who convincingly essentialized contemporary man clad in the dress of his day. [142] His early involvement in folk-art made him, willy-nilly, a founder of Pop, just as Hellenistic potters can be considered progenitors of an uninterrupted descent of ornamental sculpture which, far from being contaminated by history, depends on it. Industrialization, plus the computer, may promise an early demise of that digital mastery once required to shape clay, wood, stone. So far, synthesizers have not been able to replace those suave repertories of melodic measure for which the human body in action or repose, the human voice in speech or song, are most grateful. The machine has always seemed threatening; handcrafts have fought rearguard actions for three hundred years. There may be a dearth of recent masterwork, but perhaps it will be the ultimate irony in Nadelman's posthumous career that, long after his death, his most idiosyncratic work will indeed be produced and distributed by means of which machinery alone is capable. That he foresaw this is not unlikely, for still in his house remain dozens of prototypes which, while hand-produced, have the single perfection and identical forms of machined, shaped plastics.

Nadelman is at present best known for twin monumental female figures in polished white marble majestically presiding over the grand promenade of the New York State Theater, Lincoln Center, personal gifts of its master architect, Philip Johnson. [166] Already in 1947, he had availed himself of one of the original plaster and paper models obtained from Mrs. Nadelman, which he had set as focal accent in his splendid glass house, New Canaan, Connecticut. Forgotten in Nadelman's Riverdale attic for over a decade, the models were found in eroded condition shortly after the sculptor's death. Nelson Rockefeller, who had met and liked him when his mother acquired Nadelman's folk-art for Colonial Williamsburg, recognizing their fragile state, had the

two double figures cast in bronze. **[164-165]** Not only did this insure survival, it served as precedent for an ultimate placement in the beautiful opera-house for which, as Governor of New York State, he was also responsible. The World's Fair of 1964 offered a pretext to provide a permanent theater which would also serve as reception hall for the metropolis.

Philip Johnson carefully estimated the huge scale of the theater's foyer. This was justified as a parlor for a city which heretofore had to depend on hotels or armories for official greetings of queens, ambassadors, and astronauts. He sent his associate, Richard Foster, to Carrara, where an immaculate new vein of flawless white marble was opened. Skilled cutters, using Nadelman's models, cut the largest single blocks of stone ever dispatched from Italy. At their unveiling in 1964, their presence was largely ignored or occasionally forgiven. One visiting French critic disdained their *genre Despiau*, linking them to a Parisian follower of Rodin who bore no resemblance to Nadelman. Contractors for the erection of the State Theater, representing Lincoln Center for the Performing Arts, Inc., were dismayed when the big figures revealed themselves in metaphorical nudity. Workmen cracked dirty jokes; bulk, amplitude enhanced their plump nakedness. A hole had been left in the wall of the room to admit them, since they were too large to be brought up the stair wells. Gossip buzzed as to whether they might not still be removed; perhaps the precedent of controversy in the early 'Thirties when the huge fresco by Diego Rivera overlooking Rockefeller Plaza was hacked off provided warier consideration. Fortunately, work was on schedule; walls were sealed and travertine facing was set in place. Nadelman's masterpieces were safely imprisoned within their superb room. His marbles are burlesque divinities, their confident bosoms stockinged over with a criss-cross, see-through reticulation suggesting skin tights of circus riders, trapeze artists, or ballet dancers. The New York State Theater, now controlled by the City Center of Music and Drama, is permanent home for performances of *bel canto* singing and academic classic dancing, whose repertories are based on tradition, training; aristocratic physical and metaphysical principles.

So, finally, Nadelman has his pair of twins cut and lamped in a great hall of gold, rose marble and crystal, as festive magnets in daily ceremonial contact with big popular audiences, polarized by the excitement and fulfillment in lyric performance. Their glorified godmothers appeared in Justinian's circus alongside Theodora, a tumbler who came to be crowned empress. Their legitimate grandmothers worked for Barnum and Bailey, their mothers for Ziegfeld or Minsky. **[102, 131]** Nadelman was orchestrator of gestures, a symphonic conductor of plastic silhouettes. His statues propose standards useful in measuring the still limitless dynamics of humane virtuosity.

Nadelman's career occasions meditation quite apart from aesthetics or his surviving

relics. Their sequence in style or material can serve as one commentary on historical process in his era. This with his attitude towards the general service of sculpture forms a marginal but not entirely minor gloss on the fate of artists strongly attached to tradition in crisis.[12] As we race towards the end of one millennium, sprouts of ebullience which, despite war or revolts, still seemed green in the first half of its last century largely wilt. We hardly comfort ourselves in remembering that 1872 was no cheery year for Paris or New York. 1772, 1672, 1572, whichever, were not red-lettered for peace, prosperity or hygiene. Yet menace today reads to us here threatened the more terrifying, not only since it is we not yet dead who are pressed, but because of what Daniel Halévy called *"l'accélération de l'histoire."* Historical probing absorbed Nadelman's intelligence and imagination; his sense of a marble or gilt-bronze past was no less intense than his wooden or plaster present.

Since three recent wars, historicity has often been repudiated. Programmed triviality, applied with doctrinaire inconsequence, has tried vainly to suspend causality. Methods for utilizing systematic irrationalism have led just as often to suicide as to an extension of healthy self-consciousness. Industrialism no longer promises just provender, but more patently pollution. Conquests of lunar space are undetermined as profit or loss. One certain loss, among others, is artistic anarchy, evaporation of digital mastery or belief in academic draftsmanship, a structural ground for twenty-five centuries. Apprenticeship is canceled. Architectural adornment, once a prime function of carving, vanished as architecture itself abdicated to needs for cubic shelter. No town is free from siege conditions or garrisoned futures. On every continent, slave populations are restive. Hence, a need for the very nature of art as it has been is put to hard, insoluble questions. Hand-made artifacts, hand-painted pictures hold diminishing magic for painters or patrons. In this context Nadelman may be numbered among the last of a clan. His passion for folk-art claims him as a founder of Pop art, in itself a gross parody of the pseudo-innocence in aimless or mindless mass production. Nadelman's private response to personal extinction reads as one more footnote to Doomsday. As sexuality or extension of permissiveness in speech and act was for our parents, so Doomsday is, for us, the Big Subject. Imminence of technological violence or absurd annihilation trivializes much lonely eagerness. Energetic curiosity can easily read as vain pretension. A classic and stoic like Nadelman transcended self-pity and triviality in salvaging the monumental by the miniature.

New Year's Day 1973.

PLATES

Sculpture, Sketches, Sources

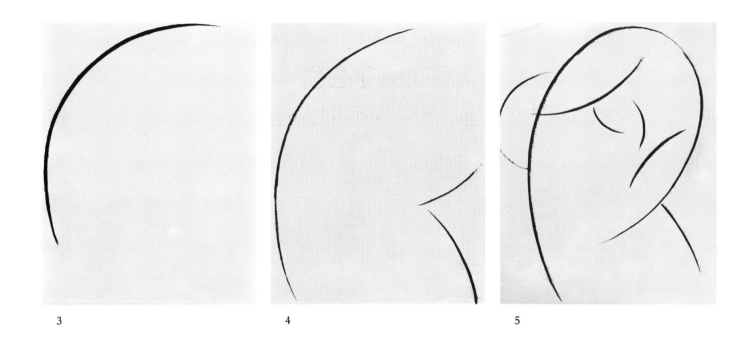

3

4

5

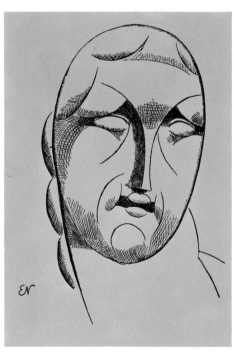

6

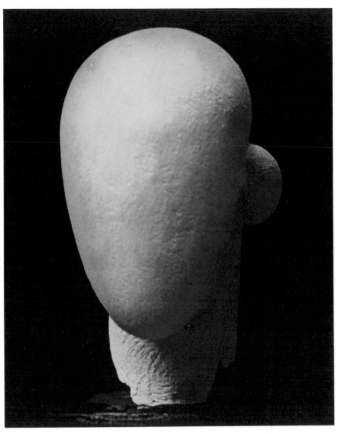

7

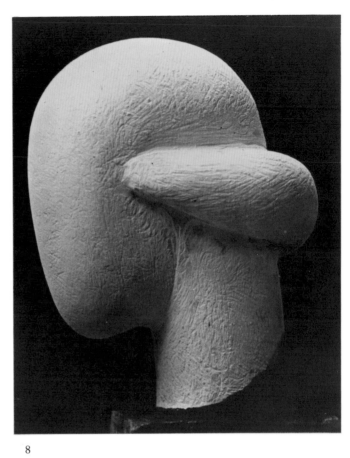

8

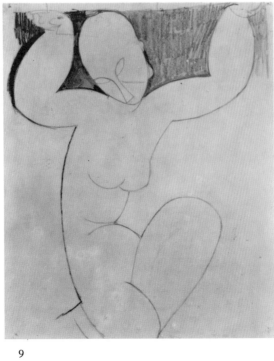

9

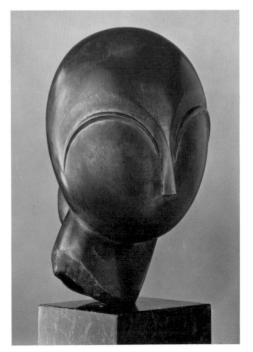

10

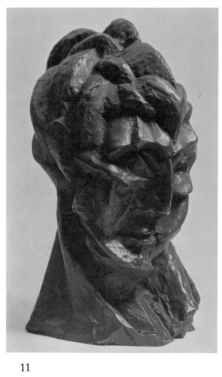

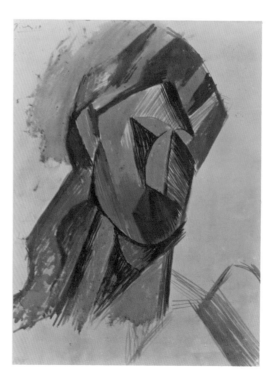

11 12

13

14

15

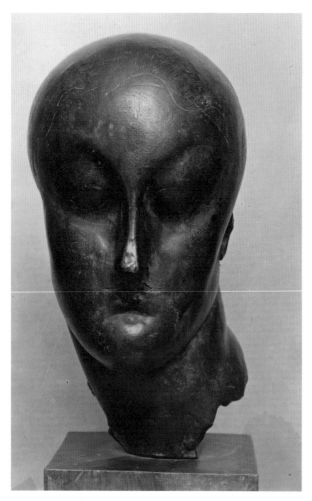

16

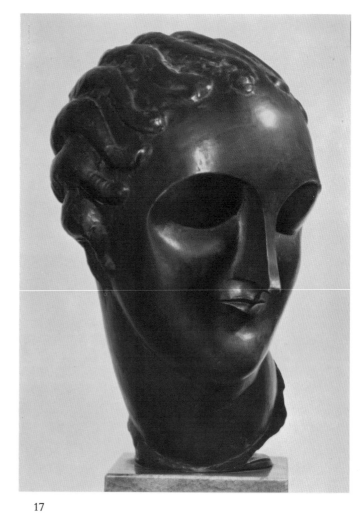

17

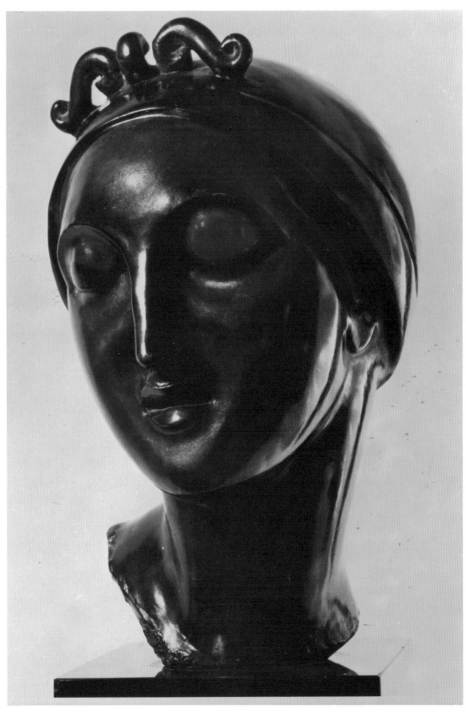

18

19

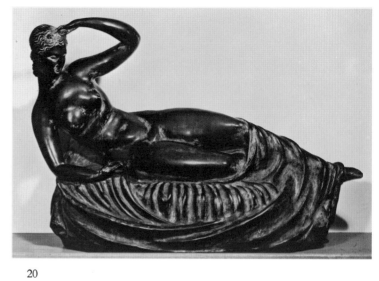

20

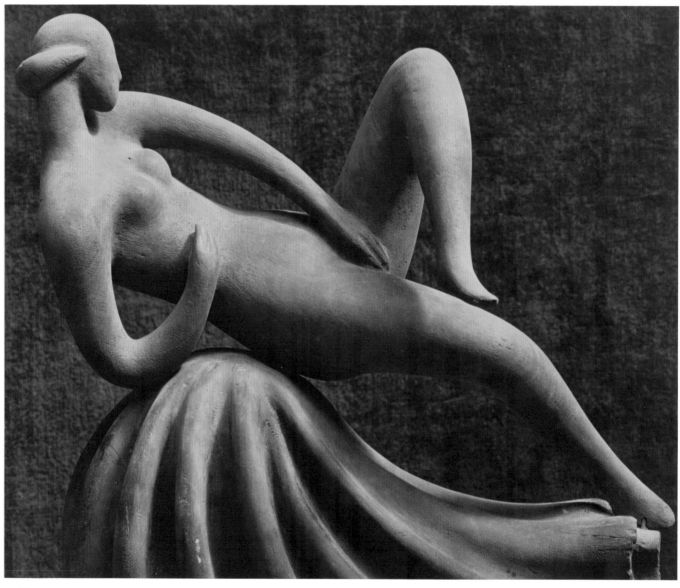

21

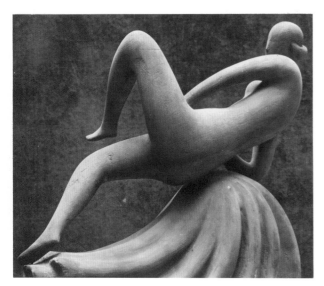

22

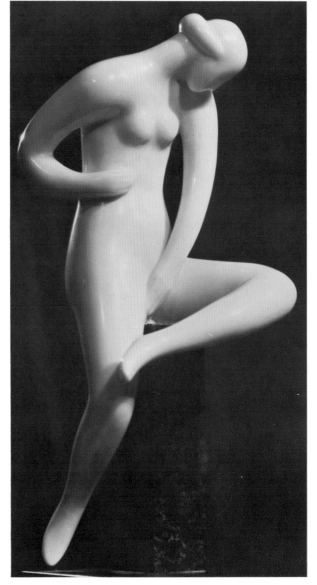

23

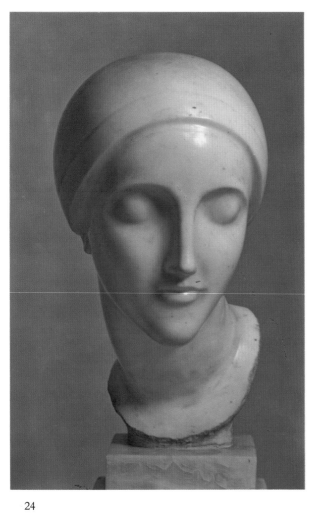

24

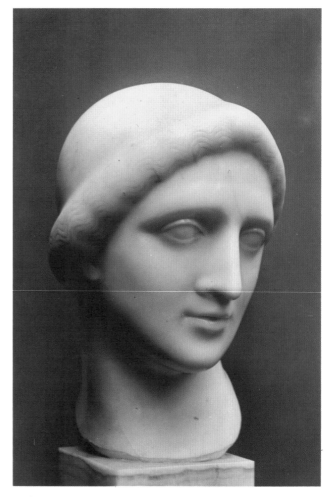

25

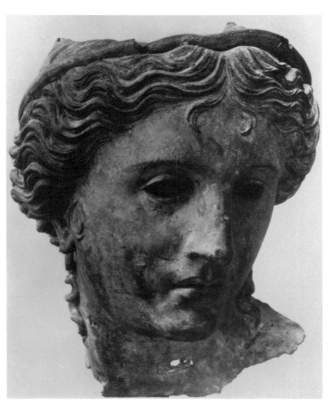

26

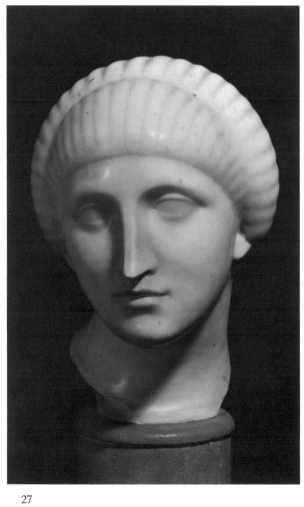

27

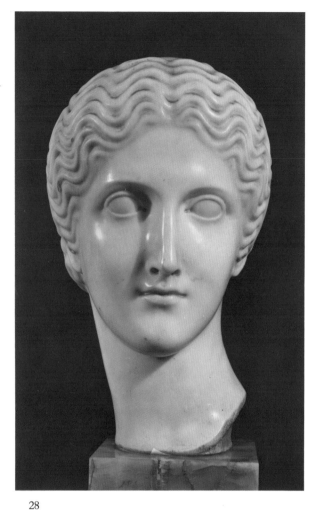

28

29

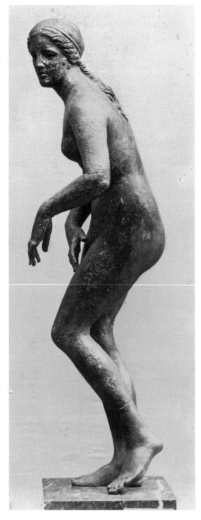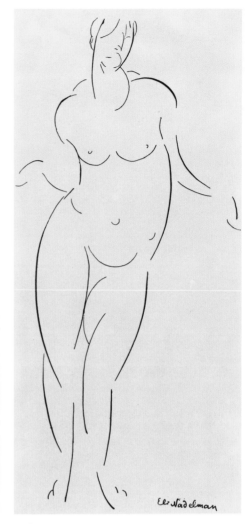

30 31 32

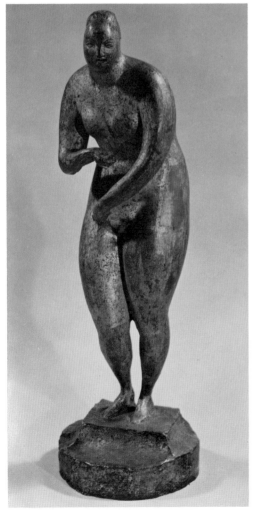

33

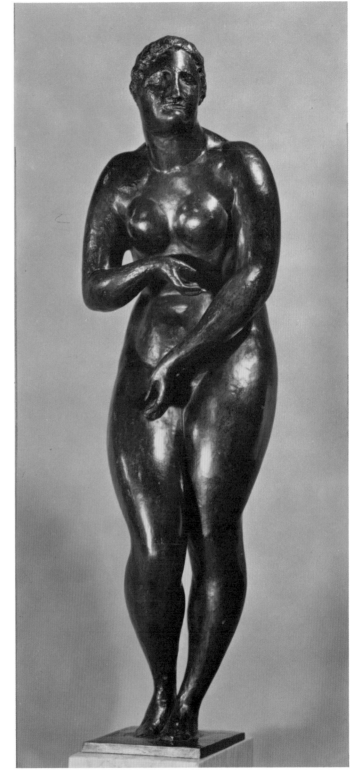

34

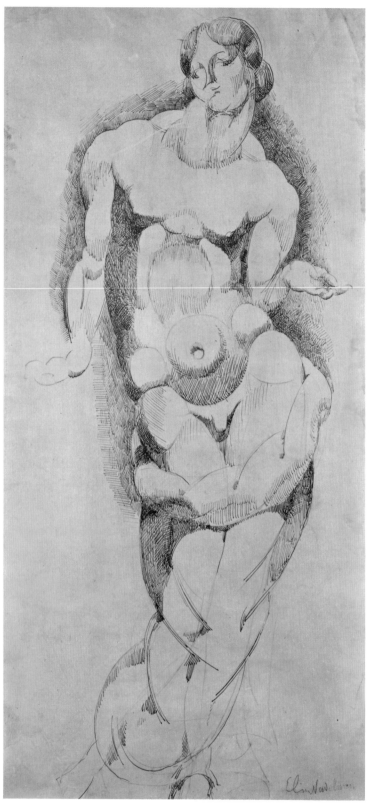

35

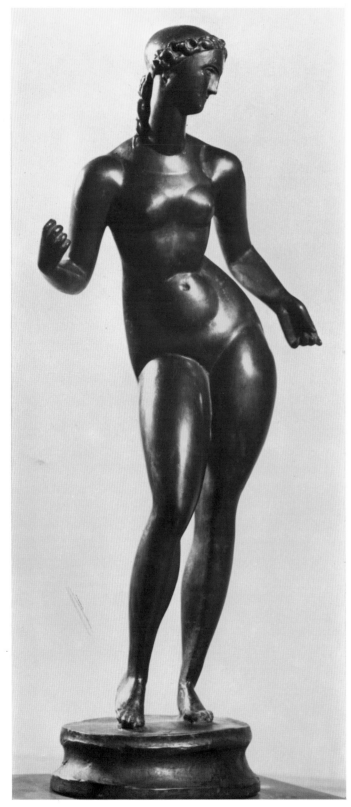

36

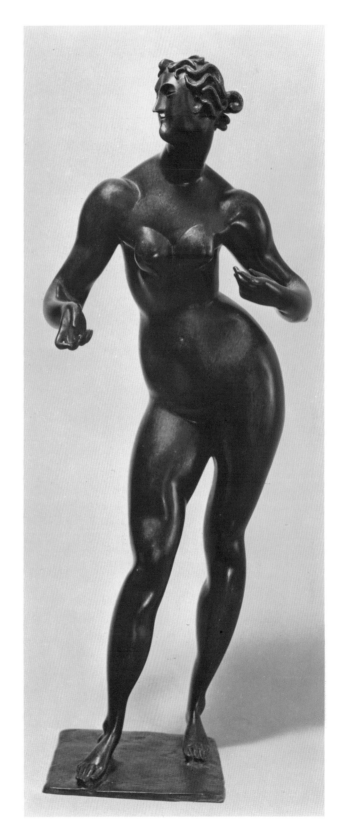

37

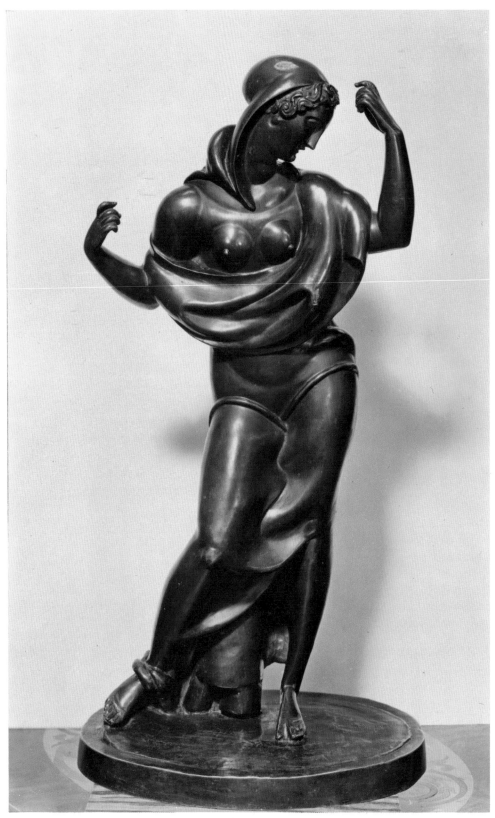

38

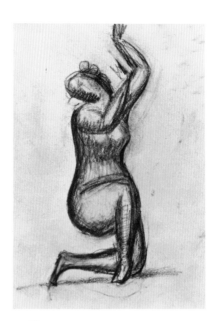

40

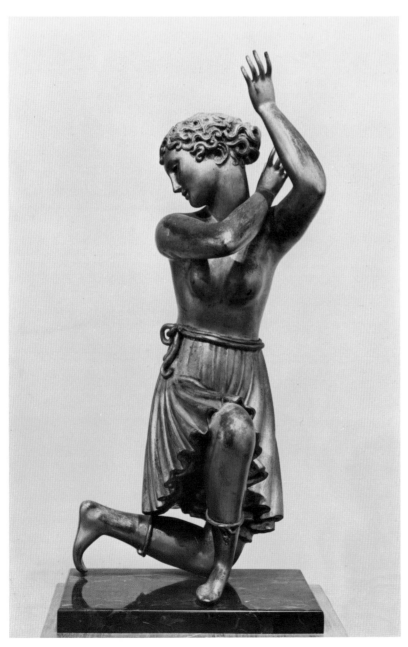

39

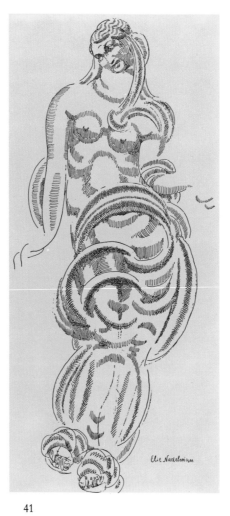

41

42

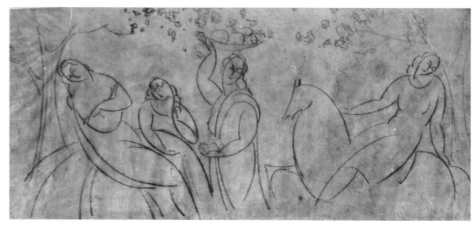

43

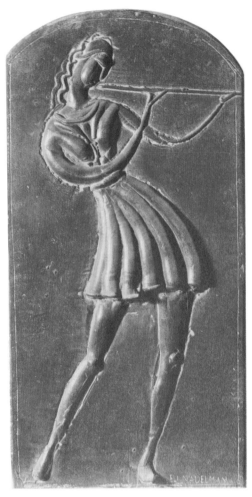

44

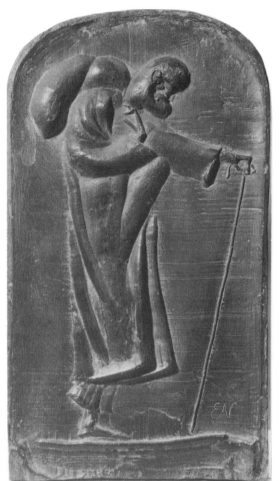

45

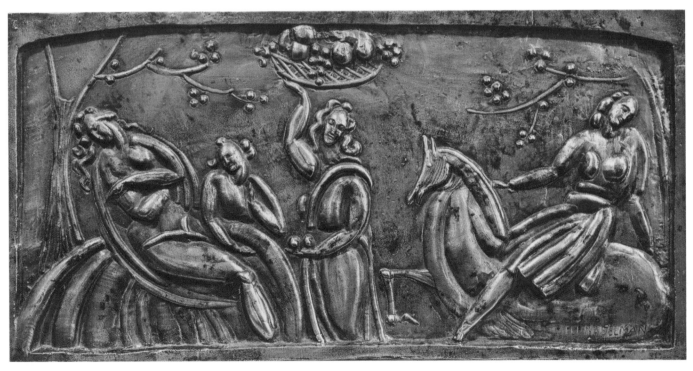

46

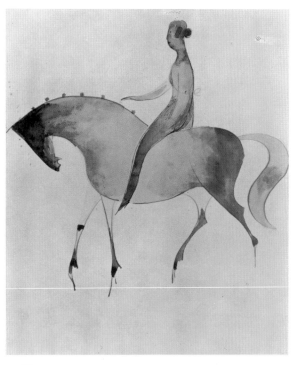

47

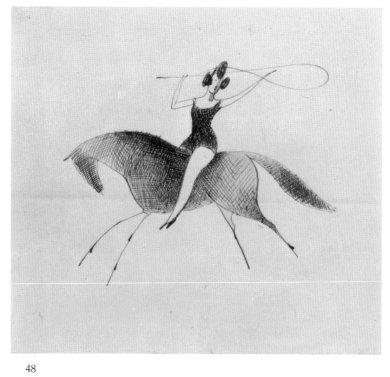

48

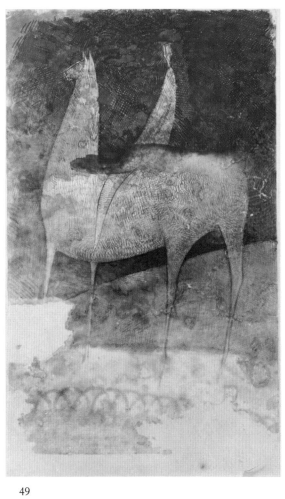

49

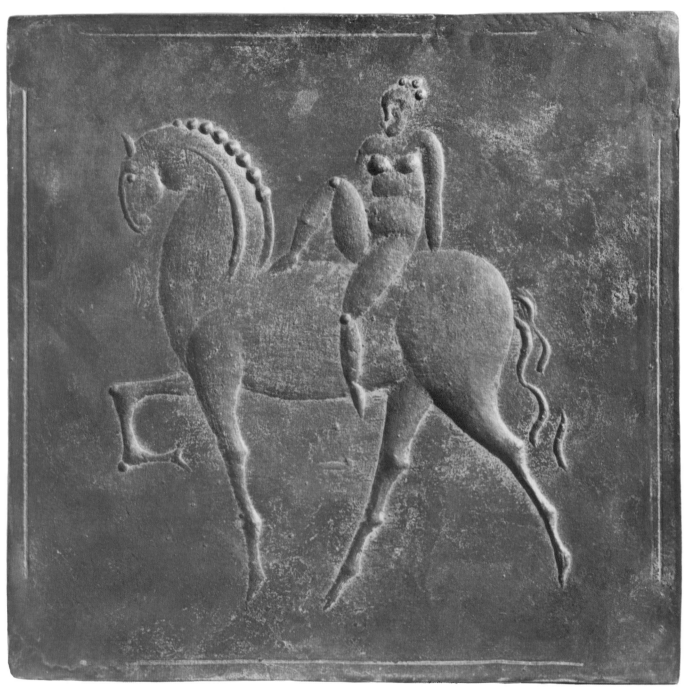

50

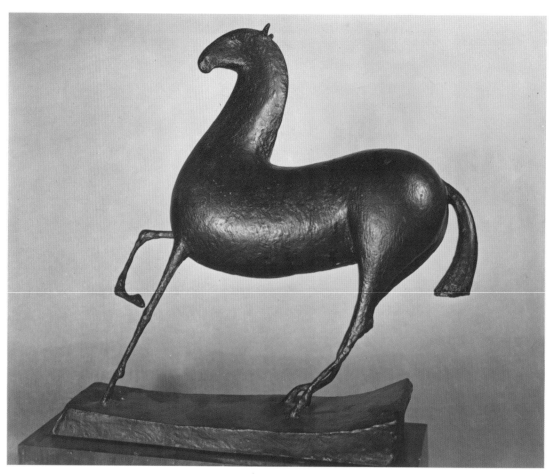

51

52

53

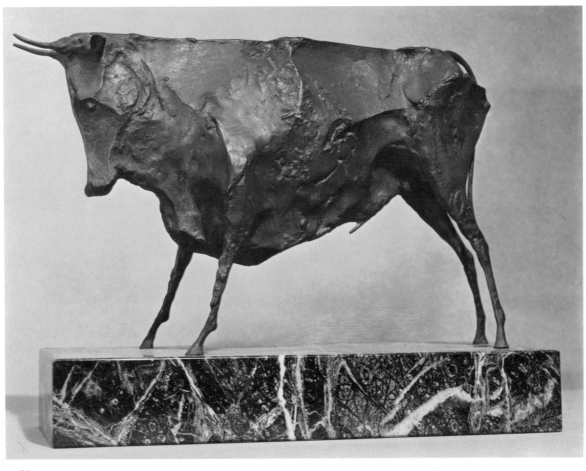

54

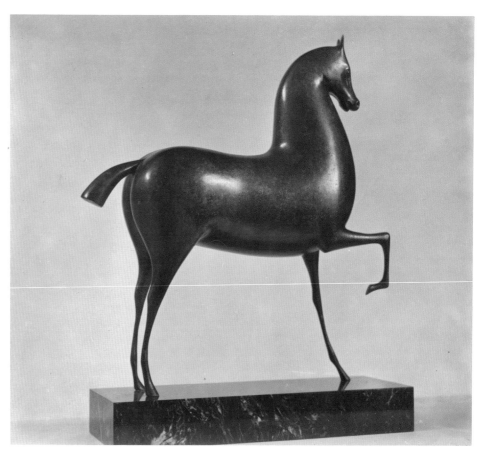

55

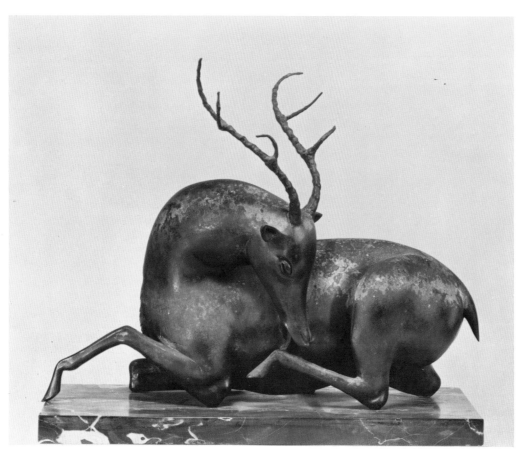

56

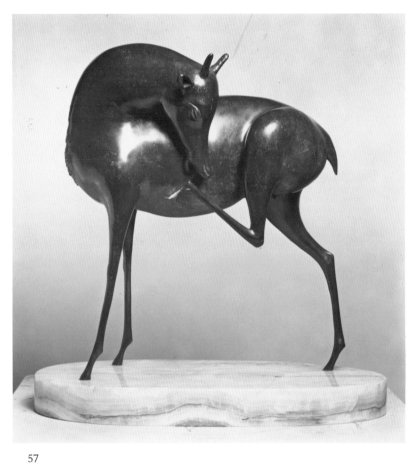

57

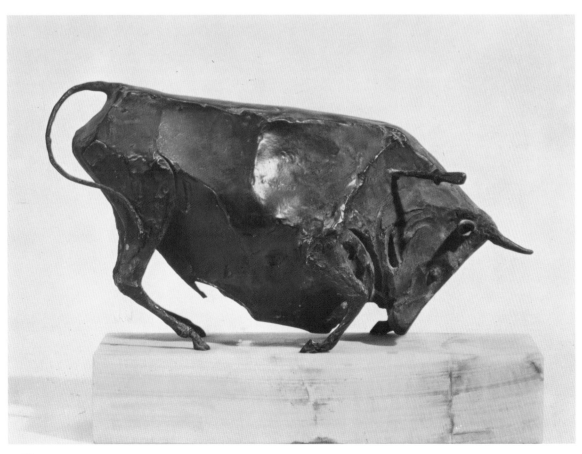

58

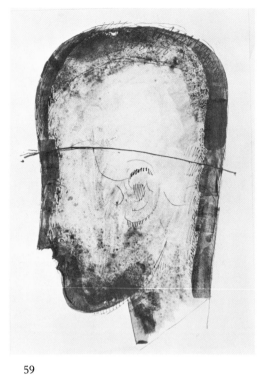

59

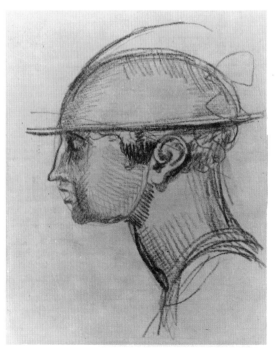

60

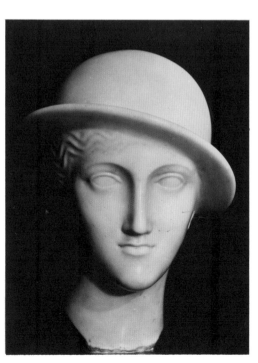

61

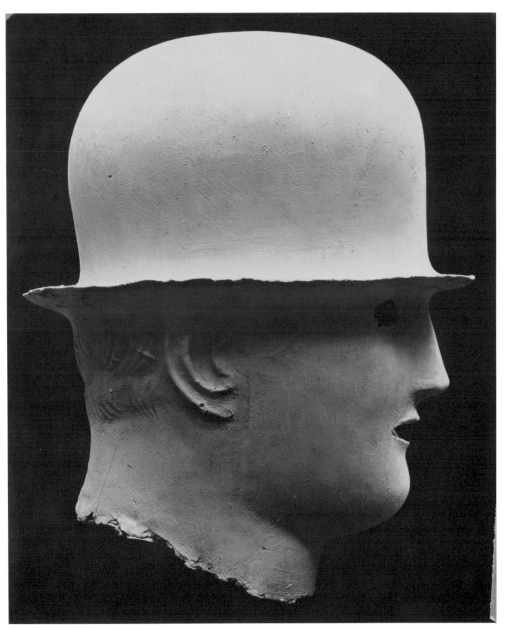

62

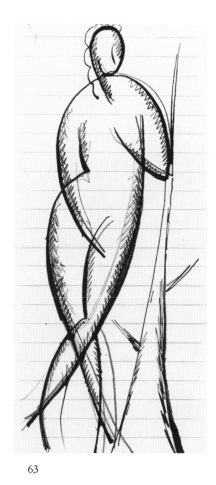

63

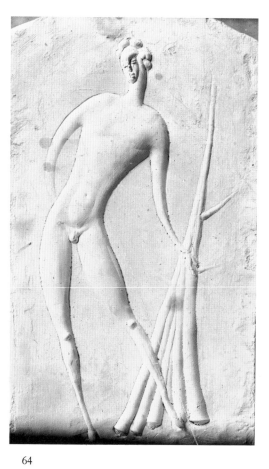

64

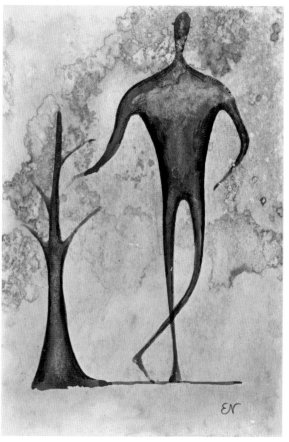

65

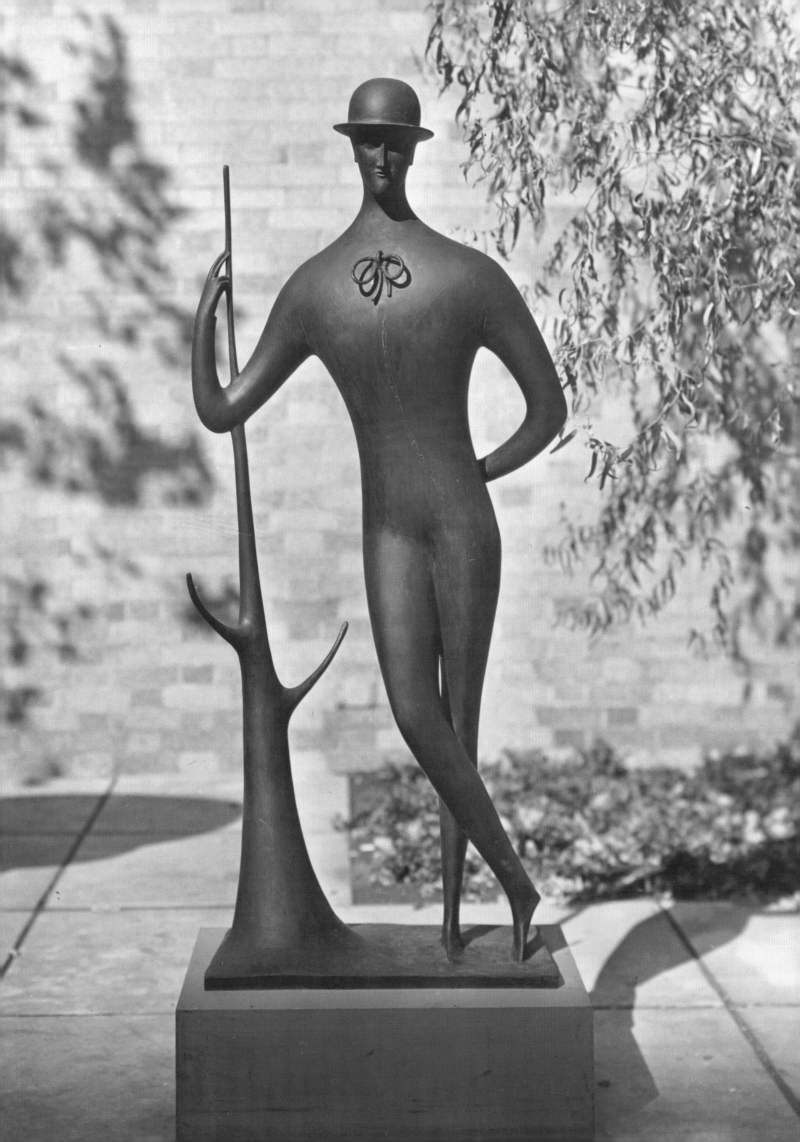

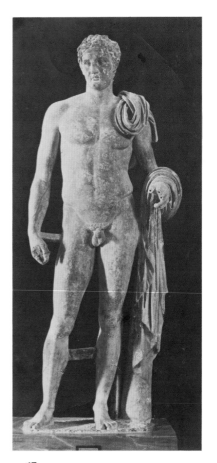

67

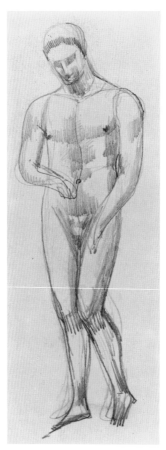

68

69

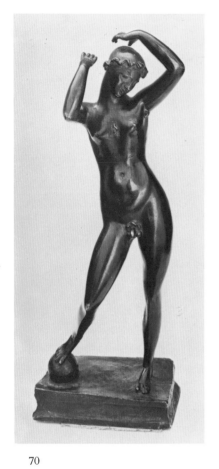

70

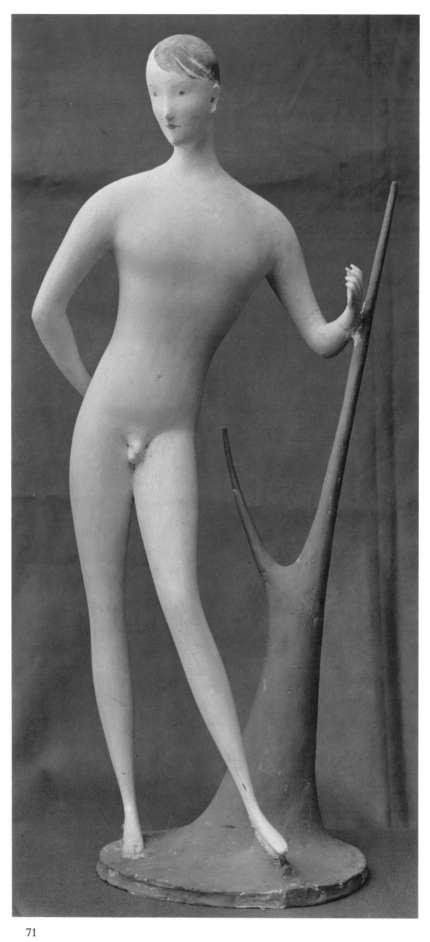

71

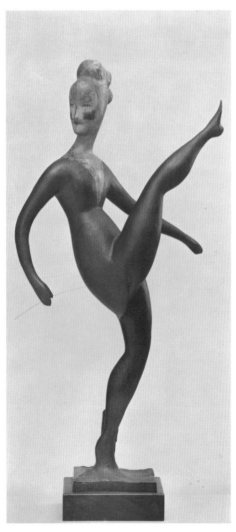

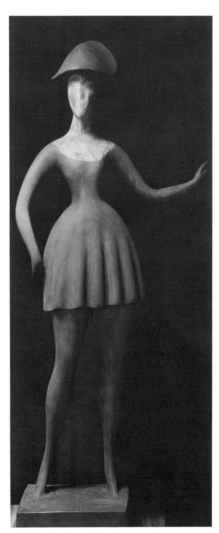

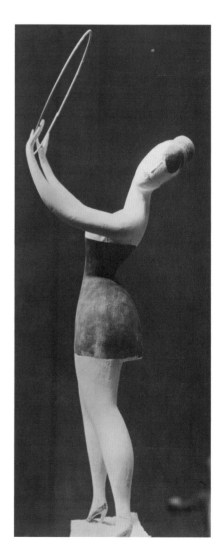

72

73

74

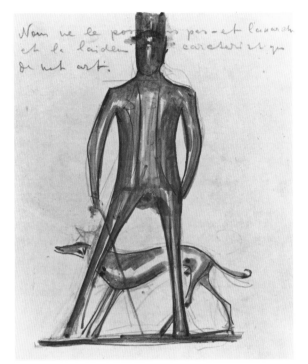

75

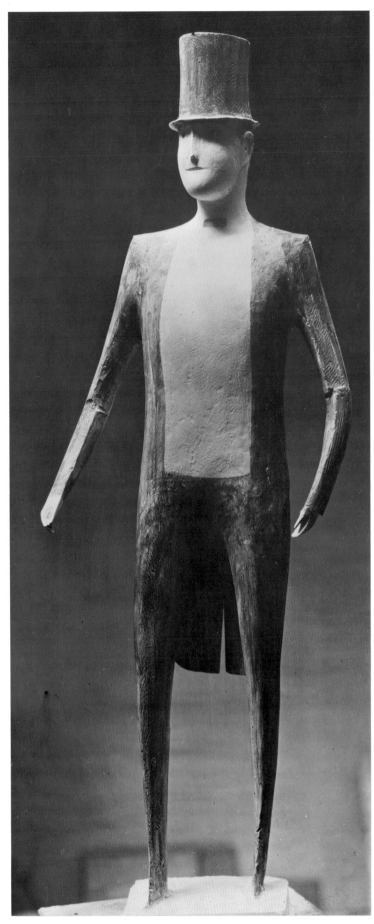

76

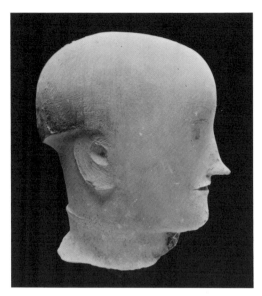

77

78

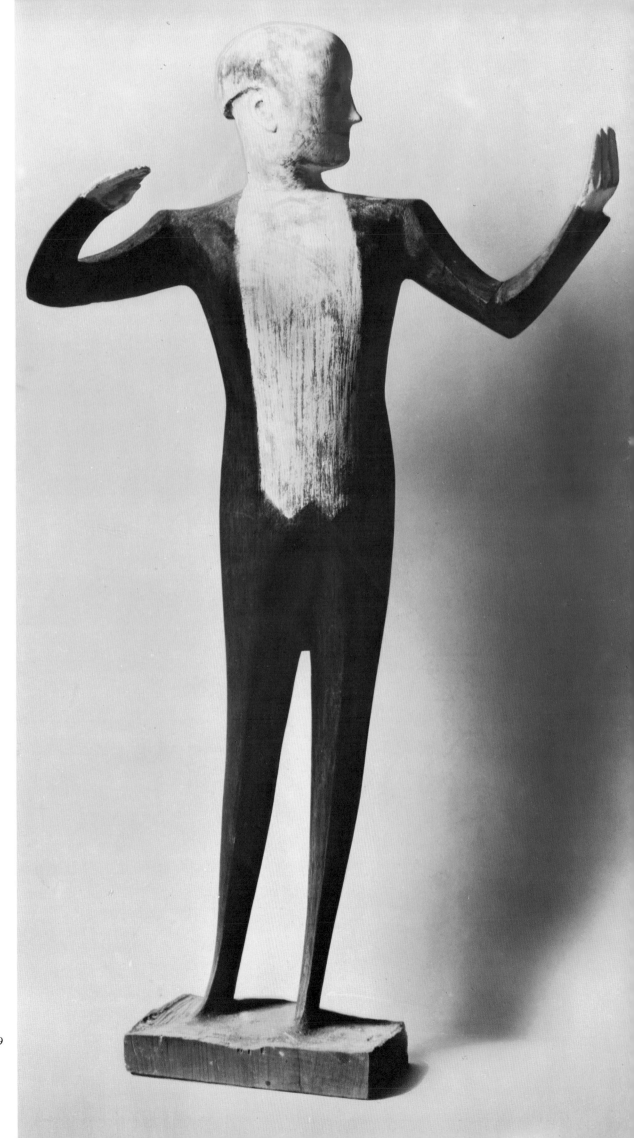

79

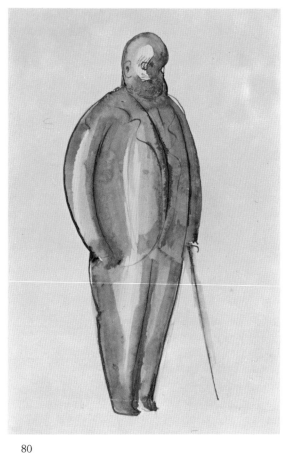

80

81

82

84

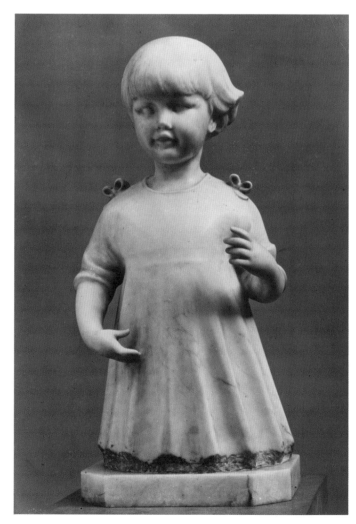

85

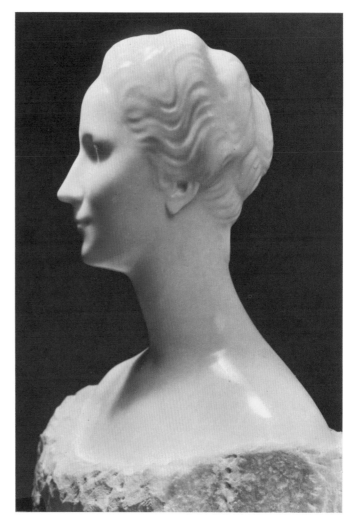

87

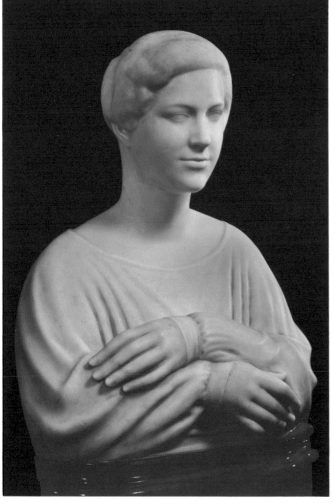

86

88

89

90

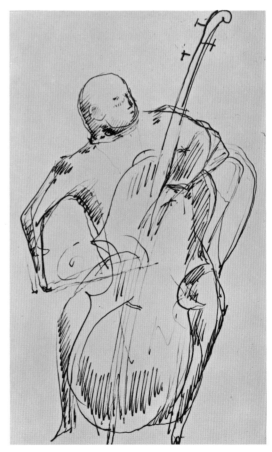

91

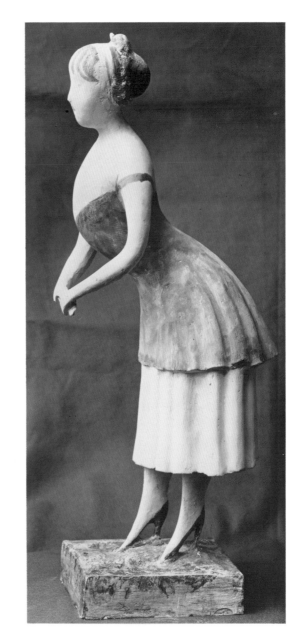

93

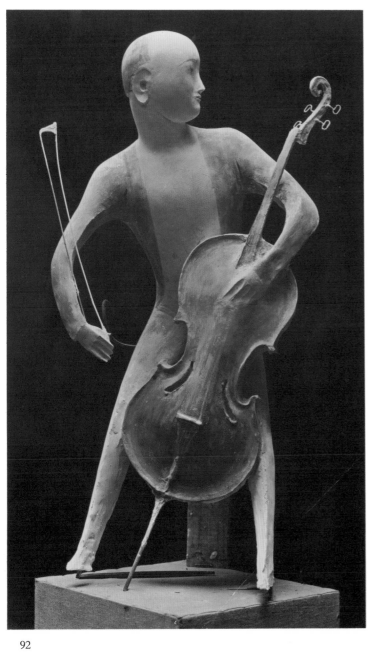

92

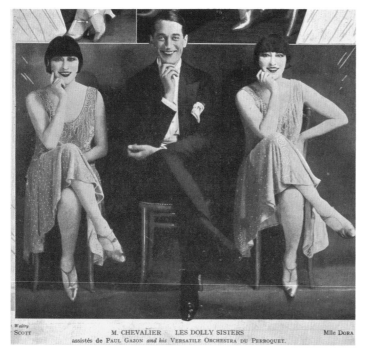

Waléry
Scott

M. CHEVALIER LES DOLLY SISTERS

Mlle Dora

assistés de Paul Gazon *and his* Versatile Orchestra du Perroquet.

94

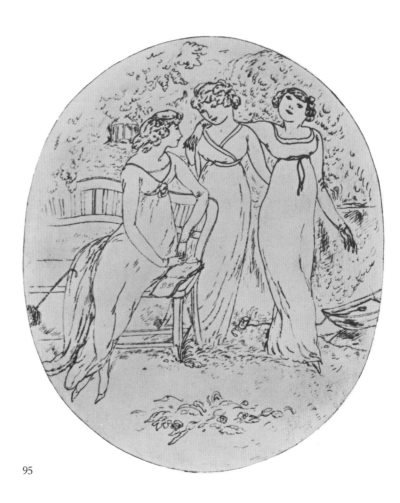

95

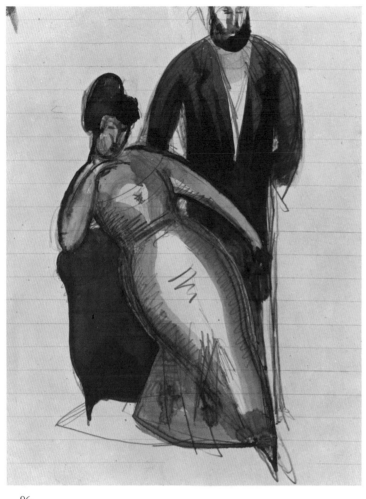

96

97

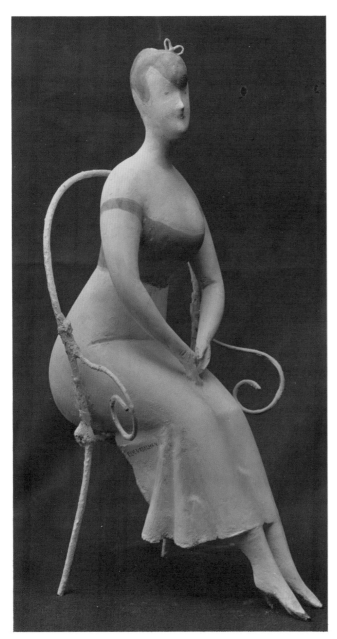

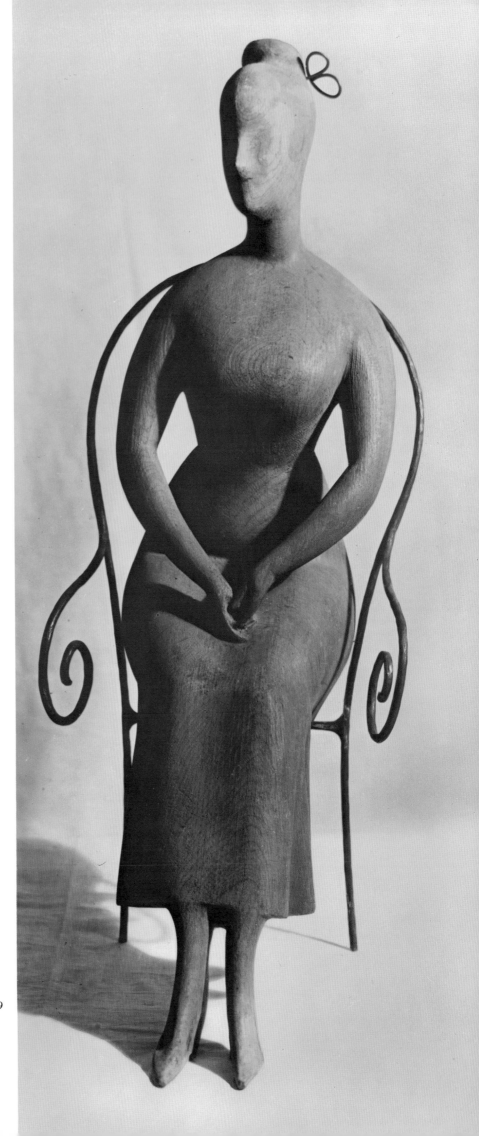

99

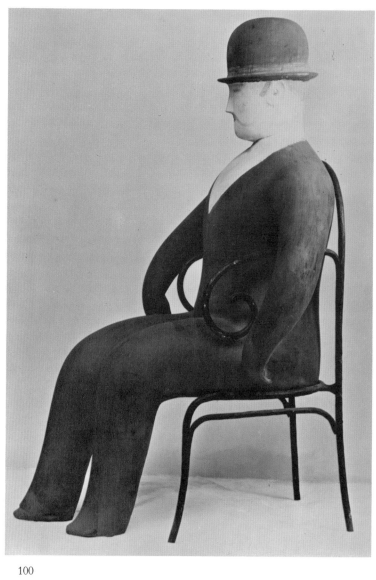

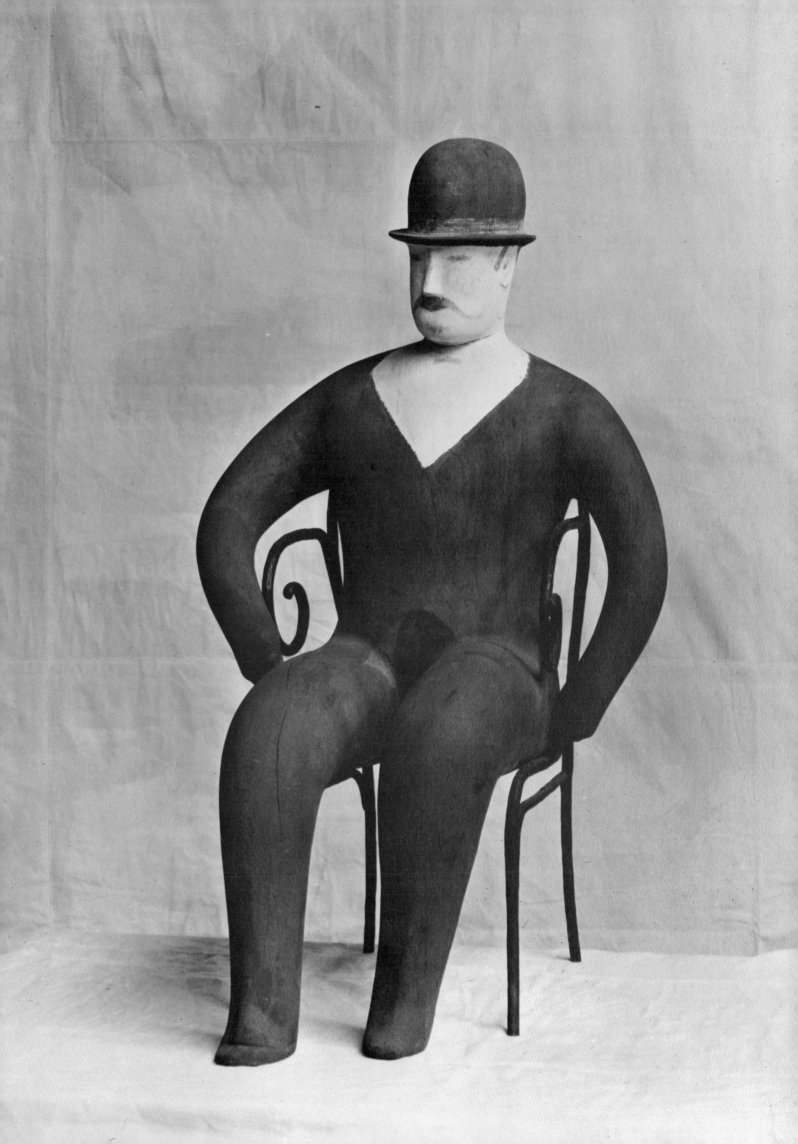

104

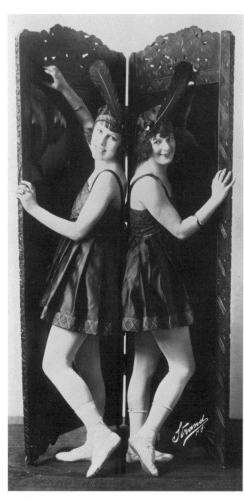

102

103

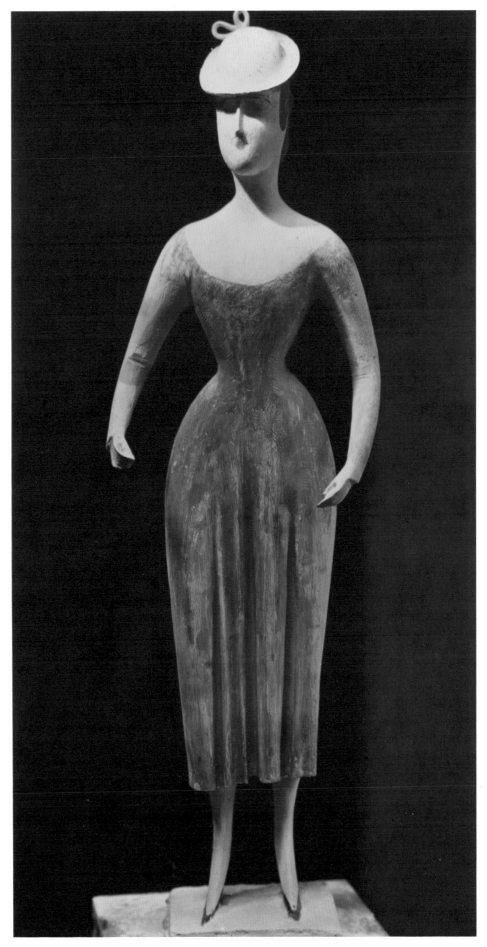

105

106

107

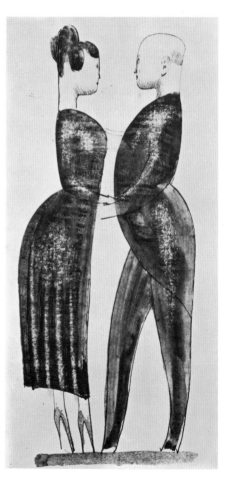

108

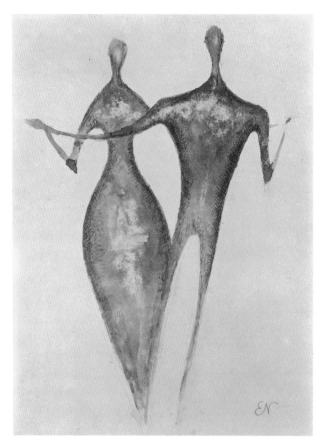

111

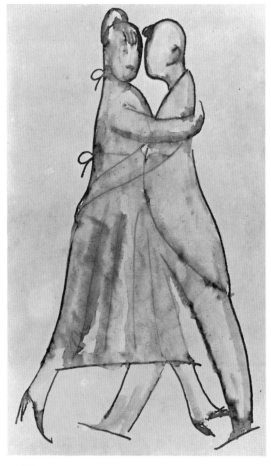

109

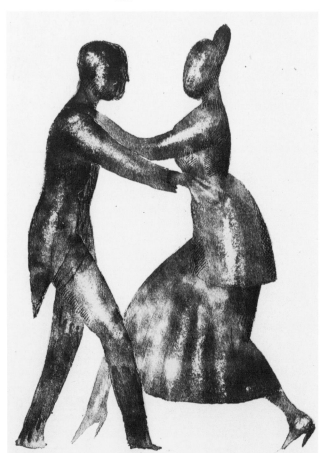

110

112

113

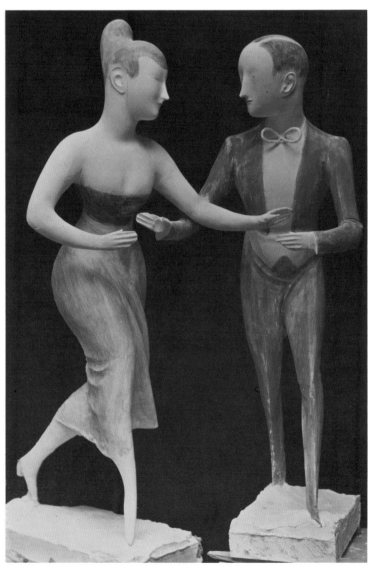

114

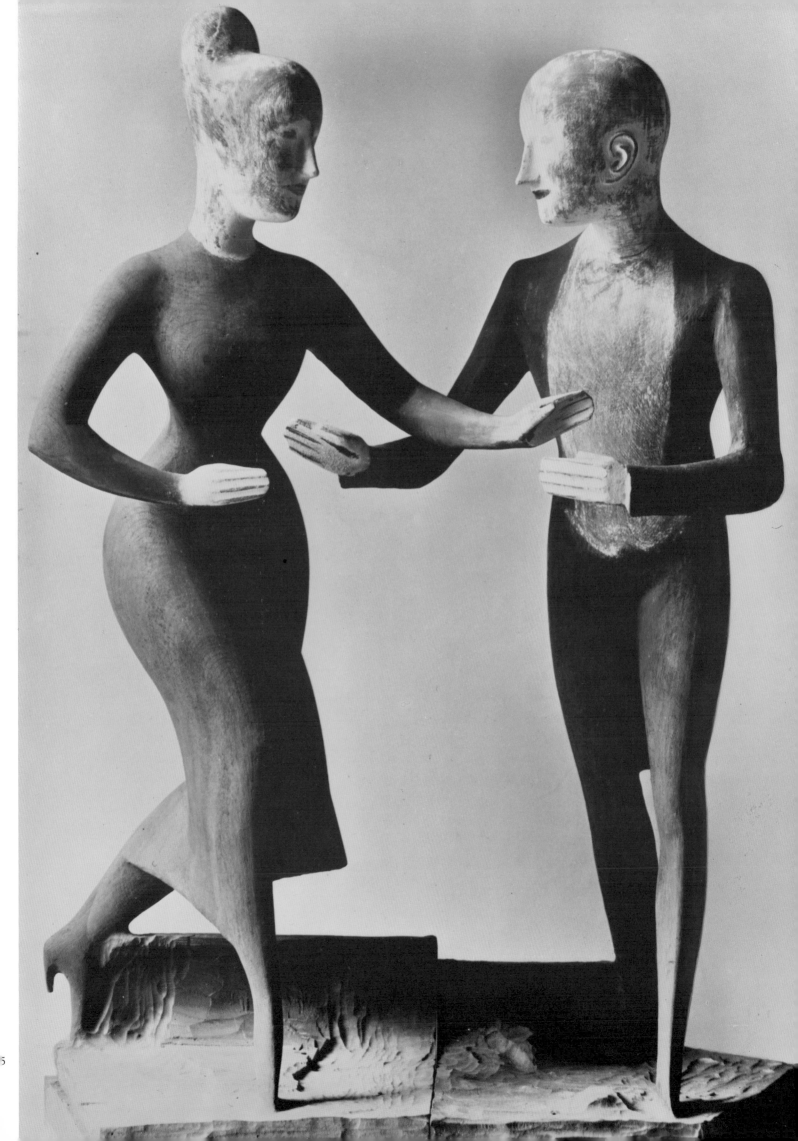

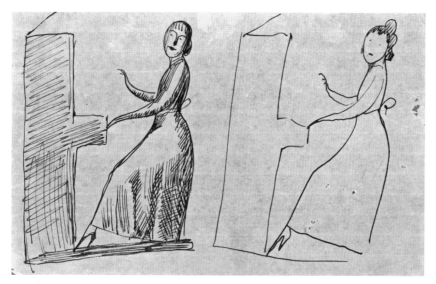

116

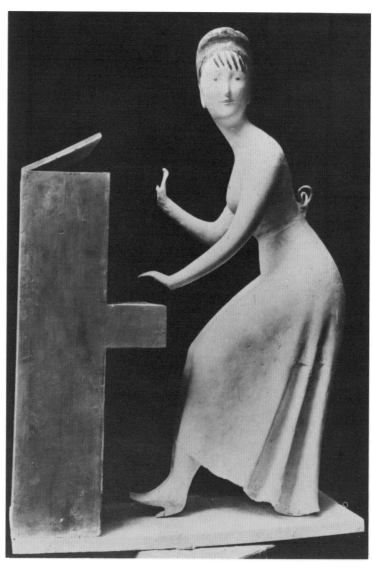

117

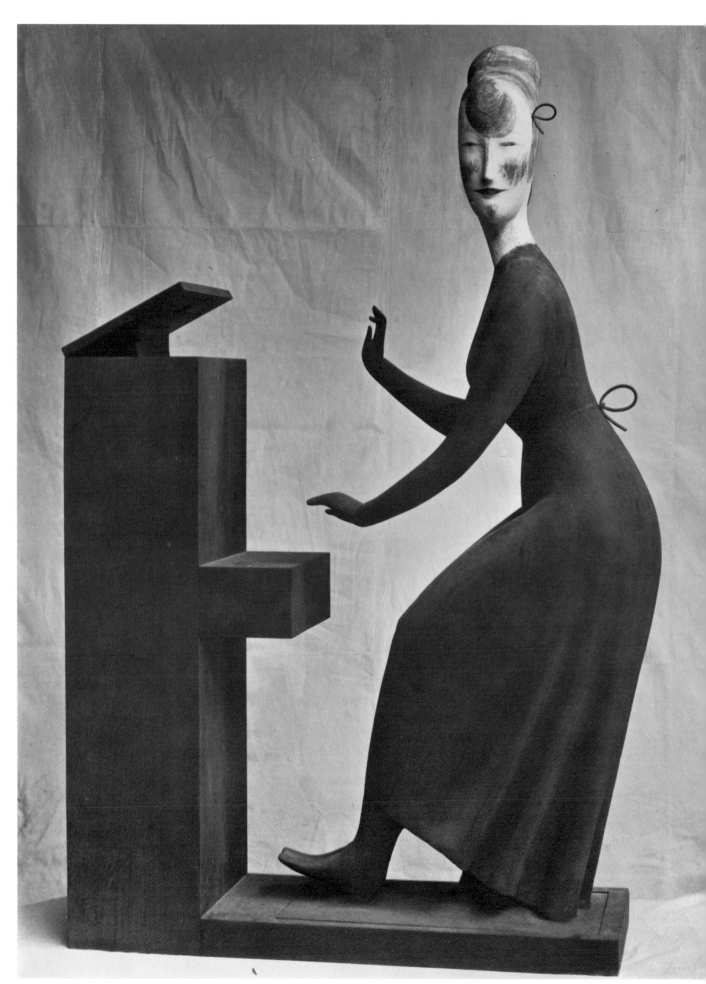

119

120

121

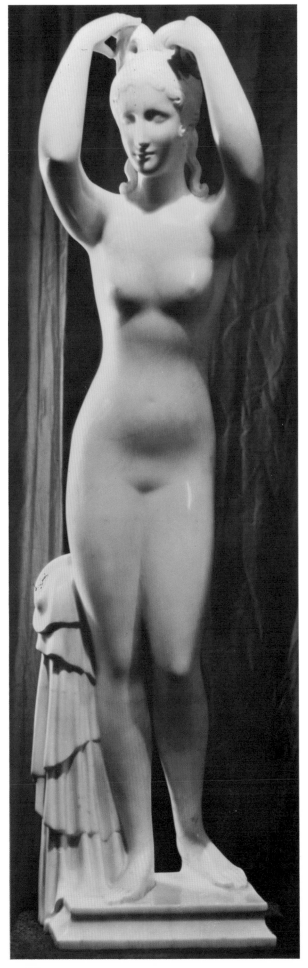

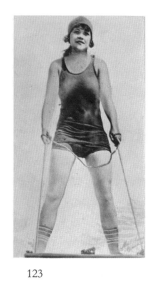

123

124

125

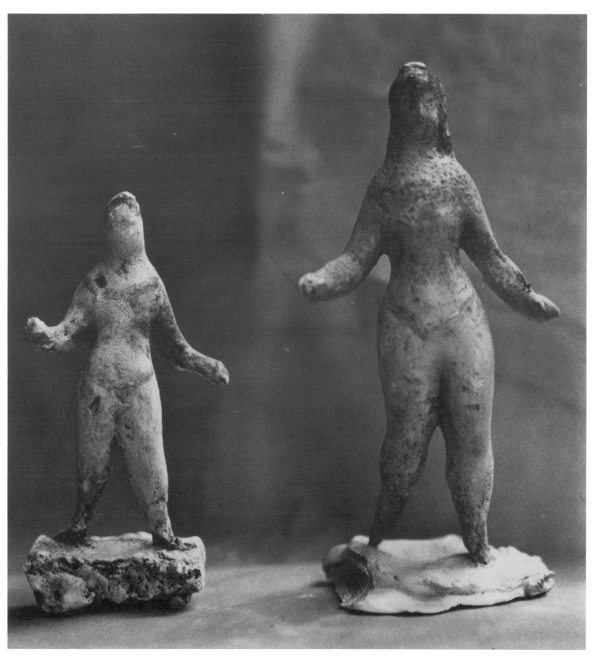

126

127

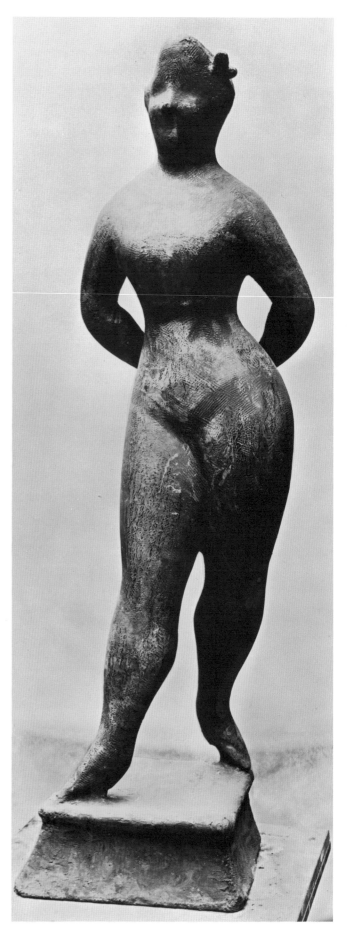

128

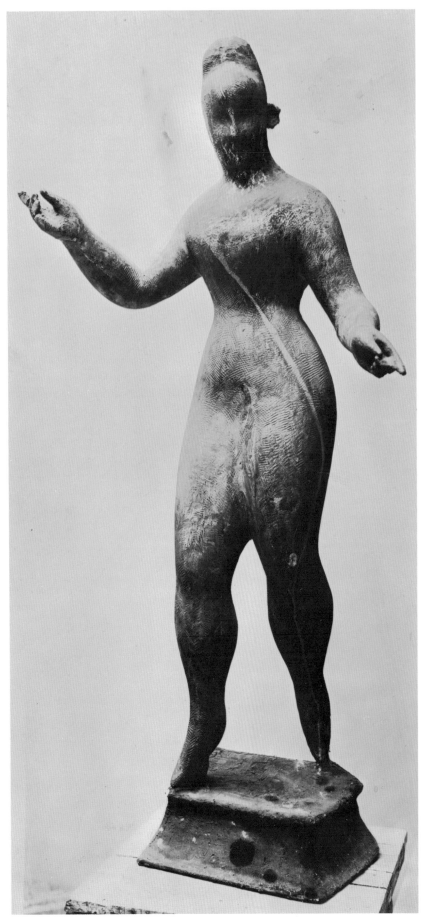

129

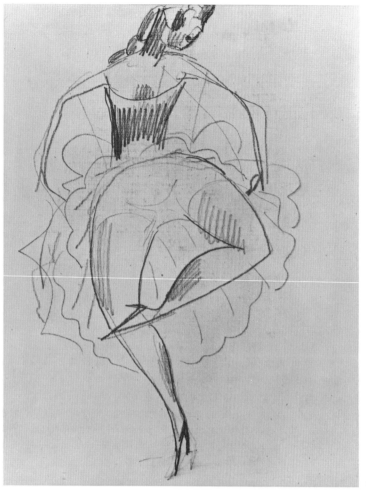

130

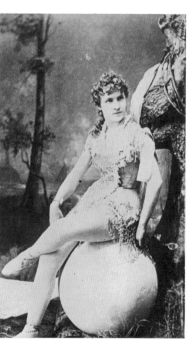

131

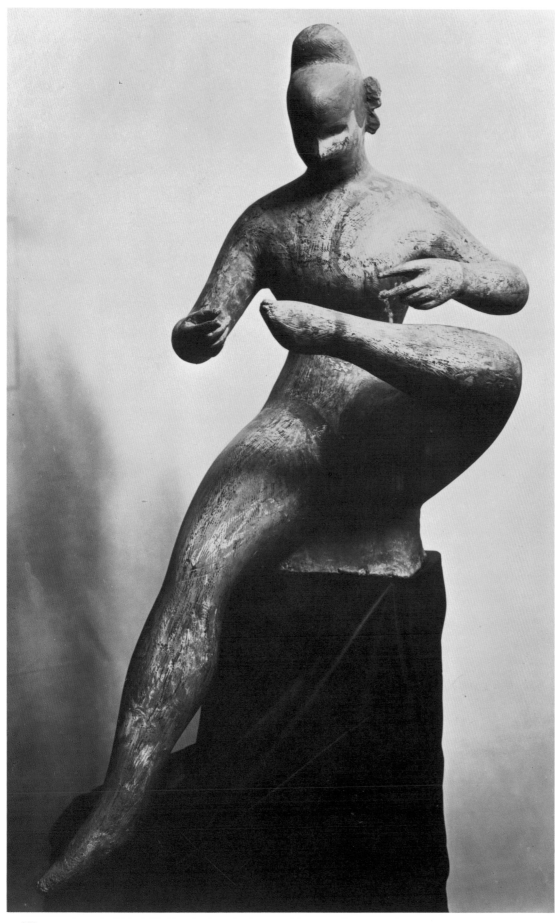

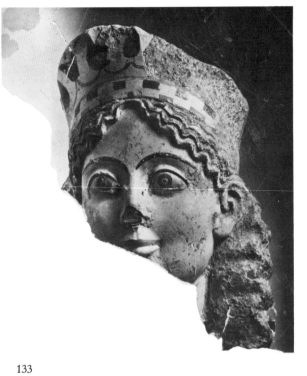

133

134

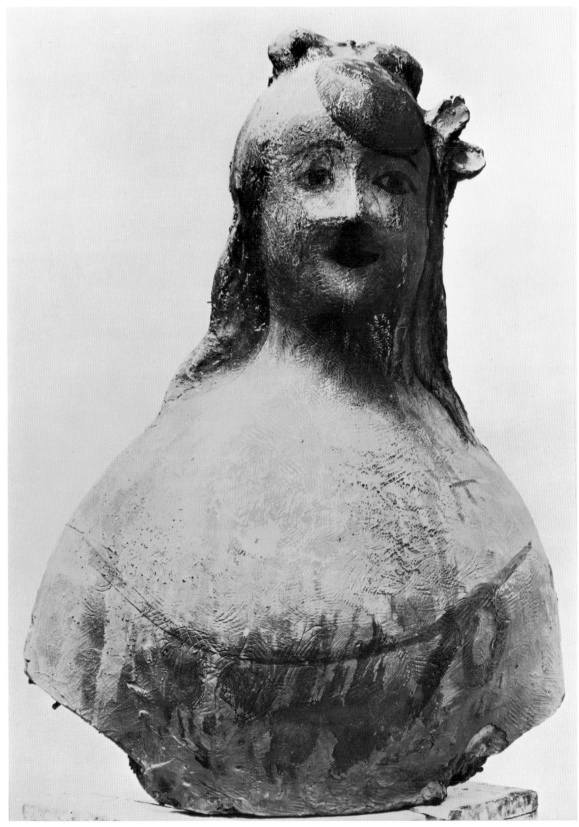

135

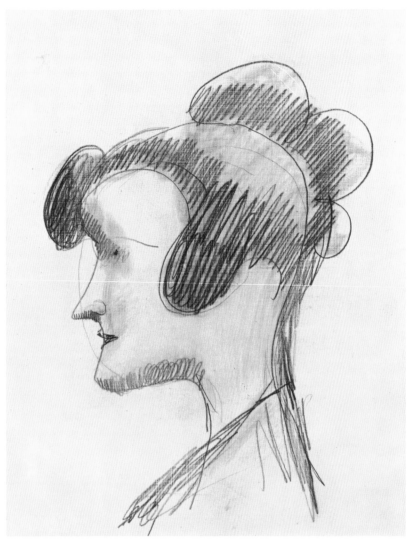

136

137

138

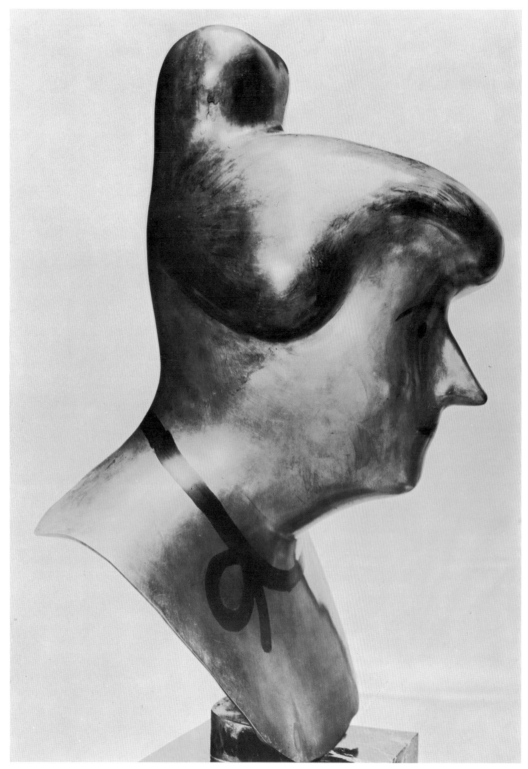

139

140

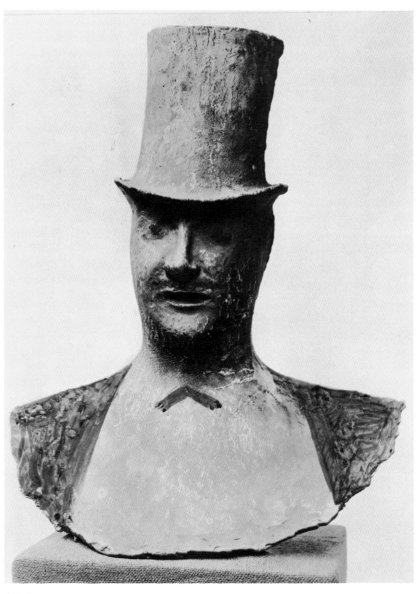

141

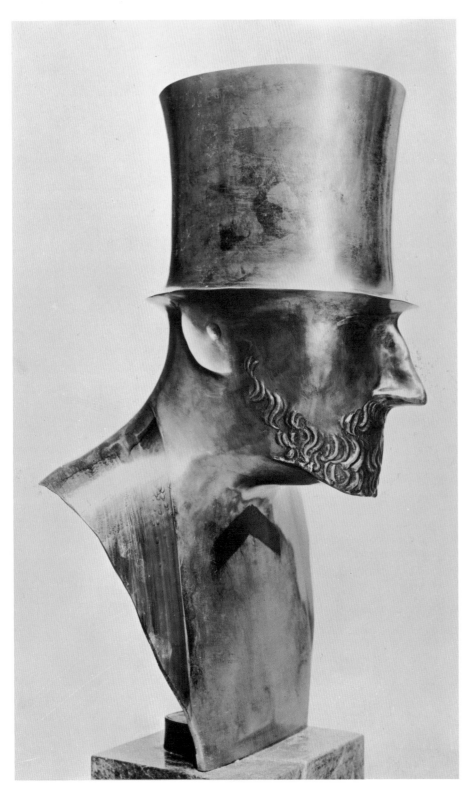

142

143

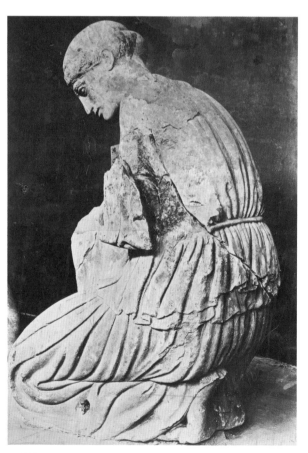

144

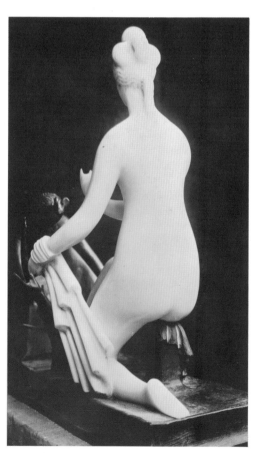

145

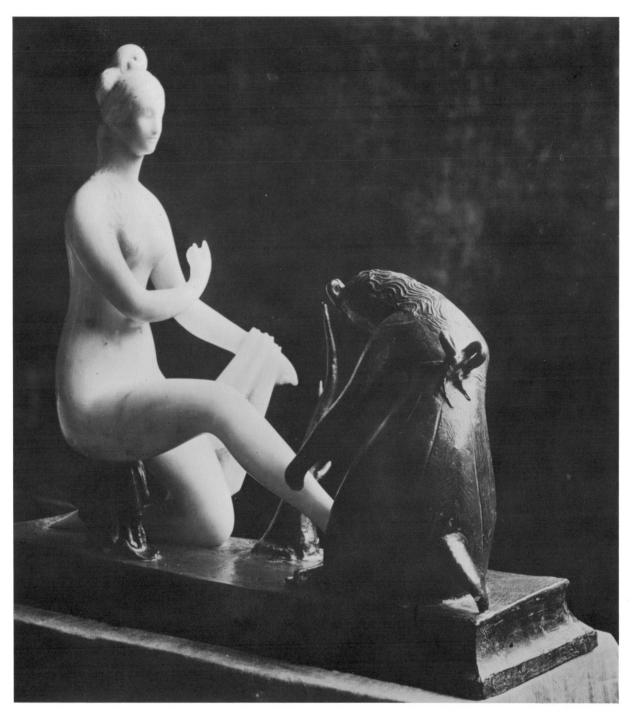

146

147

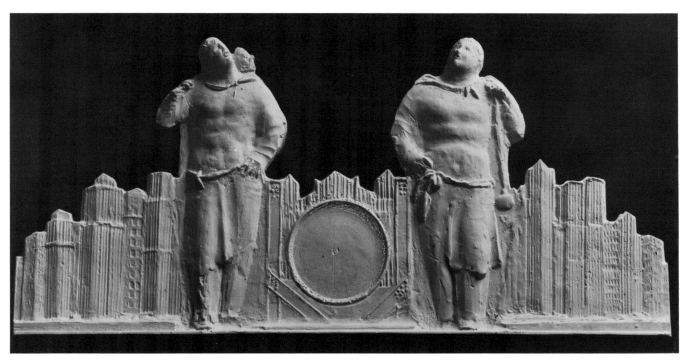

148

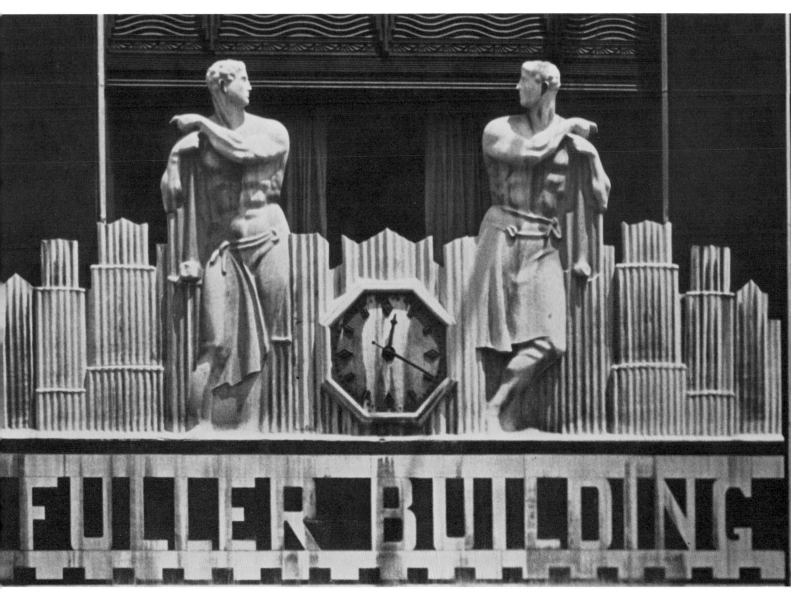

149

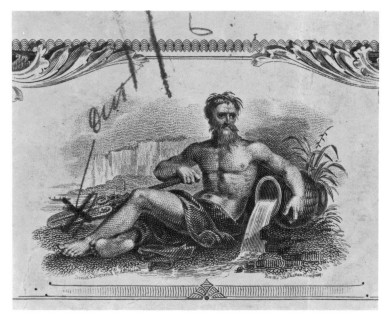

150

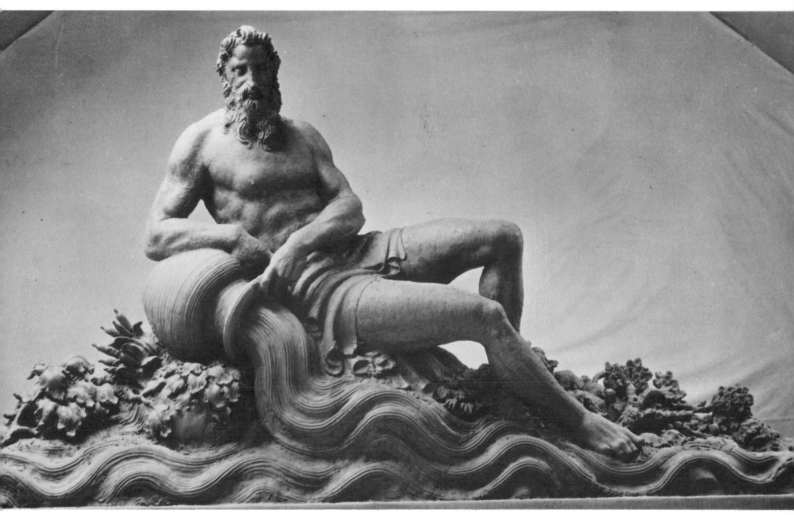

151

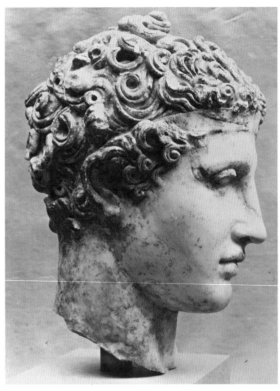

152

153

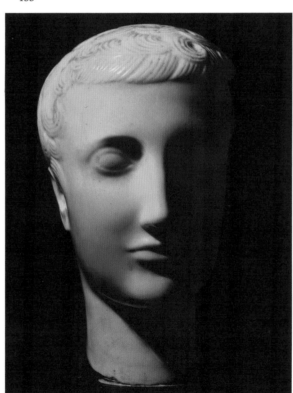

154

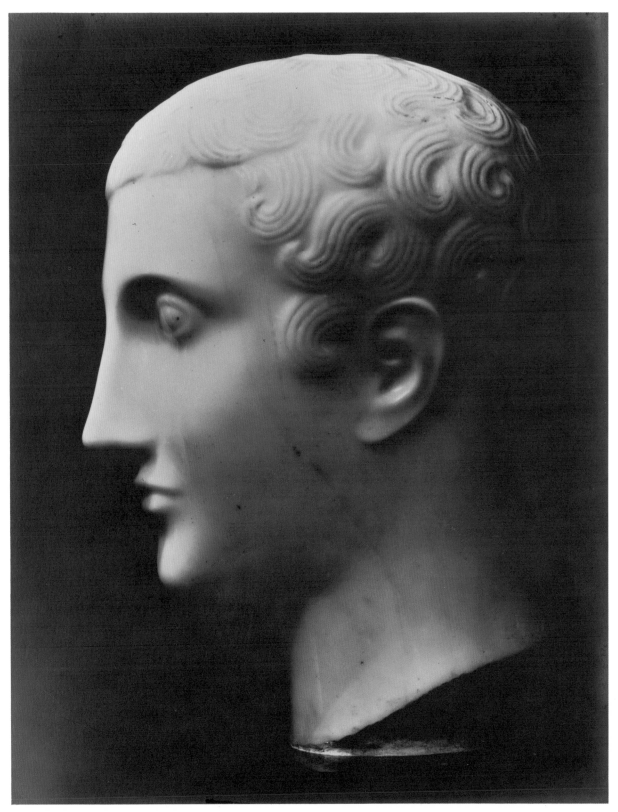

155

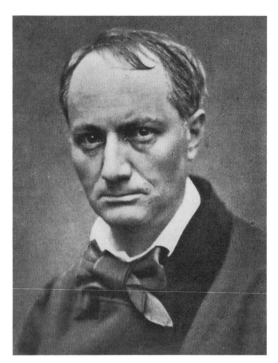

156

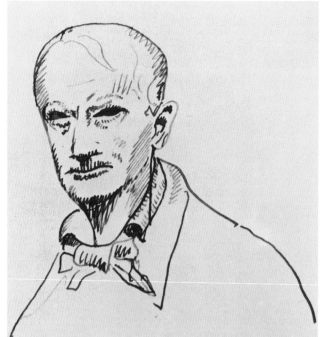

157

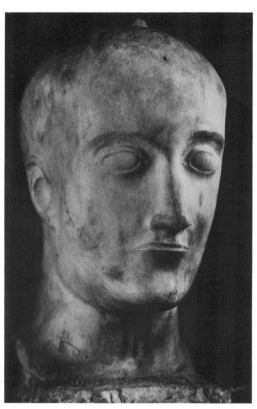

158

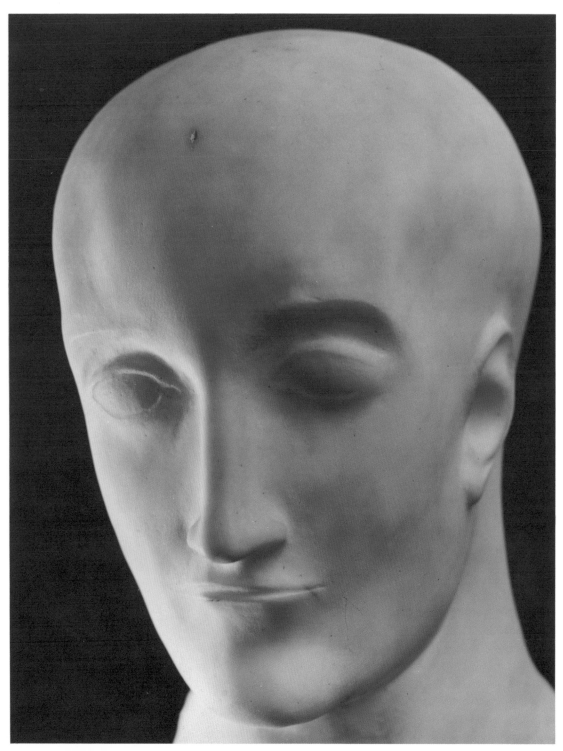

159

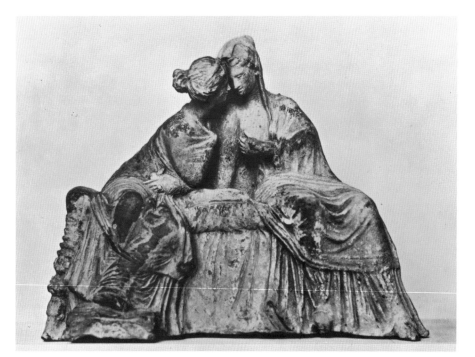

160

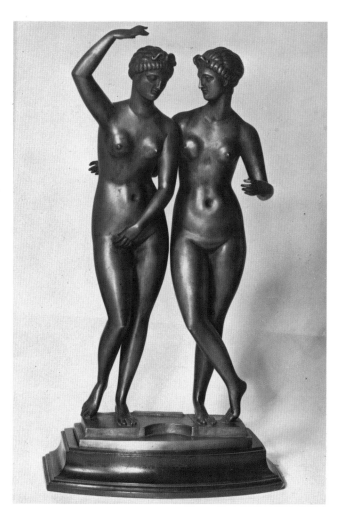

161

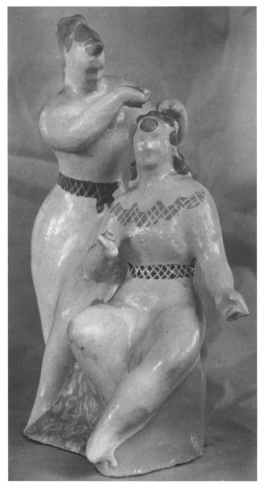

162

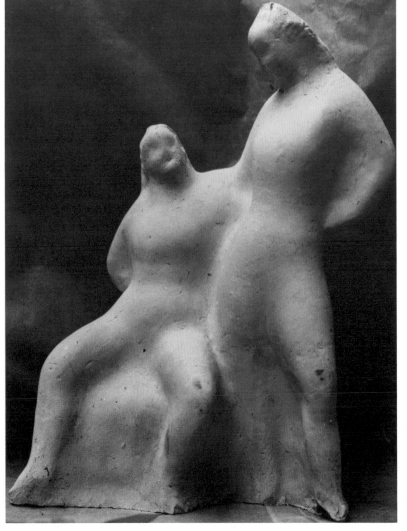

163

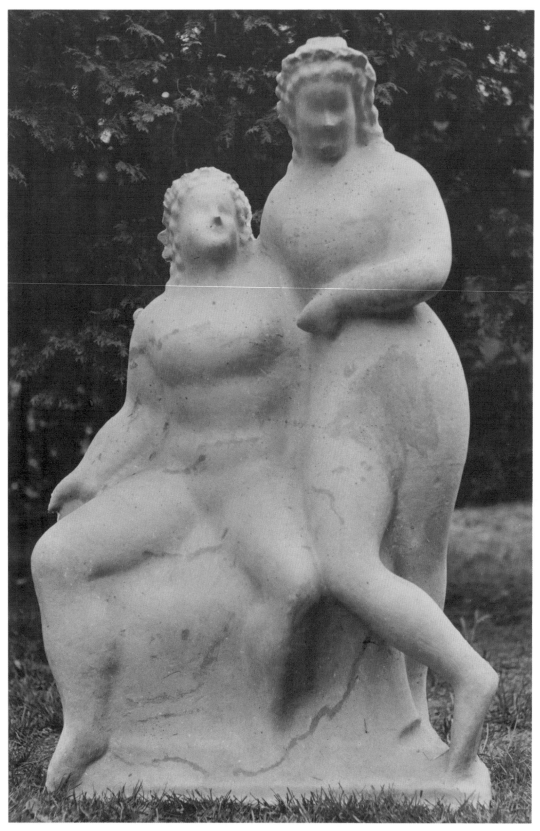

164

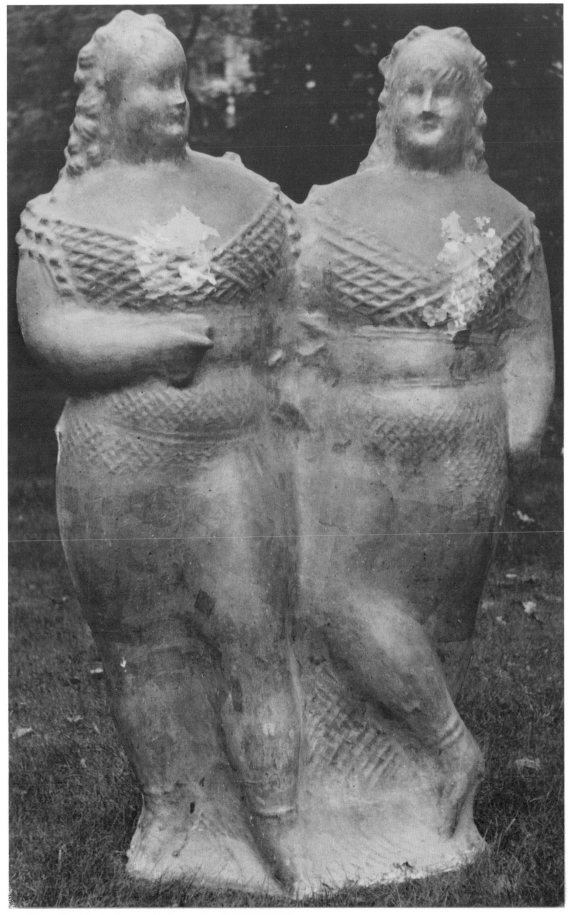

165

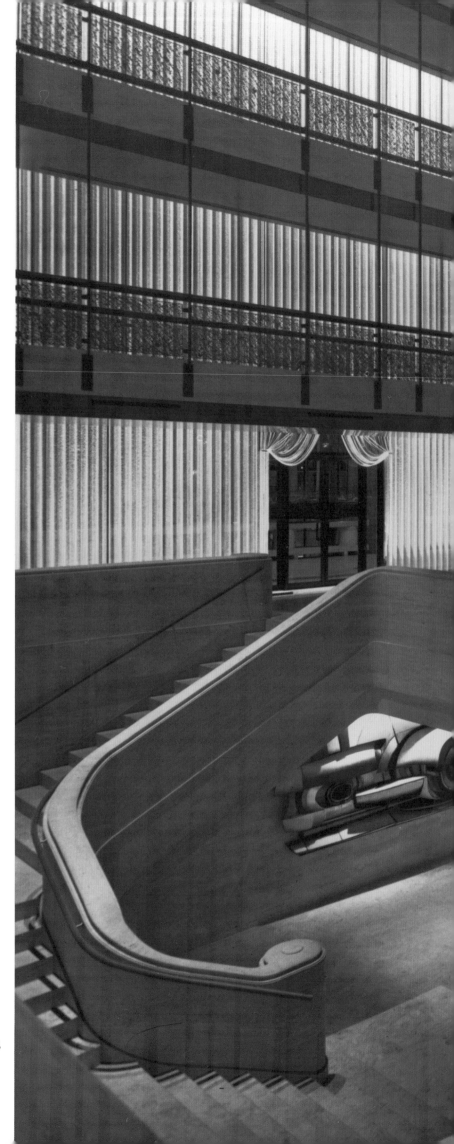

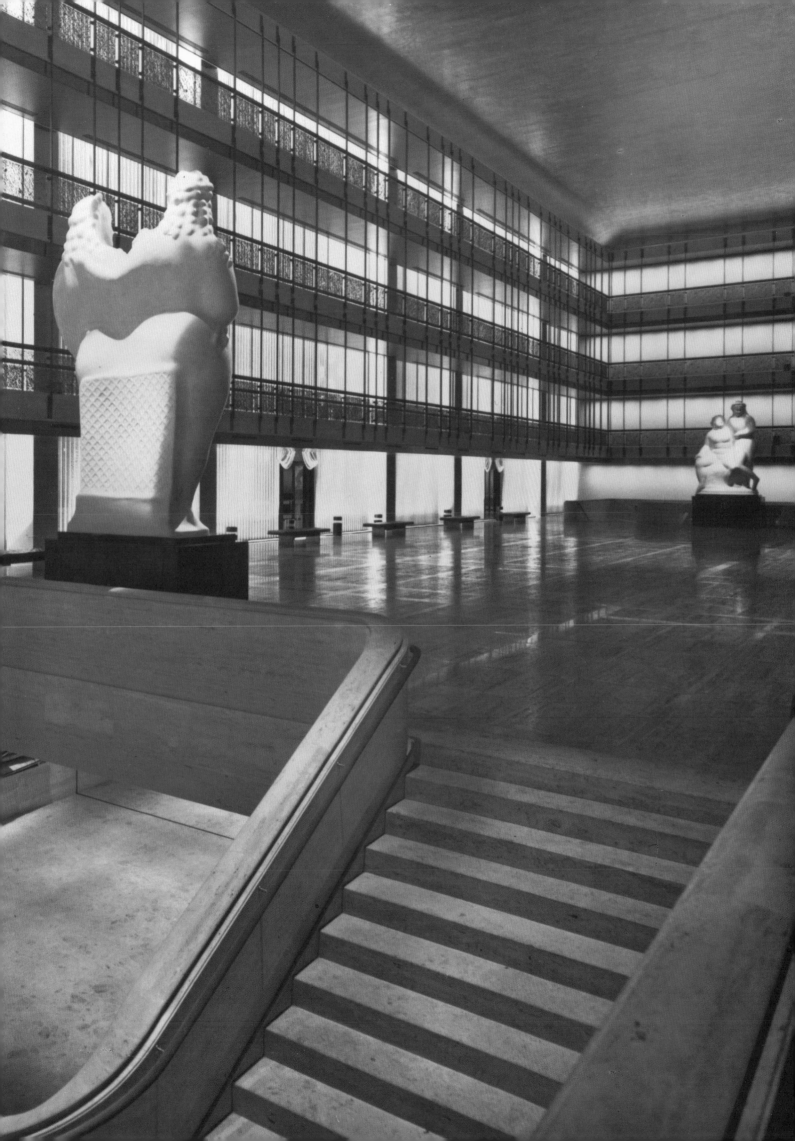

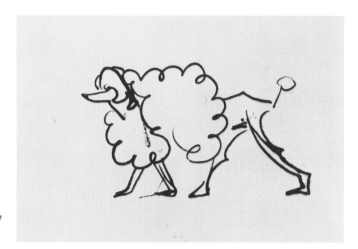

167

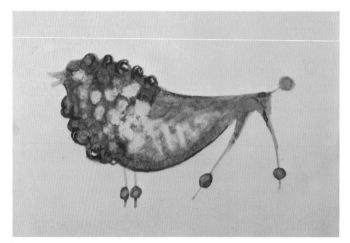

168

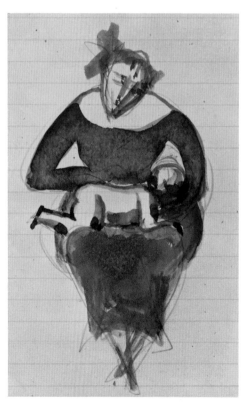

169

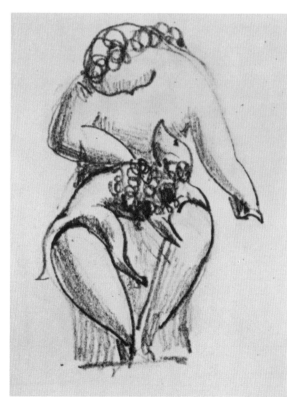

170

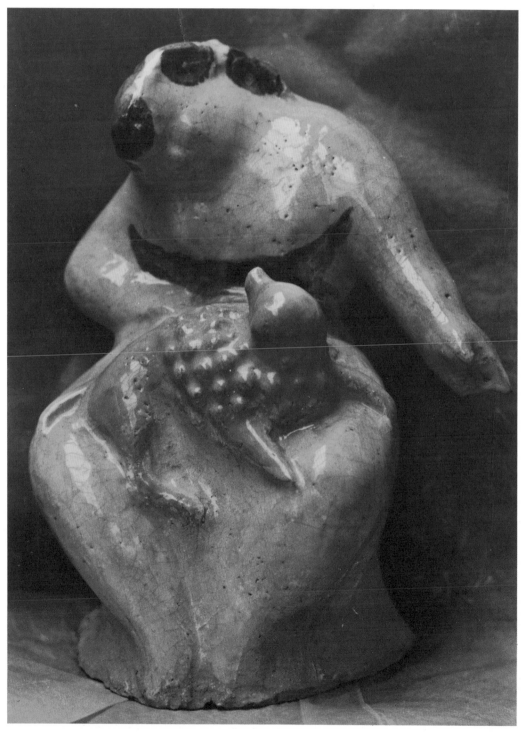

171

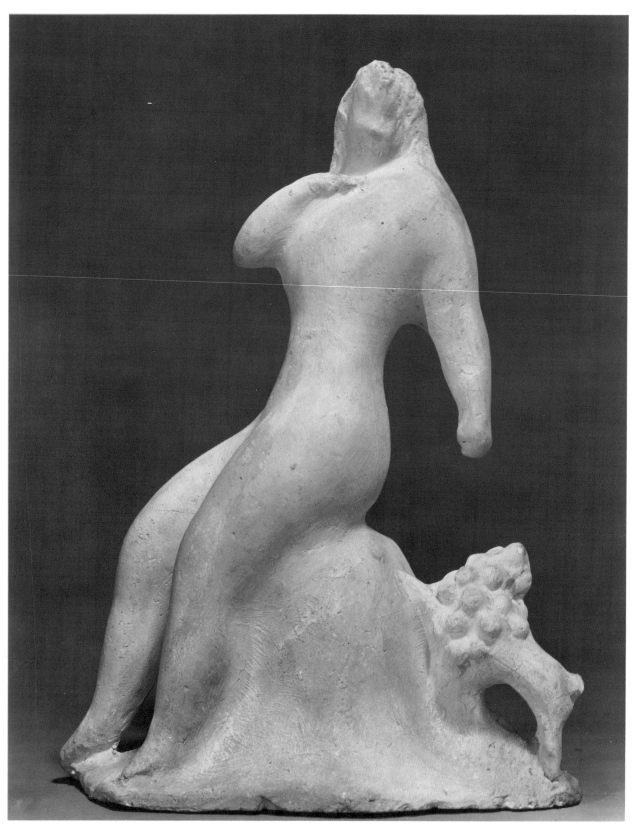

172

173

174

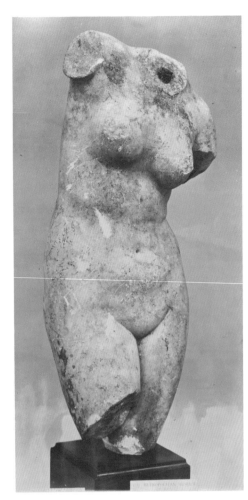

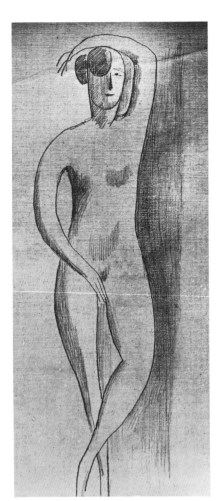

175

176

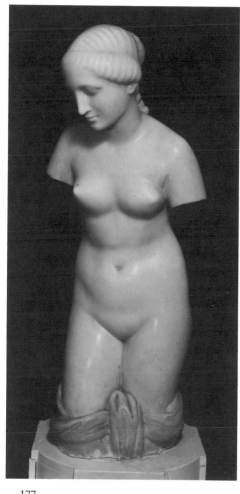

177

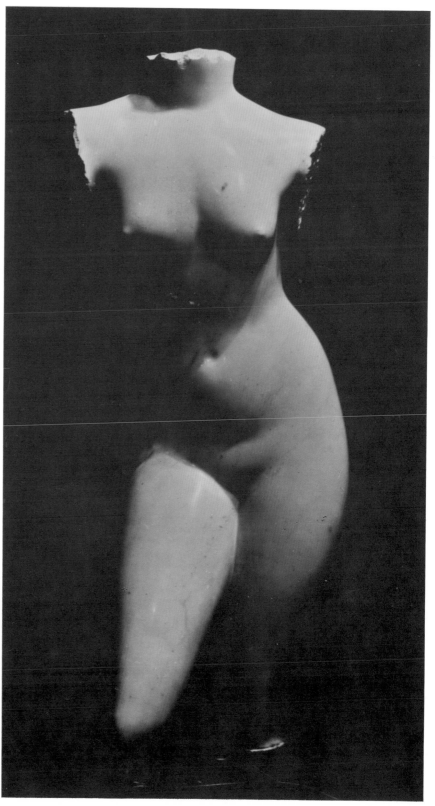

178

179

180

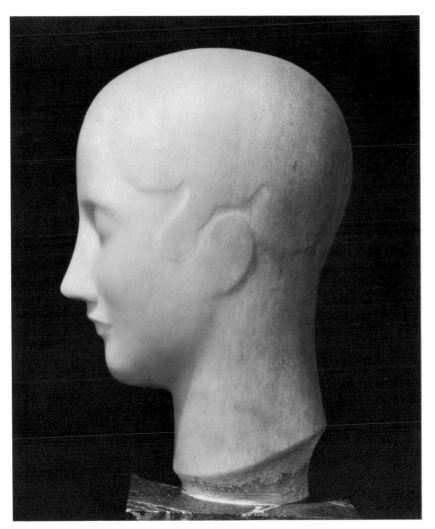

181

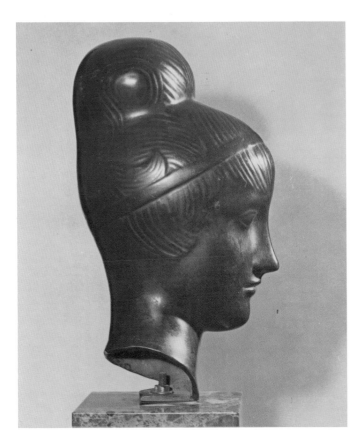

182

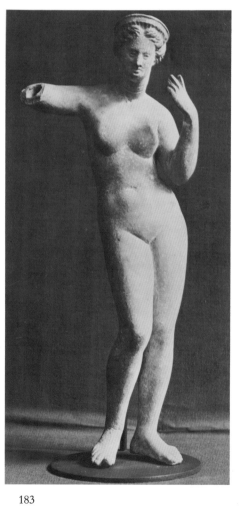

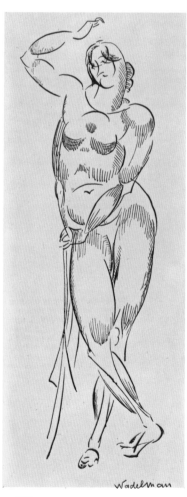

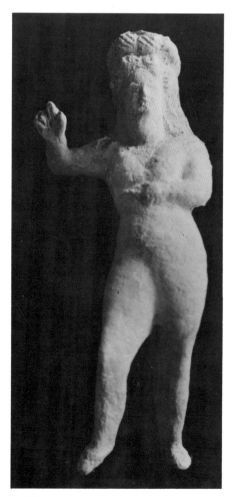

183 184 185

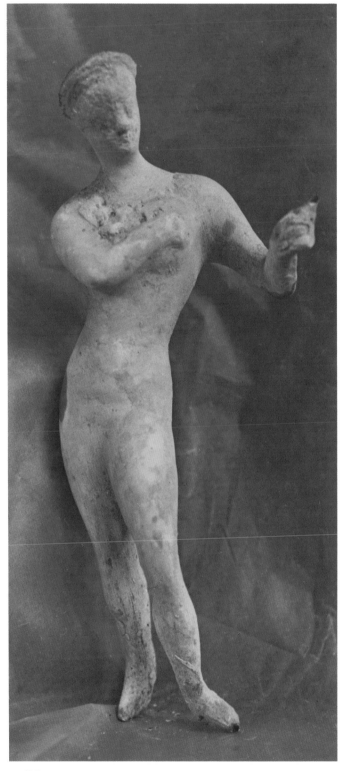

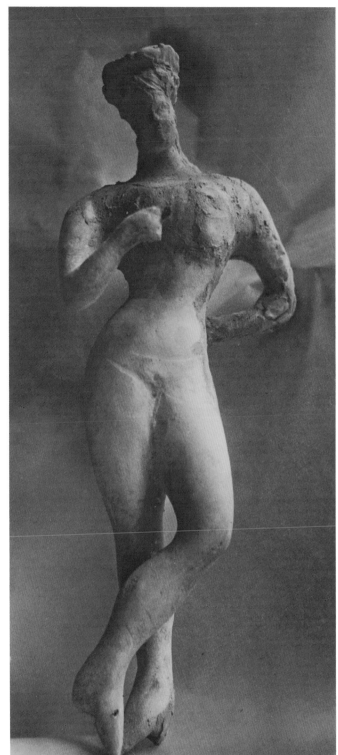

186

187

188

189

190

191

192

193

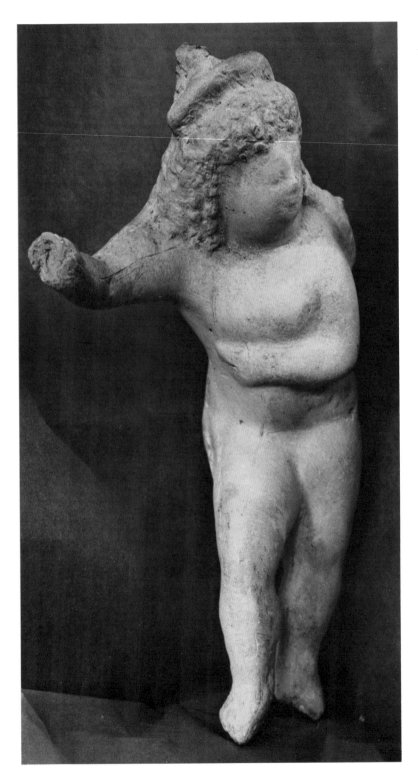

194

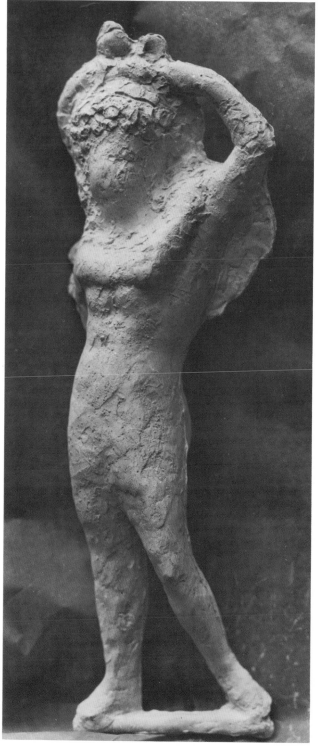

195

196

197

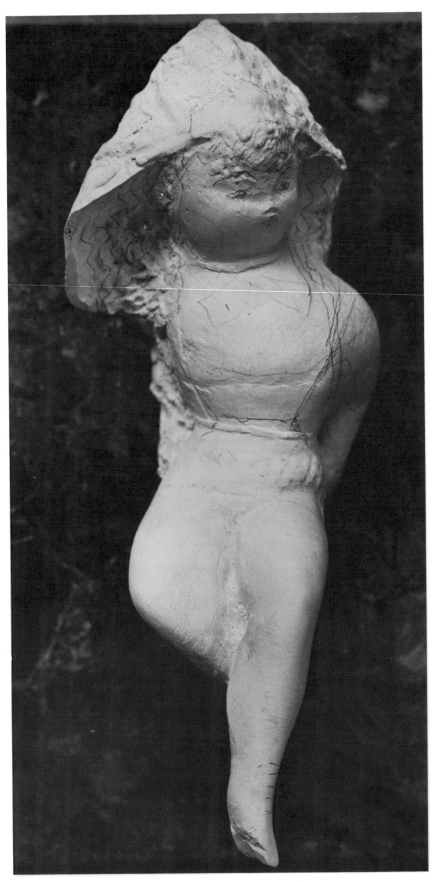

198

199

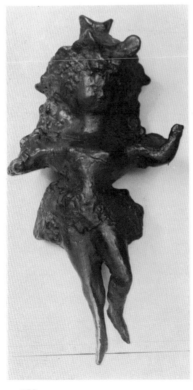

200

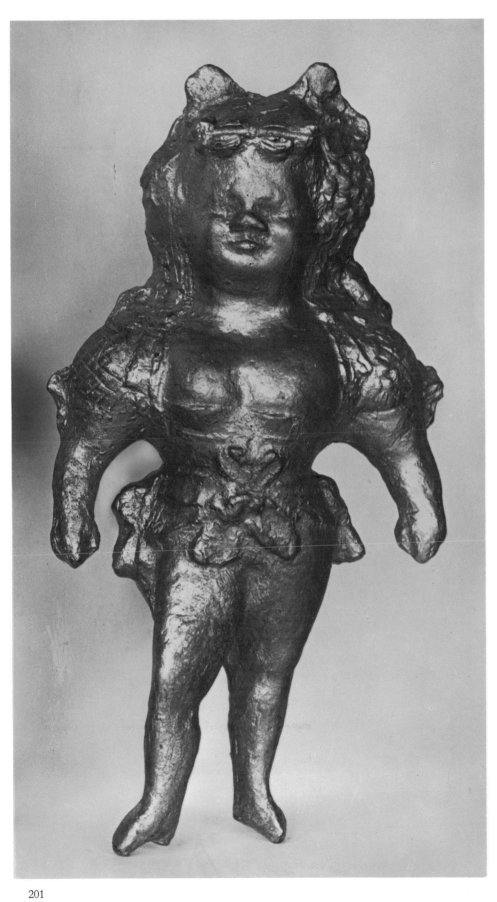

201

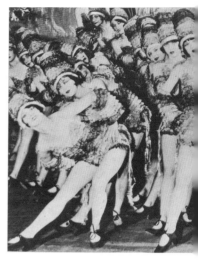

202

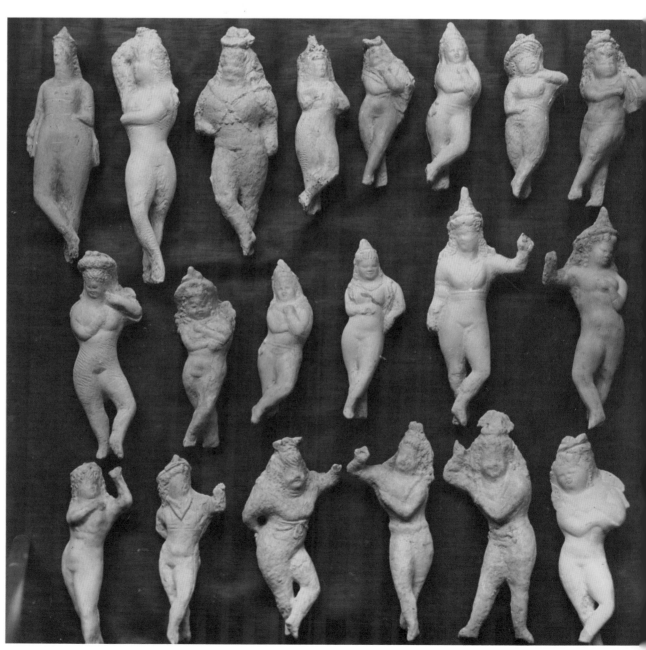

203

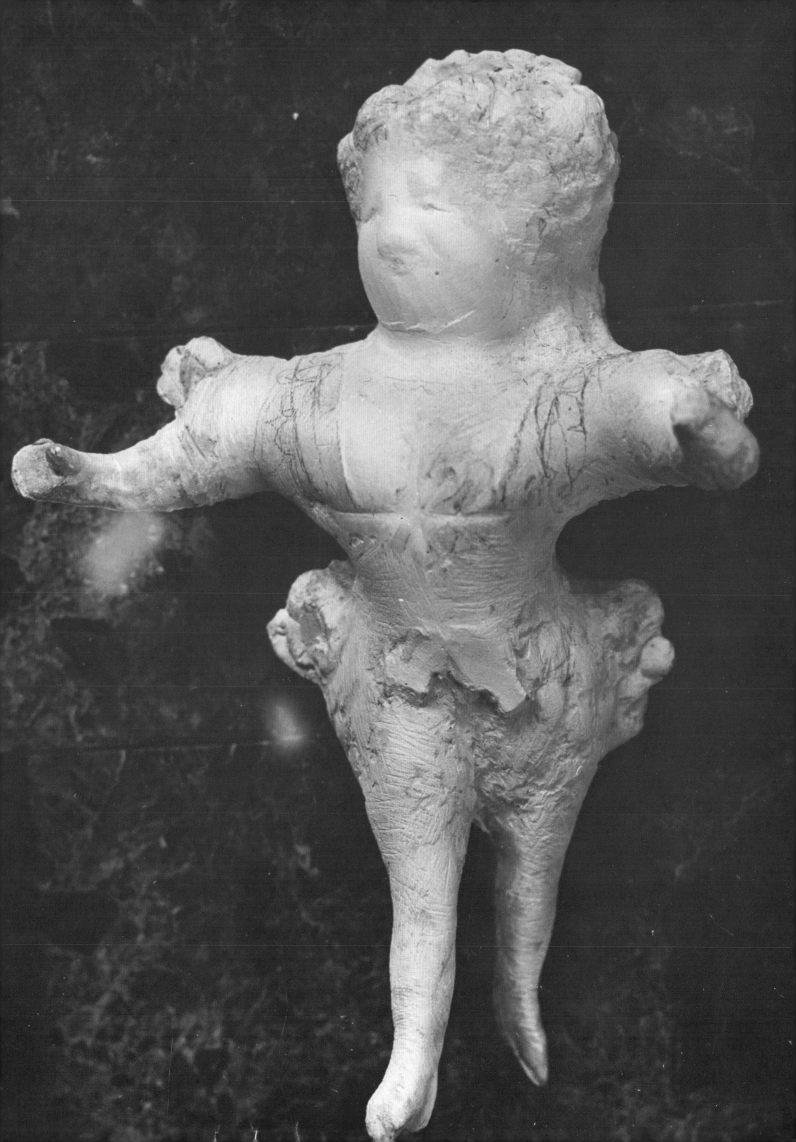

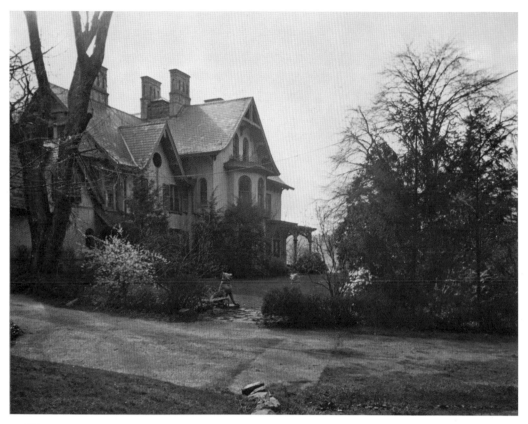

208

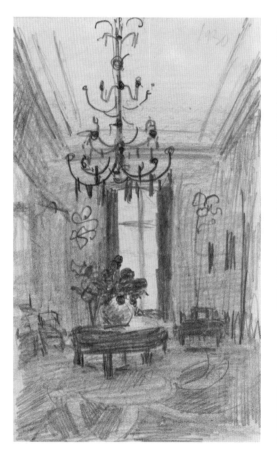

209

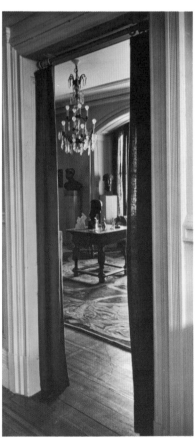

210

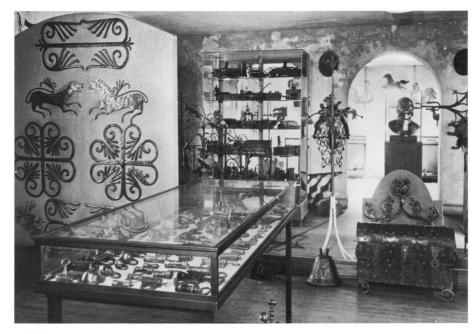

211

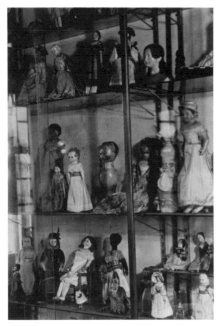

212

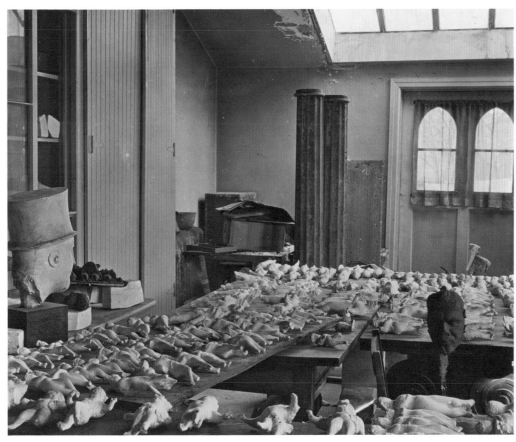

213

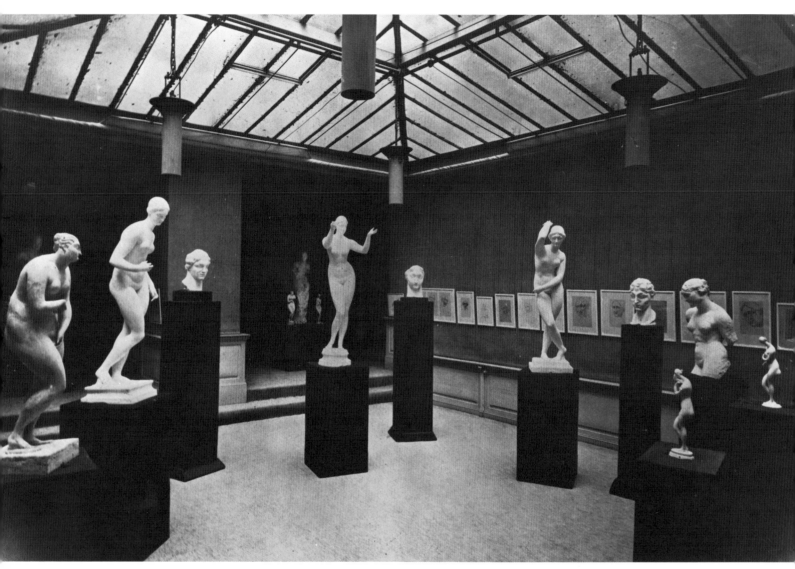

214

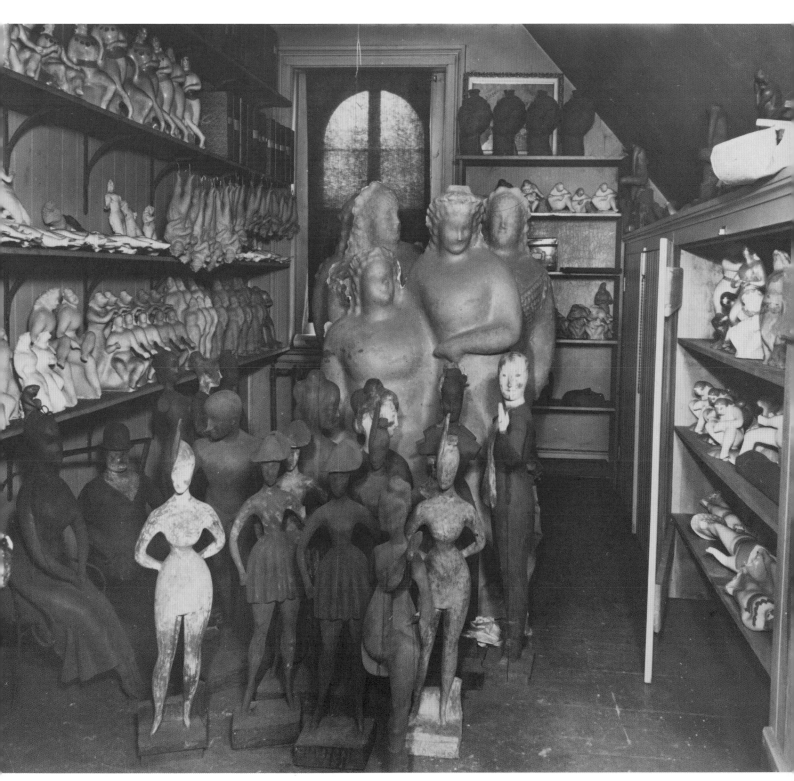

LIST OF PLATES

Most of the photographs of preliminary plasters and finished sculpture reproduced here were posed and directly supervised by Elie Nadelman. All *carte de visite* photographs, newspaper clippings and other scraps reproduced are from files Nadelman collected and used as sources for his work.

Dates marked *c.* are approximate within one or two years. Heights are given in approximate inches. "Destroyed" refers to work lost in studio moves c. 1930 and later. "Lost" refers to work, *possibly* destroyed, of which photographs exist. "Scraps" are photographs which Nadelman kept for reference. "VBP" refers to thirty-two drawings reproduced in the album *Vers la Beauté Plastique*, printed in Paris, 1912, published with nineteen other reproductions as *Vers l'Unité Plastique* in Paris, 1914, and as a single unit in New York, 1921 (see Bibliography & Exhibitions, entries 3 and 7).

1. Elie Nadelman, c. 1915.
Photograph

2. Self-portrait, c. 1913.
Brush and ink, 7". Nadelman Estate

3. 4. 5. Demonstration of Curve Principle.
Pen and ink, 6". Nadelman Estate. (Drawn for lecture at the Société Anonyme, New York, 1923)

6. Female Head, c. 1908.
Pen and ink, 8 1/2". VBP

7. 8. Head, c. 1908.
Plaster, 12". Destroyed

9. Caryatid. Amedeo Modigliani, c. 1913.
Pencil and wash, 10". Private collection, New York City

10. Danaide. Constantin Brancusi, 1913.
Bronze, 14". Mrs. George Henry Warren, New York City

11. Woman's Head. Pablo Picasso, 1909.
Bronze, 16 1/2". Museum of Modern Art, New York City

12. Head. Pablo Picasso, 1909.
Gouache, 24" × 18". Museum of Modern Art, New York City

13. 14. Head, c. 1908.
Plaster, 18". Destroyed

15. Head, c. 1906.
Pen and ink, 7 1/8" × 5 1/2". Museum of Modern Art, New York City

16. Male Head, c. 1911-1913.
Bronze, 15 1/2". The Hirshhorn Museum and Sculpture Garden, Smithsonian Institution, Washington, D. C.

17. Ideal Head, c. 1907-1908.
Bronze, 14". The Hirshhorn Museum and Sculpture Garden, Smithsonian Institution, Washington, D. C.

18. Ideal Head, c. 1908.
Bronze, 13". Robert Schoelkopf Gallery, New York City

19. Reclining Nude, c. 1910.
Pen and ink, 7". VBP

20. Reclining Nude, c. 1909-1910.
Bronze, 18". Mr. and Mrs. Constantin Sczaniecki, Paris

21. 22. Reclining Nude, c. 1910.
Plaster, 18". Destroyed

23. Seated Nude, c. 1913.
Marble, 18". Lost

24. Female Head, c. 1909-1911.
Marble, 16". Collection Unknown

25. Ideal Head, c. 1908.
Marble, 12 3/4". Zabriskie Gallery, New York City

26. Head.
Scraps

27. Female Head, c. 1909-1911.
Marble, 12 1/2". Collection Unknown

28. Ideal Head, c. 1910.
Marble, 16". Collection Unknown

29. Ovoid Head and Neck, c. 1904-1907.
Pen and black ink, 11 1/2" × 6". VBP

30. Aphrodite of Knidos. Praxiteles.
Scraps

31. Standing Female Nude, c. 1907-1909.
Pen and black ink, 10 3/4" × 2 7/16". VBP

32. Standing Female Nude, c. 1907.
Pen and ink, 10". Collection Unknown

33. Standing Female Nude, c. 1907.
Bronze, 20". The Hirshhorn Museum and Sculpture Garden, Smithsonian Institution, Washington, D.C.

34. Standing Nude Female Figure (called "Gertrude Stein"), c. 1907 (?).
Bronze, 29 $^1/_2$". Nadelman Estate

35. Standing Male Nude, c. 1907-1908.
Pen and ink, 10". Collection Unknown

36. Standing Female Nude, c. 1909.
Bronze, 24". Lost

37. Standing Female Nude, c. 1909.
Bronze, 21 $^3/_4$" (including base). Museum of Modern Art, New York City

38. Draped Standing Female Figure, c. 1907-1908 (?).
Bronze, 23". Collection Unknown

39. Dancing Figure, c. 1916-1918 (?).
Bronze, 29 $^3/_4$". The Brooklyn Museum of Art, Brooklyn, New York

40. Kneeling Dancer, c. 1915.
Pencil, 5". (Sketch for Goadby Loew marble.) Nadelman Estate

41. Standing Draped Female Nude, c. 1910.
Pen and ink, 10". VBP

42. Standing Female Nude, c. 1910.
Plaster plaque, 12". Destroyed

43. Study for Autumn: Four Female Figures with a Horse, c. 1911-1913.
Black chalk, 8 $^1/_4$" × 18 $^1/_2$". Metropolitan Museum of Art, New York City

44. Flute Player, c. 1913.
Bronze plaque, 9 $^1/_2$". Collection Unknown

45. Aesop, c. 1914.
Bronze plaque, 10". Lost

46. L'Automne, c. 1914.
Bronze plaque, 7". Nadelman Estate

47. Equestrienne, c. 1923-1925.
Fountain pen, pencil, brush and ink, 7" × 7 $^3/_4$". Collection Unknown

48. Equestrienne, c. 1923-1925.
Fountain pen and blue ink, 5 $^1/_4$" × 4". Metropolitan Museum of Art, New York City

49. Equestrian Figure, c. 1915.
Pen and brush, 9". Lost

50. Woman on a Horse, c. 1912.
Bronze relief plaque, 7 $^1/_{16}$" × 7 $^7/_{16}$" × $^5/_{16}$". The Dial Collection

51. Horse, c. 1914.
Bronze, 13 $^1/_2$". The Dial Collection

52. Horse, c. 1912-1914.
Pen and ink, 9". Lost

53. Cow, c. 1913-1915.
Pen and brown ink, reddish brown wash over traces of pencil, 5 $^1/_2$" × 8". Metropolitan Museum of Art, New York City

54. Standing Bull, c. 1915.
Bronze, 6 $^5/_8$" × 11 $^1/_4$". Museum of Modern Art, New York City

55. Horse, c. 1914.
Bronze, 12 $^3/_4$". The Hirshhorn Museum and Sculpture Garden, Smithsonian Institution, Washington, D.C.

56. Resting Stag, c. 1915.
Bronze, 17 $^1/_2$". Detroit Institute of Arts, Detroit, Michigan

57. Doe with Lifted Leg, c. 1915.
Bronze, 20 $^1/_2$". Museum of Art, Rhode Island School of Design, Providence, Rhode Island

58. Wounded Bull, 1915.
Bronze, 5 $^7/_8$" × 11 $^1/_2$". Museum of Modern Art, New York City

59. Profile of Man in Bowler Hat, c. 1914.
Pen, brush and India ink, 7 $^1/_2$" × 4 $^1/_2$". Collection Unknown

60. Head of Mercury, c. 1913.
Crayon, 8". Nadelman Estate

61. Mercury Petassos, c. 1911.
Marble, 16". Collection Unknown

62. Derby Hatted Head, c. 1915.
Plaster, 15". Destroyed

63. Androgynous Figure Against a Tree Trunk, c. 1909-1911.
Pen and ink, 9". Lost

64. Figure Against a Tree Trunk, c. 1914.
Plaster plaque, 9". Destroyed

65. Study for Man in the Open Air, c. 1915.
Watercolor, pen and ink, 10⁷/₈" × 7¹/₈". Museum of Modern Art, New York City

66. Man in the Open Air, c. 1914-1915.
Bronze, 54¹/₂" (including base). Museum of Modern Art, New York City

67. Hermes Pallatine. School of Praxiteles.
Museo delle Terme, Rome. Scraps

68. Male Nude, c. 1915.
Pencil, 9". Nadelman Estate

69. Adolescent Boy, c. 1915.
Pencil, 9". Nadelman Estate

70. Hermaphrodite, c. 1906-1908.
Bronze, 15". Robert Schoelkopf Gallery, New York City

71. Adolescent, 1917.
Painted plaster, 40". Destroyed

72. Dancer, c. 1918-1921.
Cherrywood with mahogany base, 28¹/₄" (without base). Wadsworth Athenaeum, The Philip L. Goodwin Collection, Hartford, Connecticut

73. Standing Girl, c. 1918-1922.
Cherrywood, 30". Mr. and Mrs. C. H. Tinsman, Shawnee Mission, Kansas

74. Circus Girl with Hoop, c. 1919-1921.
Plaster and wire, 30". Destroyed

75. Top-Hatted Man with Borzoi Dog, c. 1916-1920.
Pencil and ink, 8". Nadelman Estate

76. Top-Hatted Man, c. 1918-1922.
Painted plaster, 30". Destroyed

77. Head for *Chef d'Orchestre*, c. 1919-1922.
Painted plaster, 10". Destroyed

78. Barnum & Bailey Circus Clowns, c. 1915.
Scraps

79. *Chef d'Orchestre*, c. 1919-1921.
Cherrywood and gesso, 37". The Hirshhorn Museum and Sculpture Garden, Smithsonian Institution, Washington, D.C.

80. Art Critic (Thadée Natanson?), c. 1909.
Pen and ink, 6". Lost

81. Thadée Natanson (?), c. 1909.
Pen and ink, 6". Lost

82. Madame Helena Rubinstein, c. 1911-1912.
Pen and black ink, 9¹/₄" × 6". Collection Unknown

83. Thadée Natanson, 1909.
Bronze, 22". Collection Unknown

84. Marie Scott, 1915.
Pen and ink, 9". Nadelman Estate

85. Marie Scott, 1916.
Marble, 22". Metropolitan Museum of Art, New York City

86. Portrait of Jane Wallach, c. 1917-1918.
Marble, 26³/₄". The Brooklyn Museum of Art, Brooklyn, New York

87. Mrs. Charles Templeton Crocker ("Hélène Irwin Fagan"), 1917.
Marble, 29". California Palace of the Legion of Honor, San Francisco, California

88. Standing Woman, c. 1916-1919.
Pen and ink, 9". Nadelman Estate

89. Standing Woman, c. 1916-1919.
Pen and ink, 9". Nadelman Estate

90. Standing Woman, c. 1916-1919.
Pen and ink, 9". Nadelman Estate

91. Cellist, c. 1918-1919.
Pen and ink, 7". Nadelman Estate

92. Cellist, c. 1919-1921.
Painted plaster, 30". Destroyed

93. Concert Singer, 1917.
Painted plaster, 30". Destroyed

94. Maurice Chevalier with the Dolly Sisters, c. 1917.
Scraps

95. Three Biedermeier Girls. Jules Pascin, c. 1912.
Scraps

96. Seated Woman and Standing Man (M. and Mme. Thadée Natanson?), c. 1913.
Brush and ink, 9". Nadelman Estate

97. Seated Woman, c. 1916.
Ink, 7". Nadelman Estate

98. *La Femme Assise*, 1917.
Painted plaster, 30". Destroyed

99. *La Femme Assise*, c. 1918-1921 (?).
Cherrywood and wrought-iron, 33". Private collection, New York City

100. 101. Host, c. 1920-1923.
Cherrywood, gesso and wrought-iron, 28¹/₈". Private collection, New York City

102. American Vaudeville "Sister-Act," c. 1918.
Scraps

103. Two Standing Girls, c. 1920.
Pen and ink, 8". Nadelman Estate

104. La Duquesa de Alba. Goya.
Scraps

105. Standing Woman in Hat, c. 1921.
Painted plaster, 30". Destroyed

106. *La Parade* (detail). Georges Seurat, 1887-1888.
Oil on canvas. Metropolitan Museum of Art, New York City

107. Dancing Couple, c. 1917-1919.
Pen, brush and fountain pen ink, 8" × 3¹/₂". Metropolitan Museum of Art, New York City

108. Tango, c. 1916-1917.
Pen, ink and brush, 9". Lost

109. Dancing Couple, c. 1917-1919.
Pen, ink and reddish wash, 9¹/₂" × 6³/₈". Metropolitan Museum of Art, New York City

110. Tango, c. 1916.
Pen, ink and brush, 9". Lost

111. Tango, c. 1917.
Pen, ink and brownish watercolor, 10" × 7". Baltimore Museum of Art, Baltimore, Maryland

112. American Vaudeville Dance Team, c. 1920.
Scraps

113. Tango, c. 1922-1924.
Pen and ink, 2". Nadelman Estate

114. Tango, c. 1922-1924.
Painted plaster, 30". Destroyed

115. Tango, c. 1923-1924 (?).
Cherrywood and gesso, 34". Private collection, New York City

116. *Femme au Piano*, c. 1920-1922.
Pen and ink, 5¹/₂". Nadelman Estate

117. *Femme au Piano*, c. 1922-1923.
Painted plaster, 36". Destroyed

118. Woman at the Piano (*Femme au Piano*), 1917.
Wood, stained and painted, 35¹/₈" h., base including piano 21¹/₂" × 8¹/₂". Museum of Modern Art, New York City

119. Standing Female Nude, c. 1908.
Pen and ink, 10". Collection Unknown

120. Female Torso, c. 1916.
Pen and brown ink, 8⁷/₈" × 4⁵/₈". Metropolitan Museum of Art, New York City

121. Antique Greek Carved Drapery.
Scraps

122. Figure, c. 1925.
Marble, 38" × 11" × 12". Walker Art Center, Minneapolis, Minnesota

123. Girl on Surfboard, c. 1923.
American snapshot. Scraps

124. Standing Burlesque Girl, c. 1925.
Pen and brush, 8". Nadelman Estate

125. Standing Burlesque Girl, c. 1925.
Pen and brush, 8". Nadelman Estate

126. Burlesque Girls, c. 1925.
Painted plaster, 6" and 8". Nadelman Estate

127. Nineteenth Century Female Acrobat.
American photograph. Scraps

128. Standing Female Figure, c. 1924.
Galvano-plastique, 58³/₄". Nadelman Estate

129. Standing Female Figure, c. 1924.
Galvano-plastique, 60¹/₄". Nadelman Estate

130. Can-can Dancer, c. 1925.
Pencil, 7". Dance Collection, The New York Public Library at Lincoln Center. New York City

131. Circus Lady, c. 1875.
American carte de visite photograph. Scraps

132. Seated Circus Lady, c. 1924.
Galvano-plastique, 49¹/₂". Nadelman Estate

133. Corinthian Acroteria, c. 575.
Colored terra cotta. The Louvre, Paris. Scraps

134. American Film Actress, c. 1925 (pencil-reinforced lips).
Scraps

135. Girl's Half-Length Torso, c. 1924-1925 (?).
Galvano-plastique, 30". Nadelman Estate

136. Woman's Head with Hair-Do, c. 1926-1927.
Pencil, 4¹/₂". Nadelman Estate

137. Woman's Head and Hair-Do, c. 1875.
American carte de visite photograph. Scraps

138. Woman's Head and Hair-Do, 1917-1920.
Pencil, 9". Nadelman Estate

139. Bust of a Woman (Henrietta Stettheimer?), c. 1926-1928 (?).
Brass, painted with Prussian blue, 23⁵/₈". Private collection, New York City

140. Man in a Top Hat, c. 1918.
Pen and ink, 6". Nadelman Estate

141. Man's Head in Top Hat, c. 1923-1924.
Galvano-plastique, painted, 26¹/₂". Nadelman Estate

142. Man in Top Hat, c. 1927.
Painted bronze, 26" × 14⁷/₈". Museum of Modern Art, New York City

143. Lady and Maid, c. 1915.
Pen and ink, 5". Nadelman Estate

144. Kneeling Female Figure. Greek marble.
Scraps

145. 146. *Sur la Plage*, 1916.
Marble and bronze, 21". Sara Roby Foundation, on loan to the Whitney Museum of American Art, New York City

147. Construction Worker, 1929.
Pencil, 4". Nadelman Estate

148. Construction Workers Supporting Clock, 1929.
Plaster, 20". Destroyed

149. Construction Workers, 1930-1932.
Limestone, 144". Fuller Building, Fifty-Seventh Street at Madison Avenue, New York City

150. Aquarius, c. 1855. American stock-certificate engraving.
Scraps

151. Aquarius, 1933.
Bronze, 112". Bank of the Manhattan Company (now Chase Manhattan), 40 Wall Street, New York City. Lost or destroyed

152. Head, c. 450 B. C. Greek marble.
Metropolitan Museum of Art, New York City. Scraps

153. Male Head in Profile, c. 1915.
Pen and brush, 7¹/₂". Nadelman Estate

154. 155. Male Head (Ideal Self-Portrait?), c. 1916.
Marble, 14¹/₂". Private collection, New York City

156. Charles Baudelaire, 1861.
Photograph by Etienne Carjat. Scraps

157. Baudelaire, c. 1934-1936.
Pen and ink, 4". Nadelman Estate

158. 159. Charles Baudelaire, c. 1940-1945.
Marble, 17". The Hirshhorn Museum and Sculpture Garden, Smithsonian Institution, Washington, D.C.

160. Two Gossiping Women. Tanagra.
Painted terra cotta. The Louvre, Paris. Scraps

161. Two Standing Nudes, c. 1909.
Bronze, 12". Lost

162. Woman Dressing Another's Hair, c. 1935-1940.
Papier-mâché, 14¹/₄". Nadelman Estate

163. Standing and Seated Female Nudes, c. 1935-1940.
Terra cotta, 10". Nadelman Estate

164. Two Female Nudes, c. 1931.
Plaster covered with paper, 59". Nadelman Estate

165. Two Circus Women, c. 1930.
Plaster covered with paper, 61¹/₄". Nadelman Estate

166. Promenade, State Theater, City Center of Music and Drama, Lincoln Center. Philip Johnson, architect.
Nadelman's figures stand 19 feet high, including base. Photograph by Ezra Stoller

167. Poodle, c. 1914.
Pen, brush and ink, 4". Nadelman Estate

168. Poodle, c. 1914.
Pen, brush and ink, 4". Nadelman Estate

169. Woman and Child, c. 1915-1916.
Brush and ink, 4". Nadelman Estate

170. Girl with Poodle, c. 1935.
Pencil, 5". Nadelman Estate

171. Girl with Poodle, c. 1935.
Papier-mâché, 10". Nadelman Estate

172. Girl with Poodle, c. 1935-1940.
Plaster, 12". Nadelman Estate

173. Standing Female Nude, c. 1940.
Marble, 12". Nadelman Estate

174. Standing Female Nude.
Hellenistic bronze, 9". Scraps

175. Torso. Antique Greek.
Scraps

176. Standing Female Nude, c. 1925.
Pen, ink and brush, 9". Nadelman Estate

177. Female Nude, c. 1920-1925.
Marble. Lost

178. Female Nude, c. 1930-1935.
Marble, 52". Nadelman Estate

179. Profile of a Woman, c. 1925.
Pencil, 9". Nadelman Estate

180. Profile of a Man, c. 1925.
Pencil, 9". Nadelman Estate

181. Head of a Woman, c. 1942.
Rose marble, 15 5/8". Museum of Modern Art, New York City

182. Head of a Girl with High Hair-Do, 1915.
Bronze, 13 1/2". Coe Kerr Gallery, New York City

183. Standing Female Figure. Hellenistic.
Scraps

184. Standing Female Nude, c. 1908.
Pen and ink, 9". VBP

185. Standing Female Figure, c. 1941.
Plaster, 9". Nadelman Estate

186. Standing Male Figure, c. 1940.
Plaster, 12". Nadelman Estate

187. Standing Male Figure, c. 1940.
Plaster, 10". Nadelman Estate

188. Standing Female Acrobat, c. 1925.
Pencil, 4 1/2". Nadelman Estate

189. Studies for Standing Female Figures, c. 1925-1935.
Pencil, 7". Nadelman Estate

190. Standing Female Figure, c. 1930.
Pencil, 7". Nadelman Estate

191. Seated Female Figure, c. 1930-1935.
Pencil, 7". Nadelman Estate

192. Flying Figure. Tanagra.
Terra cotta, 9". Scraps

193. Standing Female Figure, c. 1935.
Pencil, 9". Nadelman Estate

194. Standing Female Figure, c. 1935.
Plaster, 6 1/2". Nadelman Estate

195. Standing Female Figure, c. 1935.
Plaster, 6 1/2". Nadelman Estate

196. Standing Female Figure, c. 1935.
Plaster, 6 1/2". Nadelman Estate

197. Child in Rain-Cape, c. 1940.
American newspaper advertisement. Scraps

198. Standing Child, c. 1943-1945.
Plaster, 9". Nadelman Estate

199. Standing Female Figure, c. 1940.
Pencil, 7". Nadelman Estate

200. Figure, c. 1943-1945.
Bronze, 10 1/2". Private collection, New York City Photograph by Rudi Burckhardt

201. Figure, c. 1944-1945.
Gilt bronze, 12". Private collection, New York City Photograph by Rudi Burckhardt

202. American Film Musical Number, c. 1935.
Scraps

203. Figurines, c. 1940-1945.
Plaster, 8" to 14". Nadelman Estate

204. Child God, c. 1943-1945.
Penciled plaster, 9". Nadelman Estate

205. Child Gods, c. 1943-1945.
Plaster, 9" to 15". Nadelman Estate

206. Standing Child Goddess, c. 1943.
Penciled plaster, 9 1/2". Nadelman Estate

207. Child Goddess, c. 1944-1945.
Plaster, 10". Nadelman Estate

208. Nadelman's Home, Alderbrook, Riverdale-on-Hudson, 1948.
Photograph by Konrad Cramer

209. Alderbrook: The Parlor, c. 1930.
Pencil, $3^{1}/_{2}$" × $2^{1}/_{2}$". Sketch by Nadelman

210. Alderbrook: The Parlor, c. 1950.
Photograph by Konrad Cramer

211. The Nadelmans' Folk Art Museum, Alderbrook, c. 1932.
This section, among many others, was devoted to forged iron; the lions and foliate door-ornaments are now in The Cloisters, Metropolitan Museum of Art, New York City

212. Nadelman Doll Collection, Alderbrook, c. 1932.

213. Nadelman's Studio, 1947.
Photograph by Henri Cartier-Bresson

214. Nadelman's First Exhibition: Galerie Druet, Paris, April, 1909.

215. Alderbrook: The Attic, 1947.
Photograph by Henri Cartier-Bresson

153

LIFE AND WORK

How the theatrical scream of passion now
hurts our ears, how strange to our taste the whole romantic
uproar and tumult of the senses have become, which the educated
rabble loves, and all its aspirations after the elevated,
inflated, and exaggerated! No, if we who have recovered
still need art, it is another kind of art – a mocking,
light, fleeting, divinely untroubled, divinely artificial
art, which, like a pure flame, licks into unclouded
skies . . . Oh, those Greeks! They knew how to live. What
is required for that is to stop courageously at the surface,
the fold, the skin, to adore appearance, to believe in
forms, tones, words, in the whole Olympus of appearance.
Those Greeks were superficial – out of profundity . . .[13]

NIETZSCHE CONTRA WAGNER: 1888

Elie Nadelman was born February 20, 1882, at Marszalkowski 143, Warsaw, Polish-Russia, seventh child of Hannah Arnstan and Philip Nadelman. Birthplace and records were destroyed in the Second World War. His father was an able jeweller of liberal opinion and extensive philosophical background. His mother's family contained artists, writers, musicians. Nadelman was schooled at Warsaw's Gymnasium and High School of Liberal Arts. His childhood seems to have been uneventfully content; although he left Poland at nineteen never to return, he was devoted to his parents through their lives. His nature was extrovert, cheerful, energetic, with no conflict in artistic ambition. He expressed an early wish to sing professionally; this his parents considered effeminate. He learned the flute instead, but sang folk and art songs all his life. In 1900 he entered the Imperial Russian army; he received preference as an officer candidate due to his education and his volunteer status. He wore a white uniform with red piping, became a crack shot, and had a batman. He served one year, some of the time teaching drawing and the flute to officers' children or decorating a mess hall with paintings which were to be almost his last. His very last may have been an airy painting of a ship which still sails on a child's bureau, done to amuse his small son during an illness.

Little youthful work survived except a full sketchbook (now lost) of careful pencil drawings with some freer notations in ink, done before and during military service. These studies were tight, accomplished notations of family life (sister at the piano, mother sewing, father asleep); peasants and farm animals; army wagons and horses; notations for setting stones in finger rings. Already he planned not to remain a craftsman like his father, but to become an artist. But his father's traditional precision in small-scale detail was always remembered. He had seen reproductions of Rodin's work, which he felt must be the greatest sculpture since the Renaissance, and made many small Rodinesque compositions in pen, ink, and pencil of entwined, struggling, or loving couples. Other notions recall groups from the Dante or Bible illustrations of Gustave Doré as well as imitations of the contemporary mystical painter M. A. Vrubl.[14] A small clear self-portrait in pen and ink imitated the etched hatching of Anders Zorn. These adolescent drawings impress by an unfaltering dexterity. Whatever his mind or eye saw, he was already able to render in complete, if conventional, terms. Later his personal vision enlarged, but early he had digital mastery which he never doubted and soon developed.

Russian Poland was hardly propitious for his gift, temperament, or class although circumstances of birth, association, and personal charm favored him. Had he wished to conform to the criteria of official academies in Warsaw, Cracow, or Poznan, he might have organized a comfortable career, living off government commissions, as did

many of his contemporaries. Before military service Nadelman briefly attended the Warsaw Art Academy to which he returned after the army. The artistic situation in Poland was a provincial reflection of broader activity in France, Austria and Germany. What schooling there was fostering young talents depended on second-hand sources. After a year, Nadelman left for Cracow. Here, in May, 1897, there had been founded, under the sponsorship of Count Anton Potocki, a progressive movement of artists under the name *Sztuka* (Art), related in spirit to Petersburg's *Mir Iskoustvo* (World of Art), the circle surrounding a young musical amateur, Sergei Pavlovitch Diaghilev. Like the Russians, the Poles were represented by an art magazine bearing the title of their movement which conducted competitions uncovering fresh capacity. Essentially *Sztuka* served as evangelist for local Impressionism, but almost as much for an aggressive cultural chauvinism glorifying Poland as Messiah of European freedom, and for her past and present genius, her heroic misery.

In this magazine, Nadelman first found himself noticed in a prize-winning project for a memorial to Frédéric Chopin. Even then, this was recognized as a sculptural rather than a painterly plan. *Sztuka*, judged by Parisian standards, was hardly revolutionary. It had more connection with secessionist movements in Munich or Vienna, resulting from earlier innovations of Manet and Monet, than with radical directions of Post-Impressionists or Nabis. Nadelman, discontented with the moribund Warsaw academy, suffering from half a century of anecdotal nationalism, sought another atmosphere in Cracow, then under the Austro-Hungarian monarchy, which he hoped might be more free. What perhaps most attracted him was the presence of Konstantin Laszczka (1865-1956), *Sztuka's* meagre representative of Rodin. After the deaths of the "epic" nationalist historical painters Matejko and Rodakowski, the Cracow academy had been, since 1895, directed by Julian Falat, a meek Impressionist landscapist and water-colorist. However, after but two days in Cracow, Nadelman abruptly returned to Warsaw. In spite of its ancient university, active theater, and journalism which enjoyed some contact with comparatively liberal Vienna as opposed to Tzarist censorship and repression in Warsaw, Cracow was at best only a provocative dilution of progressive tendencies in West European art. The more conservative teachers were heavily Germanic; the more advanced, shadows of academic French Impressionism.

In Cracow, the greatest sculpture was the high altar triptych in the Church of Our Lady, executed from 1477 to 1489 by Veit Stoss. While Nadelman was to be less affected by Gothic painting or sculpture than handicraft, one can find his echoes of figures in Stoss's "Dormition of the Virgin," a tremendous *tableau vivant*, formal as an apotheosis in opera-ballet, with that extreme curvilinear emphasis which would be apparent in Nadelman's undraped figures four or five years later. The tense attenuation, nervous torsion and intimate mannered grandeur, a controlled elegance in passionate abruptness and perfection in surface and detail are perhaps reflected in

Nadelman's first bronze figures, particularly in the averted inclination of heads, a fluent drama in exquisite hands, arms, feet; swinging mobility in balanced stasis. But apart from the heroic statement of Veit Stoss, who had been no more intrinsically a Polish artist than Nadelman would become, the young student quickly found out that he was far more advanced in skill and thought than local teachers; indeed, that Poland was no place for open-minded students. Later he would rarely consider himself exclusively a Pole, although he contemplated naming his son Jagiello after the Polish Kings and finally settled for Jan, perhaps after Sobieski, a national hero. For a short time, he continued to study in Warsaw with support from a noble Russian lady.

MUNICH 1904

Next, Nadelman went to Munich, remaining but six months. It was closer to sources of contemporary vitality, but he disliked its hot-house atmosphere and Bavarian complacency. Dominant academic influences came from the archaistic, erotic, or morbid romanticism of the painters Arnold Böcklin (1827-1901) and Franz von Stuck (1863-1928), who was also a sculptor. They shared some of the spirit of *fin de siècle* decadence, a ragged inheritance from Nazarener and Pre-Raphaelites. Nadelman was certainly affected by Aubrey Beardsley, whose illustrations for Wilde's *Salome* were popular in Germany. Characterization in Nadelman's early gilt-bronze heads, memories of Herod and Herodias, echoed Beardsley's perverse, equivocal thin-lipped smiles and Medusa curls. He found pleasure in musical theater, circus, variety shows, and particularly in the witty caricatures for the anti-Junker, anti-militaristic satirical reviews *Jugend* and *Simplicissimus*, for which his friend, Jules Pascin,[15] would be drawing from 1905 and which, a decade later, would provide models for his modern archetypes. In the Bavarian National Museum, there was a huge collection of Thuringian wood, china, and plastic dolls, with their clothes, carts and animals. These miniatures, made by knowing adults for serious children, embodied that minuscule but monumental simplicity in contour which Nadelman later incarnated in notions of a mock-heroic commonplace. Above all, Munich housed in its Glyptothek an unrivaled collection of classic marbles, ranging from the fifth century Aegina pediments to the late Hellenistic Barberini "Sleeping Faun" restored by Bernini. Throughout his career, antiquities from the Mediterranean and Aegean, folk-art from Western Europe and America polarized structures which revolve around a central focus – the reduction of human or animal forms to irreducible profiles. Nadelman's method involved a synthesis of tensions between laconic silhouette and an ample balance of volumes filling them. His inclination towards dandaical outlines was apparent from the first. The stoic perpendicularity of wooden dolls, the feminine elegance of encapsulated

sinuosity are two themes upon which his several variants will depend. Barbey d'Aure-villy, master-dandy, had written: "The profile is either the greatest peril of beauty or its most astonishing manifestation."

Bertel Thorvaldsen, the neo-classic Dane, "restored" (1815-1817) the Aegina mar-bles, already long divested of polychromy and metal appliqués of arms or armor. While there may have been stylistic discrepancies in the light of later comparative archeology, the immediate impact of veritable Greek carving on Nadelman, who in Warsaw could have known it mostly in plaster replica, was capital. He would always hold Hellas his criterion, the impassive, implacable, harmonious essence of the divinely humane, uncorrupted by time, personalism, or violence; rational, self-centered, realized to such finality that beholders are moved only by the revealed ideal, forgetful of fingers which released images from base matter. Ruskin had said what Nadelman took as gospel:

> [With the Greeks] there is no dread in their hearts; pensiveness, amazement, often deepest grief and desolation, but terror never. Everlasting calm in the presence of all Fate, and joy such as they might win, not indeed from perfect beauty, but from beauty at perfect rest.[16]

Munich was almost as vital a center for archeology and aesthetics as for contemporary art. In certain ways, one tended to paralyze the other. Methodical publication recorded excavations and proposed reconstructions. Kaiser Wilhelm II fancied himself as an Egyptologist; the Prussian "Valhalla" by the Danube near Regensburg parodied the Parthenon. Broad historical studies supported a mathematic as well as a philosophy of ancient art, which had been continually clarified from Winckelmann to Schliemann and Furtwängler.[17] Since Johann Winckelmann in the mid-eighteenth century, Germans conceived classic sculpture almost as their imperial province, a unique and universal criterion, an absolute sanctioned by Goethe: "These great works of art have come into being similar to acts of nature. Everything arbitrary, everything self-conscious vanishes: *there* is necessity; *there* is God." Now archeologists became geometers as well as historians or philosopher-critics. Mathematical formulae plotted profiles of red- and black-figured cups, jars, and vases. By digging, comparison, deduction, research, increasingly complete reconstructions were proposed on a basic reinterpretation of rules used by ancient architects, masons, and sculptors for the swell of ground-course or entasis in columns to correct optical limitation.

Long before the turn of this century, when Nadelman came to Munich, as well as afterwards, there was enormous activity in speculative aesthetics, combining physiological, psychological and metaphysical measures on a new basis of "scientific" consideration. The trend had been gathering force since Kant and Schopenhauer. This culminated in theories of light, optics and vision, worked out by Max Planck and other

physicists and chemists. Observations of color-action on the retina, from studies by Helmholtz and J.A.F. Plateau, directly or indirectly affected the broken-color, fragmented-palette concepts of many important painter-philosophers, including Seurat, Segantini and Signac. Nadelman abandoned any painterly ambitions before he left Poland, although tinting was important in his mature sculpture. His firm preoccupation was with shape, silhouette, plasticity; modeling and carving in low- and high-relief. However, as an intellectual, he could not have ignored the intense ferment of ideas in a city which was not only the center of a fruity mythological "decadence," characterized by the erotic fantasies of Franz von Stuck, Paul Klee's unlikely master, but was also an academy of classical philosophy descending from Leibnitz and Hegel. It is impossible to know what or how much popular theory Nadelman gained from books, lectures, exhibitions, private studios or public cafés. However, one may surmise he was aware of three important figures who would leave their mark, not alone on Munich, but on European progressive practice.

Herman Obrist (1863-1927) studied medicine, botany, geology and chemistry at Heidelberg; his famous "Whiplash" tapestry of 1895, involving an extraordinarily original use of vegetal ornament (here a cyclamen), is one of the key motifs of *art nouveau* decoration. His meandering calligraphic ornament was calculated to determine maximum linear tension. He wished to "raise the force of the curve by raising the force of the line." This is echoed in all of Nadelman's extant verbal analyses before 1911. But it was August Endell (1871-1925) who continued and developed further philosophical and graphic theories, including those of Theodor Lips who studied geometry in relation to optics on a basis of medical psychology. In 1897 Endell had shocked Munich with an enormous, three-dimensional mural tossed on the façade of a fashionable photographic studio. The year before he had commanded: "Show *structure*; exploit it!" In 1896, in the midst of an atmosphere dominated by von Lenbach's homage to Rembrandt and the quasi-Ovidian reveries of von Stuck, Marées and Richard Strauss, he had prophesied what was to be gospel for the coming century:

> We are poised on the brink of an entirely new aesthetic; one that employs forms disassociated from narrative intention, duplicating and recalling nothing; nevertheless, forms which can affect us profoundly, as only music does today.

While one could then hear reverberations from the past in Bayreuth, and intimations of the future in Berg, Schönberg and Webern, the progression of plastic art was also at a crisis. The long romantic attraction to Hellenic and Hellenistic models had graduated into a rationalization of absolute formal criteria through comparative measure from archeological observation and historical speculation. And the canon of The Curve which had preoccupied recent illustrators and decorators, capped by the genius of Beardsley and Obrist, could not have failed to affect Nadelman. In one of

his early gilt-bronze hermaphroditic heads there is an unmistakable echo of the sly smile often worn by Beardsley's boys. In the fragile, attenuated feet of dogs, horses and fawns in early plaques, there are correspondences to Obrist's calligraphic relief. [50] Nadelman contrived his personal method for curvilinear plasticity from 1905 through the next twenty years in the teeth of a firmly rectilinear cubism; this was probably triggered by his months in Munich.

There is one further figure who, without proof, may be proposed as an influence of weight on Nadelman. The position of Adolf von Hildebrand (1847-1921) was unique. Though the most richly patronized sculptor in Germany, he was, at the same time, isolated in work, style and thought, and he worked counter both to the pedestrian patriotic academicians and the growing school following Rodin. Hildebrand won the national contest in 1888 for a medal celebrating the Hohenzollern triumph of a united and victorious Germany, but the second Kaiser Wilhelm, whose taste was not inferior to Hitler's, suppressed it. Hildebrand had been luckier with older royalties: in 1876 he had carved at Windsor a bust of the Duke of Albany, Queen Victoria's fourth son. In 1890 he had designed the splendid monumental fountain honoring the Wittelsbach dynasty, whose Ludwig II had been the first to lend his hand to Bismarck's imperial crusade under Prussian power. When Nadelman reached Munich, Hildebrand was fifty-seven, at the peak of efficiency. His book *Das Problem der Form*, a careful exposition on the basis of his own extensive experience in modeling and stone-cutting, observation and thought, was the result of seven separate drafts. It was admired by Heinrich Wölfflin, the influential art-historian, as well as by Conrad Fiedler, an important professional aesthetician. This book could be found, years later, in Nadelman's Riverdale library.

Hildebrand was a spectacular example of brilliant craftsman, thinker and public servant; rich, successful, skillful, honored, he proceeded like an artist-prince in the company of royal and industrial patrons. His authority and prestige as well as merit emanated from integrity in personal behavior, from penetration and practice. Removed from the semi-official Bohemian milieu of the other masters of the Munich School, he was inevitably resented by other artists. He had worked ceaselessly in virtual isolation for some twenty years outside Florence, in a big studio transformed from an ancient monastery. When the Wittelsbach fountain was unveiled in 1895, Wölfflin, specialist of *Klassicker der Kunst*, hailed it as the triumphal entrance to Munich and all Bavarian South Germany. It remains today, despite restoration of the bomb-damaged male figure, one of the most impressive and original combinations of controlled water and carved stone since Bernini. If one looks closely at the head of Europa mounted on her elephantine, fish-tailed bull-god, the virtual archetype of Nadelman's early neo-classic Venuses, Junos and muses may be recognized. [18]

There are further similarities between the two sculptors which assume almost oc-

164

cult coincidence, too striking to ignore, although any physical contact seems unlikely. Had he known Hildebrand, Nadelman would surely have mentioned it, as he did meeting Rodin and Renoir. Hildebrand was, as Nadelman would become, a recluse. Like him he was generously patronized for acutely realized and highly finished portraits in marble as well as for public adornment. Both lived in an aura of social splendor and made superior collections of past art from which they drew new life. Both professional craftsmen, they were also leaders of taste with highly charged temperaments, at once *grands seigneurs* and executive artisans. Both reputations were ambiguous during their lives and after; both endured post-mortem obscurity and now enjoy a measure of recent revival. After long silence, their work will swell the full story of figurative carving in its decline as a public service.

Hildebrand was an extraordinarily prolific professional and, although he severely isolated himself, obtained important public commissions and maintained an extensive private practice. He was a master in the combining of sculpture and architecture. His fountains celebrating the Rhine in Strasbourg, Siegfried in Worms and Bismarck in Jena; his memorials to Brahms in Saxe-Meiningen and to Bismarck in Bremen were executed with the highest proficiency and taste. Only recently has his work, once famous, begun to be restudied. His position, like Nadelman's, was ambiguous; while he opposed the conservative establishment of his time, his own preference was based in classicism and aristocratic authority. His success as an elite servant of rich patrons removed him from serious consideration by progressive artists and critics.

His book *The Problem of Form in Painting and Sculpture* may be read as providing a substructure for Nadelman's analytical rationale. A decade before the close of the last century, Hildebrand enunciated a prophetic formalism, an aesthetic which Nadelman's work some twenty years later fulfilled. Opposing every local conviction, the book asserts that painting and sculpture have essentially no imitative function. Any depiction or representation of observed natural data must be elevated to a superior plane transcending trivial detail. This he proposes through his own "Architectonic Method," which has cohesive and structural parallels to musical composition. Beyond mere naturalism, his method propels grand, telling volumes into the prime focus of attention. Architectonic factors become absolutely visual, having no concern with the didactic, anecdotal, ethical, or "poetic." Spatial perception is paramount within the faculties of sight and touch, which combine in the eye. Art does not depend on *knowing*, an inheritance of formulae, or a subservience to given taste or ideas. Practice depends upon *doing*; each individual problem is resolved according to its appropriate necessity. The individual psychology of the artist, subscribing to no dogma, creates three-dimensional forms not from recipes but from heightened visual capacity. The factor of light, its movement and surface-play in the reactive eye, accommodation of forms on the retina, the difference between a stereoscopic and a kin-

esthetic vision, comprise an analytical procedure. Realistic, perceptual, or conceptual forms are of quite different orders, suitable to the different materials of metal and stone. An "artistic" and aesthetic sensory dimension exists that is superior to casual processing of visual data; mere reproducing diminishes the larges of monumentality. Hildebrand emphasized the need to consider as parts of the total spatial ensemble, the space at hand, its surroundings, volumetric relations, and clarity of profile.

He makes specific distinctions between planar possibilities and effects in high and low relief, shows the application of relief to sculpture-in-the-round and the close relationship of sculpture to draftsmanship. The architectural frame is no mere adornment but the bridge between the environs of a figure and its expressive integrity. He condemns wholesale the abject poverty of contemporary German sculpture; France did not figure in his purview. In Germany commissions were granted by philistine committees; he had no good word to say of any colleague. Hildebrand's father was a famous economist, whose reputation and wealth benefited his son's position, despite those current conditions of art which he condemned. The single value to which he continually referred, apart from the antique, was the splendor of Michelangelo, whose work, particularly in San Lorenzo, he knew intimately.

Hildebrand was the one figure in Germany who stood apart both from the romantic progressives and the academic classicists, in a special category enhanced by strangeness and success. It is difficult to believe that Nadelman knew nothing of him, and it is unlikely that his sober and splendid achievement was unknown to an art-student aware of every fluctuation of artistic politics. Nadelman would certainly have seen the Wittelsbach fountain, and would at least have heard studio-talk of its sculptor-architect. And very possibly the young Pole on his way to Paris had some dream of his own destiny as a man of the world who would be a public servant, commanded by the chief patrons of his epoch, an arbiter, exemplar and recognized artist. In any case this was what, after five years of complete self-absorption in retreat, and within a little more than another decade, he was to become.

However, it is only fair to reiterate that, as far as any concrete evidence of influence, there is none. He owned Hildebrand's book, as he did several of Wölfflin's, as well as scholarly archeological studies, monographs, and articles. From subsequent testimony it seems doubtful that he was much moved by speculative theory of any sort once he had made up his own mind about 1909. Neither the "dynamic symmetry" of Jay Hambidge, nor Matila Ghykha's and Claude Bragdon's reveries upon The Golden Section appear to have interested him; at least their books were not on his shelves. He was no art-historian except by observation and preference, or philosopher of art except in his attitude towards being and practice. He was a superior craftsman with a highly organized technical apparatus; his wide-ranging collector's eye implemented taste and talent. Erudition reinforced deduction, but the formulae he would

now improvise for himself, whatever their multiple sources, would be his own.

Later, when he could afford it, he collected monographs on Graeco-Roman sculpture, but mostly catalogues of private or public collections, photographs from which he kept by his workbench. Primarily he was interested in posture, structure, profile, and proportion. To him, definitions of absolute silhouette or scale, of attribution or chronology were less fiat than finding. His debt to antiquity was finally an attraction to a few key types of balanced movement in rhythmic repose, rather than to any abstract law, revealed or revived. On occasion, he consulted museum curators, mainly over personal purchases. Problems would remain metaphysical rather than historical or technical. However, Munich was only a step on his path to Paris.

PARIS 1904-1914

Since 1831 there had been a *Cercle des Artistes Polonais à Paris*. Count Anton Potocki, who (with the Swiss art critic, Adolphe Basler) founded the review *Sztuka* (Art), was at the center of activity which introduced gifted young Poles to a Parisian public while making sure, at the same time, they were not forgotten in Warsaw. Among Poles in Paris, Nadelman knew the eminent sculptors Ostrovski, Lewandowski, a little later Count Auguste Zamoyski, as well as the harpsichordist Wanda Landowska. The brothers Thadée and Alexandre Natanson, former editors of *La Revue Blanche*, devoted patrons of Rodin, Nabis, and Post-Impressionists, encouraged him. However, he never thought of himself as an exile. He was a discontented intellectual, at first dissident; for a decade he cast himself more as a demonstrator than an individual talent. From the start, he required a rational structure to whatever procedure his educated choices might ultimately direct him. First of all, he had to choose whether or not he would be an artist at all. This depended on whether he could find a definition or analysis for the roots of sculpture. Actually, he was an autodidact. Academies were nothing; education was seeing; working meant, what is more difficult, the intense process of thought which was as important as museums or modeling. He secluded himself for six months spent in lonely self-study, avoiding those Beaux-Arts courses which might have led to a normal entry into local professionalism. For a brief time, he drew from short life-poses at the Atelier Colarossi, without criticism. Of the powerful influences on him between 1904 and 1914, the first was the Louvre, and particularly the two bound "slaves" intended for Pope Julius's tomb, the second the extant repertory of Auguste Rodin.[18]

Nadelman made drawings from Michelangelo's marbles which were not academic copies, but translations of their balanced volume into a basic idiosyncratic grammar or geometry, derived from their own highly non-realistic, conceptual forms. These

renderings were not treated as a repository of some residual magic which might be decoded or shared; rather, outside time or place, they solved personal problems by finding bold solutions for presenting three-dimensional form in an urgent, balanced harmony. The plasticity of statuary had imperceptibly yet increasingly shrunk since the seventeenth century; the heroic or monumental now too often existed in flaccid figures by official practitioners whose very feebleness licensed public work. Excellent sculptors in eighteenth century France, Clodion, Falconet, Girardon, Bouchardon, Houdon, in spite of representative monuments, might also be considered miniaturists. Nadelman's analytical drawings were an investigation of essential plasticity rather than pretensions towards a recipe for monumentality restored. **[35]** He was interested in form, not scale. Indeed, the very idea of statuary acceptable to public taste was, fatally, a lowest common denominator, the criteria of committees systematically mocking Carpeaux and repudiating Rodin.

The third and perhaps most far-reaching influence derived not from a sculptor but a painter. While speculation in Munich tended towards abstract aesthetics or ordering historicity, Parisian activity centered more on physiological and even psychological metric and mathematics, reflecting a Gallic predilection for *la mesure*, as much decorum or temperance as "measure." After antiquity, Michelangelo and Rodin, the artist exerting capital influence on Nadelman was Georges Seurat. This effect, most visibly operative in America after 1915, subsumes many art-historical mysteries. Even after Nadelman patently echoed Seurat's silhouettes in his plaster and wooden figures, it is impossible to know how conscious he was of Seurat's sources. Since his energy and curiosity were ubiquitous, since he was in direct contact with a vocative advance-guard, it is hard to believe he did not know much of what went into the formation of this great painter's mind and method. The painter's temperament, clarity, habit of thought, psychic pattern, methodology, sense of the present, are extraordinarily close to the sculptor's. However uncertain an exact chronology of Seurat's effect on Nadelman, which accelerated over the coming decade, certain factors may be fixed.

Nadelman arrived in Paris late in 1904. In March, 1905, there was a large Seurat retrospective at the Société des Artistes Indépendants, in whose Salons Nadelman would shortly exhibit. *"La Grande Jatte," "Baignade,"* the unfinished *"Cirque"* were hung alongside his smaller landscapes. In 1908-09 there was an even larger show at the Galerie Bernheim-Jeune with two hundred canvases, many shown for a first time. The first serious magazine article on Nadelman was published alongside the first real treatment of Seurat's drawings.[19]

As a painter, Seurat is considered primarily a colorist; his uses of contrast and mixing are so dazzling that this almost hinders one from considering his equally powerful definitions of conceptual form in silhouette, profile, and plasticity. He said:

"Art is harmony. Harmony is the analogy of opposites." A venerable line of scientific observation supports Seurat's theories of color contrast. There is an equally studious background of formal research in the development of expressive gesture, linear structure, geometric schema, positioning of figures in monumental isolation. Seurat's insistence on released verticality, his reduction of persons to archetypes in a contemporary social context would trigger Nadelman's later work. Seurat depended considerably upon the Swiss aesthetician, David Sutter, who had written: "In Greek art everything is foreseen with taste, feeling and complete science. No detail is left to chance; everything is related to the mass by the play of aesthetic lines."[20] Another thinker who touched Seurat was Charles Henry, who from 1885 attempted a general mathematical aesthetic involving architectural structure. Two of his later studies were *Le Rapporteur Esthétique* and *L'Éducation du Sens des Formes*, ca. 1890.[21]

From 1906 through 1914, the only titles Nadelman attached to his analytical drawings, which in fact were independent and autonymous works of art, were *Rapports des Formes*, or *Recherches des Volumes*.[22] His researches into harmonious relationships of form and volume were undertaken first of all by linear means. Commencing by over-all indications of the swing of head or torso, larger forms were laid in arbitrarily, although all contours were projected from naturalistic observation. There was little "expressionist" or "abstract" exaggeration and no overt emphasis on sentiment. Outlines were suites of curves enhancing commanding directions of pose, gesture, inclination of head on neck to emphasize three-dimensional plasticity. After gross shape was indicated, he further decomposed bulk; descriptive arcs were bisected, trisected. Finally there was fusion, an encompassing unification derived from reciprocals of sprung curves netting or meshing interior masses. These studies have been called student-work; so they were, but by an advanced student who, testing current academic tools, found them inadequate. Here was a student who for his master's thesis offered a radical visual grammar, a new metric, as well as a novel timbre in voice and vision.

While Nadelman was primarily preoccupied with sculpture, he studied pictures and was much moved by drawings of painters or sculptors which suggested massive forms or grandly characterizing silhouettes, as in Rodin's watercolors for his *femmes-vases*. He could not have been ignorant of the analytical constructs of Paul Cézanne – radical means of composing or decomposing form and volume in terms of color. One might oversimplify Nadelman's method by saying he applied much of Cézanne's method to anatomizing classic sculpture.[23] But it was by no means Cézanne who first recognized the universality of cone and cube. It is sometimes forgotten that Auguste Rodin was also a powerful formulator of ideas. Anticipating Cézanne, he had said:

> Nature has been my great teacher . . . I came more and more to see how much analogy
> there was in all forms that nature begets . . . to realize that geometry is at the base

of sentiment, or rather that each expression of sentiment is made by a movement which geometry governs. Geometry is everywhere present in nature . . . Nature is the supreme architect. Everything is built in the finest equilibrium, and everything, too, is enclosed in a triangle or cube or some modification of them. I have adopted this principle in building up my statuary, simplifying and restraining always in organizing the parts so as to give the whole a greater unity . . .[24]

However conscious Nadelman was of structure, his self-wrought analysis was no mechanical tool applied as a formula by which all problems might be solved through one empirical panacea. He would be always more captivated by intrinsic dandyism in the human body's trim dignity in repose than by any formal charting through plastic stereometry. To him, after he had made his root decisions on the quality of form or volume, having composed various systems for its graphic or plastic rendering, questions of proportion, establishments of mass, relative dynamics of shape were simple as breathing. He had an innate gift for the appropriate, what fitted, the suitability of forms in themselves as well as against each other. However generalized, his balance of shape holds its supple vitality, a fluent alertness, reflecting immanent humanity. He was an intellectual not an academic, logician not aesthetician. Shapes, however encapsulated, derived more from external reality than from any subjective, ingenious recipe. The eminent sculptor, Jacques Lipchitz, whose background was not dissimilar but whose taste could scarcely be more different, remarked at the memorial show in 1948 that ultimately, if he was admitted to the sculptors' heaven, there he would find Nadelman redeemed alone by his *sens des formes*.

As for contemporary activity in sculpture when Nadelman reached Paris, the figure of Rodin towered over and indeed all but smothered his contemporaries. World-famous, installed at the sunset of a stormy career still promising conflict in the State's Dépôt des Marbres, rue de l'Université, the benign bearded satyr seemed, as Apollinaire depicted him, a veritable God-the-Father-Eternal of living art. The finest talents of a younger generation were proud to be his pupils. Rodin's influence on Nadelman is apparent in reproductions of early lost works in plaster, reproduced in *Sztuka* for 1904, as well as in the head of Thadée Natanson (1909).[25] **[83]** Nadelman never failed in his admiration for "The Age of Bronze," "John Baptist," the "Burghers of Calais," the "Balzac." Rodin's early bronzes were modeled towards an intensely vibrating plasticity, but his later stones, carved mostly by his staff craftsmen, were only occasionally released into full voluminous existence. His final marbles almost always respired a vaporous softness. Cut stone seemed to emerge from a clay mist; when fixed in carrara, carving was largely from the chisels of Franco-Italian *praticiens* or *metteurs au point* whose fantastic skill in rendering marble in terms of plasticene further damped down Rodin's profound sensual impulse into an enveloping haze. But it is this looming suggestive vagueness, echoing the late marbles, that can be

traced in Nadelman's own *galvano-plastique* (plaster coated with copper) heads and figures of the mid-'Twenties.

Nadelman, unattached to master or academy, developed increased manual capacity. With some help from home and local Polish patrons, he enjoyed minimal security. Yet it was not easy for a solitary young provincial to determine his direction. The crushing prestige of the Rome Prize awarded through the Beaux-Arts official Salons on the one hand and Rodin on the other, might have been all but emasculating. Perhaps only one deracinated, isolated between East and West Europe, with a rebel temperament freeing him from attachment either to academy or homeland, might risk opposing one, the other, or both. Perhaps it is not by accident that the sculptors who recognized Nadelman's significance earliest came also from Central Europe: Brancusi the Rumanian, Archipenko the Ukrainian, Joseph Brummer the Hungarian who became America's finest art-dealer of the 'Twenties and 'Thirties (as well as one of Nadelman's strongest supporters), and who, by 1904, was an assistant in Rodin's *atelier*.

Finding no master to whom he wished to apprentice himself, no school except the Louvre in which he longed to study, no modern work except by Rodin which pleased him, Nadelman came to have serious doubts about his own vocation. For six months he immured himself in his narrow studio in a courtyard behind No. 14 Avenue du Maine off the rue de Vaugirard. Here he lived with an English girl, Constance Lloyd, later with Polish and Hungarian models. After the Druet show he took a larger studio, 15 rue de Boissonade. In this *tanière*, this animal's lair, so lovingly described by Thadée Natanson, so patronizingly by André Gide, he struggled to decide if he actually could devote a life to sculpture, whether it was any longer possible, desirable or necessary to be a sculptor in the twentieth century when the entire notion of functional or architectural carving had been largely debased into moribund statuary; where, in the modern metropolis there were so many stuffed statues, so few noble monuments. For sculpture had not enjoyed the revolution or reform which had renovated painting from Romanticism through Post-Impressionism; the very medium itself seemed to be less necessary or useful than ever in history. He might have read in Baudelaire, whose poems were to become a kind of Bible, and whose prose (particularly in the study of toys, cosmetics, the dandyism of Constantin Guys) reads like his personal aesthetic, "In all great epochs, sculpture is supplementary; at the beginning and end it is an isolated art." Nadelman felt and was alone. If he should persist, how could he proceed sure of little else but his own gift (and of this, what intelligent youth can be certain?) and his roots in antiquity – the extreme past as prologue to some present or future. He forced himself with rare energy to profound personal and artistic conclusions. In the half year of initial retreat or seclusion (repeated periodically, until, towards the last of his life, it became complete), he faced one central resolution. He

was, in spite of everything, intended to become an artist. As an artist, he must devote himself to sculpture.

After these crucial months, through what amounts to moral conversion in its depth of commitment, for the next five years, as much by measure as imagination, he pursued in drawing, clay, plaster, marble, bronze his *recherches*, using as double pretext or subject his own body and, far more, those of women companions; increasingly less often the classical marbles and Renaissance bronzes in museums. From 1905 through 1907, he exhibited the results of his early researches at two annual exhibitions. The Salon d'Automne and the Salon des Indépendants offered important opportunities in the marshaling of that advance-guard which, in less than a decade, would triumph as the School of Paris.[26] He showed his early drawings *chez* Berthe Weill, rue Victor Massé, where Picasso also first showed. His early titles were always "*recherches des formes ou volumes*" or "*rapport des formes.*"

At this time, the poet-critic Guillaume Apollinaire, who did much to herald Paris as headquarters for a world revolution in verbal and visual imagery, journalistically nick-named young Nadelman "Pheidia*sohn*" or "Praxitel*mann.*" Proper names might have been reversed; he was more a remote follower of Praxiteles than apprentice to Pheidias. However, reference to the aura around these mythic names indicates his debt to Graeco-Roman ideas, his personal attitude towards antiquity and its use in his time.

While Picasso and his colleagues derived new power from Africa or the Pacific, Nadelman's sources lay around the Aegean and Mediterranean, or more properly, Greece as seen by Alexandrians and Antonines. [152] For progressive Parisians, this was a dry fount, drained since the Baroque. Nineteenth century neo-classic sculptors – Canova, Thorvaldsen, Bosio, David d'Angers, Rude, and less gifted salon-exhibitors – were devils to be exorcized to oppose that decadence which Rodin, single-handed, had arrested. Now he, too, froze into almost academic eminence. To be interested in sculpture from Benin or Tasmania was demonstrable vigor. To be occupied, at this late date, with Olympia or Giovanni da Bologna proved debility.

To Nadelman, classifications of primitive, sophisticated, healthy, decadent were without meaning. Naive categories are always denied by individual quality. Excitement for a past period, as in a chosen style, is knowledgeable preference, untyrannized by fashion. One looks for excellence in an object, judged by its intention, background, or fulfillment. Arriving from Poland, relatively unprejudiced, having lightly discarded provincial attitudes, he felt no cause to be wary of antiquities in Glyptothek or Louvre. The initial impact of the Munich pediments led him to fourth and third century carving, which he would anatomize as surgeon or semanticist. For him, it was as much an athletic effort to look anew at over-familiar relics as it was for Fauves or Cubists to discover fresh magic in Africa or Oceania. Just as so-called

172

"primitive" cultures had to be unveiled from total ignorance, ancient and Renaissance art could be rescued from drastic over-exposure.

In the range of work originating from Aegean lands, there was slight distinction at its making between what we have learned to term "major" or "minor." Today we know the grander statuary through diminished copies, reduction of bronze into stone, terra cotta recensions, or imitations produced centuries later. In classic Greece, there were smaller gaps between what we consider "artists" and what they took for "craftsmen." Sculpture, painting, its polychromed combination were more the result of studio organization than of individual "genius" or talent. When we speak of artists named Pheidias, Praxiteles, Lysippos, we might think of them even more as shopmasters than individuals. It is sometimes forgotten that, in Greece, plastic art rarely enjoyed the prestige of spoken verse, music, or dance; *poetai* were not merely versifiers, but those who worked in every imaginative sphere. The single name for what we think of as "art" was *techne*, implying craft mastery. The nine muses whom Apollo led included no patron for painting or sculpture.

Greek artisans or super-smiths modeled, cut, embossed, burnished, chased, cast, and carved. They manufactured moulds, engraved metals, cut gem-stones, carved, stained, and polished ivory and marble. Men who thus labored were distinct from what we call painters, sculptors, or jewellers. In Greece, they were known as *toreutai*; in Rome, *caelatores*. The Latin name for craft-art mastery was *caelatura*. From this came the English "celature," in use well into the seventeenth century. When such practice split into specialization the term faded, but Nadelman was, in fact, a celator. The Greeks respected celators along with painters of walls and vases; the stone-cutter was not so respected unless he wrought also in metals. Pheidias, for example, was master-celator, general manager, overseer, work-captain, impresario, contractor. Celature was the trade of free-born citizens, not slaves. If Pheidias had actually carved himself, he might have lost face. He probably designed or laid out, but most handwork was staff executed. Bard, mathematician, scientist, philosopher were deemed true "creators" since they conceived novel constructs from imaginings. Craftsmen handled materials already granted – earth, metal, wood, stone – only awaiting fashioning by trained muscle. "Laborer," "artisan," "artist," were interchangeable terms. Able ones were well paid along with other skilled workers, carpenters, weavers, but acknowledged mainly as superior technicians. Pheidias, on political pretext, was imprisoned as a fraudulent contractor. Fame as originator of chryselephantine Athena or Olympian Zeus would not redeem him.

To fully understand Nadelman, we must approximate his precedents. He would develop his independent eye, but his notions of Greek art at their first impact derived from what he saw, and what, as an intellectual, his curiosity led him to read. In general, this was a formulation by German archeologists and academic aestheticians

who imposed their own taste on what they had so far turned up. They energetically reconstructed and restored. As W. M. Ivins, Jr., said in his devastating *Art and Geometry*: "It may be that the German professors understand 'Greek' art so well because they have made so much of it."[27] Goethe, in love with his (Hellenistic) notion of "Greece," was blind to the Aegina pediments. When the "true" Greece of the archaic Apollo-youths was uncovered, Rilke refreshed himself at *his* "source" of Hellas. By the end of last century it was clear that knowledge of the *history* of a scientific discipline was as important as extant theory; similarly with connoisseurship. Greek literature had long been available. Pictorial information, until photo-engraving replaced line-cuts and "original" work took the place of dubious casts, was only general from about 1905. Hence, while Nadelman could depend on a considerable body of evidence, any absolute accuracy referred more to the taste of his times than to an objective antiquity.

However, there were certain obvious facts which needed no further excavation or restoration to alter or corroborate. The central authority of Greek (without quotation marks) art in its plastic unity is manifest on an exalted level of ordinary production, whether in pediment, tombstone, vase, or mirror-back. Stendhal said that, for the ancients, the beautiful was little more than an extension of the useful. Metaphysical necessity had daily useful result. Greek art was an embodiment of abstractions, political and philosophical, relating to humane capacity on a collective level, presupposing a slave-holding society. While its makers may have been well known, individual signatures alone did not qualify their artifacts as negotiable investments as ours do today. Pheidias was accused of impiety for including his self-portrait on the shield of Athena.

Despite a seeming lack of divine sanction for plastic or pictorial techniques, there are few other instances in the West when artist and audience existed in such close contact. Nadelman, for the first half of his career, enjoyed a similar equation. From his debut, even before his first Paris showing, he was enthusiastically patronized. While his later work sold not at all, he still attempted to obtain commissions from private patrons and public architects, fulfilling his urgent need for popular employment. His own judgement on such failed ambition was a final frustration. As for those Greeks, as then appreciated, upon whom he most drew, it was far less the descent from Pheidias than from Praxiteles, Lysippos, and the elder Polykleitos of Argos (flourished 450-420 B. C.), whose shop and school was credited with methods for establishing rules for proportion, rhythm, balance in dynamic harmonies incarnated in writings and statues – the Polykleitan "canon." This possibly derived from Pythagorean metaphysics in which measure determined metrical or rhythmic absolutes as armature for musical and architectural constructs.

Already by the sixth century (B. C.), Pythagorean mathematics, the first system to

replace elementary commercial counting, subsumed a shift from geometry to more complex measurement. Numerical relations conditioned figurative harmonics. Rhythm and proportion would be clarified or justified without distortion by number. A semi-science of harmonies or *harmoniae* (fittings, arrangements, suitabilities) may, stemming from Egypt, have had oriental origins. It served as a foundation for aesthetic morality. Such conjecture has been long attractive to men of Nadelman's temperament and intelligence. He certainly would infer that he had uncovered secrets, or discovered applicable fractions of lost method. The scientific philosophy of Pythagoras of Samos (flourished 575-530 B. C.), more exactly of his school or tradition, has preoccupied artists and students from Plato's *Timaeus* to recent "dynamic symmetries" promulgated by Jay Hambidge and Denman Ross. Among various early cubist theorizings, the formula for the Golden Section was borrowed to stabilize abstraction.[28] Profiles of Greek vases, stereometry in sculpture, entasis in architecture have been analyzed with provocative if often ingeniously unproductive results. It is impossible to compress the corpus of Pythagorean proposals in a paragraph. Nadelman was neither amateur archeologist nor educated mathematician. What he knew or ignored of academic Pythagorean metaphysics is unimportant since its basics are simple. A direct analogy exists between things and numbers. Aristotle, beholden to such thinking, said: "They [the Pythagoreans] imagined the element of numbers to be the substance of things." Our universe is unified or harmonized in a web of consonances. Now spatial and aural measure advanced past Euclid's geometry and the Pythagorean octave. Mathematics and acoustics progressed in a new order of fluency. As for visual measure, Polykleitos established a canonical height for free-standing figures about seven heads high. Lysippos slendered it to seven and a half, then eight. The eight-tone harmonic scale lasted twenty-five centuries; recently a twelve-tone scale established a new academy. Ancient canons were not tyrannous censorings but rational craft guides. The perennial magnet of "perfection," Yeats's "fascination of what's difficult," is manifest in idiosyncratic systems from alchemy through to computers, but the Greeks, whose term "idea" included "image" (with Nadelman in pursuit), always maintained a real interest in nature as mistress or model, even while subordinating complex forms to imposed formulae. Imitators, perfunctory classic revivalists, approach antiquity as an exhausted commandment, but the Greeks of the "great" periods felt that *techne*, employing a mathematical concept, might be extended "to infinity."[29]

Plato had carved over the portal of his academy: "Let no one ignorant of geometry darken these doors." Salvation also lay in poetics, governed by metre, but he foresaw the dangers of desiccation. While The Pure, The Ideal, was previsioned by The Idea, universals, absolutes, lust for an ultimate Divine held hazards. Invoking the sacred name of Eros, love, he warns in his *Phaedrus*: "He who gains the gates of creation with-

out madness from the Muses might deem craft (*techne*) alone may make him master...
but rational labor dims before skills in inspiration." Appearances were regulated by
a flexible reference to rendered precedent. Hence, the amalgam of craft, measure
and collective sensibility amounts in Hellas to individual, if often anonymous, taste
and talent. As for taste, already by 440 B. C., the canonical "Spear Bearer" of Poly-
kleitos, itself a modulation into further elegance of more heroic archetypes, seemed
to lack "soul," compared to the Pheidian grammar's sacred syntax. It had become
less heroic, more humane. After Lysippos, Alexander's court portraitist, following
fabulous activity came reaction, submission, exhaustion even. Alexander, whose
model was Achilles, split his world as we split atoms. A known human did this. No
gods were left to credit. Man alone remained, to remain alone.

In Nadelman's apprentice years, there was a comparable situation. Rodin, shaded
by Michelangelo, might stand for a Pheidian criterion. Nadelman analyzed reductions
of Lysippos; later, Praxiteles. The romantic but designedly fragmented sensuality in
Rodin's passion corresponded to the residual divinity in a vacuum surviving from the
collapse of cathedral sculpture. The agonism was between praise versus elegance,
lost divinity versus humanism, collective belief versus solitary hedonism. And so,
while he worked next door to Fauve and Cubist, Nadelman was already an anomaly –
conservative, a lone fighter in his almost feverish rear-guard action. His present and
future were firmly set in tradition; his means were idiosyncratic, his style neo-classic,
his morality increasingly stoic, all of this alien to the influential practice of his epoch.

Polykleitos says in a preserved fragment: "Beauty rests down to the slightest
shadow on the relationship of many numbers." Although credited as among the first
to emphasize an importance in metric, in a free-standing ideal released from block
and background, he recognized aleatory elements. He appears to have maintained
the basic rationale of a "canon," while accentuating those hairbreadths by which sure
workmen violate it to inform volumes with vitality. For his shop this was perhaps
less solved by theorem than by estimation of the *kairos*, an indispensable, analytical
balance of proportions, which was first harmonized in the mind's eye. Variants on
ideal themes, through sketch to clay, wood, bronze or stone, incorporate mutations
which, swerving by whatever degree from an abstract stereometry, nevertheless,
in final realization, offer new corroborations of it. Nadelman's private gloss on re-
ceived notions or personal observation established his own criterion rather than
dependence, except in philosophical principle, on any revived precedent. Evidence
that sparked his own *kairos* was heightened in museums and subsequent analytical
studies. Although he lived with women who were also his models, after Warsaw there
is nothing extant which vaguely resembles a "life" study. That there was always a
superior rationale in masterwork he never doubted – whatever the system.

Nadelman's neo-classic echoings were disturbing from the time of their initial

recognition. They were partly condoned as didactic demonstration, but when they corroborated a personal taste and temperament, at once solitary and cerebral, they were dismissed as retardative. Throughout art's history there have been recurring "classic revivals." The main failing of much neo-classic sculpture lies in imitations or approximations of an ancient heroic impulse, while coeval society has slight sympathy with such rhetoric. A style becomes stylization. "Stylization," said Cocteau, "is a term shrewdly invented to designate objects devoid of style." In the modeling and carving of the greatest neo-classicists, particularly Giovanni da Bologna and Antonio Canova, there is much to admire, particularly in their close observation. Before Nadelman, Canova had attempted to recover truth in the pose and plasticity of the so-called "Medici Venus." It derived from Praxiteles' "Aphrodite of Knidos," whose site was excavated in 1969. [30] This was possibly the first classical nude female divinity; she stands with her hands chastely shielding her treasure: *Venus pudica*. Some fifty antique versions populate our galleries. These served Nadelman as one of a repertory of themes upon which he produced variations. [31-34] An early one embodies the face and form of Gertrude Stein; she kept its plaster model on a corner table under her Matisses and Picassos.[30]

Nadelman's hyacinthine self-portrait [155], marble, cast in bronze ca. 1915, depends on drawings of his own profile made some seven years before. It reflects a tradition of idealized post-adolescence, which stems from the Praxitelean "Hermes with the Child Dionysos," and its later recension in heads of diadem-binding athletes down through late ikons of Hadrian's Antinous. Whether the "Olympian" marble was indeed from the fingers of that master we call Praxiteles or a superb copy by a Graeco-Roman follower, was not a riddle to trouble Nadelman. But what he learned of the sculptor endowed with that name makes of him a lonely character, lacking many official commissions, solitary, an isolated worker operating in a realm of cerebral sensuality, with a temperament in many ways like Nadelman's. Serene repose in sinuous balance invested the Polykleitan canon. Suave unconcern, amiable nonchalance, frank but unvaunted well-being, a healthiness unstrained by overt musculature, no deformation, tension, and an overmastering remote benevolence approaching tenderness characterize statues assigned to Praxiteles or his successors. The "Olympian Hermes," commentary upon which would occupy Nadelman for forty years, reveals grace in bemused revery, is almost listless, bored, sweet, no longer the patriotic warrior of Salamis or Marathon, but a hedonistic dandy. In fired-earth figures from kilns of Tanagra in Boeotia or Myrina in Aeolis, there are echoes of both Polykleitan and Praxitelean strains. Nadelman's commentaries incorporate vibrations of such echoes with a refined intimacy from his own insight.

Under pressure of French Revolution and Napoleonic Empire, neo-classicism strained itself. It was obvious even to the Emperor that he must not be personally

portrayed as Mars. A flattering figure on the Arc du Carrousel would be replaced by a symbol for *La Grande Armée*, not his imperial person. He would appear most memorably as no god, but as *le petit caporal*, the ordinary contemporary soldier in kerseymere britches and bicorne. Nadelman never inflated his figures with Plutarchian rhetoric. Instead, he reduced, domesticated, modernized what was apposite from antiquity, utilizing the gap between a symbol become banal and its contemporary displacement. Irony in historical recension, a dandaical but stoic aphoristic wit, more than a hint that heroism was no longer heroic supplied piquancy to Nadelman's notion of antiquity. His late small figures, following two decades devoted to aspects of contemporary fashion in which he would again borrow classical models, are not merely archeologically oriented. These gloss man's fall from grace, his loss of divine possibility, the passing of all golden ages. Graeco-Roman imperial art was born when Asiatic mystery religions proliferated, introducing from oriental cults eschatological notions foreshadowing absolute or final events. Mystical doomsday portents attracted many alongside worldlier moralities of cynic, skeptic, stoic, or epicurean. Few may have been total skeptics, wholly denying any existence of all gods, but if these still dwelt on Olympus, they were remote from mortal hearths. A middle class surrounded itself with objects supporting comforting philosophies hedging anarchy and barbarism for a few generations more before barbarians sacked Rome.

Nadelman through his own career reflected the broad development of Greek sculpture from the fourth century into its long decline. Hence it is easy to reconstruct his identification with the character of Greek craft-artists. For himself, he combined an intellectual discretion in the service of traditional technique, corresponding in his epoch to few norms of practice, and an overweening moral pride in his individual capacity, which he judged exceptional. Greek apprentices were schooled in good shops. Their skilled fingers were put to common use by a public which prized them. They were not independent workers lacking mass patronage, expressing obsessive frustration at the behest of daemonic personal compulsion. They embellished the daily lives of a citizenry with toys, pots, cups, gravestones, and figures of memorable soldiers or athletes. Their art was socially necessary, drawing attention neither to the means by which it was made, nor to the psyche of its producers. These were neither in conflict with their audience, nor in artificial competition with colleagues. Greek art expressed itself in abstract, indeed geometric, terms; austere and static, as was the polity. Artists were neither innovators, reformers, nor revolutionaries. Nadelman imagined himself in their line, corroborated at first by his youth, success and peace of mind. He was not without pride; vanity made him cast himself as an unhumble, isolated and unique worker. He always gave more praise to skilled academic professionals than to flashy local personalities. But his own eyes would force him to accept the facts of life and history. In an industrialized twentieth century, manual skill, let

alone individual talent, was at a luxurious premium; his apparatus and attitude would be increasingly rare if not unique.

The neo-classic tone of Nadelman's most familiar marbles, while over-easily digested, still troubles. Madame Rubinstein bought these heads as a lot; whether they might have found other purchasers can be questioned. Whatever her aesthetic judgement may have been, she immediately recognized them as ensigns for popularizing her beautification business. They echoed in mirrorlike marble what her clients had long known from dead white plaster, which was what they themselves aspired to be in perfected flesh. The excavators of antique marbles cleansed remnants of original polychromy by acids: color, surface, patina, were homogenized. In the case where color was found on a fragment, it had to be powdered over or removed to coincide with what was considered "authentic," before Germans restored the rationale of painted stone. Nadelman's early heads were whole, perfect, precious; their final completeness was indeed a cosmetic improvement on museum pieces pitted and fragmented by time.

Neo-classicism is too often dismissed as a dead style rather than a legitimate language. It is easy to ignore the worth of poets and painters who have subscribed to its amalgams, among whom shine Pope and Poussin. It is facile to assume that here imagination is perverted by a worship of prior forms, book-learning, museum-taste; no immediate experience; written history rather than lived experience. In Mario Praz's seductive study,[31] he reads Milton's solemn strophes as seventeenth century English aristocrats imagining themselves Roman soldiers. There was a novel magic in Milton's archaicized metric, which also sounded like a sober game, preposterous in rotundity, making one smile at the distance between Virgil and his contemporary equivalent. To the unsophisticated, the neo-classics would seem official; to the half-informed, an echo, debased or muted. But in the hands of masters, variants may be transformed to levels equaling their originals. Auden shows that Milton, despite his Latin exercises, was less interested in any academic revival than in the development of his own astonishingly idiosyncratic speech, which, nevertheless, could hardly have existed without strict practice in Latin metric. This is also true of the neo-classicism of Racine, Lully, Poussin, Dryden, Canova, Cocteau, and Stravinsky. What Nadelman's critics have ignored is that, projecting upon a past period with conviction, later artists wring ironic but loving messages from both past and present. Also, a recognition of rational descent cleanses eyes confused by novelty. Picasso quickly turned from the cerebral complexity of Cubism to a deliberate simplicity related to Pompeian murals and Greek mirror-backs. Romantics and Impressionists assumed that neo-classicism smothered nature with culture; that culture was artifice, stemming from museums alone. Poussin, David, Ingres drew constantly from nature. Canova sketched, painted, modeled, and carved from live dancers. Artificiality, overtly stressed, a mannerist

double or triple exposure whose overlays are not fused into clear vision, is the weakness in neo-classicism. Generalized formulation and orotund gesture echo over-familiar sources, with no individual comment save servile imitation. But with the great neo-classicists, nature is not denied: it is synthesized. It resolves into definitions of taste. T. S. Eliot, via Pound and Yeats, repudiated the Victorian adornments on Greek tragedy widely popularized by Gilbert Murray. Picasso annihilates Gérôme and Alma-Tadema. It is not so much a question of how classic Greece was as an archeo-logical truth, but how our ideas of it are presented. Strong hands and eyes are un-vanquished by grand precedent. Firm fingers like Seurat's or Nadelman's fuse distilla-tions of fractional reality into their suprarational syntax. Neo-classicists are concerned with metaphysical pattern, not personal psychic drama. However, this neither denies their awareness of brute nature nor diminishes a potent ordering. Temperaments operate up to bio-chemical capacity, transcending all pre- or post-conceived notions of what form, volume, tint or texture can be. Nadelman's most impersonal heads could have come from no hand but his. Yet it is plain that many formidable carvers following Canova (and this is particularly true of Americans in Rome or Flor-ence – Greenough, Crawford, Hosmer, Story) produced marbles which, if gathered in one gallery, would read as the depressing retrospective of a single industrious mediocrity.[32]

The cosmetic texture in Nadelman's glossy stones has also aroused distaste. **[122]** Some wish he had not polished so highly, or at all. Vitreous surfaces are "vulgar"; excessive finish borders on kitsch. Marble is unreflective in its virgin state; polish amounts to rape. We have been conditioned to the green-black eroded skins of antique bronzes, or to their mortuary plaster casts. Super-perfection gilds the lily. Nadelman gloried in luxurious and varied texture as well as color. The Greeks polychromed with pigment in melted wax applied by specialists, who were no less skilled than stone-cutters. Details of dress, embroidery, ornament were often drawn on the carved stone, not incised. Curls and pubic hair were red-brown; hair was powdered with gold leaf. Eyes gleamed in glass paste; lips, nipples were accented by red iron-oxide inlay; teeth were of chased silver. Lead or bronze overlays, *appliqués* of arms and armor were gilded. In Aegean sunlight, pure white stone would have been blinding. Color was part of form. Encaustic chromatics were sumptuous, not gaudy; conceptual, not illusionistic. Beards might be blue. Over the centuries, many varieties of polychromy were successively popular, increasingly flamboyant and ostentatious. Later, Roman collectors preferred more naturalistic, but no less splendid, surfaces. After an ex-panding empire acquired remoter quarries, combinations of richly variegated marbles, highly polished porphyry, alabaster, lapis, sardonyx, were doweled into extravagant wholes. Hadrian's craftsmen delighted in virtuoso textural contrasts, flesh against metal, cloth, pelts, curls, porcelainized cheeks and pectorals. Nadelman could praise,

mock, echo, and regret such splendor. Many bronzes were dazzling in heavy patinas of gold.

It is sometimes forgotten that the preponderance of Greek free-standing figures were bronze. Notions of blank white graveyard Greece are false. At eye-level, sculpture was highly reflective metal. It would be truer to accentuate the influence of metal-workers on marble than to think of stone-cutters teaching gold- or silver-smiths. Large stone figures with metal *appliqués* imitated ivory statuettes adorned with gold. Romans loved *aurichalcum* (from Greek: mountain, mystic- or magic-gold), a gorgeous brassy criterion fit for coinage. But bronze often lost its brilliant gold-leafing, secured by a thin mercury layer before it was rendered, more or less accurately, by the point-process (still in use today) in cheaper, unpainted stone. The optimum metal surface, whatever its color resulting from various chemical contents, had all imperfections, channel-vents, joints, and pitting plugged, chiseled, chased and carefully burnished. What is often left in museums is an approximate skin, half-healed from the earth-eroded acne of verdigris scabbing.

From around 500 B. C., by a process called *ganosis*, those porous stone portions representing flesh were stained and coated with toned molten wax, rubbed with waxed cords, buffed with wool pads, at first, perhaps, more for protection against weather than perfection. Iron veins in local Pentelic marble, finer-grained than from the far island quarries, glazed by sun and rain, endow the Parthenon with its honied rust. Marble crystal structure, limestone, or softer alabaster admits, holds, and reflects light. Greek sculptors knew how to flesh luminous stone. Marble profiles merge in the atmosphere, establishing edges more blurred than highly reflective metal. Their surface and substance, while less motile than bronze, never corrodes, but it can be broken or fed to kilns for lime; such has been the fate of most antique sculpture. Nadelman's marbles and bronzes are grateful for polish and chasing. No two figures, even in editions of half a dozen for many of his decorative bronzes, are identical, and everything from his chisels or gravers was exhaustively finished.

Under Nadelman's glassy buffing, contours and volumes fuse, approaching the irreducible primordial egg. [24-28] Here lurks subtle provocation. His polish is ivory more than ice. Crystalline gloss, vibrating with reflected lights, traps a metaphor of cold flesh, warmed less by blood than cool fire. Immaculate, impassive, oblivious, hermetic, Nadelman's heads attach to no particular divinities, not Pallas, not Aphrodite. Rather they belong to a family of muses, sybils, vestals. Vesta protected household mysteries; her virgins kept the sacred flame of The City which hallowed every hearth. Nadelman's heads are numinous. This supranormal essence Romans called *numen*. *Numina* were anomalous spirits awesomely, hence inclusively, addressed "whether ye be male or female." They were impersonal energies not recognizable as differentiated individuals except by sign or gesture. The word came from *nuere*, to

181

nod. If one is superior to mere earth, there is no cause to lift a finger. Nod only; thy will is done. Nadelman's *numina* are neither generous nor inviting. They exist in fulfilled amplitude, alert, impassive, replete with serene secrets. We are required to share nothing but pleasure in their plasticity. One does not caress the muses. They are not whores but harmonies. And yet:

> Pythias, Sybils, prophets, are dreamers, who dream not for themselves but for us. They do not so much translate as directly express, by means of voice, gesture and attitude, the indivisible universe that reverberates within them . . . And since the future depends upon the present, the fact that the Sybil speaks and trembles involuntarily is enough to convince me that those things that concern me and of which I am ignorant are encompassed in her prophetic frenzy . . . There was very great maturity, genuine wisdom, in this Greek credulity, which, always and everywhere, was accompanied by its shadow, doubt.[33]

In spite of some mannered early drawings, the last of which seem more exercises in calligraphy than translations of form or volume, Nadelman in his early full-length, free-standing figures took few expressionist liberties. [34] There is slight deformation; no extreme anatomical dislocation. His bodies are gloved in fluencies; forms swarm, poured into silken sheaths. There is no praise of flesh; only sensuous luxuriance in sinuosity, buoyancy, fullness. [36-38] He held to the human heads or bodies as points of departure, but whatever his size or scale, he remembered the monumental.

What has disturbed most tasteful critics who admit the mastery but reject a metaphysic is Nadelman's sobering and discreet playfulness. His version of the classic ideal is embedded in sportive familiarity. This denigrated the dignity of canonized art, or seemed to attack opinion which had accreted around museum culture. The still-accepted classic absolute was fixed in the mid-eighteenth century by Winckelmann as "noble simplicity and tranquil grandeur." François Dufresnoy, who before Winckelmann had tried to make an exact science of figurative art, spoke of the necessity of "grave majesty and seemly repose." Earlier, the poet Tasso had defined the revived heroic style as "not distant from tragic gravity nor lyric grace, but surpassing both in the glory of miraculous majesty." Behind them was Greece, echoing through Rome.

Nadelman did not lightly mock such sentiment; he was in love with it. He embraced it as his essential substructure. However, he recognized his era as decreasingly heroic; his own purview, while dedicated to past mastery, was more modest, special, mundane. He reduced a scale for temple pediments to apartment-house proportions, taming heroic rhetoric to a domestic vernacular. Canova managed to remain his own man despite Napoleon's patronage, but he worked in that grandiose ambiance transforming Consulate into Empire. Nadelman did not produce at the behest of Helena Rubinstein's beauty-shops, but his taste coincided with a luxurious antiquity already familiar and flattering to customers. He utilized the vast gap between ancient

and modern ideals in form, craft, and manners, as well as the mercurial persistence of fashion. He reveled in this ambiguous area; his figures delight in discrepancy.

It was already conceded by 1909, even before the Druet exhibition, that Nadelman was a formidable presence. The American critic and collector, Leo Stein, Gertrude's brother, took their friend Picasso to Nadelman's studio in the late summer of 1908, the critical year of that analytical movement which Apollinaire (using a phrase of Matisse) was to proclaim as Cubism. Stein bought a considerable number of Nadelman's early drawings, as well as the small plaster commentary on Praxiteles' "Aphrodite." [33-34] When the Steins split their *ménage*, Leo moving to Florence, their works of art were divided, and most of the drawings returned to Nadelman for reproduction in his proposed portfolio, *Vers l'Unité Plastique*.

In Nadelman's studio, Picasso saw the head of a man [13-14], the intention of which he perhaps did not fully grasp, but which, as has so often happened in his voracious career, he cannibalized for his own purpose. Nadelman's head was a rational fragmentation of curves, demonstrating his theorems of balance and reciprocal harmony, not so much decomposing form as drily describing gross anatomy. The head by Picasso, dated 1909, a bronze cast of which is in the New York Museum of Modern Art, resembles Nadelman's plaster, now lost, which was exposed in the Druet show in April of that year. Comparison between the two hardly illuminates significant stylistic differences between Nadelman's researches and what came to be defined as Analytical Cubism. Nadelman's head is more consistently curvilinear; distortion is neither accidental nor expressionist, but demonstrates his structural geometry. Picasso's is by far the more intense work of art. [11] It is notable that Nadelman did not take pains to preserve his plaster, nor did he cast it in bronze at a time when he might well have afforded it, since he was now able to give considerable work to the foundries.

In 1948, Alfred H. Barr, Jr., correcting an over-partisan draft of the catalogue proposed for the Nadelman retrospective exhibition at the Museum of Modern Art, wrote its author:

> As for N.'s influence on Picasso: I think N. did affect Picasso's analytical cubism of 1909, but the influence faded rapidly and is scarcely discernible by 1911 . . . Starting in 1907 with the composition of studies for the *Demoiselles d'Avignon*, and some of the "negro" figures, the almond-headed dancers and sleeping heads and proceeding through the highly abstract and curvilinear compositions of the three women of the winter of 1907-08, I think you will find that before he saw Nadelman's drawings at the Steins, Picasso had gone well beyond him in reducing the human figure to rapports of curved lines – and not only in the figure but the whole composition of figures and scene, an effect which Nadelman, a sculptor, did not conceive although it is an essential element of cubism.

> However, cubism is a far richer and more complex affair than Nadelman admits, confining his attention to one brief phase which, I agree, he influenced. Rather than a

"seminal" influence upon cubism, I would say N.'s analytical drawings seem to have had a modifying and clarifying effect upon Picasso's cubism in 1909, the third year of its development.

Nadelman's effect on Picasso was scarcely as important as he was later to claim; his protest tells more about Nadelman than Picasso. Whatever the extent of a debt incurred, it preoccupied Nadelman, and one must adumbrate his attitude. In 1921, he wrote a foreword to the New York edition of his drawings published in Paris in 1914:

> These drawings, made sixteen years ago (1905), have completely revolutionized the art of our time. They introduced into painting and sculpture *abstract form*, until then wholly lacking. Cubism was only an imitation of these drawings and did not attain their plastic significance. Their influence will continue to be felt more profoundly in the art of the future.

When the American critic, Walter Pach, together with the painter, Arthur B. Davies, were collecting advance-guard work for the Armory Show of 1913, they chose a dozen Nadelman drawings, [35] plus the male plaster head cited as affecting Picasso. [13] Oddly enough, the drawings had already been in America, for Alfred Stieglitz had imported them through the critic, Adolphe Basler, in the summer of 1910, prompted by the Druet show of a year before. Stieglitz never exhibited them; they were recalled for Nadelman's 1911 exhibition in London. However, he did print a statement intended as a preface in his splendid review *Camera Work*, October, 1910. (See p. 265) In it there is an initial enunciation of "significant form," later to become a rallying cry of the 'Twenties through the evangelism of Clive Bell, the Bloomsbury art critic. Nadelman asked:

> But what is this true form of art? It is significant and abstract: i. e., composed of geometrical elements.

> Here is how I realize it. I employ no other line than the curve, which possesses freshness and force. [3-5] I compose these curves so as to bring them in accord or opposition to one another. In that way I obtain the life of form, i. e., harmony. In that way I intend that the life of the work should come from within itself. The subject of any work of art is for me nothing but a pretext for creating significant form, relations of forms which create a new life that has nothing to do with life in nature, a life from which art is born, and from which spring style and unity . . .

Later, when early participation in the revolution in vision and rendering which mark the key current of our era became a mandatory qualification for a progressive reputation, Nadelman pushed claims as precursor. These were personal, plaintive and largely ignored. While the matter may now seem ancillary or vestigial, for him it became an obsession. Obscure testimony from Leo and Gertrude Stein exists. André

184

Gide's *Journals* contain relevant entries. (See pp. 273-4) Nadelman battled for his claims; there are several drafts of a letter written to Henry Goddard Leach, editor of *The Forum: A Magazine of Controversy*, for a symposium "Is Cubism Pure Art?" in which this note was printed, July, 1925. (See pp. 270-1) Here he offered to debate with anyone, anywhere, his priority over Picasso. The challenge went unnoticed; later, he tired of the question. His final judgement was scribbled on the back of a photo of a Tanagra figurine shortly before he died:

> Cubism . . . towards external (rather than essential internal structure) . . . feverish changes while unsatisfied.

Today it is hard to consider as more than marginally apposite those once desperate genealogical claims of veterans engaged in forging a new grammar. Individual contributions, distinct at their enunciation, very soon homogenized to lose any individual attributes. Nadelman felt deprived of historical precedence in whatever part he had actually played, a part distinct from the roles many men less involved were assigned by historians who had intervening decades to define and invent issues. He was embittered on this and other accounts, too preoccupied in his isolation to recognize deep and lasting forces in Cubism itself. Few artists since 1909 have not learned from its vision. But in attempting to place Nadelman, one must indicate the position he awarded himself.

Alexander Archipenko, another sculptor of East European origin, who came to Paris in 1908, said Nadelman was then presented to him as an exponent of extreme "modernism." The two Natansons, arbiters of literary and artistic taste, had owned pieces for some time. Patrons they found enabled him to have numerous bronzes cast, chiefly at the foundries of Valsuani, Rudier, or Bingen who also worked for Rodin. The Natansons prevailed upon friends and colleagues, the novelist Octave Mirbeau, early defender of Rodin and Van Gogh, the playwright Romain Coolus, Frank Burty Haviland, his brother, and André Gide, to buy work. Joseph Brummer, then working for Rodin, told Philip Goodwin, first architect of New York's Museum of Modern Art, that Henri Matisse, briefly maintaining an open *atelier* on the Boulevard d'Orléans, posted a notice admonishing students: *"Défense de parler de Nadelman ici!"* The early European reputation of Nadelman was fixed by reactions to his first major one-man exhibition, held in Druet's large rooms on the rue Royale, of which the *vernissage* was April 25, 1909. Gide, who attended among *tout Paris*, wrote:

> Nadelman draws with a compass [*sic*] and sculpts by assembling rhomboids. He has discovered that every curve of the human body accompanies itself with a reciprocal curve, which opposes and corresponds to it. The harmony which results from these balancings smacks of theorems. The most astonishing thing however is that he works from the live model.

The show created more excitement than any sculpture in Paris since Rodin's at the Pont de l'Alma during the International Exposition of 1900. The talk of studios and bistros, it was also something of a triumph shared by his supporters. It launched him into public success which he was to enjoy more or less uninterruptedly for a decade. Bernard Berenson, already famous as a connoisseur, wrote Leo Stein from *I Tatti* after the opening.

> I found Nadelman's work interesting and have sent influential people to see it. Of course it is hard to say what will become of a person who begins with such a pronounced and echoing manner.

"Pronounced, echoing": at once accurate, if deprecatory. What have teased, fascinated and puzzled people then and since are Nadelman's apparent roots in antiquity, plus his well-defined, authoritative, and personal comment or projection on it. As rubric, or self-explicatory exegesis, there were also those drawings defining how he arrived at his formulation. The Parisians received these as demonstration of Cartesian logic. But was this art? Unlike Fauves or Futurists who were generating their own electricity, Nadelman proposed no discontinuity in tradition; on the contrary, he reaffirmed as constant the lively old principles of structural formalism. Without exaggeration or deformation, honoring recognizable features of head and body, he presented novel renderings of ancient notions – unfragmented, impersonal, highly crafted, metaphors of preciousness without preciosity working towards a perfection which it had been long assumed the academies, salons, and official *pompier* artists had diluted into pomposity. Baudelaire's *Luxe, calme et volupté*, against all romantic or rude passion, was reactionary to the point of forming a new attitude.

In 1928, twenty years after the Druet show, Adolphe Basler wrote in his *Sculpture Moderne en France*:

> The initial figures of the Pole, Nadelman, astonished the elite of Parisian amateurs fifteen years ago. His researches had even the power of disturbing Picasso, that eternally nervous creature, who is rendered ill by any novelty. The principle of spherical decomposition in the drawings and sculptures preceded, in effect, the inventions of the Cubists. But Nadelman not only pretended to have discovered the mechanics of Greek sculpture, but also to establish the laws of plastic construction. An artist as able as he was intelligent, he had assimilated the Hellenistic formulae of the Second Century [B. C.] in his bronzes, chiseled with the virtuosity of the Renaissance Florentines, and in his marbles polished as in antiquity, he united a rational science of proportion with a refined elegance of form.

As for echoes in others, it is no longer difficult to detect an impact on Archipenko, Brancusi, Modigliani [9-10], Gaudier-Brzeska, to say nothing of artists less remembered – Arthur B. Davies (in his early Detroit murals), Marie Laurencin, Eugen Zak, Paul

Thévanaz, the sculptors Joseph Bernard, Chana Orlov, later Hunt Diedrich, Hugo Robus and other Americans. The Druet exhibition was an activating lecture on various aspects of modeling, the nature of which had hardly been questioned since Rodin. Does one wish to learn of what sculpture consists? Does one care to discover how it is done – how I do it? Here is how mass is attacked and recomposed; how style clothes form and my (or any) individual vision determines a merger of volumes. His means were exposed; his smooth surfaces involving construction, decomposition, and reconstruction were less experiments than handsome lessons.

What was Nadelman's discovery: a useful working method, practical grammar, or personal preference rationalized? Was there indeed some plan, or did he merely impose order on his increasingly individual means? Was his quarrel with Cubism antagonism, or prolonged fury over priority denied? He proposed as grounding for search and achievement a supreme figure, plane or solid – the globe or circle and its segmentation. He measured by intersecting curves. He believed in the life of line tending toward enclosure, with rhythmic accent in direction, one that was finite,which could be read to delimit outlines of form encompassing volumes. A straight line, shortest distance between two points, is static, arbitrary, non-descriptive, dead. The strictly rectilinear simplification in Cubism, from which Braque and Picasso were not slow to depart, was the reverse of Nadelman's. And with him, there was no doctrinaire compulsion for an ultimate split between form and subject, structure and content, ends and means, which the Cubists (although by no means Cézanne, their master) fancied freed them from history. The separation did, however, promise that direction towards non-representational or abstract art, which would shortly aspire to a lack of figural reference except as a means by which a construct was rendered.

Unlike Cubists, Nadelman did not desire to deny, decompose or destroy humane imagery, but rather to revive carving and modeling from its academic somnolence. Later, he aimed to surprise an embodiment of its inherent vitality out of habitual banality, even under clothes of serge or satin, ordinary as the ones we customarily wear. This he managed by ringing endless variations on his stated theme of curves, alternating intersections, reversals, reciprocals, controlled imbalance. These were never swung, *pace* Gide, as mechanical segments of some arbitrary circumference. He used them to define, within limits of taste and skill, a clear reduction, the least common denominator or greatest common divisor of figurations of head, arm, trunk, and leg. He was constantly saved, as many imitators were not, from monotonous stylization or facile ingenuity by insatiable interest in the metaphorical significance of human anatomy itself.

Nadelman's drawings did not ask as Cubist drawings did: how do I *interpret* the human face or figure? – referring to some underlying, but largely capricious, pattern. Rather they assert from what force of tension or balance its dynamics, muscular or

plastic, are derived. **[31-32]** Where is the shifting fulcrum for stance and weight? Where is the source for the degree of spring emphasizing spinal curvature, or thrusting accents in hip or shoulder? What are the roles of wrist, kneecap, elbow, ankle? What are their attachments as hinges or conductors of flow? What are the harmonics in opposition (*contrapposto*) and fluidity of limbs, or the harmonics of the subservient component forms and volumes which comprise them? What curves in their insistent push, pull, twist, slice, or break compose that liquid skeletal dynamism, upon which I may endlessly and easily drape any descriptive expression plus adornment, with which I may choose to invest my basic structure?

The root of his process was to swing free-hand a simple curve, almost an absolute ellipse, from some geometrical plane-figure. The grand enveloping sweep can serve as backbone for a torso; two further enveloping reverse curves, opposing the first swung line, read as breast and belly. This calligraphy is more than ideogram; it is a graphic device demonstrating plastic principles. Proceeding to split segments towards a more detailed description of further factors, the nervous snap in his line, aided by the swell of ink pressing from his pen, describes an amplitude which enhances suggestions of enlarged plasticity.

Nadelman took Cubism for a combination of naive generalization and stylistic caprice, rather than as a universally applicable method. He felt that straight lines as such, the Cubists' initial stock in trade, were less efficient than curves since they could neither be bent nor modified, but only stopped or started. They created angles in opposition, unreflected in nature, which had to be translated or transformed into curves by the eye's tolerance or adaptability. Ruled lines, or those that approximated them, were mechanical, inexpressive. Cubism, with emphasis on rectilinear edges, presupposed underlying enclosures as gross blocks, or at best cones, capable of being shattered, but never refined nor subtly differentiated. Or else, as the blocks were reduced, or were further refined through curvilinear contours – which the Cubists soon enough used – the straight cubic quality disappeared and took on, although inorganically, the very type of formal segmented delineation which Nadelman himself proposed.

In the Druet exhibition, variety in his nude figures, which extended from a relatively straightforward presentation of a female standing in the classic position of prayer with arms uplifted (*orans*) to an extremity of balletic or baroque stance in small bronzes, all but managed to brand Nadelman as some maverick academician. **[214]** The meagre triumph of formalist academies lay in accumulations of fractional truth, in worriment of small exactness in parts attached with veristic logic to some preconceived norm, rather than in the freedom of an authoritative handling that could, through intense sensitivity, find monumental wholeness in supranormal forms no matter what the scale, miniature to magnificent.

Early researches mark his deliberate steps towards bronze and marble. In their exaggerated courtliness, their minutely estimated dandaical slouch, hip-thrust, extreme *déhanchement* governed by intersecting curves, his early nudes might seem nearer post-Renaissance mannerism than demonstration of his own doctrines. In 1913, Apollinaire compared him to Primaticcio and El Greco. At first, one might fancy Giovanni da Bologna, or one of his shop, or Florentine, Flemish, or German bronze-masters were models. [36-37] Sir Anthony Blunt, in his precise study of Seurat, asks if "*Le Cirque*" is indeed not the court-art of a late nineteenth century bourgeoisie. In linking him with sixteenth century mannerism, he notes "the distortion of space, the repetition of curves . . . the atmosphere of sophistication and artificiality." While Seurat's paintings were not yet obviously affecting Nadelman's sculpture, the affinity of the two artists' temperaments was already apparent.

However, Nadelman's curvilinear phrasing dictated his own conceptual anatomy; it coincided with baroque rhetoric, but was due to his personal grammar rather than to stylistic recapitulation. His individual metric comprised an analytical, rather than a histrionic, swagger. His tone of elegance derived from a cursive calligraphy, first delineated in pen-and-ink, then translated into thin rolls of clay with which he indicated a two-dimensional draftsmanship finally projected into voluminous rondures. [41-42]

As for his marble heads [24-28], they seem similarly ambiguous, offering a first coincidence with familiar echoes. Their resemblance to, or adaptation from, late Greek idealized fragments was readily recognized, although their absolute completeness and abstract blandness were disquieting. Further, less audible echoes referred to the type of wonder-working Virgin such as Our Lady of Vladimir, an ikon from the mid-eleventh century, which, in its dogmatic stylization, was disseminated unaltered for seven hundred years. Its extreme curvilinear refinement surpasses mere affectation. The Holy Mother's face and neck, as in drawings mapping Nadelman's marbles, embrace an egg-like whole.

Nadelman's first analyses commence with absolute frontality [15], a symmetry of head-on, static focal authority, recalling mosaics and ikons of the Redeemer presented as Arch-priest. When frontality is forsaken, heads incline, echoing beatific or prophetic mildness beaming from angels in Pskov or Novgorod. [29] Nadelman asserted an intransigent, lodged mildness. Viewers supporting the violent improvisation of Fauve or Expressionist read them as distasteful, or in more comfortable terms, as "bad taste" – which meant impersonal, anonymous, complete. Théophile Gautier had explained Ingres:

Although he may seem classical to the superficial observer . . . [he] is by no means so: he goes directly to the basic sources, to nature, to Greek antiquity, to sixteenth

189

century art, and nobody is more faithful than he to *local* color . . . nor has anyone expressed contemporary life better . . . If he knows admirably well how to fold a Greek drapery . . . in no way does he obey the stale formulae of the Academy.

Yet this superfetation of blandness, from which any sentiment pretending towards passion or nervous accident has been distilled or removed, as it is in *kouros*, Khmer smile, or Umbrian angel, was a meditation on essence. It was an attempt, and in his grandest marbles a triumphant one, to propose a visage of consciousness refined from the accidental or momentary by methods and in materials approaching traditional metaphor in his own philosophical program. Nadelman, in spite of innumerable echoings, was no *pasticheur*. Today, art-history is edited into predigested capsules, so that, unless work is heavily underscored by some licensed signature, it is dismissed as subordinate, hence inferior. Helladic, Hellenistic, archaic, archaistic – epochs fuse, centuries merge, layers of sifted leaves form a numb and faceless compost. But exact choice of models and of ideas forming and framing them, particularly in a mentality as erudite as Nadelman's, offers a key to his distinction from and opposition to several contemporaries.

The main current of twentieth century art has been expressionist, whatever labels have attached themselves to styles rooted in idiosyncrasy. From Cubism through a splintered rendering culminating in Non-objective art, the modernity of modern art is, finally, only a more puritanical expressionism. Rebellion against or abdication from historicity in its manual and metaphysical descent seeks salvation in negotiable signatures. The more eccentric an individual drama, the more valued its fragmentary expression. Self-pity, in particular, magnetizes and titillates mindless compassion, a comfortable sympathy with personal tragedy, at safe remove. Byzantine artists, of whose type Nadelman was perhaps the last, misprized the vanity of individuals. Byzantine man was *homo ludens*, an actor-maker seriously playing at work. Analysis, an exercise in placing the self as one atom in a universe of unimaginable complexity and ordered possibility, was consolation as well as prayer. Aesthetics were rules in a game. Art was also labor: *laborare est orare*; work is prayer, not the self-praise of suffering psyches.

> To him [the Byzantine artist] the world was a theater, created and directed by the Divine Poet. And he perceived the conquests and catastrophes of history, and his personal destiny in their midst, with the detachment which is at once the detachment of contemplation and of play. Hence his untiring labors, as theologian, artist, and legislator, to crystallize the riotous carnival of the world in an austere pattern, to see the abstract in the concrete, and to distil symbol, metaphor, and dream from the reality of things.[34]

The most vivid portrait of young Nadelman was made by Gertrude Stein, who kept notebooks crammed with psychological observations which she later mined for her *Making of Americans* and subsequent prose-portraits.

Nadelman, like Pablo and Matisse have a maleness that belongs to genius . . . Nadelman attacks [as opposed to a list of those who "resisted"] . . . very like Paderewski [the Polish pianist-statesman]; he has that same kind of sensibility . . . Nadelman exalted . . . the light would be glad to bathe itself in his statues . . . a complete [rather than a split] thing. An artist, an exalted sensitive scientist like Goethe . . . really passionate, insight and realization of women, men and beauty . . . Pure passion concentrated to the point of vision . . . Nadelman, like Leonardo, when he is a scientist is not an artist . . . gives real sense of beauty directly, not derived [as in the case of X.] who has . . . emotion for beauty rather than direct realization of it . . . The magnetic pole, that queer paleness they all have, only Nadelman has the steady brilliant inside flame that gives his outer thing alive and moving . . .[35]

He was able to move into a larger studio in an *impasse* then leading off rue Campagne Première. He immured himself preparing for shows he had promised London, Berlin, Barcelona. However, over the next three years, he became more visible in cafés, then local, now legendary – Dôme, Rotonde, La Closerie des Lilas, the Gare Montparnasse Bar, whose habitués included Brancusi, Picasso, somewhat later Modigliani, Eugen Zak, Moïse Kisling, Alice Halicka, Marcoussis, Hermine David, Marie Laurencin, Gaudier-Brzeska, Horace Brodsky, Pascin, Derain. Ernest Brummer, brother of Joseph (whom the Douanier Rousseau portrayed), recalled young Nadelman in a turtle-neck sweater, hair *blond-cendré*, so handsome he was known as *Elie le Beau*. **[154-155]** An incisive, didactic talker, he carried himself erect with an elegance that disdained his day-laborer's coveralls. *"Il faisait partie de ce décor-là."* Eloquent to the point of arrogance when aesthetics were involved, he preached passionately anti-Fauve, anti-Cubist, anti-Futurist, anti-late Rodin dicta. He was observed, respected, but rarely intimate with other artists, whom he seldom invited to his studio. Aside from the brothers Natanson, Leo and Gertrude Stein, and two or three women who also served as models, he kept to himself. Later in New York, he boasted of friendship with Renoir.

The sculptor, Jacques Lipchitz, met Nadelman in 1912, among other artists and journalists frequenting the Café de Versailles. His biographer, Irene Patai, writes in *Encounters* (1961):

> [He] accompanied him home to his studio. He thought Nadelman an extraordinary virtuoso, very eloquent, but a talent unsupported by depth or great intelligence. He could never draw Nadelman into a discussion of art. Nadelman, strikingly handsome . . . could speak of nothing but women and his manly powers.

Nadelman would tell his son thirty years later that he then prided himself as methodical conversationalist. Since conversation was skill, he prepared himself before going out to a gathering with a list of topics he presumed would be useful. Many found this more like lecturing than exchange of ideas. He was filled with himself;

he had meditated over the nature of work more than most; he could not have been easy to know. Adolphe Basler, the first critic to acknowledge him, spoke, after four decades, of his *grande allure* matched by almost total lack of humanity. [1] Supple, with feline grace, able to insinuate himself into the society of those who might advance his career, he was equally detached from making or keeping friends. With Nadelman one did not converse; he constated, brutally self-assertive; Basler added: "*Il allait trop fort.*" He went too far; came on too strong. His patron, Thadée Natanson, remembered forty years later that he "had much of the angel, but something also of the prophet; it was easier to offend the angel than convince the prophet." Alice Halicka, wife of the painter Marcoussis, recalled that he was an inveterate gambler, near genius at *belote* and poker. André Gide, with characteristic penetration, supercilious yet unctuous, noted that the young sculptor had survived six miserable years; that, shut up in his studio-prison, he seemed to have been nourished entirely on plaster; and said that "Balzac invented him." Petronius, Nero's arbiter of taste, observed in his *Satyricon*: ". . . and, if you turn to the plastic arts, you find examples of the same selfless dedication. Thus, Lysippos . . . became so utterly absorbed in the formal problems of a statue that he forgot to eat and starved to death . . ." Nadelman, however, was certainly *au courant* with studio gossip. It was he who reported to Leo and Gertrude Stein that "Madame Picasso has flown with a Futurist of 22 years, and Picasso is in the Pyrenees with Madame P's best friend." Alice B. Toklas, Miss Stein's companion, wrote in 1948:

> Nadelman was then [1909] like no one I had ever seen before or since. He was the young poet with a vision – the image of eternal youth – walking in the clouds, possessing an unearthly beauty.

Gertrude herself was fascinated, if repelled. In 1934, on her visit to America, she spoke of pleasure in seeing him and his work again and was touched by "the same illuminating flame; the same human warmth." In her notebooks of 1909 she had written:

> Nadelman [has] no profundity of emotion . . . A finicky choking sense of beauty. A profound sensitiveness to lyrical beauty . . .

Perhaps the most accurate picture of Nadelman at the close of his first show and peak of early success is a self-portrait. In a letter to Leo Stein, then in Florence (whom he preferred to his sister), he wrote with dashing candor:

> I cannot help but thank you again for the Giottos [postcards], which I examine almost every day. That rascal knew all the tricks which make art perfection; it is really odd to call him a "primitive."
> There have been two weeks in which I have played the social whirl; theaters, con-

certs, visits, visits, visits . . . But if I wish to have anything more to do with sculpture, I must give up all that grand life; it is impossible to reconcile the two. One happens all day, the other all night. It's miserable, and I am very unhappy on account of it, because I have had in my life enough solitude, and nevertheless I must still have some more.

Tomorrow I am going into the country. Not with the [Alexandre] Natansons . . . I took all my courage and refused. I will go with a girl-friend to Normandy, thus hoping to rest a little, and yet not be entirely alone. In order not to hurt them by my refusal I told them that I was madly in love, that my heart could not resist, etc . . . They answered: Well, in that case, if your heart, etc. and everything was arranged. Today M. Druet came to see me; he bought five drawings. He is a very nice son of a bitch . . .

From Rouen he sent Gertrude Stein a postcard of the Church of Saint Maclou:

> I am on my way from Dieppe to Paris. I have stopped here for a few hours. It is a veritable museum of cathedrals. I have never seen such marvels. God must pardon me, but their great beauty astonishes me far more than the sea [which he had not seen before] . . .

Nadelman went to London in 1911 for a comprehensive exhibition at Paterson's Gallery, Bond Street. Besides work exposed earlier, he now showed some fifteen more highly polished marble heads, less severely generalized than those before, their modeling more developed in detail. There was also a large plaster horse, a nude reclining on elaborate drapery, and the quizzical head of a Mercury, which might also have been a modern boy in a bowler hat.[36] Madame Helena Rubinstein [82], his compatriot, did not encourage him by a token purchase: she bought his entire exhibition outright. This was the most generous patronage in his career. She mounted many pieces in her handsome establishments in London, Paris, Boston, New York, Buenos Aires, Melbourne; they became her trademark for the quasi-scientific beautification of modern womanhood. She also commissioned him to decorate the billiard room of "Solna," her house in Putney Park Lane. The big high-relief plaques in terra cotta, derived from drawings imitating thin rolls of clay, together with the "Four Seasons," free-standing figures developed in the same style, affected a whole school of commercial and display art, to much the same degree that the decorative engravings of Piranesi subsumed Percier's and Fontaine's patterns for Directory and Empire interior design. These luxuriant ornaments, achieved in the grammar of Nadelman's linear formulae, contributed decisively to the style of decorative art, currently labeled "Art Deco" [43-46], that culminated in an important exposition, *L'Art Décoratif Moderne*, Paris, 1925. Nadelman's curvilinear structures can be traced through fashion sketches, murals and paintings by Georges Lepape, Georges Barbier, Paul Thévanaz (illustrator of Emile Jaques-Dalcroze's influential system of "Eurythmics"), Erté (Roman de Tirtoff), and the American cartoonists of the 'Twenties, A. H. Fish and Hogarth, Jr. (Rockwell Kent). Art Deco is now enjoying something of a popular revival as a kind of canonized *kitsch*, while Nadelman's role is ignored.

It was appropriate that a queen of cosmetics commanded him as court-sculptor. Nadelman's marble cheeks had never been blemished, nor had his heads ever had a hair out of place. His nudes never sweated; they seemed just wiped dry of asses' milk or champagne suds. Yet there is teasing sensuousness in his dispassionate chiseling. Warm flesh is treated as iced ivory, firmly passive to the point of petrification. Preenings, pamperings, impervious caresses produce a metaphor for the indolence of absolute luxury. Idealization is all but incredible; flattery inherent borders on the preposterous. His marble heads do not promise that you, too, ordinary as your mirror shows you, can be as beautiful. But in fashion's masquerade, by artifice, powder, lipstick, coiffure, those are the models for a brand of magic which is "beauty." Nadelman started by carving such idols; he would end with the same exercise, with a difference: commercialized vanity deliquesces into cretinism. **[204]**

On February 5, 1912, the Italian journalist, Marinetti, lectured on his theory of Futurism in the Galerie Bernheim-Jeune. There was excitement in the audience when Nadelman shouted that "M. Marinetti declares he will demolish all art of the past. He shows he does not in the least comprehend the nature of past art." Marinetti leaped from the podium and slapped Nadelman, precipitating a free-for-all. Lights were switched off; discussion was adjourned to nearby cafés.

Filippo Tommaso Marinetti (1876-1944) first came to Paris in 1893, attaching himself to the tail end of a dying symbolist movement. An admirer of Walt Whitman, Zola, Mallarmé, he was close to the brothers Natanson and the circle of *La Revue Blanche*. An energetic cultural entrepreneur, editor, polemicist, poet, he described his personal Pegasus as a hybrid of automobile and aeroplane. Commencing by contacts with orthodox Anarchism, Marinetti ended as an apologist for Mussolini. The "First Futurist Manifesto" appeared in *Le Figaro*, February 20, 1909. It was a general call to youth to be inspired by modernity, to repudiate tradition (including all museums and libraries), to condemn all values of contemporary society as bourgeois aesthetics, politics, and morality. "At last Mythology and the Ideal have been surpassed . . . A racing car is more beautiful than the 'Victory of Samothrace.'" He homogenized ideas from Nietzsche, Bergson, and Benedetto Croce, to propose a program of doctrinaire "Dynamism." Close to the Fauves in their rejection of the vagueness of the Symbolists, he canonized the Machine, the industrial potential of a nascent century. In 1910, Futurist painters adopted Marinetti's new manifesto: "Sweep the ideal camp of art free of all previously exploited motifs and subjects . . . Profoundly despise all forms of imitation." There would be no limitation of time or space; the present was a sole eternity; no rules had meaning; new methods were mandatory not as guidelines but for liberation. "For us the gesture will no longer be an *arrested movement* of the universal dynamism: it will clearly be the *dynamic sensation* itself made eternal." Marinetti also declared against the dominant Female, Goethe's *Ewig-Weibliche*, or more

194

precisely, Gabriele d'Annunzio's modish decadent echoing in his morbid *femmes fatales*.

The Futurist exhibition of thirty-four paintings in the plush-hung galleries of Bernheim-Jeune was managed by Félix Fénéon, the intellectually elegant apologist for Georges Seurat. The galleries were the arena for various demonstrations similar to that in which Nadelman had participated. In a preface to the catalogue, a new principle was enunciated as "Lines of Force," the term borrowed from magnetic physics. Essentially, this defined the Futurists' compromise or combination with analytical Cubism, as well as their firm rejection of abstract expressionist or non-objective art. According to their program, their subjects were seized from objective reality expressed in "scientific" terms:

> One is not aware that all . . . objects reveal in their lines calm or frenzy, sadness or gaiety. These diverse tendencies give to their formative lines a sentiment and a character of weighty stability or of airy lightness. Each object reveals by its lines how it would be decomposed according to the tendencies of its forces. This decomposition is not guided by fixed laws, but varies according to the characteristic personality of the object and the emotion of the one that looks at it.[37]

As for sculpture, Umberto Boccioni (1882-1916), one of the most able Futurist painters, commenced modeling in the winter of 1912. He had a powerful mind and talent; except for the factional air of the times his analytical intelligence should have appealed, simply as that of a professional, to Nadelman. But Boccioni called for war to the death against Pheidian ideals, real to Nadelman, but which Boccioni identified or confused with a moribund academy, with "a hellenized Gothic style that is industrialized in Berlin and enervated in Munich by heavy-handed professors." His personal Manifesto of 1912 concluded that the aim of sculpture "is the abstract reconstruction of the planes and volumes which determine form, not their figurative value," and "one must *abolish in sculpture*, as in all the arts, the *traditionally exalted place of subject matter.*"[38] Boccioni intended to show forms in space as continuities, as bodies in progressive action, to make heads merge with their environment, to extend objects kinetically in space, "to model light and air." Nadelman, on the contrary, wished to establish ultimate serenity, absolute stasis, a discrete, contained canon of sculpture as ikon. Boccioni projected a sequence of fractional parts; Nadelman, a unified whole. The one pursued the cinema; the other held to the egg. **[7-8]**

As for Futurism as a doctrine, there could be no attitude more likely to oppose Nadelman's own researches in those immutable structures which underlie all art, whatever its bracketing by an ephemeral "modernity." Naturally, he was particularly outraged by Marinetti's flashy proposal to demolish the Louvre. Modigliani, who through recent contact with Nadelman had begun to interest himself in carving stone **[9]**, had already an underground reputation as a painter.[39] Boccioni and Gino

195

Severini urged him as compatriot, colleague, and representative of the advance-guard to sign their Manifesto. In it past art *in toto* was anathematized. Italy was damned as "that land of death, immense Pompeii, white with graves." Modigliani refused to sign since he used Tuscan painting – Botticelli, Piero di Cosimo, even Boldini – just as Nadelman projected from Praxiteles or Seurat.[40]

Now, half a century later, such skirmishing in the crusade for Modern Art brings tolerant smiles. Passionate brush fires around Wagner, Debussy, Stravinsky, Satie, Dada and Surrealism, have become as quaintly incomprehensible as hair-splitting duels in patristic theology. Today, is not every schism resolved by every fraction finding its triumphant niche in concert-hall, opera house, museum? – all passion spent. Is not every move forward recognized, accommodated, and made available through a constant repertory of annual exhibitions, catalogues and printed coffee-table editions? Is not each sketch or fragment prized as priced? Orphism, Synchronism, Vorticism may still push up from footnotes, but Cubism shortly became an academy far more used than any Polykleitan canon. Futurism already realizes an important investment.

Nadelman was not the first progressive theorist to cast cold eyes on advance-guard contemporaries. April, 1865: Charles Baudelaire was in Brussels. Edouard Manet complained that the poet (terminally ill) would not return to Paris to do battle for his nude "Olympia" in her grand Salon scandal. Baudelaire had a gimlet eye; mind and metaphysics were tempered by far seeing and strong thinking. He stayed unseduced by modernity for its own sake; rejected automatic and hysterical abdication from historical process. Baudelaire, no *retardataire* philosopher, first defined Modern Man as precursor and heir; he wrote Manet that geniuses before him had endured censure with more fortitude and, while sympathetic, shot a reverberating dart whose prescience chills a few of us today: *"You are but the first in the decrepitude of your art."*[41]

However, heat or energy stimulating ideological fracas early in our epoch had conviction and validity schooled by classical or Jesuit education. Impassioned manifestos from café or studio had a style more engaging than press releases from Madison Avenue gallery proprietors. Nadelman was not pitting himself against Marinetti's personality, but against his vaunted contempt for the service of tradition. The weight of an as yet inexhaustible past could not be cast off in a season; unpredictable futures were no problem. As for an immediate present, contemporaneity within a decade furnished Nadelman with his most personal pretexts. When he came to fashion industrial men as inverse folk-figures, many notions first enunciated by the Futurists served to annotate his own work – although they were far more optimistic about the issue of the Machine than about timeless quality in craft or the humane ideal.

So now Nadelman, who but three years before had been classed as revolutionary, appeared to radical students as reactionary. The poet André Salmon, writing on

Rodin in 1914, whose latest bronzes Nadelman had praised against opinion which rejected Rodin at the same moment that his most heroic figure was officially repudiated, said: "The 'Balzac' is not an *oeuvre* [an autonomous work]. It is a plastic lecture similar to those given by Elie Nadelman."

In June, 1913, Nadelman held his second major Paris show at the Galerie Druet. Smaller than that of 1909, it could hardly be expected to cap the reception of his debut. Nor did it. Nadelman was already to a degree *démodé*; success had softened him; his style was declared *mou*, too soft, at the time the most crushing of advance-guard dismissals. The supplement of the *Gazette des Beaux-Arts* observed:

> M. Elie Nadelman is clever in noting the essential in physiognomy, in endowing the female face with sweetness, and in combining his taste for the archaic with the trembling nervousness of nature. He stylizes his attitudes in order to express their roundness, dominated by his wilful fantasy, in all human gesture . . .

Alexander Archipenko, in Paris in 1913, later recalled Nadelman's polemics. While considered among the advanced figures of the time, Nadelman separated himself from an *avant-garde* which was increasingly recognized as a clique, soon to approximate an academy. He and Archipenko argued over the direction progressive art should take.

In March, 1914, Apollinaire, writing for *Der Sturm*, commented:

> Archipenko possesses the strength necessary to achieve this goal of internal plastic unity. The only artists who have seriously attempted to attain this goal are our new painters. The sculptors have not given it any thought, with the exception perhaps of the inspired Rude (of the Call to Arms on the Arc de Triomphe) . . . The others, Carpeaux, Rodin, Schnegg, Despiau, observed the plastic power of light, liberated forms, allowed them to take on color, and subjected them to the sensual perception of the eye. Nadelman, on the other hand, attempted, albeit timidly, to construct *musical* compositions, thus going beyond the Greeks and Egyptians. He tried to bring sculpture closer to architecture (scientific cubism). The way is thus opened to an art that unites internal plastic structure with the supreme charm of a sensuously beautiful surface.

Nadelman, having satisfied his own needs, proclaimed against tentative aesthetics. "Experiment" was finished. One had only (or *he* had only) to proceed. Cubism and Futurism were merely insecure and exhausted intermediate phases; Archipenko's increasing abstractionism seemed a self-limiting translation of analytical cubism into three dimensions. From the start, Nadelman was a logician, distrusting experiment, which he read as unconsidered, discounting "inspiration," basing every effort on order and logical research. For him, instinct was energy directed; all else was dilettantism or luck. He relished his own professionalism, his capacity for massive production without waste motion, or dependence on chance.

The first full-length appreciation of Nadelman appeared in the semi-official *L'Art Décoratif* for March, 1914. It was by André Salmon, to whom Apollinaire had dedicated a charming "Marriage Ode." The titles attached to reproductions, whether of drawings or sculpture, were invariably, "Research in Form and Volume," or "Harmonies of Forms." The article was soberly sympathetic, a guarded introduction:

> A great number of his admirers take him for a precious young master – almost Byzantine, although his work tends towards a unity, a great plastic whole. Neither, although it is often said of him, is he a sterile imitator of the Greeks. Nadelman is, above all, a theorist, a theorist in spite of himself . . . Let us not forget that Nadelman sacrificed everything to the relations of volumes a long time before the Cubists . . .

Illustrations included the witty study of a horse which, with other related drawings and bas-reliefs, formed a basis for the big plaster prancing thoroughbred owned by Madame Rubinstein. [55] After seeing bullfights in Barcelona with the sculptor Hugué, known as Manolo, a Cuban-born Catalan, when he was there for his exhibition, and also having been deeply impressed by cave paintings at Les Eyzies-de-Tayac[42] in the Dordogne, Nadelman made extremely personal designs of bulls, cows [53], poodles, in pen, ink, and russet water color. These resulted in a series of plaques, which included hounds as well as horses. [50] There was also a splendid pair of bronze bulls, charging erect and kneeling wounded, which, in surface treatment, are unique in his work. [54, 58] They were left deliberately rough, tool-marks brusquely incising their flanks, planes abruptly sliced, no curvaceousness, angularly defined by emphatic thumb-print or scalpel. The impending bulk of monster bodies (nine and one-half inches high by ten long) is borne on wiry legs and hooves; looped thrashing tails, tiny puncturing spiky horns imply a capsulated charge of lethal ferocity.

Nadelman, during the increasingly ominous summer of 1914, was at the Shakespeare Hotel, Ostende, where Pascin also spent vacations, making rough sketches of his landlady, her daughter (?), their poodle. This pet's formal coiffure would reappear much later in many figurines, the dog's tight curls reduced to wigs of bump or boss prefigured in his earlier pen researches. [167-168, 171] There is a sequence of thumbnail indications of this landlady, a redoubtable harpy, with a young man (himself?) and a girl (daughter?) surprised in an embrace by *maman*. Three years later, in New York, these sketches would trigger plaster figures in contemporary civil dress. [76] Later still, the figures were carved in cherry – possibly that reddish wood was suggested by the rusty tint he used for the drawings of cows, bulls, and toy-people. [49]

The explosion igniting universal European war caught him almost unaware. He sought the Russian embassy in Brussels; as a reservist, he volunteered for the Imperial army. The Kaiser's cannons were already advancing on the Liège fortresses. It was impossible to cross international boundaries to the east. He managed to reach London,

198

where he had left much of his work. Through the generosity of Helena Rubinstein, he obtained passage on the *Lusitania*, arriving in New York October 31, 1914. He was thirty-two years old.

NEW YORK 1914-1929

When Nadelman set foot on Manhattan, at the outbreak of the First World War, his situation was similar to that of a young sculptor from Pergamon, trained by the sons of Praxiteles, landing in Rome around 200 B. C. America was a vigorous imperial magnet; Paris had been proxy for an older Athens – or so New Yorkers then imagined, not over-aware of Picasso, Braque or Matisse despite the Armory Show of 1913. Nadelman's comparatively easy adjustment was due to his artistic ancestry; he could utilize accumulated prestige from both past and present. Advance-guard and intelligentsia, equally with High Bohemia and High Society, welcomed an acknowledged innovator. Conservative professionals, schooled in the powerful American Academy in Rome, greeted him as an exemplar of traditional discipline. Two thousand years before, the rising towns of Alexander's succession in Asia Minor insisted on their continuity with grandeur across the Aegean. Now, McKim, Mead & White, Carrère & Hastings, Delano & Aldrich, an oligarchy of palace architects serving Morgan, Astor, Frick, Vanderbilt, had done their exuberant best to transform mid-Manhattan's Victorian brownstone into the marble of post-Augustan Rome or post-Haussmann Paris. The older cities of Asia Minor had repeated classic styles, legitimizing a *nouveau riche* establishment. In ascendant Pergamon, the spirit that raised the Parthenon was invoked for energetic building since the Attalid kings wished to show their tombs and temples not only equal but even superior to Periclean Athens. In Greece, sculptors of the mid-second century B. C. practiced uncertainly, at the whim of military tyrants in the Levant or parvenu patrons in Rome itself. In Manhattan, Nadelman found a plutocratic clientele happy to be portrayed in marble in a style that might have pleased "the companions of Alexander." It is significant that when, within little more than four years, he abandoned a manner reminiscent of Hellenic precedent, he would all but lose his market. This was not important, since by then he was independent, but when he revealed himself as an original, with no similarity to familiar models, he was dismissed as a serious contender, although persisting as a social presence.

He had little difficulty finding himself. At first, Helena Rubinstein lent him her garage in Rye, just outside the city, where he could prepare an exhibition. He had already been in contact with a number of influential natives from the time of the Armory Show – the painters Anne Goldthwaite, Arthur B. Davies, Walter Pach, as well as Alfred Stieglitz. However, his first important American support came from Martin

Birnbaum, connoisseur, critic, and merchant, who had been instrumental in assembling the superb collection of French and English painting and drawing as well as Chinese sculpture later bequeathed by Grenville Winthrop to the Fogg Museum at Harvard. After long experience as dealer and enthusiast, Birnbaum joined the firm of Scott & Fowles as junior partner. He had known of Nadelman in Paris from the brothers Natanson. The critic Adolphe Basler, happening to be in New York, insisted they visit a walk-up studio on West 14th Street, which Nadelman had rented. He had been able, through Madame Rubinstein, to bring pieces from London and Paris; to Birnbaum, these proved a revelation. He immediately began arrangements for an important one-man show and prepared an enthusiastic article which appeared in *The International Studio*, December, 1915. Through him, Mrs. Herman Radeke of Providence presented a marble head to the Rhode Island School of Design, the first museum, here or abroad, to acquire a Nadelman. Within the next five years, pieces would enter the museum collections of Brooklyn, Cleveland, Corcoran, Carnegie, Chicago, and Detroit. Martin Birnbaum introduced his protégé to Sir William van Horne, an influential Canadian collector, and obtained numerous commissions for decorative pieces [56-57] as well as portraits in wood, bronze, terra cotta, and marble. In the meantime, before arrangements were settled with Scott & Fowles, Nadelman held a small introductory show at Alfred Stieglitz's Photo-Secession Gallery, his famous launching-pad for progressive activity, at 291 Fifth Avenue.

Here Nadelman hung new drawings, a series of recent bronze and plaster plaques in low relief [44-46], a new sequence in pen, ink, and auburn water-color, inspired equally by prehistoric murals in the Dordogne and sixth or early fifth century Attic vase-paintings. The pair of bronze bulls was included with other carefully finished drawings of wooden toy-type single figures, or families of idols, mother, father, and monster-child. There were also heavy-uddered cows, poodles, and prancing steeds. [51-53] These last followed forms from the large white-plaster horse acquired by Helena Rubinstein in London. He had on file reproductions of horses by Eugène Lami and Constantin Guys; one might say of him, as Baudelaire did of Guys: "He not only understood the generalized horse, but also applied himself to the personal beauty of horses." Horses in energetic profile suggested the stance, spirit, and discipline of the ideal *dressage* mount, as incarnated in the traditional craft of the Spanish Riding School in Vienna. [50, 55] He kept pictures of these; and his own horses fit the description in some verses by Cavafy, the contemporary Alexandrian – purportedly composed by a sculptor in the Hellenistic succession:

> And now for some time I have been busy
> making a Poseidon. I am studying
> the horses in particular, and how to mold them.

They must be made so light that
their bodies, their feet, must clearly show
they do not tread the earth, but run on the sea.[43]

Some of the human figures were fiddle-shaped, recalling Cycladic votive marbles as well as Rodin's *femmes-vases*. Feet were vestigial, arms but match-sticks; men with tiny heads had columnar top-hats, while every body, male or female, was a pouter-pigeon's. These creatures breathed a capricious naivety, at once archaic, innocent and vaguely idiotic. They would lead to a first plaster model for the now well-known "Man in the Open Air," his only extant full-length male bronze. [63-65] With forms strengthened, the head made more massive, it now stands in the sculpture-garden of the Museum of Modern Art, New York. He wears a bowler hat, foreshadowed in drawings shown at Stieglitz's. Its brim was a disc, developed from the sketch of an egg-head sliced by a single curve. The sole interruption in the figure's suave attenuation is the bow string-tie which casts a thin linear shadow on its broad chest. Precise, yet abstracted, this was the culmination of a new development, a turn towards the essence of contemporaneity, personal, strong, light-fingered. Nadelman's figure was not exactly nude. Today, man wears hat and cravat, but this manikin offers himself in the metaphorical nakedness of an acrobat's tights or dancer's leotard. Bow tie and bowler are lone badges of modernity. The hat, possibly a debt to the habit of his friend Pascin who kept his own on, indoors or out, echoes the type worn by a Pheidian "Hermes," formerly at Broadlands, England, while the whole figure derives from a "Paris" formerly in Lansdowne House, London, attributed to Euphranor, a Corinthian painter and sculptor of the Polykleitan school. Head, hair, and hat are one form; the brim characterizing a British bowler is but a lid haloing an egg. Anatomy is without muscular articulation; all volumes coalesce to fill a gloved skin.

The presence of a generalized tree trunk is an important feature, redolent of Nadelman's wit and erudition. Bronze requires no exterior support, since hollow metal is capable of bearing its own weight, whatever the exuberance in modeling. But marble copies of metal figures tend to snap at their weak attachments – neck, wrist, ankle. Hence tree trunks, posts, or drapery ingeniously accommodated antique compositions, or sometimes frank untreated struts were left to bolster stone. Nadelman's "Man," while iconographically referring to the persona of Hermes-Adonis-Narkissos, was definitely an allusion to the Praxitelean "Apollo Sauroktonos" (ca. 350 B. C.), a youth in momentary frozen dalliance about to toss a pebble at a lizard crawling up a tree. Nadelman's recension sports an entirely superfluous armature of a branch which outrageously pierces, rather than sustains, the right arm. In this preposterous triple exposure, modern metal surcharges Roman marble cut after Greek bronze. What was a languid revery for Praxiteles becomes an imperturbable doodle on scholiast texts.

The nonchalance of the crossed serpentine legs was a further parody of the self-conscious elegance with which eighteenth century English painters endowed baronial youths, alumni of the Grand Tour refined by a light taste for Latin verse and Roman portraits. In plaster at Stieglitz's it was not well received; it vaunted caprice; it was taken as a tactless joke, and found no purchaser in Nadelman's lifetime.

While Stieglitz's gallery was small and unpretentious, its influence and prestige were large. However, his clientele were mostly artists or intellectuals, taste-makers rather than collectors. Birnbaum had been wise enough to let Stieglitz show Nadelman before Scott & Fowles. Word had been spread that a new representative of the Parisian advance-guard had arrived. To Stieglitz, Paris was but one source of modern art; to rich buyers further up Fifth Avenue, it was the fount of fashion. Hence, when Nadelman was viewed uptown, it was as if he had been given a new character; elegance rather than innovation was emphasized. His exhibition was a success; it all but sold out. As a result, he was swamped with commissions for decorative figures and portraits.

Using a formula of tasteful verisimilitude in the line of the Graeco-Romans as refined by Laurana[44] and Houdon, cutting marble or walnut with equal adroitness, he produced some thirty busts, including several in wood and terra cotta. The most beautiful, made in 1917, is that of Mrs. Charles Templeton Crocker [87] (later Mrs. Paul Fagan) of San Mateo, California, a queenly *saloneuse* whose smooth, boneless shoulders glorify her as a Renaissance hybrid of American Beauty, a *grande dame* who, in youth, had been the Gibson Girl.

Today, the concept of a professional – painter, sculptor, composer – in the express service of exigent patronage is almost forgotten. Even in Nadelman's time, the notion of artists laboring for bread without the benison of Inspiration evoked the horrid epithet of "pot-boiling." However, Henry James, the arch-professional, advised a young artist to do what Nadelman never doubted:

> Make the pot boil, at any price, as the only real basis of freedom and sanity . . . the pot-boiler represents in the lives of all artists, some of the most beautiful things ever done by them.

The term came into common use early in the nineteenth century when individual sensibility claimed a new liberation from craft-service as the rigid rules of guild-apprenticeship were broken. Artisans and artificers were no longer held as shop-slaves, but as possessors of personal talent which might be considered divinely inspired. In not too short a time, individual talents would be exploited as earthly divinities.

Apart from decorative work, small bronzes, garden figures and ornamental plaques, Nadelman worked at portraiture well into the 'Thirties. Among the busts were those of Grenville Winthrop; Francis Neilson, the Swift heir; Mr. and Mrs. Robert

Sterling Clark; Francis P. Garvan, Jr.; Mrs. Clarence Hay; Carll Tucker; Stewart Walker and Stevenson Scott. His last considerable commission was undertaken for Robert Sterling Clark, founder of the fine collection now housed in Williamstown, Massachusetts, who commanded a head in marble of Senator Carter Glass which was executed in Washington. There is no record of Nadelman refusing an order; he liked to work within contractual limitations of scale, material, style and occasion, as did Stravinsky. He presupposed skill as being equally applicable to private imagining or public presentation. He was in service as an image-maker, not as a purveyor of his own personality. His sensibility was but one tool, along with visual and manual mastery, not to be valued uniquely for itself. From 1910 through 1930 he worked in a social ambiance in which it was still normal to have busts commissioned and portraits painted. The camera had not yet conquered; the domestic patrimony of the family ikon was bequeathed like jewelry, plate, lace, linen, china and grandfather's clock.

Most of his portraits were modeled first in clay, in the big sky-lit studio atop his Manhattan mansion. Like Saint-Gaudens, Sargent, British and French portraitists of fashion, he provided clients not alone expertness but also a milieu in which they could patronize, but need not pity, the serving artist. There was a symbiotic respect in the security of this exchange, which is reflected in the placidity, ease and perfection of his portraits.

One may castigate Nadelman's salon heads as Baudelaire did Ingres'. Each person depicted belongs to the same family; in fact, the manipulation of volumes in several of Nadelman's male heads recalls a fresh fullness in features similar to that of Ingres' colleagues at the French Academy in Rome. Photography killed the genre of battle-picture; it has all but done for portraiture. Nadelman was not primarily a portraitist; he undertook jobs as a professional obligation, but his best work compares with that of more famous contemporaries: Jacob Epstein, Charles Despiau, Jo Davidson. Nadelman alone carved consistently in wood and marble. Epstein's corrugated bronzes are stamped by energetic expression, but one recognizes his hand before any likeness. Despiau, an over-refined follower of Rodin, developed a monotonous formula of hazy sweetness. Davidson, a hard-working journalist of sculpture, is on a lesser plane. With Nadelman, there was no compulsion whatever to stamp his personal grammar on a given skull structure. To be sure, his heads flattered insomuch as they presented optimum aspects of a sitter's face. There are few signs he profoundly interested himself in the personality of patrons. He sought serenity in marble metaphors; if moral distinction was marked (as in busts of Senator Glass or Francis Neilson), he emphasized it. Scrupulous, discreet, these stones testify to expensive taste and gracious manners at one remove, impervious domestic monuments to independent incomes.

Yet in half a dozen there is residue more penetrating than skill or flattery. Taken as objects rather than personifications, what do these represent? They are *objets de vertu*, luxurious souvenirs of that American affluence whose accumulators or heirs composed distinguished private collections which now delight us in the splendid rooms of the Frick mansion and the Morgan Library. They may also be seen as participants in the fastidious fables of Edith Wharton and Henry James, where "The European" is pitched against "The American." James, a New Englander, deeply moved by the stress of our Civil War, was a European by election, but always hypnotized by tense discrepancies between ageing and immature Atlantic cultures. Nadelman was an East European, exiled by world war, who, in love with American possibility, was able to offer luxurious replicas in implacable marble to a comparatively barbarian society. The characters incarnated by both novelists and sculptor, their *dramatis personae*, masks, players, chessmen, toys, or composite archetypes, compete in ritual games. Opposing teams were chosen from ranks of impoverished European feudalism in its fast, picturesque decline, which purveyed hereditary prestige to energetic, ambitious American provincials, many of whom were already superficially polished by a European gloss, taking Paris or Munich for their modern Athens. Marriage by treaty as well as the gossip that matched it was surgically rendered by James with lapidary skill. At the very start of the century, his friend Henry Adams observed: "New York or Paris might be whatever one pleased – venal, sordid, vulgar – but society nursed there, in the rottenness of its decay, certain anarchic ferments, and thought them proof of art. Perhaps they were." The chill composure of Nadelman's portrait-heads may describe sphinxes without secrets; no trace of compassion betrays a lurking pathos. Murray Hill, Fifth Avenue from the upper Thirties, the tallies of Four Hundred or Social Register suppressed any hint of that savagery through which their serenity is less calm than petrified. Exquisitely polished stone hardly reveals or secretes any morality by which international alliances, at once social, financial and political, were negotiated. Nadelman's heads are imperial, impersonal, authoritative, achieved; Antonine. To comprehend the glamorous butchery attending relations between old world and new, read *The Glitter and the Gold*, the memoirs of Madame Jacques Balsan, born Consuelo Vanderbilt, who, to her sorrow, was for a time Duchess of Marlborough.

Nadelman was familiar with this atmosphere. His wife had been educated at the court school of a minor German principality. Her younger daughter by a first marriage had close connection with Italian royalty and became the wife of a noble Italian land-owner, a much publicized figure in international high society. Nadelman, given the key to this peculiar area, strode through it with gusto. He was not dazzled, nor did he indignantly reject its charm. He had conquered Paris and, to a degree, London. He would win Manhattan. Later, he might seem to judge it. He was, first and last,

an observer of historical process. However Nadelman estimated his patrons, they considered him at their service. He accepted the relationship as normal. To many of them, irreducibly, he was, however gifted, a foreigner of mixed ancestry. His status might change when he married; by then he would seem to have become rich and could afford to disdain all patronage and any patronizing. But some matters had not been and many would not be so easy.

A grim exchange of letters exists concerning the commission for a small full-length portrait of a boy, star of an Ivy League gymnastic team, heir of a Wall Street magnate. The youth posed in a firm hand-stand; photographs were taken, specifications indicated. Clay and two complete plaster studies were prepared. He took enormous pains; realistic detail is pushed further than in any of his extant work. The final figure is a miniature masterpiece of precise observation. But the piece was refused, because the boy, even wearing gym trunks, was obviously male; it was not cast in bronze at the time.

After the Scott & Fowles exhibition, Helena Rubinstein (now married to Edward Titus) invited Nadelman to share a vacation with her family at the Greenbrier, White Sulphur Springs, West Virginia. Here in the huge rambling old hotel, exotic to him, he had a vision of upper-class America at play in the busy idleness of fashion, luncheons, tennis, bridge, *thé-dansants*, palm-garden concerts, a hygienic regimen for aimless amusement. Several types of *habitué* served as model for his painted plasters a year later.

Soon he frequented the Stettheimer family's circle. Under the eye of their matriarch, the daughters Carrie, Florine, Ettie, three virginal muses, devised a fantastic fringed and flowery décor that framed the comings and goings of Marcel Duchamp, Albert Gleizes, Leo Stein, Edward Steichen, Carl van Vechten, Maurice Sterne, the Lachaises, and numerous European refugees and native talents. Carrie spent days designing a doll-house for adults (now in the Museum of the City of New York), furnished with characteristic miniatures by artist friends. Florine was a busy intimist painter of attenuated fancy and fluorescent palette; Nadelman appears importantly in her group portraits.[45] In "Picnic at Bedford Hills" (1918: The Pennsylvania Academy of Fine Arts, Philadelphia), he is a mini-Byron, depicted much in the style of his own "Man in the Open Air," flung full-length, cross-legged on the lawn, worshiping sister Ettie.

Henrietta Stettheimer had written her Ph. D. thesis at Freiburg in Breisgau in 1907 on the metaphysics of William James. Thanking her, he wrote that had she been his student at Harvard, she would have won a *summa cum laude*. Her novel *Love Days*: (*Susanna Moore's*), by Henrie Waste, dedicated to E. S. (herself?), appeared in 1923. Her style, an aromatic mélange of Marie Corelli, Elinor Glyn, and Floyd Dell, could have been illustrated by Florine's pictures. In *Love Days* Nadelman is "Pol Grodz"

(father Finnish, mother Greek), a painter whose canvases "seem utterly modern, and yet to partake of the certainty of the Renaissance and its sense of harmony." Susanna, a high-strung American philosophy student (and a distant cousin to Constance, Lady Chatterley), is hypnotized by Grodz's lurid fame long ere they meet. A friend calms her curiosity:

> "His work says what there is good to be said about him . . . He says pretty good things about himself otherwise, too, and quite unnecessarily since he's a great talent; but he's become an egocentric – conceited – boring – egoist since he's the rage . . . Before that he was a poor struggling young genius who hadn't time to talk about himself . . . and was glad and content if his work progressed and he found an omelette and a glass of absinthe or whatever he drinks . . . He's handsome in an unusual way. Delicate and yet very – very male. Yet he's . . ."

> "He's half-starved looking [another friend continues] and it's because he's unconscious of when he eats and what he eats . . . in a kind of hurried cataleptic state that makes you feel sorry for the food, when it's good."

Susanna-Ettie describes the "white nothingness" of his vast studio, fascinated by both art and artist long before they merge:

> "Oh, this is the one I know so well from reproductions, this lovely Virgin of the Mists or Venus of the Mists, or virginal Venus of the Mists!" she cried . . .

In cyclonic passion they marry; then off to Capri: "he was like a golden wasp." Six months – divorce. But she would send him a souvenir, something special and beautiful, a Tanagra statuette, for instance – a Tanagra amourette. She might say, "From one victim to another," for he was caught up in his own fate, that of a great artist who "loved life hotly," and loved the whole of it more than any of its particular manifestations.

For anyone interested, *Love Days* is indispensable, however excruciating. But Robert Morse Lovett, perceptive critic, reviewing it for *The New Republic*, decided that Henrie Waste followed close on the heels of Henry James, and her heroine had the playfulness of Walter Savage Landor's Greek ladies.[46]

Nadelman returned the compliment half a dozen years later by a heroically ironic bust [139], brilliantly ample in brass, Prussian-blue coiffure and necklace – Susanna Moore with the sibylline stare of a complacently intelligent doll. He remained amused by her, although his wife, who had been raised along with her sisters in Stuttgart, discounted much heat in their Platonic duet. While the Stettheimers presided over a generous support of art, letters, and theater, this hardly compared with patronage which flowed from the Union or University Clubs or the estates at Tuxedo or Oyster Bay. Over the next decade, Nadelman passed easily between the two worlds as a local

leader. The press for the Scott & Fowles show established him. Royal Cortissoz, for many years New York's most powerful conservative art critic, wrote in the *Tribune*:

> We could...call him a, or the, Brummel of the sculpture world...The archeologist crops up to hold back the extremist. The two are Nip and Tuck. There is rarely a compromise between them...

Henry McBride of the *New York Sun*, Nadelman's earliest and most loyal supporter among progressive American critics, had praised the earlier Stieglitz show. Now he fixed the general impression:

> [His work] is, in a word, refined. It is in the highest degree a before-the-war art. It is culture to the breaking point...It seems to breathe out all the rare essences that were brought by the wise men from all corners of the earth to be fused by the Parisians ...into the residuum called "modern civilization," which now, so many millions are dying for...In this sculpture, the past and present are blended almost cruelly.

By 1918, Nadelman had become a positive force in that "High Bohemia" which was productive background for a confluence in which busy architects, painters, interior designers met. On this same level, the conservative yet able and influential American Academy in Rome gave its New York alumni head starts on important commissions. The academicians of that time had a genuine position which was neither retrograde nor intolerant of the progressive younger generation. Beaux-Arts disciplines were not yet under attack; post-Renaissance Europe still provided criteria for luxury taste; but managing architects with big contracts were not slow to employ progressive skills. Although there may have been little real intellectual ferment from the issuance of manifestos for new movements, a mandatory activity for maintaining radical excitement in Paris or London, there was in Manhattan a working arrangement between young men and an old guard. The United States, from Europe's viewpoint, had been naively barbarian, its first centuries marked by few innovators unless, like Sargent, Whistler, or Mary Cassatt, they became, effectively, expatriate. Now New York was relatively free from faction. In its paucity of initiative on an international scale lay a permissive if interstitial area of tolerant change and welcoming possibility. Paul Manship, the establishment sculptor-in-chief, hired Gaston Lachaise to carve the Metropolitan Museum's massive memorial to J. P. Morgan, asking him to sign it as collaborator, although the young sculptor proudly refused. The Armory Show of 1913 with its influx of war-exiled talents had uncovered what the rest of the world was doing, and America would now be no less fast to avail herself of futures in art than she had been in science, or industry. Time was ripe for Nadelman; he coincided with a cultural necessity primed by historical pressures; for a decade, his reputation was advanced by shrewd judgement of his chances on such ground.

It was perhaps the last period of a genre of private patronage in this country which,

while still imitating European precedent, proposed an exuberance in luxurious collaboration freed from precise pastiche or the prestige of specific precedent. Now big new country houses would not be based on measured drawings of Blois or Chenonceaux. F. Burrall Hoffman, Jr., designed, Paul Chalfin and Muriel Draper decorated James Deering's sumptuous baroque Villa Vizcaya on Biscayne Bay. In its fantastic marine grotto, flanked from the sea by granite barges, Robert Chanler frescoed ceilings. He was already famous for huge lacquer screens of giraffes, zebras and flamingoes. For its splendid formal gardens, Lachaise modeled handsome cast-stone peacocks.[47] At the same time, Nadelman was executing bronze and marble dancers for fountain figures, stags and pheasants for gate-posts [39, 57], on Long Island and Westchester dukedoms, which estates were only a trace less lordly.

The lawyer John Quinn was backing James Joyce and T. S. Eliot abroad while buying Pascin's drawings and Seurat's *"Le Cirque"* for his New York apartment. In Philadelphia, Christian Brinton, an energetic amateur impresario, was introducing Ignacio Zuloaga as successor to Sargent, numerous White Russian painters and Slavic folk-artists. In Chicago, the composer John Alden Carpenter and his wife encouraged new music; Nadelman soon exhibited at her progressive Arts Club. In Baltimore, the Cone sisters, stimulated by Gertrude Stein, were building their own enterprising collection, which included Nadelman. Nearby, Léon Bakst stenciled Mrs. John W. Garrett's private theater in the style of sets for *Ballets Russes*. Diaghilev himself was surviving war through a disastrous American tour backed by Otto H. Kahn. In the magazine *Vanity Fair*, Frank Crowninshield publicized the artistic and literary advance-guard with taste and dispatch. He put his own "poetic" titles (tags from Byron or Poe) under good photographs of Nadelman's latest marbles. Nadelman was in this forefront, more and more an arbiter of luxury taste and values.

He became a member of The Penguin Club, whose annual banquet menus were etched by Pascin, his friend from Munich and Paris, whose recent drawings made on trips to New Orleans would presently influence him. He was a familiar of George Bellows who would borrow certain elements of Nadelman's wooden figures. Eugene Speicher would be his sponsor when, in 1927, he became an American citizen. He had a genuine respect for efficient academic sculptors. So much the professional himself, he could converse with colleagues without impugning quality or style as long as they served their *métier* with honest skill. He admired George Grey Barnard, originator of The Cloisters, with whom he shared a passion for medieval handcraft and, as well, the academicians – Edward MacCartan, Edmund Quinn, Frederick MacMonnies (who frequently asked his opinion), Mahonri Young, Paul Manship. He felt close to Gertrude Vanderbilt Whitney, particularly in her efforts to provide an atmosphere in which patronage might further local innovation. He was active in the politics of artistic organization and lectured briefly at the Beaux-Arts Institute of Design and

at Katherine Dreier's *Société Anonyme*. He noted that, while there were some gifted students, the system revolved around annual prize-awards, and that competition thus fostered mediocrity. He designed floats for Beaux-Arts Balls and participated in improvising an example of "Indigenous Sculpture" for a show at Mrs. Whitney's Studio Club. The Club some dozen years later led to the founding (with Juliana Force) of the Whitney Museum of American Art.

Kenneth Hayes Miller, who followed Robert Henri as perhaps the most influential painter-teacher of progressive painters until the mid-'Thirties, said to Nadelman at the opening of his first Knoedler exhibition (1919): "You know, Nadelman, we all go by what you do." For by then he had fixed a typology of metaphors for current society, not one that was an echo of an older and richer Europe, but one which corresponded to notions of a new world-town which, almost for the first time, delighted in its autonomous contemporaneity. Nadelman's immersion in the European past led him logically to incarnate American immediacy.

In December, 1917, a group of society women and conservative lady-sculptors arranged a war-charity show entitled "Allies of Sculpture" on the Ritz-Carlton's roof garden on Madison Avenue. Nadelman dispatched four plaster figures, among others "*La Femme Assise*" [98], a seated hostess two-and-a-half feet high, coiffure indicated in pale peacock blue. She was poised in the wrought-iron skeleton of a two-legged chair, which balanced her bulk. He had previously sketched a fortune-teller on a skeletal stool, perhaps from memories of fun-fairs at Ostende, Coney Island, or on Atlantic City's boardwalks. In antiquity, enthroned virgins were midwives for wisdom, not only earth-symbols, sibyls, but also like the Pythian who, perched on a steaming tripod, prophesied in vaporous riddles. Interpretations of her oracles were left to crafty priests who promulgated self-hypnotized or hysterical ambiguities according to political pressure. In Nadelman's latter-day version, she abdicates from bronze or marble to plaster – halfway on to red cherrywood – a priestess shrunk to a figure in the salons which Proust anatomized. In the lilting supremacy of blue-stockinged silliness, her great-great-grandmother presided over Parisian drawing rooms in whose cerebral democracy was fomented bloody revolution. Her granddaughter, mistress of Radical Chic, would be pushing cocktails for Black Panthers.

"*La Femme Assise*" (The Seated Woman) – Guillaume Apollinaire's title for a momentarily scandalous *roman à clef* of 1913, which shadowed a notorious Parisienne – was also a pun on "Helvetia," the Swiss national divinity, enthroned on her republic's five-franc piece. Devalued in wartime, the image served cartoonists as current lampoon for false coinage, bogus value, *ersatz* culture: *kitsch*. New Yorkers may not have recognized every allusion of Nadelman's, but many were instantly, instinctively offended by the thrust in his nice wit. For there was in his figure's false-naive parroty pertness a smug assertion of the dubious triumph of The New Woman, already can-

onized in Ibsen and Shaw. And it would by no means be only women whom Nadelman mocked. Writing of Candida, Shaw said: "[She] . . . is a counterblast to Ibsen's *A Doll's House*, showing that in the real typical doll's house, it is the man who is the doll." But since men were busier at business than their wives, it was left for the women to be furious. Nadelman offered his New Woman as placidly patriotic, presiding over the Ritz-Carlton's *thé dansant* roof garden, self-satisfied, self-righteous, reigning on the invisible cushion of Women's Rights. Suffragettes had won their token vote. Now – what to do with it?

She caused a mini-scandal and was removed from the exhibition for three days. When the affair got into the newspapers, she was returned, banished to a far corner. Half a century later it is hard to fathom the fuss, but its faint ripples are perhaps worth a footnote in the history of American manners. Henry Adams, archetype of the American intellectual who spanned two centuries and two civilizations, wrote at the start of our era in his *Education*:

> Sometimes, at dinner, one might wait till talk flagged, and then, as mildly as possible, ask one's liveliest neighbor whether she could explain why the American woman was a failure. Without an instant's hesitation, she was sure to answer: "Because the American man is a failure!" She meant it.[48]

It was not only "*La Femme Assise*" which caused mockery and outrage. The plaster adolescent, a perkier version of Nadelman's "Man in the Open Air," in plaster, with hair tinted blue and the tree against which he leaned lemon yellow, was reported in the *New York Herald* of December 16, 1917:

> Certain notable viewers at the exhibition of the Allies of Sculpture for four war charities, formally opened on the roof-garden of the Ritz-Carlton Hotel, continued yesterday to express a mild harassment over the bright blue hair and the altogether original expression of the nude young man, No. 121 in the catalogue, who, placed in the center of the exhibitions, appears to be in the act of setting out upon a morning's walk clad only in the splendor of a yellow staff.
>
> While the names of those expressing a certain disgruntled disapproval of the phenomenon of the blue locks were withheld, it was learned that they were of prominence and that they had taken the matter somewhat to heart. The Seated Woman, No. 120, also has been the target of some criticism, some finding a discomforting spirit of the unique in her pose. Both of these works, in carved wood, are by Elie Nadelman, whose third work on display, Resting Deer, is admired by all.

On December 19, the *World* had headlines:

HIS "MODEST" ART OFFENDS EXHIBIT

Nadelman Thinks His Figures at Ritz-Carlton Show Have Too Many Clothes On to Please Committee: Man Wears High Hat; Lady Has Fluffy Skirts. They Are Put in Obscure Corner and Sculptor Blames Public's "Bad Habits."

Discussion over the proprieties of sculptural art – whether humor is seemly in that medium – looms in prospect by the removal from central floor space of two statuettes by Elie Nadelman . . .

The figures look equally like vaudeville characters, or exaggerated types of current fashions. They are dressed and colored . . . Mr. Nadelman issued a statement yesterday in which he names Mrs. Perry Belmont, Mrs. William Jay and Mrs. Ripley Hitchcock as the chief objectors to his work. They have been active in the promotion of the charity which is under the patronage of Mrs. Gertrude Atherton, Mrs. William Adams Delano, Mrs. Charles Dana Gibson, Mrs. Thomas Hastings, Mrs. Ralph Pulitzer, Mrs. Charles Cary Rumsey, etc. etc., Mrs. William K. Vanderbilt, Jr. and Mrs. Harry Payne Whitney. The statement implies that all of these patronesses sided with the objectors, and he accuses all who protest of such blind adherence to art conventions that they have lost their moral perspective in this regard.

However, Gertrude Whitney, whom Nadelman aided in founding an artists' club which promised the eventual existence of the Whitney Museum of American Art, sprang to his defense. Muriel Draper, no mean mistress of salons herself, was photographed with Christian Brinton, over from Philadelphia, in front of "La Femme Assise," now unequivocally labeled "Hostess." The Herald's cartoonist, Edward Lynd, sketched Nadelman's figures alongside "The Sleeping Muse," by Brancuse (sic), and two Matisse bronzes, which he labeled "Figure Trying to Recline" and "Youth Worn to a Shadow Trying to Drag Her Feet Around." The Brancusi, the two Matisse figures and Nadelman's "Man in the Open Air" are today in the Museum of Modern Art in New York; then, headlines in the Herald read:

EARLY MORNING OFFENSIVE SAVES ELIE NADELMAN ART FROM SUICIDE

The art exhibit and argument of the Allies of Sculpture . . . remained quiet on all sectors yesterday following a successful early morning raid by the constituents of "modest" art. The result of the post-dawn offensive was that [the] four dressed figures were replaced in the heart of the exhibition after passing twenty-four hours within hurling distance of a window's ledge.

The contention has been raised, or lowered, that Mr. Nadelman's work was not art, and on Tuesday some persons with more strength than discretion had taken the four figures . . . and put them in a well-ventilated corner where the slightest accident would have propelled them into the street. Other patrons of the arts, discovering that the four chagrined figures seemed on the point of taking their own lives, after the example set by S. [Steve] Brodie, removed them at an early hour yesterday morning to the very heart of the big show, where the visitor, unless exceedingly lucky, is sure to see them.

A week later "The Hostess" was knocked off her pedestal and her head smashed. The Herald pursued her with comic relief:

PLASTER LADY LEAVES HALL OF LAME SCULPTURE IN A DUSTPAN

That Mr. Hadelman's (sic) Masterpiece Was so Highly Surcharged with Inspiration That it Exploded May Provide Some Consolation to the Heartbroken Creator.

After weathering a few weeks of life such as few plaster ladies have ever lived, the figure of "A Lady, Seated," which Elie Nadelman considered one of his masterpieces, was found yesterday morning on the floor of the Allied Sculptors' Exhibition, in a pool of its own dust. Its head, than which there never was a harder one, seemed to have been removed by hand and the rest of the figure gave the impression of having been drop-kicked as it hit the floor.

Ever since the Allied Sculptors began their struggle on the roof of the Ritz-Carlton the Management has been anxious to know who wrote the rules by which art shows are conducted. They suspect the Marquess of Queensbury . . .

A sad-eyed group of Allied Sculptors stood about the wreckage yesterday morning as Mr. Nadelman thrust himself through the portieres and saw the havoc. He leaped across the room and knelt beside the broken figure, wringing his hands and exclaiming: "Ah, ma cherie, ma cherie!"

Mr. Nadelman speaks French.

A more sober account attempted to sum up Nadelman's own artistic concepts in the *Times*, presumably from the pen of Royal Cortissoz, the magisterial art-critic who, decade after decade, protected nineteenth century criteria as exemplified by the National Academy of Design and the American Academy in Rome:

NO SUBFUSCOUS NICHE FOR NADELMAN'S ART

"The Allies of Sculpture" Decide To Let Him Show Life as He Thinks He Sees It.

. . . A Disinterested observer . . . came to the conclusion that life to Mr. Nadelman looks mostly white, with occasional blotches of blue, and that in contradistinction to the cubists, to whom existence appears as a series of sharp points, corners, angles, and projections, Mr. Nadelman views it as smooth, round, bulbous or ovoid.

Nadelman himself had written an extended defense of his position (See pp. 269-70), which appeared nearly complete in the *New York World* of December 19, 1917, and in shorter versions in the *Sun* and *Herald*:

At "The Allies of Sculpture," where as in all exhibitions of sculpture, the subject matter of almost all works represent nude men, nude women, and nude men having the bodies of nude women, I have exhibited some works whose subjects are dressed women as one sees them in every-day life.

Well, the majority of the visitors on seeing the dressed women found them indecent and were so shocked that they removed them from their original place to a remote corner where they could not be seen. This fact is significant.

It proves the tenacity of habits and especially of bad habits. It proves that habit and not logic makes people accept or reject things; when the public does not find nude women in sculpture, they wonder whether the works are artistic or not . . .

212

It may seem strange today that the principal cause of scandal lay in the use of contemporary costume; however, similar results from violations of conventional taste had occurred before. In 1861, when Edouard Manet showed his "Picnic on the Grass," he was pilloried for indecency in setting nude girls side by side with clothed gentlemen, in a lovely parody of a famous Italian Renaissance engraving. Had he removed the velvet trousers, his composition would have passed as modestly mythological. That young Parisians would share an al fresco lunch with their *petites amies* was a public assault on morality, showing *la vie de bohème* as casual as it always is, but here elevated to a deliberately provocative Arcadian superrealism. Nadelman's clothed "Hostess" and "Singer" were placed next his naked stripling; the juxtaposition appeared even more insolent from the adolescent insouciance of his frontal innocence. To give the devil his due, perhaps it was not so innocent, for the figure also was a parody of an ephebe, derived from, but less "decadent" than, one of Beardsley's young admirers of Princess Salome. Nadelman's adolescent could have served as Carl van Vechten's "Blind Bow Boy," an updated Cupid, now an urban sprig, whose wayward allure and perverse elegance expressed a Manhattan cocktail. He was not Arcadian, but rather a spoiled brat disdaining his parents' notions of propriety.

In large part due to notoriety generated by Nadelman's work, the exhibition declared itself a huge success. As for sales, Mrs. Henry E. Huntington (streetcars, Los Angeles), who under her professional name, Anna Vaughan Hyatt, was sculptor of the equestrian Joan of Arc on Riverside Drive, paid $4,000.00 (about five times that in current value) for a pair of granite Great Danes, her own work. One final note:

> In recognition of the courtesies extended by Albert Keller, manager of the hotel, in connection with the display, he has been presented with Abstania St. Leger Eberle's "Old Woman Picking Up Coal," a bronze he has admired. Miss Eberle donated the gross proceeds of the sale to the war relief charities.

In Henry James's early novel *The American* (1877), its eponymous hero, Christopher Newman, a god-bearing Adam in search of an edenic Europe with the culture he feels himself so far denied, encounters a Unitarian minister, representing those notions licensing sober and ethical rapture. Young Newman's naivety was reflected in an adoration of artistic prestige, as well as merit, adopted by our ascendant capitalism. But he shocked Dr. Babcock in affirming that a single particular High Renaissance artist (Luini) "was enchanting . . . like a beautiful woman." A pained dismissal severs their amity. James wryly mocks the Puritan intonation:

> "Art and Life seem to me intensely serious things, and in our travels in Europe we should especially remember the rightful, indeed the solemn, message of Art. You seem to hold that if a thing amuses you for the moment this is all you need ask of it; and your

relish for mere amusement is also much higher than mine. You put moreover a kind
of reckless finality into your pleasures which at times, I confess, has seemed to me
– shall I say it? – almost appalling."

Nadelman risked joking seriously rather than cartooning comfortingly. His slyness,
subtlety and finesse rankled. It seemed clear he had betrayed his backers. Like other
alien artists before him, he was unmasked as parvenu, ungrateful, ill-mannered.
In Paris, battles at *Hernani* or *Le Sacre du Printemps* had world-wide implications; what
happened to Nadelman was little enough, but it marked a break in his reputation as
a "serious" artist, since he dared to be amusing rather than amazing – in itself, a cause
for moderate astonishment. His subsequent marriage to a widow of means was
followed a decade later by the stock-market debacle. A reputation confidently pro-
mised by his early success in New York increasingly faded.

Brancusi, before his one-man show at Brummer's in 1926, was involved in notorious
litigation with the United States Customs to determine whether his "Bird in Space"
was bulk metal, hence dutiable, rather than "a work of art" which was duty-free.
Today, when slackness licenses as negotiable instant trash equally with hard-core
pornography, it is difficult to account for taste which could be offended by artifacts so
evidently the result of dexterity and humor. Nadelman's adult toy-men and doll-busts
were more legible than Brancusi's abstraction, hence by journalistic explication more
offensive. His adoption or adaptation of the antique had been respectful and respected.
It was patently luxurious, hence legitimate. Sequences in history were serious enough
as long as they held no pressing immediacy. Also, working artists should not demean
their craft by carving wood rather than marble. Critics had no business measuring
exact mileage between Baths of Caracalla and Pennsylvania Station, except to praise
tycoon taste. Nietzsche said that a joke is an epigram on the death of a feeling. He
associated *Übermensch* with *Übermut*. The exalted (not the *super-*) man contained prank-
some exuberance, grave gaiety, elevated levity. Socrates had "a prankish wisdom."
This *Übermut* also embodied the Attic element of *hubris*, a residue of self-satisfaction,
conceit, superiority, disdain; a considered pride, even an icy lack of compassion. In
Nadelman it was wit more than sarcasm; characterization more than caricature, but
his light rapier thrust wounds no less hurtfully for all its elegance.

Despite superstitious regard for residual magic in battlefields or antiques, Ameri-
cans had little interest in why or how history happened. Events, souvenirs were
filed to be hauled out when comparisons were convenient. Stamps, coins, Colonial
furniture were collected as status securities. Schiller had said that men mistook
history for the Last Judgement; Americans read history as investment, profit or loss,
not process. History never menaced Nadelman; he lived on it. He was not a competi-
tor, but a maker. For him, history was matter, meat; metal or marble. Even as he

toiled on transfers in his own treatment from quasi-heroic to proto-popular, Bulfinch's *Age of Fable* gave way to Frazer's *Golden Bough*. Greece and Rome retired; dim pre-histories of Africa or Oceania joined Southeast Asia and Amerindia as exemplars of purity in craft and content. Pre-history might be equated with no history. America had been given but three centuries of her own; she seemed to need less. Already in New York, Glackens, Sloan, Bellows, Luks, Henri – freshness emanating from our "Ashcan School" – had pushed painting into an urban, industrialized universe. But in sculpture, only Saint-Gaudens's magnificent parade of black volunteers in Colonel Shaw's crusade (1897) demonstrated an heroic plasticity coined from a commonplace. Nadelman's own collection of folk-art, Shaker furniture, whaling pictures, Pennsylvania *fraktur* hung alongside Roman glass and medieval forged iron [211], recognizing a continuity in traditions of intrinsic beauty sprung from necessity and inextricably linking America to Europe.

But when he revealed a new development in his own direction, emphasized by its tiny attendant scandal, he allied himself with, and to an extent took command of, our real advance-guard. In time to come, things then thought unthinkable except by a vanguard would come true. Progress defined as galloping acceleration would repudiate any contributive past as tyranny. Paris as focus of ferment would give way after another war to New York. As for 1917, when he offered the everyday as historic immediacy, the results were not negotiable. Not for the first or last time, "bad taste," "insolence," "decadence" furnished their furtive admonitions.

When the sequence of plasters was exposed two years later in Knoedler's handsome Fifth Avenue galleries, criticism generally, except for Henry McBride's constant and cultivated voice, was even more savage, since he had compounded the impertinence in insubstantial sketches by transferring plaster to wood, wasting some skill on work which was trivial or worse. In the *Sun*, W. G. Bowdoin reported:

> No one else is comparable with this artist. He is a joke, and he clothes his subjects with the grotesque and the bizarre . . . Certain of his symbolizations are realistic enough, but he works with crudity, and not one of his numbers even remotely suggests aestheticism . . . His *"Vaudevilleistes"* typifies the Vaudevillian all right, but the modelled thing is inane, and the face detail suggests most vividly a putty mass . . . "In Evening Dress" [*"Chef d'Orchestre"*] [79] . . . utterly lacks all nobility. Degeneracy is left after all else has escaped, and the smirk of the face stands out with refined repellence . . . "Pianiste" [*"Femme au Piano"*] [118] might easily be a demonstration in a department store show window. All these . . . are certainly "different" but that alone fails as an adequate excuse for them.

History inevitably stammers. When Seurat's *"Grande Jatte"* was first exposed, 1886, *La Vie Moderne* as well as other reviews expostulated: "Indeed; so that's painting! What are those rigid folk, those wooden dolls, this bundle of Nürnberg toys? Badly

215

made manikins, a procession of pharaohs; immense, detestable: *fantaisie égyptienne."* In an interview with Henry Tyrrell in the *New York World,* the headline read: *"Is Nadelman Serious? Are these things art, or only insolence? Where does plastic beauty end, and decadence begin?"* Nadelman was thus reported:

> For reasons of my own – and I have at least 156 of them – I show the ladies dressed as we always see them, and the men with their hats on. Consequently people jump at the idea that there must be something wrong.
>
> But the blue hair?
>
> Ah, the blue hair! you, too, question that blue, though you never think of questioning the glaring white of plaster or marble, nor the metallic glitter of bronze… (See pp. 276-8)

What was equally unsettling in his new figures was obvious borrowings from toyland. [105] There was no recognition at the moment that he was also much indebted to Seurat's *femmes poteaux,* his post or stake ladies, one of whom stands implacably elegant at the heart of *"La Grande Jatte."* Nadelman also found in wooden dolls primary corroboration coincident with his own needs. He had never been attracted to Egyptian or archaic Greek sculpture; while he cherished their carving for unparalleled plasticity, they hardly served him as a source. He preferred earlier or riper epochs. Just as he had been affected by cave paintings, now his vision was refreshed and impelled by dolldom. He was enunciating an ancient attitude in a new accent. He was abandoning humans or superhumans for a world of toys. Apart from a few important decorations and a diminishing number of portraits, the rest of his career would be devoted to dolls on one scale or another, monumental to miniature. While he would individuate types, he deleted personality. Idols were unique prototypes, attached to temples at Olympia, Knidos, Samothrace. Toys are universalized artifacts from families which resemble one another all over the globe, in every epoch. Starting in the nineteenth century, by new technologies in plastics, they were stamped out as a lowest common denominator of consumer goods. They became a metaphor for the spare parts which came to service but finally encapsulated mankind, playthings all but mindlessly computerized. Seurat had forged his firm profiles in the sunset glow of middle-class holidays. Nadelman brought his personages indoors, into drawing-room, concert hall, variety theater. He carved images to populate play-rooms for grown-ups less adult than petrified. In play-rooms we make-believe and make-do. Disguising ourselves as Mummy, Daddy, Doctor, Nurse, Fireman, Soldier, we learn rules of games by which we later win prizes allocated by position, expertise, negotiable values and competitive snobbery. Nadelman well knew the frantic adjudications of journalistic taste. Bland smugness, self-serving promulgation of trends are busily static. Dolls are implacable, heartless – basically: brainless. Patrons without

passion, impregnable in their received opinions, are Philistines who always hold their nursery-fortress.

Beginning in the summer of 1914, Nadelman had sketched pin-head, match-stick figures. [65, 111] Eighteenth century toys (and there are few earlier ones extant) are residual archetypes, naive, hieratic and knowing. Stylization is fixed in tribal types, with suggestive detail in minimal form. They were made by dynasties of artisans who inherited the trade, father to son, with a formal grammar which was, on whatever level of luxury, more or less irreducible. In the wooden types, shape and volume derived directly from the mechanics by which they were carved. As John Noble writes in his clear study:

> A block of wood was roughly turned on a lathe into a series of spheres and cylinders, and into this rough shape the features and bodies were carved. A thin wash of gesso was applied to make a smooth surface for the painted face. Crude limbs with forklike hands were added.[49]

This traditional method is, basically, what Nadelman used. Wood was a material that had appealed to him as early as 1909. The first figure he gave his wife was a small female nude exquisitely carved and polished in walnut. He had carved wood portraits which were highly finished. His new departure would employ bolts of glued rosewood which, when gesso was later applied, would be painted rather than polished. His early researches had led him from the decomposition of complex volumes back to root forms, which in his practiced hands would emerge more subtle, suggestive and even florid, due to his long apprenticeship to Greece. Among his personal collections of dolls were many of the "pegwooden" type. The most elegant examples belonged to the Biedermeier epoch and were carved in the Bavarian or Austrian Tyrol. Lopped from a lean wooden dowel, the pegged button-head rests on a spare, smoothly turned torso. In spite of mass production, these toys, many tiny, are masterfully refined and finished. It was hardly by accident that he chose for his own female figures, as characteristic coiffure, neck, or hem-line, styles from the Directory and Empire, of which the Biedermeier was a provincial echo, adapting them to modern dress. Part of this adaptation can be traced to Pascin's illustrations for Heine. [95] But the innovating couturier, Paul Poiret, and his draftsmen, Paul Iribe and Georges Lepape, inspired by certain "reforms" in costume proposed by Léon Bakst, Diaghilev's great designer from about 1909, had already suggested a return to Napoleonic classicism, with its high uncorsetted waistline and columnar sheath-skirt.

On February 3, 1917, the *New York Times* had announced Nadelman's engagement to Miss Judith L. Bernays, a niece of Sigmund Freud and daughter of Edward L. Bernays, a prominent publicist, who was handling Diaghilev's American tour for Otto Kahn. Nadelman carved for Bernays an exquisite marble mantelpiece in the

idiom of Helena Rubinstein's London billiard room. Stylization was extreme, and it was the last work he would execute in his early Art Deco manner. His engagement to Miss Bernays was broken. On January 1, 1920, Nadelman married Mrs. Joseph A. Flannery, a wealthy widow. She had cultivated taste, was a serious amateur of lace and textiles, aware of all the arts. Her portrait and those of her two daughters had been beautifully etched in color by Paul Helleu,[50] a friend of Sargent's and one of the facile Frenchmen who served New York society early in our century. Nadelman himself was now doubly independent. Since his wife was unwell, they purchased Alderbrook [208], the Percy Pyne estate at Riverdale-on-Hudson. A fine old American Gothic mansion of the school of Andrew Jackson Davis, with gables, crockets, sheltered by an enormous primeval copper beech, it commanded heights overlooking broad fields stretching down to the Hudson, lands which were once crown grants to Dutch patroons. Nadelman installed himself in a studio-shop with a splendidly equipped professional apparatus. He sent for Albert Boni, his faithful *praticien* from Paris. At one time he employed three assistants: besides Boni, there were Italians – Ferdinand Terenzoni, Julius Gargani, Teo Fiorato. Editions of a half-dozen replicas of many figures were made in wood or bronze, including earlier ones which were now variously restudied. In his Riverdale studio, after his death, were found many roughed-out figures, versions of others completely achieved in several materials, including a life-size youthful male torso, similar to a sixth century *kouros* and unlike any other figure he had finished.

At the same time, the Nadelmans bought a large house, 6 East 93rd Street, Manhattan, formerly owned by Jacob Ruppert, the brewer. Its interior was gutted. Nadelman redesigned everything to include a top-floor studio sixty by forty feet with a huge skylight. The interior was entirely white and sparsely furnished, except for collections of Roman glass and marbles acquired from the eminent dealer, his one-time Paris companion, Joseph Brummer.[51] The mansion was ceremoniously opened at the end of January, 1923, with a studio banquet for one hundred guests. Mrs. Nadelman was seated between George Grey Barnard and John Sloan, deans of American sculpture and painting. The party represented New York's cultural elite. Nadelman was now one of a group of "radicals" invited to exhibit at the conservative National Academy. He showed his painted plaster male "Adolescent," the more epicene version of the "Man in the Open Air" – to be rewarded by a satisfactory display of raised eyebrows. His manner of living was now extravagant; the Nadelmans' Sunday evening receptions were events. He became friendly with many local artists, important among them Hunt Diedrich, a stylish craftsman of delicate forged-iron silhouettes cut as if by enormous nail-scissors. He liked Louis Bouché, a charming intimist painter, admired the dash and grace of the portraitist Cecilia Beaux, and the energetic practice of the sculptress Anna Vaughan Hyatt. For the annual Beaux-Arts Charity

Ball of 1925, whose theme was *"Le Cirque d'Hiver,"* immortalized by Seurat and Lautrec, he designed a processional float upon which a band of playing musicians rolled into the ballroom. Over the next five years the Nadelmans spent more than a half-million dollars (some five times that by current calculation) on their folk-art collections. They bid against John D. Rockefeller, Jr., for the Unicorn tapestries, now a glory of The Cloisters.[52] Nadelman went abroad each summer to work as well as buy. In 1926, he attended the wedding of his wife's daughter by a previous marriage to Count Guido Branca, admiring the suave gestures of an officiating priest. That summer was spent in Versailles; a *mouleur* was dispatched from Rudier's foundry to help cast new figures. While contributing to many artistic and charitable causes, he also sent twenty thousand dollars to his parents in Poland. His position in New York was exceptional; few men since Saint-Gaudens or Sargent occupied a place which was at once that of preëminent professional, taste-maker, patron. To understand the mystery of Nadelman's subsequent disappearance, one must frame him in the decade from 1920.

From 1920-1922 he devoted himself to creating a world derived from archetypes in the society he daily observed, and from performers in circus, vaudeville, or concert-hall. [94, 102, 113] He made numerous drawings from a variety of sources, scraps torn from newspapers or magazines – *Film Fun, The Police Gazette, Town Topics.* Sometimes his proposed compositions indicated such complexity that they could not be accommodated in wood carving. Ideas were sketched for a girl kicking her heels on a sofa, a woman on a chaise-longue, a wheelchair with pusher and rider on Atlantic City's boardwalk, a horse balancing its *equestrienne* [47-48], a man supported by his hound [75], a drummer with his battery of traps and gongs, a virtuoso dandy with his bow across his cello's baroque bulk. [92] Nadelman bought ships' figureheads for his folk-art museum, roughhewn images of Indians and Blackamoors, Scottish chiefs, American eagles, of Andrew Jackson, Daniel Webster. These large carvings, often from a single log, followed the dominant curve and grain in the trunk. Columbia, Britannia, Hibernia, "The Lily G. of New Bedford" swelled their bosoms to split waves along the cleavage of oak bolts from which they were hewn.[53] Similarly, Nadelman imagined his "Circus Girl" [74] in a large curve, which could be confined within one of his composite cherrywood blocks. These he had built up from matched bolts, glued against warp or split, since there was no fine-grained fruit or nutwood thick enough when sawed from a single piece. In the plaster model, developed from drawings, he raised her arms, turning her whip into a wire hoop. The result was unsatisfactory; this, with other plaster studies which displeased him by over-extension of forms or inorganic complexity, he destroyed. The most logical and simple of the designs were ultimately carved in composite blocks of grainless cherry, a wood grateful for carving, which had particularly pleased Biedermeier cabinetmakers. Its

surface took gesso well and cast a warmth suitable to the intimacy of his everyday subjects. On the thin gesso (which age flakes to look like white slip over terra cotta), Nadelman lightly brushed on boiled (or stuffed) shirts, gloves, moustache, hair, in delicate washes of pale Prussian blue. Feet were attached to base-blocks with the leanest possible support, heightening a sense of gently looming bulk, a benign parody of ballooning ambition, as if weight or pretension depended on slim chances. Nadelman, guided by Seurat, had his own knack for fixing suggestive posture and gesture, a critical placement of authoritative stance, of expectancy, queenliness, self-satisfaction, not alone in nude silhouettes, but also by tactful suggestion of the very style of seasonal fashion which marked modes for our early 'Twenties. The carved wooden "Hostess" was a final version of his plaster *"Femme Assise."* [98-99] Her companion "Host" [100-101], set on an iron skeleton of an armchair, insists on keeping his hat on, indoors and out, further dignifying ducal complacency. This may have been wry homage to Adolphe Basler, his early apologist, whose moustached mask it parodies. But also, his friend Pascin was well known for keeping his hat on.[54] "Standing Woman" [105] echoes the hauteur of Goya's "Duquesa de Alba" (a reproduction of which was filed with his photographs), and has her hands poised at high tremble, as eager to insert a gossipy barb as to have her fingertips lightly kissed. "Woman at the Piano" [118], tilted head, arched spine, poises a suspended hand to magnetize her unseen listeners by the tingling promise of an unstruck chord. *"Chef d'Orchestre"* [79], a suave monolith in swallowtail *frac* is a sober clown, a solemn puppet who both rules and is ruled by his musicians. This mastering figure was first intended to be a solo violinist, but Nadelman felt addition of an instrument unbalanced his body. He kept the posture, but eliminated the violin, since it was as suitable for virtuoso conductor as virtuoso soloist. There is a story that when Pierre Monteux, long conductor of the Boston Symphony Orchestra, was a young man, his First Violin reputedly said: *"L'orchestre a bien dirigé M. Monteux."* Nadelman's *chef d'orchestre* is in one body star performer, *premier danseur, pontifex maximus*, a high priest conducting secular rites in our music temples, and is also, as synthesis of them all, a Clown or Great Fool. Bathed in impalpable spotlight, a bifurcated monolith, the epitome of showmanship, he is no caricature warped by professional deformation. He is the reverse of fiery exhibitionist. He is music's master or maker, poised, a craftsman at play, a player whose game is ruled by notes in a score which he knows by heart. He is puppeteer and puppet, pulling on his own strings – violins, violas, bass. Nadelman carved the mind behind performance – interpreter rather than composer – the mind which makes composition flesh, the man whose own corporal choreography and gesture measure motion and sonority as passed through subordinate brains and bodies, and without whose directives there would be no music at all.

There is in this Conductor a prime *persona*: The Clown. Nadelman had already made a Chaplinesque figurine in bronze, ca. 1915, in baggy pants, thumbing its nose. He kept many photographs, old or recent, of circus group-portraits and individual painted faces. [78] Among them are profiles in make-up, with black grease-paint snubbing off noses. An imperturbable clown's mask reduced his Conductor to toy-dom, yet the face is no funny-face. It has power, control, serenity, yet the stance is ironic. Traditionally, the Clown is archetype of Assassinated King, symbolizing the reversion of absolute authority. Irreverence replaces mastery; gaucherie, pratfalls on banana peels reverse majesty. In the circus ring, clowns polish techniques of professional parody which toe a tightrope between buffoonery and *lèse majesté*. Nadelman's clowns are of the race of Wise Fools. Stoic philosopher and painted clown wear fixed smiles. "A learned fool is worse than an ignorant one," said the Catholic metaphysician Charles Péguy. If one must say *something*, then "at dawn, at dusk, when anything occurs to you, just keep saying: Thanks for everything. I have absolutely no complaints."

The licensed jester, the captive dwarf, the tension between grandeur and its opposite, hubris, measured by a lowest common denominator, are echoes resounding in Nadelman's gamesome figures. This will be increasingly manifest towards the end of his life, when come deliquescence and despair. But what is constant, at this period and later, is dignity incarnate in actor, dancer, acrobat. Professional skills are protection, even salvation. Mask or mirthless grin is armor. Laughter is silent, unwinking, unblinking, since the cosmic jokes are too serious for sounding. Also, the security of balance in profile, form and volume, the modest elegance of rubbed and painted wood make their small scale majestically noble.

Nadelman comprehended the peculiar nature of self-elected virtuosi, their lodged yet extroverted focus of self-exhibition which fixes their Act, their Number, Routine in intense evanescence. When the curtain falls, lights come up; the Act is lost and over, yet vibrations recur as an unforgettable scent. Nadelman modeled in plaster, but never completed in wood, a "Concert Singer" [93] in her reverse S-curve. One can imagine her in the full bosom of a Bechstein concert-grand, all bust and bustle. She clasps her hands, clears her throat to launch into some art-song by Tosti or Reynaldo Hahn. Nadelman sang himself, generally old Polish and Russian songs. He played the piano a little, strumming chords like a liturgical accompaniment. He played the flute well; during the Second World War, he gave his own away when there was a collection made for the U.S.O. Since Munich and probably Poland, he had frequented concert-hall, circus, variety-theater as the apogee of art in action. In New York, he found our vaudeville in its sunset glory, before Hollywood killed the Keith-Albee and Loew's Orpheum circuits. It was also the age of wildly popular ballroom teams: Vernon and Irene Castle, Maurice and Walton; and of the musical-comedy stars, Eva Tanguay,

Marilyn Miller, the Dolly Sisters, in annual Ziegfeld Follies and George White's "Scandals." [102] He filled his files with them, torn from magazines – big family portraits of entire circus companies, as well as small sepia nineteenth century *carte de visite* portraits of stage and burlesque queens. [131, 137] These served him as reminders for the rest of his career.

Nadelman presented theater ritual more originally than anyone had since Toulouse-Lautrec and Seurat. He, also, knew how to choose the climactic silhouette that focused an entrance, accentuated a climax, held a phrase, framing the magnetism of performers at their briefly frozen peak. A dancer is revealed by the rising curtain: her instant apparition is visual fanfare for a whole routine. At first immobile, she may arrest and stagger an audience by her calculated sequence of gestures, quitting one pose for more violent action which leads logically to smash finale. Nadelman's "Dancer"[55] [72] recalls Seurat's "*Le Chahut*," which he might have known from reproduction, but there were high kickers at Sakara in Egypt, and throughout the Middle Ages on many cathedral portals the tumbler Salome kicked up her heels. Nadelman's drawings in profile have a full plasticity, although final versions in painted wood gain from the judicious play of white gesso wiped off to show red cherrywood cheeks beneath. From front, side, or back, from every conceivable aspect, this dancer moves. The criss-cross and opposition of arms and legs releases her into one huge precipitous kick. But, in wood at least, his masterpiece is surely the "Tango."

To us, the "Tango" stands as a smiling epitome of some modern version of a minuet, a metaphorical mating dance, distilling in an elegant order both coquetry and mutual consideration. [107-115] The Argentine Tango was immortalized by Rudolph Valentino in his film of Blasco Ibanez's *Four Horsemen of the Apocalypse*, the first novel attempting an epic treatment of the 1914 war. Dance-forms have marked epochs since antiquity; Holbein imposed his own penetrating contemporaneity on the medieval Dance of Death; the *minuet* stamped the *ancien régime*; *carmagnole*, the French Revolution. Waltzes were still another revolution in rhythm and tempo, defining Romanticism by their own inebriation. Guillaume Apollinaire in *La Femme Assise* defined the epoch immediately preceding his fatal August:

> . . . the year 1914 commenced with mad excitement. As in the days of Gavarni, the period was dominated by the Carnival. Dancing was all the fashion; they danced Everywhere, Everywhere having taken the place of masked-balls (in ballrooms) . . . Life seemed to grow light-hearted, and perhaps later, when with Tango, Maxixe, Furlana, the war and its *bombes-funèbres*[56] would be forgotten, one might say of the peaceful portion of the year 1914, as in Gavarni's famous lithograph: "They will be pardoned much because they danced so much!"
> . . . They lacked a Gavarni in 1914, but dancers, men and women, were not lacking . . .

the Tango, that marvelous and lascivious dance . . . seemed born upon a Transatlantic luxury liner . . .

Nadelman's tango did not show it as a folk-dance from the pampas, transferred to the *bajo*, the lower industrial port of Buenos Aires, an intense, drugged, fatalistic, groggily syncopated duet, but as an ironic echo of resort hotels or spas where international high society consoled itself by taming any savagery in folk-expression. Public ballrooms were now the site of parties once held for children of the faubourgs in big private *hôtels*. The Tango had become another dancing-madness like the medieval choreomania which pranced after the Black Death. Now, one danced in spite of machine guns, tanks, gas masks, or on account of them.

The source of his wooden "Tango" may be traced to drawings of a couple (himself, his companion?) surprised by an older woman, from the Ostende summer of 1914. A number of matchstick figures, a few in the style of the cave murals, were sketched with deliberation and ended in seven highly finished pen-and-wash drawings, indebted to the masterful profiles of Seurat in the "*Parade*" and "*Cirque*." On each sketch he scrawled a day: *Lundi, Mardi, Mercredi,* climaxed by a double exclamation for *Dimanche!!* His sequence mounted in the relentless acceleration of a brush-fire fad. Apollinaire asked:

> One never dances more than in time of revolution or war and what peculiar poet has thus invented that entirely prophetic expression: "to dance on the edge of a volcano"?[57]

The partners in Nadelman's "Tango" passed through many stages before they found their final stance of frontal convergence. We follow sketches almost as choreography for an animated cartoon. First, profiled, they gingerly clasp each other with opposing raised feet. They divide to rejoin in stiff confrontation denying physical contact. Finally (in his only pencil sketch in the series, dashed off in a few blocked lines) the pair stand separate yet locked, together yet discreetly apart, a conclusive framing of all formal encounters, divisions, and rejoinings in their dance.

Nadelman did not interest himself in the classic ballet nor in ethnic or exotic forms. He preferred the cruder smell of three-ring circus, National Winter Garden, Irving Place Burlesque or concert-halls. [127] What delighted him in the performing arts was professionalism, technical proficiency in traditional presentation of each polished routine, focusing single artists by distilled experience in what best built their act. There was intense consideration of personal projection by which a particular clown, *chanteuse*, or *equestrienne* managed to invest a quite unsurprising repertory of serviceable gags, gestures, tunes, with absolute authority. Audiences were controlled by the flick of a wrist, stretch of a toe, sliced-off grin, throaty quaver. In his wooden

figures he praised the hardy science of hypnotizing a public which crowns performers with handfuls of thunder.

In October, 1919, his plaster figures, portions brushed pale blue, with their wire attachments were shown at Knoedler's. He had not then decided on their ultimate material or whether to cast them in bronze. Later, the ones best accommodated to bolts of cherrywood he carved; those too complex were destroyed. The exhibition was lit theatrically, a novelty at the time. Spotlit, his players and dancers were seen as if by lightning flash. People were amused, but the show was hardly taken seriously. These *jeux d'esprit* set up in impermanent plaster seemed dubious jokes; neither then, nor later in their finished state, would one be sold until after his death. Technical mastery was ignored when carved in cherrywood – this was not considered a noble material. Their folk-art echoes were hardly recognized. Small talk agreed he'd married rich and stopped "creating." He never stopped, but now devoted himself also to a wife who was ill, to an infant son, and the folk-art collections. Their private museum soon comprised the finest in quality and most representative in content of any in America. Its start had been in Mrs. Nadelman's already extensive collection of laces and embroidery. In Taylor's Auction Rooms, by no means a fashionable source, but for him an unsuspected treasure-trove, he began to find a heterogeneous wealth of artifacts which were then misprized as little more than awkward or naive mementoes, salvaged from tidying up attics or store-rooms. His scope broadened; Nadelman avidly amassed eighteenth and nineteenth century carving and painting from Maine to Virginia at a time when our most prized "antiques" were provincial adaptations of Sheraton or Chippendale originals. At that time there was so little interest in native artifacts that when "folk" art was mentioned, it was assumed one meant Navajo weaving or Zuñi pottery. In 1924 the Nadelmans built the first half of a hewn-stone building on their Riverdale estate and over the next few years spent a fortune to correlate a gamut of popular crafts, not alone from the United States but from all over the world. [211] With difficulty he managed to extract from the reserves of the Hungarian National Museum a pair of important late medieval marriage-chests; from Germany, tin, wood, and ceramic dolls; from Holland, tiles; from Sicily, painted carvings for festival wagons. A rich variety of glass, forged iron, faience, dolls, lace, furniture were arranged in well-lit rooms, which formed a precedent for subsequent collections when Nadelman's holdings were dispersed. He loved to have old objects pass through his fingers. Their patina, the forms in their fragmentary survival, the essence of their refined but irreducible shapes corroborated his own work in America, just as Greek sculpture had inspired him earlier and would later. Nadelman became an enthusiast for calligraphy as practiced by Pennsylvania Germans in the eighteenth and nineteenth century. He made three important collections of *fraktur* certificates – the *Haussegen* or family blessings – birth, marriage, and death certificates with naive

224

embellishments of cherubs, scrolls, and garlands. These are the final efflorescence of medieval manuscript illumination, just as the breasty beauties carved for Barnum and Bailey's parade wagons are a last full echo of the Baroque. Nadelman was among the first in this country to recognize our popular crafts, not as quaint Americana but as related to European tradition and sharing a mutual Gothic ancestry. Some of this he made use of in his own work; his penmanship of lips and eyes starting about 1918 is clearly indebted to *frakturs*; the muscle-men and strong-ladies of circus wagons and sideshows are found again in his *galvano-plastiques*.

As an art student, Nadelman seems to have had no interest in the popular revival of Slavic folk-traditions sponsored by the ethic of Count Tolstoy and the purse and aesthetic of Princess Tenisheva, under the capital influence of William Morris and neo-medievalist craft movements.

His first and most dominant source was classical Hellas; then, Michelangelo and the circle of bronze-masters around Giovanni da Bologna; finally Clodion, Houdon and Rodin. But by 1918, imagination was captivated and curiosity kindled by the instinctive simplification or generalization of forms in folk-fashioning, which he drew on and handled in the same way as his more orthodox models by analytical method and plastic mutation. To this were added debts to Seurat's profiles and Pascin's postures.

In 1921, the Nadelmans rented for the summer Henry Sleeper's home in Gloucester, Massachusetts. A wealthy New Englander with a passionate sense of the past, Sleeper had transformed an existing shingled waterfront house, creating a sequence of period rooms. One large hall was papered with fine China-export painted panels of trees and birds; another small alcove-like den was organized as a shrine to Byron with one of the poet's beds and his first editions on a night-table beside it. Another splendid ensemble entirely in red combined heaps of crimson morocco bindings, scarlet tôle lamps and painted draperies carved in wood by a ship's carpenter. These rooms were an eccentric evocation of domestic extravagance. Nadelman's own taste was corroborated and stimulated in the Sleeper house, which is today maintained as a town museum. This experience contributed to an evolving program for collecting folk-art, which would be far more comprehensive, scientific and useful than the expression of a cultivated gentleman's fancy. Objects by which Nadelman was first amused, probably spurred by his wife's long-time interest in lace and embroidery, began to serve his own plastic needs and to assume an ever broader general reference. Another possible influence was Basler, who had been a friend of the best of Sunday painters, Henri Rousseau, and who was among the first to grant him serious critical attention. Nadelman bought American naive pictures of the eighteenth and nineteenth centuries, formal family groups, whaling pictures whose icebergs were sprinkled with mica, stenciled still lifes on velvet and mourning-embroideries, long before these were recognized as having much more interest than charming souvenirs.

In 1925 he showed in New York and Chicago, exhibiting a new family of figures. [128, 129, 135] The process used was an old one, long developed industrially in Germany, by which, over a core of plaster, deposits of metal were laid by electrolysis. The resulting surface was metallic; it simulated bronze, but cost a fraction of casting. However, its skin is thin, the tensile strength fragile. Whether or not Nadelman felt dubious about sending his new figures to a foundry, or was determined by economy alone, is uncertain. He was spending considerable sums on the folk collections; perhaps he wished to obtain as many precious objects as were still available in a rapidly expanding market which he had done much to create. He never sold one of the galvanos. Since his death, some half-dozen have been cast in bronze without damage to the painted originals. The galvano heads are over life-size; the bodies, full-length, three-quarter, standing, or seated, are people of pneumatic plumpness. A memory of Rodin's dreamy envelopment generalizes their volumes. They are deftly posed, benign, even cheerful, fulsomely content, alert in amplitude, waiting poised or momentarily seated before launching into their act. Columnar rigidity appropriate to the wooden figures is now succeeded by a fluency, as if the volumes were poured into articulate sacks of molten metal. They seem taut with air. Here again is his deliberate dialectic. Weighty shapes are lightly massed: bulk is buoyant. Resistant material is rendered fluid as wax; people are dolls; masks are faces.

Galvano-plastique imitates the surface of bronze save for its grosser grain and duller sheen. However, Nadelman, with his instinct for the capacity in material, adapted plaster cores appropriate to this unfamiliar medium, profiting from the coarseness through his reconsidered volumes, transforming an inert mass into elephantine delicacy. It is well known how dainty and light-footed pachyderms are in the arena – similar to Nadelman's strong-ladies or burlesque queens. He appropriated the shape and proportions of cigar-store Indians for girls of the Beef Trust as they appeared at Niblo's Gardens, Coster & Biall's, or for burleycue long before it became strip-tease. Those music-hall amazons, whose sepia *carte de visite* photos he treasured [127, 131], were massively muscular, satiated, yet sympathetic. They were animal trainers and weight-lifters, not man-eaters. They were not freaks, but small giantesses of a super-human species, respiring only in the humid air of grease-paint and tan-bark. Nor are they precisely nude; Nadelman clad them in their own self-replenishing power, mistresses of mares and pythons, busty toe-dancers, not of the ballet but the circus, their benign bulk, erect or enthroned, afloat. It was a commonplace that the skills of the music-halls were hearty and vulgar; its health and disciplines were not so readily recognized. Caricaturists had demonstrated the sadism in the raw stripped grin of burlesque. Nadelman reduced a savage grossness into ostentatious female complacency. Where Daumier was hilarious or horrendous, Lautrec ferocious, Rouault agonized, Nadelman (along with Seurat) while not deaf to its hoarse laughter also

knew the practiced finesse beneath tights and spangles. His *galvano-plastiques* were never popular: they appeared coarse or vulgar. However, there was some compensation. An editorial in the *New York Times*, March 1, 1925, referring to scandal occasioned by attempts to censor Eugene O'Neill's New England tragedy *Desire Under the Elms*, in stating that the play was not "obscene," said: "The play is a neo-primitive as clearly as a painting by Matisse or a sculpture by Nadelman."

In his busts fashioned in the *galvano-plastique* medium [135], later in painted brass, Nadelman was again inspired by doll-types. But now his models were not Germanic and wooden, but French ceramic. France manufactured one-piece, polished china head-and-shoulders for families of carefully produced playthings, beginning about 1880. Earlier dolls were known as *poupées*, and were reductions of adults to dolldom, although there were children among them. The new type was specifically for *bébés*, chubby infants, immediately recognizable, with big eyes, bee-stung cupid lips, combed-out eyebrows. These dolls are appealing, solemn, expressionless. The ceramic head-and-shoulders had drilled holes into which could be sewn a lower torso of leather, papier mâché or stuffing dressed in dainty *trousseaux*. Nadelman dispensed with bodies, but combined the starkly painted porcelain heads with an ironic memory of some of Rodin's aristocratic Chilean and English *grandes dames*.

There were also, particularly in later work, echoes of the Kewpie Doll, designed by Rose O'Neill, which had just appeared in book illustrations in 1909, and which developed into a considerable fad after 1913. Among the scraps torn from catalogues that Nadelman kept by his workbench are numerous cuts of commercially designed toys, including many imitating film stars from Betty Boop to Shirley Temple.[58]

Just as his first figures presented an achieved stylized family or tribe, and were followed by groups in cherrywood and *galvano-plastique*, Nadelman next produced a series in painted brass. [139] In some ways, these are his most consummately individual works. He used a series of *personae* or masks familiar since the wood-carvings; now these were presented in a more sumptuous material, on a more massive scale. In this style, he made only busts; there are no full-length figures. Perhaps the finest is the "Man in Top Hat" [142] (Museum of Modern Art, New York). It derived from the early bowler-hatted "Mercury," which had turned into the head on his "Man in the Open Air." The highly burnished cylindrical topper fused sharp edges in a subtle columnar geometry. The beard was indicated by delicate curly rolls, recalling his low-relief plaques before 1914, echoing the rendering of curls and hair on antique Greek coins. The boiled-shirt front was left in its brassy shine; coat and tie were crisply brushed in with Prussian-blue lacquer. Around the neck or attached to the head of his ladies were indicated his now characteristic *petits rubans*, which had been worked in wire for his wooden women. These ribbons, now in bronze or paint, were vestigial knots, a discreet metaphor for all adornment, at once comb, brooch, or

necklace. Simple grandeur in the ample volumes was enhanced by the sheen of gold glowing against acrid accents in peacock varnish. These heads are scarcely caricatures. Their afterimage is ambiguous; they are neither puppets nor persons, but essences in-between. He would do further fine work, including large cut stone and a big bronze, but in these masterfully accomplished forms, richly glowing, a core of social irony is refined towards majesty. The gold and painted surface, immutable flesh, impassive visage, recalls Baudelaire's sonnet – which applies equally to the marbles, but which in gilt-bronze defines his most luxurious expression.

> *J'unis un coeur de neige à la blancheur des cygnes;*
> *Je hais le mouvement qui déplace les lignes;*
> *Et jamais je ne pleure et jamais je ne ris.*

The sentiment of an impervious spirit that abhors any disarray or finite limitation either through imprecision or violence; of lips that neither laugh nor weep; the bland smile of private consciousness encompassing every personal ambiguity is common to all esoteric art, whether neo-Platonic, Gothic, or Buddhist. Nadelman's subject matter was ostensibly laic, rooted in the society of which he was a member. He celebrated no male deity but the dandy, a secular demigod, a residue of self-conscious moral supremacy. The modern role of dandy from Beau Brummel and Byron through Wilde, Max Beerbohm, Ronald Firbank to the Beatles is an important, sometimes unsuspected, mask of social protest. Reforms demanded by the dandy derive from the top, rather than the middle or mob. It is an idiosyncratic revolt, disdaining the support of those masses who may accept a coarser general amelioration or temporary revolution. Baudelaire knew:

> Dandyism is not even, as many unthinking people believe, an immoderate taste for the toilette or material elegance. These things are merely, for the perfect dandy, a symbol of the artistic superiority of the soul . . . Dandyism is, before anything else, the passionate need to create out of one's self an originality, contained in the external limits of convention . . . The nature of the beauty in the dandy consists above all in the cold manner which comes from the unshakeable resolve not to be moved; one might say . . . a latent fire which makes one guess its presence; which could, but which does not choose to, burn . . .[59]

In 1929, at the collapse of Wall Street, Mrs. Nadelman's fortune, overextended in real estate, was abruptly wiped out. Their large town house was first rented, then soon sold for arrears. They retired to Alderbrook in Riverdale, which also figured in their bankruptcy. However, before his death, Nadelman managed to regain title. There would be endless litigation and harassment over unpayable back taxes. All this was devastating; while courage and his wife's devotion supported him, a period

of increasing seclusion commenced. He quit cities physically and spiritually. He saw Europe for a last time in 1933; embarking, he said he could hardly wait to return to Riverdale. When people came to call, as at first they did, from friendship or curiosity, he showed nothing except his splendid white raspberry bushes which he carefully mulched and harvested.

NEW YORK 1930-1946

It is sobering to attempt a reconstruction of the state of mind which shadowed Nadelman's last years. Almost the only construction which required monumental sculpture during this time was the complex of Rockefeller Center. At the outset, academicians Lee Lawrie and Paul Manship obtained key positions; later, lesser jobs would go to Zorach, Lachaise, and the young Noguchi. Nadelman was considered; nothing came of it. In 1925, he had been proposed for an important war memorial in Worcester, Massachusetts; this was awarded Maurice Sterne, primarily a painter. Nadelman, having married money and of independent temperament, hardly qualified as a deserving case. Skyscraper architects of the depression period handed out any available commissions as charity. They did not need work which might damage real-estate values. The destruction of Diego Rivera's large mural in the foyer of 30 Rockefeller Plaza was provoked partly by his deliberately Marxist polemics, but reaction against its vandalism warned future renting-agents to limit further adornment, if any, to anomalous abstraction. Nadelman was granted no aid under the Public Works Administration which Franklin Roosevelt supported as a make-work project until it was killed as boondoggling by Congress, although for two years (1935-36) some twenty water-colorists occupied the first floor of his Riverdale house, making careful renderings of objects in his American collection for the *Index of American Design*. For personal reasons this ended in friction. In 1935, Mayor Fiorello La Guardia tentatively accepted the Nadelman Museum of Folk Arts for the City of New York. There was some hope of maintaining its integrity, but due to the depression's effect on city budgets nothing happened; holdings were let go piecemeal. The fieldstone fireproof building erected to house the collection was sold and put to other use. In 1937, Nadelman wrote to a friend who sent condolences over the end of the folk-art collections: "The dismantling of the Museum did also dismantle something in me." A final request to the Carnegie Corporation for funds to open the collections to the public had been refused. The Whitney Museum and the Museum of Modern Art assumed he was in no need, and his shyness and refusal to show in group exhibitions did little to encourage further interest. It was generally assumed the Nadelmans still had means, but actually they maintained themselves entirely from the sale of folk-art plus the rent from a Manhattan garage Mrs. Nadelman salvaged from her

first husband's estate. Nadelman at first solicited portrait commissions; when these did not come quickly, he made little further effort. Apart from early work given to Brooklyn, no New York museum possessed a piece. At first it was assumed he didn't need money; later, he was ignored; naturally he grew embittered.

Through the architectural firm of Walker & Gillette, he obtained two sizeable commissions for public sculptures, both extant. The first was a stone clock supported by idealized construction workers over an entrance to the Fuller Building, 57th Street at Madison Avenue. The second was an heroic bronze "Aquarius" for the Bank of the Manhattan Company (now Chase Manhattan), Wall Street. For his attenuated laborers on the Fuller Building [149], completed in 1934, he had first made a model in his mature "late" manner [148], in which soft ample forms of cherubic workmen echo late Roman copies of an original Hercules by Myron made five hundred years before. His sketch served more as a springboard for himself, pointing to later figurines, than as a means to convince A. Stewart Walker, for this sensitive architect was an old acquaintance who had commissioned family portraits and garden figures for clients ten years before. When the clock was cut in limestone (supervised but not carved by Nadelman), there were clear echoes from the marble "Meleager" by Skopas in Dresden, and the Lansdowne House "Hercules," a presumed original from the fourth century, B. C., now in J. Paul Getty's museum at Malibu. As executed, the Fuller Building clock seemed characteristic of an earlier Nadelman. The two supporting workmen are mannered dandies; the skyscrapers which frame them are finically indicated; the ensemble suggests an Empire mantel ornament enormously enlarged. It has a severe Napoleonic luxury.

The fine reclining "Aquarius" [151] was cast from clay modeled in three weeks. It might be taken for a reclining river-god, similar to Bernini's Piazza Navona fountain, imitating Roman statues of Nile and Tiber on Michelangelo's Campidoglio. It was the last time Nadelman drew from sixteenth century court art. The statue was set on a broad lintel over the portal of an important mercantile bank. Aquarius is a meteorological (rather than astrological) sign for the year's eleventh month, traditionally that of want and rain, appropriated since the Middle Ages as a symbol to indicate institutions where human needs are recognized and metal loans granted. Water fructifies parched fields. The sculptor was sent an engraved certificate showing Aquarius with his appurtenances. In nineteenth century America, bank buildings aped Greek temples. During boom years, after the First World War, precedent advanced in time and purchased the taste of the founders of modern finance. Around the corner from the Bank of the Manhattan Company, the Federal Reserve Bank paid its crushing homage to the rusticated fortress town-houses of the Riccardi, Strozzi, and Medici. Nadelman, as usual, borrowed from tradition; as before, it paid him back at a high rate of interest, but in his own coin. Particularly in Florence had

rules and norms been synthesized according to individual analyses of exhumed antiques. Proportion, internal balance, external rhythm inherent in actual gross anatomy were subordinated to "idealized" or conceptual canons. These did not deny nature, but imposed metrics on it, quasi-scientific yet licensing very personal rendering. They accommodated structure to preconceived norms, the forms of which seemed, then as now, ab- or super-normal. These served to intensify expressionist exaggeration of optical facts. In mannerist art, proportions are warped from academic rules according to measure orchestrated by idiosyncrasy. Mannerism mixed a sort of science with reckless fantasy, virtuosity with caprice.

Three decades before, in Paris, extreme stylization in Nadelman's analytical drawings proposed standing nudes which were identified at once as mannerist echoes. [36-37] Art-historical studies of the precise aesthetic of mannerism as style in successive epochs tend to dissolve into semantics. Whatever can be adjudicated Grand Manner or High Style generally derives from *la maniera*, attached to the overwhelming authority of Michelangelo's titanic, indeed crippling, universality. Accurate definition in any given decade from 1560 on must filter through spectra of geography and taste. Modes changed from idolatry of *terribilità* to its balletic parody, from a reduction of giantism to a repudiation of the rhetorical tenor of all post-Renaissance sculpture as languishing "in the confines of an odious manner."[60] Sinuous impersonations at various removes of elegance – artificial, epicene; approaching hysteria or satanism; displaying a dislocation of psychic emphasis; extravagant, yet strictly formalized – have been, over four centuries, welcomed, rejected, and highly prized for being advance-guard, retardative, sophisticated, repulsive and, more recently, surreal.

European mannerism was developed by self-exiled wanderers who, in enforced or ambitious dispersal, spread their amalgam of classic models and Michelangelesque vibrations from Florence through France, the Low Countries and Germany. A native Fleming, Giovanni da Bologna, became a Tuscan master. Florentine painters celebrated François Premier's triumph at Fontainebleau. Mannerist artists raised themselves to an intellectual elite by insistence on professional virtuosity, by the assumption of an aristocracy of craft, which endowed them with new social independence since they were enthusiastically employed by competitive princes to enhance cultural and political prestige. It is not hard to place Nadelman at the end of such a line.

Mannerist sculptors proliferated *bronzes d'ameublement*, magnificent table-ornaments reminiscent of open-air civic statuary from ancient Rome or recent Florence. These seemed triggered by volatile or neurotic temperaments; were derived increasingly less from nature and more from earlier art drained of religious conviction. Intense energy, muscular and cerebral, spent itself incarnating fever-dreams of unwonted heroics, reflecting the turmoil and frustration of day-to-day living up to and

through the Counter-Reformation. The unimaginable had indeed happened; Rome was sacked in 1527. The papacy, central authority, heir to imperial dominance and unity, was on a threshold of interminable decline. Highly conservative, dispersed communities were garrisoned in provincial courts where they consoled themselves among other gauds and baubles with portable souvenirs of a golden age. Modern Rome was a disaster: Ancient Rome could be revived. Artists offered patterns of elaborate contrivance prompted by metaphysical anxiety and personal desperation; madness and suicide were the fate of many of the most talented. Deformation, dislocation, transmutation of given elements helped artists attempt their unique stylistic salvation. Elegance, erudition, subtlety, virtuosity replaced pretensions to sincere pathos. Operating in an interstitial society, artists might read anarchy as aesthetic freedom in which, on whatever reduced scale, the imagination, at least, enjoyed its flagrant liberty.

Nadelman's early standing nudes [36-37, 161], still unfamiliar as a fairly large group (although increasingly higher priced at auction), exhibit themselves in their suave, faintly insolent, sensuous ostentation. They refer more to art than to male or female impersonation, but the factor of self-display (of image, not artist) runs through much of his work. Exaggerated according to his curvilinear formulae, the small figures are studiously modeled, supremely casual, highly finished in their marriage of excessive formalism and unashamed preciosity. But when he came to work on his huge "Aquarius," though the style is similar, he wrought something grander than an exercise, bolder than professional solution to a necessary commission. This majestic statue has a Jove-like mask of faunish or cynical paternalism – recalling the visage of Thadée Natanson [83] whose beard and brow had served him for something of an archetype. The statue's bushy profile recurs in many previous drawings for men in top-hats. A lavish surround of cattails, cress, and moss cushions his tense sprawl. Water flooding strongly from an ample jar, which bears sharp scoring from a potter's wheel, flows in its strong pyramid of linear rhythms. The god's foot dabbles lightly in the massive stream of mineral opulence.

Around the same time, he modeled a bold American eagle in "Federal" style to support a flagpole for the First National Bank at Broadway and Wall. Similarly expert, but on a domestic scale, were a pair of delicately hooved deer [56-57] for gateposts on Myron Taylor's Long Island estate, their clay models executed breathlessly in two days. Like Giovanni da Bologna, he delighted in garden-sculpture. Animals intended for outdoors were conceived with accurate naturalism in an economical elegance of fur or feathers. Such ornaments as well as others in marble, nudes and dancers, were done for merchant princes by a princely artist. [122, 146] It was the last sigh of that aristocratic patronage which had been born in Tuscany four centuries before. Later, banks would acquire works of art, but personal involvement by in-

dividual patrons with chosen artists would largely lapse into collective purchase from gallery dealers on the recommendation of museum curators.

There was some desultory correspondence concerning a competition for an enormous monument to Christopher Columbus in San Salvador, in which, finally, he did not compete. There exist ideas for an Abraham Lincoln with an elaborate "Federal" pedestal studded with stars, unprompted by any patron. Among his papers are notions for practical inventions, tools, appliances which he may have hoped to patent. Such relics hold their sadness: great potentials stillborn as dreams; magical practical solutions which, at one throw, might solve every pressure of daily survival.[61]

Starting about 1930, Nadelman kept a large kiln to experiment with ceramics. Few pieces survive without flaws. [163] He worked in glazed and unglazed firings, colored and blank, but never mastered the delicate processes. He seems increasingly to have become interested in the possibility of larger editions of small sculpture. He studied the old process of papier mâché, by which coarse paper from wood or linen pulps is macerated, impregnated with glue, and pressed in plastic moulds. He made dozens of figures by this method; some he covered with gesso which tended to crack and buckle; others were coated with tempera, oil, or metal paint. Most were left gray and untreated. It is impossible to judge whether these are unfinished or abandoned. He showed none.

In 1935 he lost both kiln and large coach-house studio. All remaining works, including early plaster models from his years in Paris, finished and unfinished marbles, painted bronzes, *galvano-plastiques*, wooden and terra cotta pieces, were shoved summarily into cellar or attic. [215] In this move much was lost. The attic was at least dry, but the damp cellar ruined the original patination of Rudier's fine bronzes. It was a severe wound, unhealed by further withdrawal.

As a poverty-stricken provincial aspirant, Nadelman had nourished himself on ambition. His images of insouciant godlings in arrogant health, independent of human need, sprang from the secret protest in a poor dandy's erudition. Corroborated by traditions of apostolic authority, he boasted in silence of unrecognized genius. By energetic pretension he played the courtier to become a prince. At first he merely impersonated what he would indeed be. His early mask melted into a matured expression. It was a veritable metamorphosis that later reversed itself. Silence reclaimed him. His mask froze; his energies were short-circuited. From now on, Nadelman abandoned any semblance of appearing as a practicing sculptor. Few entering his home for his next dozen years would have suspected it housed an artist. There was no framed sketch or photograph hung; he buried his past. As a result, many fine drawings were attacked by mold; paint on wood flaked its gesso; polished marble lost its satiny sheen; bronze corroded. [50, 64, 158] It took more than ten years

233

following his death to restore what was left to something approaching his intention; conservation or completion has by no means been finished.

Work he did from now on would be chiefly in plaster. [172-173] There were some dozen fine small marble figures of standing or seated nudes; forms were full, the mood elegiac – but few were completely achieved. Nothing more was carved in wood or cast in bronze. His energy went into clay images of the human body, seldom over twelve inches tall [186-187], meticulously modeled, expertly cast in white plaster from immaculately crisp moulds of which all components still exist. Few have bases; it is impossible to know how they were to be supported. Since many are unfinished on their backs, he may have wished to have them held by pins against plaques. It is logical to suppose he would have ultimately fired them in terra cotta. Fifteen years earlier he had portraits cast in rosy baked earth by H. Aimée Voorhees and her sister, Mrs. Marie Le Prince, at their Inwood Potteries in the park near his home. After his death, bronze casts were made of some of the finest for Nelson Rockefeller, chosen by René d'Harnoncourt. Experiments in terra cotta were also made by Mrs. Le Prince, and later in Japan. Editions were small due to lack of technicians. Defeating Nadelman's express purpose, his figures now could only be sold as luxury products.

Nadelman's extant unused moulds, of which there must be some hundred, are in themselves masterpieces of exquisite fitness, their parts locking with jewellers' finesse. These were prompted by museum models and original fragments which he kept on his workbench from Tanagra, Myrina, Tarentum, Priene, Athens, Alexandria. The antique figures were fired in factories; many moulds have been recovered. Bodies were composed by assemblage of individual parts for head, leg, arm, determined and modified by many makers. Details were delicately defined for dress, flower, shell, wings, hair and ornament. Powdery color, even light gilding was laid on top of a cream, pink, or white base, then deftly wiped away to reveal the form beneath, which still seems to hold warmth from the kiln, delicious in texture as fresh baked bread. [160, 192] Figures deriving from identical moulds resulted in quite different statuettes. Instead of being entirely mechanical reproduction, this was a means for mass-producing a multiple repertory of diverting objects. They showed genre scenes, children's games, knuckle-bones, pick-a-back forfeits, paired girls gossiping, athletes, masked actors, mimes, dancers, winged victories (nikai), cupids, and love-gods (erotes). Their specific purposes remain obscure. They may have served the entombed dead either as memories for eternal domesticity, or as votive offerings for some cult of Aphrodite. They were surely used as modest house ornaments. In any case, they propose themselves as general-purpose sculpture answering real needs, with their various functions from toys to household gods satisfying buyers perhaps more than their makers. Such had been baked since before the sixth century B. C., but Nadelman, ignoring archaic types, was most attracted to those made from about the third century B. C. to the

second A. D. He particularly cherished those in the Boston Museum of Fine Arts (superbly re-installed, 1968), of which he kept many photographs. Here was a complete family of twenty-eight *erotes*, all from one tomb yet each different, all composed from but eight parts. Nadelman never employed multiple units; each of his own figures was complete in its single-piece mould, although there were some twenty types, members of the same family. Later antiques, coming from Myrina in Asia Minor near Pergamon, found in graves around 1880, are more elaborate than Tanagra figurines. Their scale is larger, posture more exaggerated, often to the brink of caricature. There are few periods in the range of Western art where there is so much feverish vitality, such shifts of novelty in mass production. Not only was demand widespread, but supply was of superior craft and quality. Hopefully, Nadelman equated such conditions with his own time.

Calling his precedents "Hellenistic" is perhaps misleading. The term refers to the epoch between Alexander the Great's death and Augustus Caesar's accession. The treasure of three centuries is not monolithic; "Hellenistic" cannot imply the scope of late Greek sculpture. Nineteenth century critics, reinforced by ancient opinion, considered it the Grecian climax. Present taste differs, but this is a reaction from white plaster casts, prompted by comprehensive archeology and ethnology. However, Alexandrian sculpture itself was still nourished by the firm classic tradition. After Alexander's Asian conquests a lively Greek art was transformed by Italian hands. On Pompeian walls are adaptations of Greek murals; in Roman marbles we recover Greek bronzes and carving. This art is not "decadent," and remains Greek rather than Hellenic or Near-Eastern.

Nadelman was finally more influenced by Lysippos, Alexander's official sculptor, than by either Pheidias or Praxiteles. Basing his work on the Polykleitan canon, which he modified, as well as on earlier masters, Lysippos released Greek plasticity into baroque virtuosity. Alexander was the prototype, the boy god-king, born of a witch, a famous horse-tamer at twelve, pupil of Aristotle, enemy of Demosthenes, who inspired athletic images which appeared as fresh theophanies of Apollo Victor incarnating reserves of cool self-awareness with the moral and military superiority of Greek civilization. Nadelman shared Alexander's taste through its more intimate reduction. On his workbench, among fragments from Asia Minor, Attica, and Italy, was a black basalt-ware Wedgwood reproduction of a boy wrestling a goose (after Boëthos), the (Roman) original of which he might have seen in Munich's Glyptothek. This infant agonist, carefully coifed, is a parody of the professional hero. Thus Prince Alexander in provincial Macedon strangled serpents and slew tribal enemies in early preparation for his Persian conquest. Nadelman also modeled, carved, and cast a number of female figures based on the "*Spinario*," a bronze youth pulling a thorn from his sole. This anti-heroic, insignificant act might be taken merely as genre like

235

the goose-boy. But the Spine Puller is no peasant, but well-born, which we may deduce from his curls. Groomed, hair carefully set, his unshod foot has been pierced by unsuspected peril in his path. Highly civilized men, even Greekish Romans, must still allow for harsh nature's cruel hazard. Alexander, the human god, is dead in his prime. The "*Spinario*" was a warning and apotropaic offering.

Nadelman's projection, comment on, or use of early archetypes is not easily decoded. [203] Certainly he wished to provide cheap, small-scaled, handsome sculpture, mass-produced for apartment-house units, but his aesthetics are complex. In a formal sense they recapitulate all he had learned or loved about fashion, texture, volume, gesture, ornament. These works of minuscule magnificence superficially seem little more than witty or sophisticated palimpsests on venerable models. However, a residual humanity has suffered a sea-change into something rich but extremely strange. Nadelman always preferred assertively simple or heavily matured styles suggesting absolute innocence or the overblown. His final figures attach to a world that has lost any purity, and are heavy with the ripeness of fruit left to rot or wither. They read as cult-manikins for a faith whose prime impulse is forgotten, but whose exhausted rites persist more even as habit than as superstition. First seen, they seem delectable miniatures, but when warm in the hand, ranked in progression, mutation after mutation towards deliquescence, more ominous elements appear. Whatever their size in scale and volume, they are masterful, indications of ornament spryly tactful, redolent of subliminal luxury. [201] The professional slouch of footlit queens is again emphatic, burlesquing adult imperial pretension. But now they have slunk into *femmes-bébés*, naughty heiresses of ducal households, petulant embryos in a line which links Mae West and Cléo de Mérode to Messalina or Salome. They are not provocative, but pornocratic – souvenirs from provinces ruled by enthroned whores. They seem drugged, sleepwalking coyly through musky limelight, their preposterous drag applauded by inaudible leering applause, indifferent competitors in a dwarves' beauty contest rigged by morticians.

Entering his abandoned studio in the early winter of 1947 where dozens of these small white corpses were laid out was as if one had stumbled upon an archeological treasure, relics of hecatomb or mass sacrifice. [213] No single pair of hands could have been responsible, rather some eunuch clan that had inherited secrets of abandoned practice. This haul seemed to derive from a collective rather than an individual source. Here was the phosphorescent flowering of a lapsed code one sensed but could not decipher. The figures are fastidiously, hypnotically fearful. Nadelman despaired. One day a plain diary of his despair may be edited from his baby-parade of pert, ambiguous waifs. Sexuality is mute, but its strong residual enigma teases easy answers.

In a talent as powerful as Nadelman's, the sexual element can hardly be ignored.

236

His models were overwhelmingly feminine, yet one vainly searches for any assertion of the erotic. Even in his legacy of informal sketches, there is little approaching that playful obscenity so often found in the doodles of artists preoccupied with the nude. His art was never confessional; normally, it was the insistent demonstration of depersonalized ideals. But suggestions shadow his later years, hinting at a transformation in his metaphysic. Towards the end, in plaster he points to private, deeply personal undertones. It is easy to collate his aims with the progress of Greek art from the fourth and third century before Christ to the second and third after. However, observers who ignore various aspects of late Greek sculpture and verse, who often in judging them lump Elgin marbles with Vatican copies of Skopas and Praxiteles, or read Euripides as if he were a contemporary of Seneca, also ignore that ambivalence in archetypes which Nadelman echoed.

Dionysos, Eros, Hermes, Hermaphroditos and Narkissos attach to the same tribe. The inheritance of the hermaphrodite is tricky. Nadelman's final statement is inextricably involved with precedents that were the ancient embodiment of such notions. One might dismiss his final proliferation of *erotes* as mindless or mechanical, except that everything else from his head or hand was consciously contrived, and there is no decline in quality from first work to last. His final plasters are neither simply decorative nor accidental. At the risk of shouldering his shade with concepts nowhere enunciated by him (except in the sculpture itself), one can only plead that to him they can hardly have been alien. Nadelman's insistence on these symbols elucidates what may seem insoluble in his ultimate work, which is saturated with the enigma of Narkissos and the androgyne. The mannerist, the neo-classicist are twin personalities inhabiting one imagination. Mario Praz's absorbing essay on Johann Joachim Winckelmann[62] covers many facets of neo-classic philosophy, which is now again interesting historians, long immersed in a romantic reaction against it which has persisted down through contemporary expressionism. He writes:

> In Hellenistic art, Winckelmann found the confirmation of his fixation upon the hermaphrodite; the Greeks had represented ideal beauty "taking it partly from the natural figures of beautiful youths, partly from the soft forms of beautiful eunuchs, so sublimated in the structure of the whole body as to have a superhuman quality"; the figure, in order to be beautiful, must be undefined, must not express any emotion which, by destroying its unity, would cloud its beauty; hence the ancients took their inspiration from persons "the greenness of whose age had been maintained for a longer period by the removal of the spermatic vessels, as with the priests of Cybele and Diana of Ephesus; since in them the soft convexity of both sexes comes to be united." [70-71]

"Unity," "Harmony," and "Beauty" re-echo through Nadelman's notes. These terms have little general significance now; in reference to modern sculpture they are

237

almost meaningless. The eighteenth century concept of classicism governing artists from Canova to Nadelman was defined by Winckelmann:

> It can be said of beauty, as of water drawn from a spring, that the less taste it has . . . the more devoid it is of all extraneous matter, the more healthful it is esteemed.
>
> It was in youth, more than in the features of virile maturity, that the artists found the sources of beauty, that is unity, variety and harmony, as youthful forms . . . resemble the surface of the sea which, seen from a distance, seems quiet and smooth as a mirror, although in fact it is always in movement . . . A beautiful youthful figure seems smooth, even and uniform, and yet a thousand changes are taking place in it at the same time.
>
> The part that beauty plays both in expression and in action, in other words the beauty of these two occurrences, when added to the figure of this or that person, is like the image of someone reflected in a pool, which does not appear – not clearly at least – except when the surface of the water is motionless, limpid and quiet . . .

Mario Praz suggests that the figure of Narkissos gazing in a mirror pool at his own reflection is a metaphor for many palimpsests. [154-155] He quotes Paul Valéry's compact, complex *Fragments du Narcisse* in which is expressed a longing for that perfection enshrined in the "vertiginous calm of water," that equilibrated vertigo canonized by Winckelmann as a motionless passion for the unattainable in the self as well as in the exterior universe.

> Just as Plato sought the type beyond the appearances, so Winckelmann sought in marble the serene fount of beauty: there must be bodily forms that were exalted above sex and above matter, forms that were quintessential. And these forms, snatched, as it were, from the limbs of the statues, exquisitely indefinite and resulting from subtle selections, the arrival-point of profound metaphysical meditations on beauty and on the perfect line, were no more than those which Winckelmann's innate sensibility carried within itself – Winckelmann, that ambiguous Narcissus reflected in an astonished mirror of clear waters.

In the first century after Christ, the elder Pliny wrote: "Formerly, hermaphrodites were thought horrible; today, they seem only figures of fun." Hermaphroditos was the mythical child of Hermes and Aphrodite; brother to Eros and Anteros. As Marie Delcourt writes in her subtle survey *Hermaphrodite*, androgyny is at the twin poles of all things sacred. Pure concept, it is the abstract union of male and female, the supreme expression of human potential. However, to early votaries of Hermaphroditos, this notion incarnate in the flesh of new-born babies was monstrous. Infants cursed with double sex were exposed or burned. In Hesiod's *Works and Days*, gifts from Hermes and Aphrodite were malevolent and unlucky; their patronage also extended to Pandora, who released evil on the world. In time, the cult became domesticated; increasing popularity divested it of the god's formerly maleficent androgyny. Hermaphroditos, in whose single body male and female organs combined, became protector

238

of marriages and, specifically, of sexual intercourse. There had been confusion from the start between the figurations of Priapos, a garden-god who insured fertility in barns and fields, and those of Hermaphroditos, who blessed happy unions. Bisexuality developed an iconography in vase-painting and sculpture, which did not demonstrate increased powers due to doubled sex, but the contrary. Hermaphrodites were considered deprived; they became asexual. Ovid pictures them not as fertile, but as impotent. Hermaphroditos was no longer an angel, but a eunuch.

Ovid's *Metamorphoses*, the magical lectionary of divine shapes and types transformed, tells how Hermaphroditos leapt into a mirror-pool to escape a nymph who consumed him with love. In the pond they became one. Many desired Narkissos; yet he was so self-absorbed none but his own self was real to him. His nymph was Echo; she only spoke by repeating his last word. Hence he was always corroborated, although such penumbral dialogue grew more and more self-centered. He saw he starved himself adoring his own image, his self's shadow, alter-ego, daemon, genius. It was a fraud. He must free himself from his own form. "Spellbound, transfixed, a statue carved in Parian marble": What should I do: woo, or be wooed? What I desire is my all: mine, mine. My plenty makes me poor. I kindle fire I must endure. Quench it; shatter my mirror. Drown.

Gertrude Stein and Meyer Schapiro sensed in Nadelman a chill perfectionism, a tyrannous idealism which, instructed by Freud's categories, we term narcissistic. The perilous ambivalence of self-love; loneliness in voyeurs; emotional distrust in self-absorbed artists, are problems for metaphysicians as much or more than for psychiatrists. With Nadelman, who revealed so little of himself on the surface, whose private personality seems as impenetrably reflective as the stony skins he polished, such ambivalence or arrested development poses puzzles which his final figures may solve. Was Nadelman only a self-conscious artist, or a soul attempting to probe consciousness in a self?

Greek sculpture, from the archaic to its decline, shows comparatively little differentiation in male and female characteristics. Some students feel that the male body was the basis for most plastic representation; female breasts or buttocks were additive. It was as if Greece obeyed a firm absolute in which sexual polarity was always fused in a single figure. At peak periods, the heroicized male dominated. While loving gods were anatomized from Homer through Ovid, it is hard to imagine bodies from the Parthenon pediment pleasuring themselves in bed. Herein is surpassing majesty, but their remote descendants, reduced to miniature, were metamorphically altered. The types of Tanagra, Myrina, Alexandria which most moved Nadelman are anti-heroic, intimately provocative, tending towards the grotesque. Superhuman constructs of chryselephantine splendor and divine proportion shrink to rococo baked-earth homunculi.

Nadelman loved women; by them he was vastly admired. In his youth he had adored particular girls; towards the end of his life he was frequently enthusiastic about some marvelous "kid" he had just met. Usually, to his wife's amusement, these were ladies over fifty, but he persisted in seeing himself as a Great Lover, and flattered outrageously. Male bodies interested him less; the male nude scarcely at all. He left unfinished a single almost full-sized marble youth. But his women were either muses or dolls; except in a few portraits, rarely individuals. In his innumerable late nudes, there is little overt sensuality, unlike the physicality of Clodion or Rodin. With him, desire passed into passion for whatever material, stone, wood, plaster, clay, or metal, his hands caressed. His last plasters fulfill such fondling. While these creatures are indecisively aged, they seem rooted in fixed immaturity, however ripe their forms. At the end, they become hebephrenic, reverting precipitately towards the embryonic. Not all are infantile; some are regal virgins. Lingering ambivalence is disquietingly sly. Negation of sex is positive; fubbed erotics mock lurking echoes of the fuller-blooded passions when divine appetite stirred storms over Olympos. These earthlings are from a Satyricon:

> Mark my words, we're in for bad times if some man or god doesn't have a heart and take pity ... Who observes the fast days any more, who cares a rap for Jupiter? One and all, bold as brass, they sit there pretending to pray, but cocking their eyes on the chances and counting up their cash ... Well, that's why the gods have stuffed their ears, because we've gotten unreligious ...[63]

Once the Olympians were a holy family; they've become vestigial, neither innocent nor malevolent; neutral, possibly admonitory. Such declension is metaphor for dissolution. If deliquescence holds its own decadent energy, Nadelman's worldlings generate supranormal power. They've learned to exist, monstrously, in what interstices of gaiety are left, adaptive to disaster, current or imminent. Luxurious hints of ornament vaunt small defiance. Personal vanity still unfurls its slim pennon. Unnecessary, wilful, mindless, they guard their pint of pride, or even, possibly, courage. [194-196] They vaguely echo happier health, but a lolling assertion of baby-fat promises some future, however sick. Forms which at first appear amusing, nostalgic, or elegiac assume more sinister aspects as one hermit worker's soliloquy on modern morality.

Nadelman's grand race of plasters could fill no shrine of sea-born Aphrodite, amorous, fertile or maternal. The androgynes and cupids of Alexandria float in optimistic airs, disdaining mortality. The hope intrinsic in Western humanism collapses into an erudite pun. Any faith that rational mind through divine aid might impose order on anarchy is abandoned. Naked adult maleness castrates itself. Stuffed on drugged candy or sacred mushrooms, idiot infants retain adipose tissue with dignity. They will never blossom into kindly Hermes or Dionysos. Incisive fables based on con-

vinced pessimism are neither huge nor heroic. Tragedy, through purgation, resolves itself as benevolent absolution. Domestic horror is less easily absolved. Nadelman's scores of humanoids are playthings to comfort victims of historical fever. [204-205] In their tight dimension and shy lewd wealth, they exude a rankling pathos which their promiscuity denies.

Once there was art: fixed, an absolute. It filled superior needs, surpassing vague images of how ordinary mortals imagined gods. Once there was a craftsman who thought he learned secrets of this lapsed craft. As a student, he proved it: his obvious gifts were acknowledged. Godlike in youth, his genius carved idols. But the gods died; now, even their ghosts paled. Divinity was dubious, along with gifts formerly presumed divine. One's nervous muscular productivity can't compete with omniscience, nor one's busy mind with mortality.

Nadelman worked industriously in his studio. He lectured on Tolstoy's *War and Peace*, which he discussed with total recall after forty years. He recited extended passages from Pushkin and Lermontov; he sang old Polish and Russian songs. He was impatient with early critics of the United Nations; Americans did not understand the nature of time; nothing good happens quickly. He underscored a much-thumbed Pascal:

> 67. *The vanity of knowledge.* In time of affliction, knowledge of external matters will never console me for my ignorance of morality, but my knowledge of behavior will ever comfort me for my ignorance of external information.
>
> 148. We are so presumptuous that we wish to be known by the whole world, and even by those to come when we are gone; and we are so vain that we are both amused and satisfied by the fair opinion of five or six people we happen to know.

He wrote himself notes in Polish, French, English:

> *Assez de dilettantisme; l'art n'est pas un amusement. L'art est une verité qui s'appuie sur les éléments du monde exterieur, comme sur les émotions du coeur humain.*

In 1939 when the Museum of Modern Art was organizing an exhibition for the World's Fair at Flushing Meadows, Alfred H. Barr, Jr., then director, requested Nadelman to lend his *"Femme Assise"* as an important modernist work. He refused; this museum had never troubled to acquire anything of his. In 1944 the Whitney Museum planned a show of "Pioneers of Modern Art: 1908-1918" and wished to exhibit several pieces. He refused; but he had been devoted to Gertrude Whitney and indicated that he soon planned to break his silence.[64]

This last period must be read against a sombre background, a growing need for surgery; preoccupation with a second world war. In February, 1942, he enrolled in the Riverdale Air Warden Service; in spite of a bad heart which he never mentioned, he

241

took late night or early morning watches and kept punctilious records. In 1944 he appealed to careless members of his unit to put nightly duty ahead of social engagements. He was officially thanked for his efforts. He volunteered for instruction in occupational therapy at the Bronx Veterans' Hospital, Gun Hill Road, where he provided ceramic materials, firing the kiln himself. He was particularly useful to those who were wounded and suffered shock affecting their hands, aiding in some notable cures. If the men were disheartened by their new awkwardness and clumsy fingers, he surreptitiously completed their models, pretending it was their own work. After his death the manager of the Bronx Veterans' Hospital wrote his wife, thanking her for her husband's contributions of time and materials for which he had paid:

> In bringing his highly developed skill in sculpture and ceramics to the disabled boys, twice weekly for two years, he brought much beauty and inspiration to their lives. His bright enthusiastic personality did much to combat their suffering and fatigue.

While he had not been able to see much of his son, now twenty-one and in the army, since the boy had been at school and Princeton, he followed his military adventures with passionate interest. Among his few letters are those to Staff Sergeant Jan Nadelman. In one he wrote:

> As I watch these events unfold around me, my very old regret comes again to my mind: why did I not participate in the making of these events? I would have loved so much the joy of working with others, *shoulder to shoulder*. This I always greatly wanted, but never had the opportunity to experience. My work was always a single-handed job. I always had to stand alone and manage to muster the constant fortitude which such a condition requires. Frankly, Jan, it is too difficult and it is not conducive to easy-going happiness. This is not a complaint; I accept my life fully. What I wish to say is, that I do not wish a life like this for you. But to work successfully with others one must have a long and early training for it. I wish to say that I thank God daily that you have a full measure of such a training.
>
> I am now for two weeks on Jury Duty,[65] but I wish that they would send me on some war duty somewhere in Europe so that I could join you.
>
> As I am writing you the snow on the old leaking roof and the icicles all around are dripping and melting away with such fury, that it seems the old house is melting away too. Or is it just Nature's spring cleaning before her annual exhibition of violets and sunshine? Be that as it may, I still love your saying, in one of your recent letters, that at heart you are a city-dweller. Well, Jan, that goes for me too, all the way! Give me the wide open spaces of the city any time!

On September 24, 1944, he wrote words to his son which may serve as a valedictory, although he did live on for two years:

> Stretch my imagination as I might to figure where and how you are these days, it still remains a vague guess only. But I hope you have safely reached Europe.

Europe is my continent; it is the place where I was born, lived my youth, was inspired to dream my dreams of achievement; and it is the land that was good to me and helped me to achieve my first success. It is in a real sense my closest friend.

This friend, this friendly land, I beg to be good to you, as you enter it; to help and protect you as it helped and protected me when I was your age. This I beg her in all my prayers, and I have a strong feeling that she won't fail me.

Be, dearest Jan, of good cheer and good hope.

Your devoted
POP

In his electrifying "autobiography of western man"[66] Eugen Rosenstock-Huessy, defining the concept of "Europe," speaks of the nineteenth as "the Grecianizing century" (as the eighteenth and seventeenth had been Romanizers):

A loving arm stretched back from the West to the East, a grateful echo of the former hegemony of Greece – this is the attitude of the Occident when it calls itself "Europe."

Nadelman was a child of nineteenth century "Europe"; his early thought was fixed by Warsaw, Munich, Paris, largely by German formulations of classical art and society. So in his peroration to Europa, although a patriotic New Yorker, he saw himself as heir of European culture linking old worlds and new, his own art cross-fertilized like that of modern Paris or ancient Alexandria. He had seen culture cracked by two onslaughts. He might claim his son a conqueror, but he would not number himself among victors or survivors. He had transmitted what he could. Always there was consolation from Marcus Aurelius.

It is possible to exist on earth as you intend to exist in heaven. But, if this is not permitted, then quit the house of life; though not with any sense of ill-use. "My hut smokes; I move." No need to make a great fuss of it. Nevertheless, as long as nothing obliges me to leave, here I stay, my own master, and none shall stop me from doing what I wish, – and what I wish is to live the life that nature demands for a rational member of society.[67]

In his little community of Alderbrook in Riverdale-on-Hudson, few any longer placed him as anyone so special as a sculptor. Older inhabitants recalled a decade before when there were evidences of his handiwork. Now nothing betrayed the secret that he was daily modeling in a small studio attached almost apologetically to the rear of his rambling old house which was shedding its Victorian crotchets from crumbling roof and gable. In his small world, Mr. Nadelman was simply known as a retired gentleman with European courtesies and an ironic formality which reminded one friend of a character out of some novel by his great compatriot Joseph Conrad, who specialized in types of humanity characterized by their metaphysical mystery. His

thick curly hair had gone steel-gray, his commanding countenance was now a trace granitic with wrinkles around his eyes less from age than from staring hard at the world and his work. Far-sighted, he wore glasses at his bench. Of medium stature, he gave the impression of height and maintained an athletic presence. Summers he wore heavy white linen shirts and pants; in winter brown corduroys and a leather wind-breaker. He often kept pyjamas on under his street-clothes; shoes went habitually unlaced. Venturing into Manhattan perhaps twice a month, half an hour away, he dressed meticulously in Brooks Brothers' serge, white silk shirt, purple tie, carefully shined boots, to play bridge for low stakes at the Cavendish Club, which he had joined twenty years before. Here he played with, and in the class of, Lenz and Culbertson, masters of their time. He loved to walk; swam with his son at Etretat, canoed on Lake George. He was most sympathetic when his boy had problems at Princeton – the girls and drink of the Jazz Age. He was vastly amused by the capers of Mayor Jimmy Walker as well as W. C. Fields. The most pejorative word he used was "false"; his anonymity was distinguished by his lively elegance, his temperate courtesy and protective banter. "To be not remarkable" was George Brummel's definition of The Dandy. He puttered in his garden, shaded by a stupendous primeval copper beech, already old when Hendrik Hudson had cast anchor in the broad river at the shore of property both Dutch patroons and he had once owned. He was expert in transplant-ing bushes and cultivating grass and borders; winters, he skated. He overfed the family's monumental mouser. Hating to write even his few letters, he pressed any-one handy to take dictation (usually his wife). He loved films, especially those showing overmastering feminine ambitions, Barbara Stanwyck's for example, and took sand-wiches and fruit along which helped his running commentary. A gourmet, he had also a vast capacity for varieties of delicatessen, believing everything combined well enough. He read John Marquand's novels with pleasure. He liked young people, was helpful to them; the more around the house the better. Few older people came by, except perhaps once a month Al Frueh, whose caricatures of theatrical personages in *The New Yorker* amused him. He subscribed to *The National Geographic*, belonged to no museums, never visiting exhibitions or galleries. Distinguished, impersonal, court-ly, he appeared as a pleasant gentleman in retirement. If he hid his *métier*, at least he made a nice neighbor.

Ultimately, in gauging Nadelman's "success," "failure," or "genius," we must dis-tinguish between his early attraction to heroic Greek prototypes and to their later Alexandrian domestications which prompted his last labor. What started as natural individuality in Athens ended as abstract if forbidding stereotypes in Rome. Starting in Paris, Nadelman became less attached to stylization than to his own efforts to de-duce underlying skeletal structures which could be used as method. What first absorbed him was the idea of universal law governing a harmonics of volume rather

than any imitation of fifth or fourth century originals. His individual portraits became increasingly generalized. The intensely personal heads of Alexandrian, Republican, or early Imperial epochs had been transformed, due to the accelerating crisis in a dissolving empire, from the third century A. D. on more and more into fierce ikons intended to present a unifying imperial authority. Images of majesty were imposed from a pyramidal peak [28], since such a legible mask of unitary power might contain magic useful in salvaging the eroding political system. Facial characteristics were suppressed or moulded into one official face of *divina maiestas*. As H. P. L'Orange writes in a penetrating study:[68]

> Man's image is formed according to suggestive formulas of expression, which are associated with something higher and more essential than the individual himself. One may compare the stereotype character-masks of the antique theater, which "depict" the role played by the actor, and at the same time conceal the actor's personal features. We see men, not as lifelike individuals but in the role they play upon the stage of eternity. One's thoughts go to the late antique priests of the Eleusinian mysteries who, upon entering their office, gave up their names...
>
> In the classical period, beauty is defined as proportionality: a proportionality which can be expressed in measures and numbers and thus is based upon the proportions of the human body [Polykleitos' Canon]. This ideal of beauty applies to all fields of classical art, in sculpture as well as in architecture. A completely new aesthetic was developed in the third century: beauty does not reside in the proportions of the body, but in the soul which penetrates and illuminates it, that is, in expression [the *Enneads*[69] of Plotinus]. Beauty is a function of the inner being...

Nadelman's preoccupation was always – as he claimed – abstraction, not simply reduction to essentials, but a reconstruction of epitomes. [17] His idiosyncratic abstraction was ultimately less occupied with formal aesthetics than with metaphysics. On technical levels he methodically analyzed and described form and volume, eliminating irrelevancies in moving towards irreducible archetypes. Having only generalized formal faith, he nevertheless kept traditional morality. Ancient legends might have slid into modern lies, but reconstituted, re-revealed, they might also secrete numinous exemplars if vividly translated. Hence in early work he provided reminders of canons of physical beauty, largely lost but still divine, contrasting them with their most immediate stylization in contemporary civil dress. At the end, he sloughed off transient modernity to distill in small doses a domestic godhead. [206-207] This philosophical urgency compacted in figurines may prove his most magnetic monument. Art which he long insisted depended entirely on plasticity may finally be judged as service to superhuman needs. In his time, the last shreds of traditional creeds dissolved. His whole *oeuvre* might be read as a gloss on so vast a dissolution. Compare Nadelman's last figures to those holy reminders still on sale at any Christmas or Easter.

If his contain any qualitative superiority, it is not due to his technical "genius" alone.

The era of Alexander the Great and its succession (336-146 B. C.), in whose forms Nadelman found his final most powerful precedents, saw a fantastic efflorescence both of near-Eastern mystery religions and oriental cults alien to Graeco-Roman orthodoxy, together with cynic, stoic, or epicurean philosophies which either denied the existence of gods or deemed them unoccupied with the destinies of men. The world had lost its first youth. Civilization would collapse from strain in overextension. Byzantium, a Christianized Second Rome, succeeded Alexander and the Caesars, but was anarchic. Constantine Cavafy's poem, incredibly apposite today, pictures the citizens of Alexandria as at first fearing the barbarians. When these moved off leaving their city unsacked, edgy and bored, they found little left to occupy them. They were not amused and rather disappointed. Mystery cults incubated vague fright; central confidence drained. Nothing might be changed or hoped for, only endured. Alexander's heirs were stoics; no gods to turn to, man was left alone. As for concepts of love, *Eros* was primarily an Alexandrian ideal, embodying notions of romantic affection as a replacement for primeval lust. [204] In Athens once an athlete, Eros in Alexandria is transformed to a pretty cherub, still an archer, but a mere echo of winged victor, his arrows now invisible darts.

However, among the mass of middle-class householders, fixed for us in Juvenal or Martial, few were complete skeptics. Most preferred to honor semi-sacred figures in whose niches resided relics of superstition or comforting faith. Small baked-clay divinities refined memories of immortals once imagined under Pheidias or Praxiteles, recalling a less chaotic epoch. The eschatology that terrified Rome, Athens, Ephesus, Antioch, Alexandria, that in its very fragmentation became the seed bed for a new catholicity based on signs for The Child, contained parallels to the meditations of one neo-classic, Judeo-Christian who, late in 1946, approached the end of his term.

Nadelman's early marble heads were big in scale. Then chance diminished the need for large statuary and Nadelman became increasingly occupied with mastering the diminutive in miniatures. The Child is a small man; its potential is not shrunk by smallness; it can be salvaged as heroic by realization of appropriate proportion. In an odd tale Hawthorne tells of a craftsman whose passion is perfection:

> The beautiful idea has no relation to size, and may be as perfectly developed in a space too minute for any but microscopic investigation as within the ample verge that is measured by the arc of the rainbow. But, at all events, this characteristic minuteness in his objects and accomplishments made the world even more incapable than it might otherwise have been of appreciating [his] genius.[70]

A proliferation of androgynous infants or child-gods in Nadelman's last years leaves an unfinished story. It is possible that one day these images, as planned, may be

produced in quantity. Advanced development in synthetic materials over the last twenty-five years has resulted in surfaces in color much superior to the first unappetizing plastics. Until then, these figures may simply be considered as curiosities of quality, echoing historic culture or symbology, or as tense final testimony to one artist's "genius." Viewed as bipeds, infantile or adolescent, they are inhuman; at the least, cupids or *erotes*, kin, however distant, to Homer's ageless Olympians who neither withered nor died. The name *Eros* means demanding or needing – love. What is the nature of these creatures who long to be loved?

Heraclitos said: "Time is a lad at draughts who moves pieces across his board; dominion belongs to the child." In many cultures child god-kings are abandoned foundlings who miraculously survive nocturnal menace, enemies and fear. The Cretan Zeus-child, who became all-father to Greeks and Romans was fed by swarms of bees, butterflies, or angels. Psyche, the soul, was seen as a butterfly. The theophany of the god-child was also revealed by Dionysos, Hermes, Hermaphroditos; later, Adonis, Narkissos, Antinous; last of all, Jesus.

As C. G. Jung wrote,[71] there is tense equilibrium in symbols of new-born babes on the brink of life, in their contrast to souls trembling at the edge of death, in symbols of disappearance or reappearance, death or rebirth. Strongest heroes are born from weakest embryos. Mortality leads towards divinity and eternal life; great art, incarnate in skillfully wrought forms, is metaphor for that relative immortality even humans can handle. Babes are beginnings in whom futures are contained. Child-gods were invoked as saviors, mediators, healers, redeemers, combining starts with finishes, marrying opposites. Jung defines them as unifiers, partial ones who make wholes, potent symbols for the Self. Nadelman's child-figures may be read as variously differentiated psyches, expressing in their individual stance or attitude aspects of self-consciousness. Fated to survive natural and supernatural disaster, at birth the babe is already half-divine. But its superhuman potential always contains humane elements, for it is never divorced from the common run of individuated, matured, or corrupted adult selves. The single ordinary self, considered in the light of all selves existing in our universe, may be "smaller than small"; but as a reflection in minuscule complexity of the vaster microcosm, it is "bigger than big." Hence the child-god embodies and encompasses age and youth, great and small, male and female, humanity and divinity. It is unifier of opposites in capacious psychic wholeness. Eros-Cupid with his phallic torch aflame lights processions not only to marriages on earth but to judgement below it. Divine youths appeared frequently on Attic gravestones. In Alexandrian art, a boy clad in a cloak with a pointed hood was cast in that role which Latins personified as *genius cucullatus*, a child in limbo, neither alive nor dead. [198] His peaked covering cape made him invisible to mortal eyes, an infantile preceptor, shadow of Hermes Psychopompos, guide of ghosts to Hades.

Graeco-Roman houses kept shrines honoring family gods. The *lar familiaris* was a fertile field-spirit; it dwelt in small house-front niches, graced by fruit and flowers. *Penates* guarded larders and store-rooms. Master and slave shared household rites before hearth-altars, whose well-kept fires were relit each New Year's morn. While Jupiter All-Father reigned somewhere cloudwards, angelic cherubs kept closer comfort. If gods were gone, a sacred potency in childhood might still be credited. In Nadelman's day, two thousand years later, there was similar shrinkage. It was his presumption to provide private deities for modern houses. Perhaps now it appeared to him that other art – ornament, portrait, grand figures of men and beasts – was vain. Necessary images testified, not to nation, tribe, or clan, but to precious family units, their perils or possibilities.

Apart from *lares* and *penates*, Romans believed in man's *genius* or tutelary spirit, a reflection of his inherited self, his psychic twin or double. Plato termed this a *daemon*, or intermediary conscience between god and man; Marcus Aurelius, who meditated on endurance rather than hope, believed that God gives us each our special guiding *daemon*. This appeared later as the angel-guardian of each Christian gentleman. At first, this shade only protected members of a family or clan (*gens*). It was their *genius* which was honored when men received honors. This did not exactly imply divine origin nor guarantee immortality, yet it indicated continuity in personal and familial survival. Later, *genius* came to infer special gifts or talent, personification of immaterial quality. A *genius loci* was resident protector of a site; *genius cucullatus*, a hooded cupid, represented both the soul of a departed person and its immortal guide.

Figures embodying such androgynous infants, which were the entire subject-matter of Nadelman's last labor, traditionally combine primitive and sophisticated symbols. Early, babies represented undifferentiated matter in a vague zone of promise, holding prospects of fruitful multiplicity. Later, anticipating millennial crises when chiliast terror gripped Rome, splitting a thousand years of civilization, during all the time the exhausted world-empire was menaced by energetic barbarians and revolutionary slaves, the Child as ideal persisted with the gnostics well into Catholic mysticism. In the medieval demi-science of alchemy, the Divine Child represented marriage of intellect and instinct; consciousness and unconsciousness. The former is masculine, the latter, feminine; they unite under the sign for Self. In the ant-heap town where Rome, Greece and near-East fused, in whose kilns were fired figures prompting Nadelman's minuscule apocalypse, Clement of Alexandria spoke of that moment when "the twain shall be one, outer as inner; male with female, neither male nor female." Child-gods represent preconscious nature as well as man conscious of his history. [205] The instinctual focus of early childhood leads to apprehensions of spirit by which *erotes* and *genii*, servants, playmates, and playthings of the Divine Messenger, conduct us through mortality towards eternal adventure.

Belonging to this huge incorporeal family were also *keres*, winged souls. Hermes Psychopompos, judge and guide, evokes as well as revokes these souls. Nightmare, blindness, madness spring from animalcules, bacilli, fluttering insectile, disease-bearing essences, wicked cousins to butterflies or angels. Gradually in antiquity, the concept of *ker* narrows to one magnet: mortality. Each man keeps his *ker* within, which nurtures the destiny upon which his life depends. In art, the winged *ker* is also Eros and Hypnos; love, then sleep or death. Eros quit the herm-form, returning it to Hermes, Hermaphroditos and Priapos. Love, the egg- or germ-born cosmic shape or force assumed the body of winged Fate; later – Fury. Finally, when the gods had decided to die, it became a plump baby-gladiator **[194]**, an idle impish cupid, a child strangling a goose. Nadelman kept such relics by his bench. The goose-boy was probably a votive offering for a child's recovery from danger or illness.

In industrial society, values atrophy to a level in which much sensation seems similar. Events telecast from interplanetary space are tolerated but seldom felt. Capacities for sentiment, indeed for sensibility, shrink. Stimulants scarcely inebriate; in a true sense, they drug, are an-aesthetic. Before dissolution populations dream in a dolls' limbo, awaiting in negative innocence whatever fate's naughty fingers may have in store. Nadelman was sixty-four at his death. Marcus Aurelius, who died at fifty-nine, had said life was more like wrestling than dancing. A new year approached for Nadelman, and with it the twenty-seventh anniversary of his marriage. He endured vicious acceleration of pain in body and mind. Stoicism was hardly a palliative. The ancient stoics had no interest in art; firm cultivation of the stiff upper lip was not conducive to creativity.

> Greek art ended in a blind alley limited by its own philosophy. If we would understand the passing of the Greeks, we must remember among other things, the implications of the fact that they had many gods and no theology.[72]

Marcus Aurelius spoke also of physical pain: if it lasts, it can be borne. If it is past bearing, it makes an end of us. As for metaphysical suffering, demonism and the demonic are deep brands of twentieth century art. Nadelman long resisted their anarchic power, commencing with his immoderate passion for formal purity. Acceptance of the inchoate was sin. Salvation lay in wholeness alone. By virtue of historicity and metric he managed significant sculpture which, in the end, subsided into the demonic, since he was also, inescapably, a "modern" artist. His career can be read in orderly chapters, each terminated by a stylistic solution, less progression than anthology; more choices to or from which he turned by a logic of caprice. Towards the last, when loneliness and suffering reduced sensitivity to that gulf where neither imagination nor morality operates, he pursued a compulsive proliferation in elaborately adorned statuettes with *"the finical elaboration of a ghostly syntax."*[73] It served

as substitute for contact with detestable reality. Elegance is maintained. Fastidious formality ritualizes despair into an idiom of courtly finesse, whose identical tone can be read in the ultimate correspondence of Hölderlin, Nietzsche, Nijinsky. Form eradicates matter. Nadelman commenced by trying to penetrate universal and unifying secrets encompassing the structure of a rational order, and ended defeated by human weakness, unable to encompass totality. Such was his greed. Research led to more facts and objects. Such did not spell wisdom, except at last in the knowledge that his hands could hold no more.

Although he rarely discussed sculpture with his wife, a week before his death he told her he considered he had accomplished what he had intended. The day before he died, a young student of sculpture, unknown, unannounced, nameless, rang his bell, asking for photographs which he'd only seen in a lost book. None had been taken in some years; old ones were found. Nadelman talked uninterruptedly for two hours, later complaining of exhaustion. His body hurt, anticipating surgery. Cavafy's poem on an emperor's exit is called "Footsteps." It also describes another artist's home:

> . . . in the alabaster hall enclosing
> the ancient shrine . . .
> how restive are his Lares.
> The small household gods tremble
> and they try to hide their insignificant bodies.
> For they heard a sinister clamor . . .
> one little god falls over the other
> for they understand what sort of clamor this is,
> by now they already know the Furies' footsteps.[74]

During the days immediately preceding his death, December 28, 1946, he modeled a sequence of small plasteline figures culminating in hooded infants. Among scraps torn from newspapers was an advertisement for plastic rain-capes. On the blank heads and dwindling members of these last wan plasters are penciled vaguer and vaguer indications of smiles; then no smiles. [198] His private *genius cucullatus* summoned a fading self. A storm-cloak protected his corporal presence from the unknown; the phallic cowl pointed towards posthumous commencements or continuations.

POSTSCRIPT

Imagination is like the sun, whose light is not tangible, but which can set fire to a house. Imagination leads the life of man. If he thinks of fire, he is set on fire; if he thinks of war, he wages war. All depends only on the will of man to be the sun; that is – entirely what he wishes to be.

<div align="right">PARACELSUS</div>

Nadelman's mercurial career and ambivalent renown may be scanned as an arc of talent and taste, bracketing the curve of a self and gift, impressed upon the practice of plastic art in his epoch. For two-thirds of our century, influential artists repudiated figural re-presentation as reflected through ordinary retinal response. An "objective" subject-matter depicting, by means of digital mastery, phenomena capable of being corroborated by more than one pair of eyes, had been for two millenia the aim of pictorial craft. Now art divested itself of its former attachment to a primarily imitative, illustrative, narrative or didactic function. Art abandoned metaphorical service. Isolated components, formerly esteemed as scaffolds for a structure, were now promoted as autonymous programs through novel devices. A structuring of fragments became dominant. Variations of "expressionist" style and "expressionism" as a philosophy, backed by promiscuous nomenclature, subsumed most schools. Fractional idioms were elevated to rank as schematic autonomies. Careers were projected based more on facets of personality than on actual residual content. Progressive careerists, nominated as martyrs by themselves, their dealers, collectors and annotators, established a loose anthology of presumedly authoritative styles. A repertory of their self-licensed innovations came to be labeled as hierarchic "schools" or "movements."

Careless if energetic improvisation paid off for a time as galloping invention, termed "creativity." Disjunct mannerisms or stylizations, each a journalistic novelty at the outset, soon exhausted veins which were seldom rich. Rationales of fragmentation attached to timely romantic notions of chaos or apocalypse led to productions that battened on abrupt turns, shifts and reversals. In all this, neurasthenia was accredited as a compassionate aesthetic norm, and self-pity, under several signatures of vested interest, replaced metaphysic. The agonies of the latest heirs of romanticism, more than their residual artifacts, were proposed as redeemers or intercessors for the salvage of sensibility. Organized hysteria was conducted by teams of toughs who abdicated or retired in favor of fresh gangs accelerating profitable confusion. Each new game grabbed at its own self-assigned trophies for transient markets. A semi-permanent cannibalizing advance-guard promoted eternal progress and negotiable security. Thus means became ends.

The self-fondling products of foundered conditioning, bundled into stencils of fashionable commodity, replaced the "classical" tradition. Pictorial presentation and

<div align="right">251</div>

re-presentation had, for longer than man can remember, made men and beasts the most memorable figural resonances of historical, scientific or religious necessity. However, memorable images made between 1909 and 1969, whether abstracted or concretized, still retained legible symbolic reference beyond the self-satisfaction of mannerists. As our century weathered its climacteric, quality in handwork withered. Paris was early exhausted; little came from the ruins of the rest of Europe. Fashion substituted for vision, proving again, if proof were needed, that mass-taste is capricious, ill-founded, and to be adroitly manipulated. But laws of eternal return operate, like weather, in their retributive constancies.

Nadelman's epiphany glowed in a transitional era, which some have taken as an age of gold and others of scrap-iron. He, among many others, started by reconsidering the roots of plasticity to formulate his tools. These developed as means, not ends. His volumetric surveys were inventive in their dispassionate exercise, and served his own unpredictable future, as well as those of artists more famous than he. Expressionism became for some a licensing of psychic disquiet and personal agonism. By extension, idiosyncratic despair at cosmic or human conditions under one dispensation or another developed by and large into a catch-all for externalizing sentiment or sentimentality. To these usages, he was never a party. As man and maker, he was aware both of suffering humanity and personal adversity. His purview was too sober to proclaim his destiny as a solitary or unique sufferer. His own pretensions were on a superior plane of simple service. He was not seduced, even at his most schematic, into abandoning a dialectic which fused a cool perfection of rendering with the mysterious perspectives of order. He did not espouse clumsiness as a crusade, naivety as innocence, nor did he purvey private despair as public grief. He rejected blight or benefit of vernacular distress in method or subject-matter, finding dreary inconsequences uninteresting or unworthy of his own clearly recognized psychic and historical limitations.

A maker whom Nadelman much admired, one who might aptly have portrayed his archetype of agonist and exile, was a compatriot tragedian, the novelist Josep Konrad Korzeniovski, whose precise and elegant ambiguities vibrate in the stoic climate of lyric realism. The sculptor's technical aplomb and social conscience did not permit the dissipation of his powers in self-pity. Those who chided him for marrying wealth and abdicating forthwith knew nothing of his commencement or final years, both of which were rooted in either abject poverty or anxious subsistence. His pride, as with Joseph Conrad's ironic tragedians, transformed peradventure into a harder substance than stone, and more enduring. In Conrad's *Heart of Darkness*, a testament for the times, is found chapter and verse of Nadelman's personal fate:

> Destiny. My destiny! Droll thing life is – that mysterious arrangement of merciless logic for a futile purpose. The most you can hope from it is some knowledge of yourself

– that comes too late – a crop of unextinguishable regrets. I have wrestled with death. It is the most unexciting contest you can imagine. It takes place in an impalpable grayness, with nothing underfoot, with nothing around, without spectators, without clamour, without glory, without the great desire of victory, without the great fear of defeat, in a sickly atmosphere of tepid skepticism, without much belief in your own right, and still less in that of your adversary. If such is the form of ultimate wisdom, then life is a greater riddle than some of us think it to be.

Nadelman's father named his seventh child Elie, another spelling of Elijah, Elias or Eli. This name, by historic or poetic coincidence, can be conceived as a curious paradigm. The great experimenter Theophrastus Bombastus von Hohenheim (1493?-1541) called himself Philip Aureolus Paracelsus, since he believed he surpassed Celsus, the Roman master-physician. Paracelsus came to be known as "the Luther of Medicine." He was a close companion of the historical Johannes Faustus. He burned canonical texts of Galen and Avicenna, insisting on close observation and radical experiment. From him, through the descent of ideas, extraordinary concepts have long been appropriated, not alone in scholastic philosophy but into everyday common sense.

Paracelsus claimed as his familiar, throughout his life and labors, the biblical Elias, who he believed had neither died in flesh nor spirit, but who had survived through centuries, subsisting on the shewbread of Pythagoras, the neo-Platonists and the Kabbala. Currently he was fed off still another neo-Platonic revival, following Luther's Protestant revolution. Paracelsus was convinced that *Elias Artista* guided him in alchemical exercises as mentor of his morality and monitor of his imagination. Elias the divine artificer was seen by no one but his adept, and the experiments conducted under his auspices were more concerned with a metaphysic of a superior order than with the far simpler alchemy of turning base metal into gold.

Elias Artista was an Hebraic archetype in the line of Enoch and Noah who explored extreme dimensions of earth and heaven. He was, according to Paracelsus and his tradition, present and available when terrestrial or celestial last-judgement seemed nigh. Elias Artist stood by him, like his diluvian forbear, forty days as midwife to magic. Through his patronage, Paracelsus like Faust, his stepson, manufactured *homunculi*. These were tiny replicas of men, hand-fashioned from air alone, without sex or weight. But – and this was their virtue – they might give birth to mandragora, *les mains de gloire*, miraculous handsized, five-membered man-shaped roots which shrieked when torn from the earth, but which, if handled with love, paid seekers, finders and keepers with twice whatever they might win thereafter. Mandragora, the forked-root White Bryony, was also folk-medicine. The mandrake plant, broached in rose-water and red wine, cured bloodshot eyes and strengthened sight and inner vision. It was double-sexed, which in spagyric art intends the active principle.

253

According to the inheritance which Paracelsus revived and acted on, *Elias Artista* preceded *Elias Propheta*, or rather a later prophet was re-incarnate in an earlier master-craftsman. Primordial Elijah, the Man in the Fiery Chariot, was a solar demiurge, linking earth and heaven in aspects of supernal harmony. His labor was prayer; his artifact, metaphysic. His spirit still partakes of the mindful active Will which fixes continents within limits, balances oceans by mountains, keeps species to kinship – restricting flood and supervising chaos. When this essence operates, caravans rest, beasts sleep and men dream. When the regenerative imagination is moved to memorable utterance, it speaks through Elias's prophetic lips. This speech, often art or science, is a bridge-maker over elements, a pontifex hidden from many eyes, but under one name – Elias, Elijah, Eli – poet, prince and prophet.

NOTES

1. See *Art Deco*, catalogue of an exhibition at the Minneapolis Institute of Arts, July-September, 1971; text by Bevis Hillier and David Ryan. Among paintings and drawings (items 741-810) are reproduced half a dozen designs affected as a whole or in part by Nadelman's curvilinear system. In designs for the Omega Workshops by Vanessa Bell, 1913-14, reproduced in *Apollo*, March 1970, p. 224, are further evidences of the appropriation of his principles. Other examples are in the drawings before 1914 of Henri Gaudier-Brzeska. See also *Style and Design: 1909-1929*, by Giulia Veronesi, New York, 1966, p. 230 ff. The influence of Modigliani, Brancusi and Picasso are frequently cited as sources for the new decorative style; that of Nadelman, never.

2. Hawthorne's *The Marble Faun* (1860), based closely on his *Italian Notebooks*, is a perfect preface for James's life of Story.

3. *William Wetmore Story and His Friends* (1903), while an onerous task for Henry James, is still the most searching study of an artist dislocated between America and Europe.

4. "Robert Gould Shaw Memorial," Boston Common; "Sherman," 5th Ave. at 59th St., and "Farragut," Madison Square, New York; "Diana," Philadelphia; "Adams Memorial," Washington; "Lincoln," Chicago and London.

Saint-Gaudens and the Gilded Era by Louise Hall Tharp (1969), poorly illustrated, is of slight aesthetic judgement.

5. Stravinsky's relations to Russian folklore, Claude Debussy and American ragtime are parallel to Nadelman's debt to Hellenistic sculpture, Rodin and folk-art. Stravinsky, writing of his neo-classic ballet *Apollon Musagète* (1928), echoed the sense of Nadelman's first "researches in form and volume." "*Apollon* was my first attempt to compose a large-scale work in which contrasts of volumes replace contrasts of instrumental colors."

6. *Reminiscences and Reflections*, by Max J. Friedländer, New York, 1969, p. 54.

7. For ikons of the Stroganov school (ca. 1550), six specialists painted a single ikon. The first shaved, sanded, and gessoed a pine panel. The second laid on a linear pattern of mandatory form and meaning. A third gilded gesso halo and ornaments. A fourth painted dress and architecture. A fifth finished trees, flowers, rocks – super-natural nature. The sixth and most skillful achieved the physiognomy, expressing divine ideals in humane figuration. Faces were never agonized; there were no profiles showing a single eye. Twin orbs magnetically and hypnotically focused the visible source of invisible, ineffable, transcendental wisdom (*Hagia Sophia*). Lips were shorn of fleshy fullness – thin, bloodless, vestigial, showing absence of sensual appetite. Consciously or unconsciously, Nadelman's earliest conceptual designs closely resemble this recipe.

8. *Letters of Thomas Mann: 1889-1955*, selected and translated by Richard and Clara Winston. London, 1970. Letter to Agnes E. Meyer, October 7, 1941. Volume I, p. 375.

9. Lachaise's letters, deposited in the Collection of American Literature, Yale University Library, show the extent of his interest in Nadelman's work. After seeing Lachaise's first one-man show, New York, 1918, at the Stefan Bourgeois Galleries, Nadelman exploded: "*Il m'a tout volé!*"

10. "Whispers of Immortality," from *Poems* by T. S. Eliot, London, 1920. This section of the poem continues:

> The couched Brazilian jaguar
> Compels the scampering marmoset
> With subtle effluence of cat;
> Grishkin has a maisonette;
>
> The sleek Brazilian jaguar
> Does not in its arboreal gloom
> Distil so rank a feline smell
> As Grishkin in a drawing-room.
>
> And even the Abstract Entities
> Circumambulate her charm;
> But our lot crawls between dry ribs
> To keep our metaphysics warm.

11. John Russell: *The New Statesman*, London, 18 July, 1969.

12. See *The Savage God*, by A. Alvarez, New York, 1972, for a survey of key artists whose sense of failure led to suicide.

13. *The Portable Nietzsche*, edited and translated by Walter Kaufmann, New York, 1954, pp. 682-3.

255

14. Mikhail Alexandrovitch Vrubl (1856-1910), an extremely original draftsman and painter, attached himself to what was liveliest in Russo-Byzantine tradition. His highly personal style developed with support from West European impressionist and divisionist color-theory, but also along lines of an intense semi-mystical vision, parallel to, if unconnected with, Gustave Moreau, Odilon Redon, the Nabis. Since he showed with the *Mir Iskoustvo* group in Petersburg even before 1900, and was already famous in Russia, it is possible that Polish art students could have seen his work. His extraordinary idiosyncratic systems of rendering form may well have impressed Nadelman. See *Vrubl*, no. 238, in the series, *I Maestri del Colore* by Alla Gusarova, Milan, 1966, as well as the excellent Soviet monograph by A. A. Fedorov-Davidoff, Moscow, 1968.

15. Julius Mordecai Pincas (1885-1930), calling himself, after 1904, Jules Pascin, was a Bulgarian of Sephardic origin. He directly affected Nadelman as a draftsman. While the latter's life-style was "high" and Pascin's "low," they shared spiritual affinities. Both were East Europeans with semi-oriental ideals of an Eternal Feminine. Nadelman was more Byzantine; Pascin, Levantine. With the sculptor, She breathed the air of temple, throne-room, salon, circus. With the painter She reclined in *bain-turc*, harem or bordello. Both shared admiration for great commentators on manners and fashion: Hogarth, Rowlandson, Gilray, Debucourt, Boilly, Gavarni, Daumier, Doré, and Constantin Guys. Both studied fashion-plates (as did Seurat).

16. Quoted by Jane Harrison in the first paragraph of her *Prolegomena to the Study of the Greek Religion*, Cambridge, England, 1903.

17. Adolf Furtwängler (1853-1907), archeologist, art-historian, excavated at Olympia and Aegina, developed and clarified distinctions between schools, analyzing individual contributions of Pheidias, Praxiteles, Myron, Polykleitos.

18. Rodin was in Florence, 1875, studying the Sacristy of San Lorenzo. He noted: "I have been making sketches in my room in the evenings, not of his [Michelangelo's] work, but of all the structures and systems which I devise in my imagination in order to understand him."

Nadelman's personal contact with Renoir (see p. 277) and Rodin is obscure. However, the following excerpt of a letter, printed in the general correspondence of Rainer Maria Rilke, who was briefly Rodin's secretary, is significant:

"Some three years ago, E. Nadelmann [*sic*] showed a torso in the Salon d'Automne to which Rodin paid particular attention. It was a good 'early' work, dominated by suggestion which derives from nature as profoundly felt. What he has done since, in my opinion, is at one remove from nature, rejecting naturalism in favor of a certain formalistic prepossession which soon enough will have obliterated any reference to the incalculable suggestibility of a natural wholeness. To do full justice to the world within the restricted idiom of an elementary planar language seems to me obstinately prejudiced; it is to interpose a factor which brings the work-of-art dangerously close to the artificial.

"I recalled what old Hokusai (who had become as wise as one can be only by being a painter) wrote to his publisher. 'Images of objects tend to become calligraphic figures; our task is always to keep them within the realm of the pictorial.' That kind of sculpture [Nadelman's] seems to me to be turning into calligraphy, a particularly idiosyncratic and formalized handwriting as a means of expressivity; – which contrasts demonstrably with the fact and intention of that *étude* [*recherche de forme*] of a few years ago."

From a letter to Edith von Bonin, May 9, 1910, in Rainer Maria Rilke, *Briefe aus den Jahren 1907 bis 1914*, Leipzig, 1933.

19. *L'Art Décoratif*, March, 1914; article on Nadelman by André Salmon; on Seurat by Lucie Cousturier.

20. *Le Phénomène de la Vision*, essays by David Sutter, 1880. See also "Seurat: Allegory and Image," by Leslie Katz, *Arts* (New York), April, 1958, pp. 40-47.

21. Also important for Seurat's determination of expression, both physiognomic and corporal, is David-Pierre Humbert de Superville: *Essai sur les Signes Inconditionels dans l'Art*, Leyden, 1827.

22. Drawings he considered most significant were announced for publication in a finely printed four page brochure, November, 1913. The portfolio was to have contained forty reproductions, preceded by a commentary, followed by an "epilogue." This appeared as *Vers l'Unité Plastique*, a portfolio of fifty-one unnumbered line cuts printed on heavy absorbent paper dimming the linear crispness of more delicate proofs on glazed paper laid down on thick stock. Using the same sheets, he issued a bound volume of thirty-two reproductions as *Vers la Beauté Plastique*, issued through E. Weyhe, New York, 1921.

23. Cézanne died October, 1906. The following year there was a large retrospective at the Salon d'Automne, first publicly demonstrating his vol-

umetric system. In this year, Picasso was composing his "Demoiselles d'Avignon."

24. In conversation with Judith Cladel.

25. The portrait of Natanson recalls both Rodin's head of Antonin Proust (ca. 1883), as well as the type of Antonine portrait-busts represented by several extant of Marcus Aurelius. See *Roman Imperial Art in Greece and Asia Minor*, by Cornelius C. Vermeule, Harvard, 1968, p. 227, *et seq.*; plate 147. Natanson, fearing Nadelman's 1909 exhibition *chez Druet* would "seem too exclusively abstract . . . too uniformly theoretical" commissioned his own portrait, completed in two sittings, and later cast in bronze. See *Peints à leur Tour*, Paris, 1948, p. 238.

In New York, during the 'Twenties and 'Thirties, Nadelman was considered an expert, determining true from forged Rodin drawings, and aiding in attribution for the Mastbaum donation to Philadelphia.

26. In the Salon d'Automne, 1905, he showed three drawings *en crayon*; in 1906, the bust of a young girl, now lost, with drawings of café- and street-scenes. In 1913, he'd become a *sociétaire* of Les Indépendants, showing a female nude and male "Adolescent."

In a masterly article on "Elie Nadelman's Early Heads (1905-1911)," by Athena T. Spear, in the Allen Memorial Art Museum *Bulletin*, Vol. XXVIII, No. 3, Spring 1971 (Oberlin College, Ohio), there is a complete listing (p. 204) of the available information about group exhibitions in which Nadelman exhibited up to the time of the first Druet show. Ms. Spear's analysis of the early "classic" heads is penetrating and conclusive.

27. *Art and Geometry*, by William M. Ivins, Jr., Cambridge, Mass., 1946, p. 32.

28. See *Les Vers Dorés de Pythagore*, edited by Fabre d'Olivet, Paris, 1813. Referring primarily to verbal metric, this contains Pythagorean fragments and a discussion of the sacred tetrad derived from Egypt: ". . . pure and immense symbol, source of nature, model of the gods."

29. "What I mean," said Socrates, "what the argument points to, is something straight or round, and the surfaces and solids which a lathe or carpenter's rule and square produces from the straight and round . . . Things of that sort are beautiful, not, like most things, in a relative sense; they are always beautiful in their very nature, and they offer pleasures peculiar to themselves, and quite unlike others. They have that purity which makes for truth. They are philosophical." From the "Philebus," translated by R. Hackworth, in *The Collected Dialogues of Plato Including the Letters*, London, 1963.

Ikonometry, as a substructure for metaphysical programs in plastic art, is shared by other cultures. Attributed to the Buddha Himself is a work which treats as divine revelation the inviolability of ikonometric rule. "The scheme is based on a vertical and a horizontal line, crossing at right angles, which act as a skeleton to build the figure on. The measuring unit is the middle finger, which corresponds to the 116th, 118th, 120th or 124th part of the height of the image; with very large figures this finger measure is replaced by another, the *tala*, equal to twelve or twelve-and-a-half finger breadths." From *Tibet: Land of Snows*, by Giuseppe Tucci, London, 1967, p. 103.

The Pythagorean tradition was kept alive through the Middle Ages. See *The Sketchbook of Villard de Honnecourt*, Indiana University, 1959. Plate 36 is a geometrical analysis of a head; plate 37 can be compared to Nadelman's analysis of his "Man in the Open Air" as an A or V (See p. 277). Pythagoras himself appears on a portal of Chartres cathedral, correcting a manuscript.

30. There were several small plaster versions. The largest and most developed was cast in bronze in New York, ca. 1925. It was exhibited at the Museum of Modern Art, New York, 1970, in the exhibition "Four Americans in Paris" (the collections of Gertrude Stein and her family). Praxiteles supposedly used Phryne, his mistress, as his model.

31. See *On Neoclassicism*, by Mario Praz, London, 1969; also *Neo-Classicism*, by Hugh Honour, London, 1968.

32. See Henry James's ineffectual warnings, ca. 1907, to Hendrik Andersen, a young American sculptor with "heroic" ambitions, then working in Rome. *The Treacherous Years*, Volume IV of Leon Edel's biography of James; New York, 1969, p. 307, *et seq.*

33. Alain: *Esquisses de l'Homme*. Quoted in *Greek Oracles*, by Robert Flacelière, London, 1965, p. 86.

34. From *Sacred Fortress: Byzantine Art and Statecraft in Ravenna*, by Otto G. von Simson, Chicago, 1948, p. viii.

35. Deposited in the Collection of American Literature, Beinecke Rare Book and Manuscript Library, Yale University, New Haven, Connecticut. Quoted by permission of the Library and of the Estate of Gertrude Stein.

36. Mercury-Hermes, god of roads and travelers, favored a broad-brimmed hat to keep off sun and rain. In Greece, the hatted Hermes in sculpture was known as the *Petassos* type, which was part of traditional iconography down through the eighteenth century. (See Jean-Baptiste Pigalle's "Mercury," 1744; Metropolitan Museum, New York.)

A version of the reclining nude with drapery in high relief is now in the collection of the Whitney Museum of American Art. This is a bronze cast probably taken from one of the decorations in Madame Rubinstein's billiard room.

37. Quoted from *Futurist Art and Theory: 1909-1915*, by Marianne W. Martin, Oxford, 1968. At the time of the theft of the Mona Lisa from the Louvre, which aroused the press against museum policy, and in which Guillaume Apollinaire was dubiously implicated, the poet at one of Paul Fort's readings at the Closerie des Lilas, declared his sympathy with Marinetti. "All museums should be destroyed because they paralyze the imagination." The Paris in which Nadelman moved is vividly adumbrated in *Apollinaire: Poet among Painters*, by Francis Steegmuller, New York, 1963; also in *Childhood and Youth: 1891-1917*, Volume I of *Men, Years – Life*, by Ilya Ehrenburg, London, 1962.

38. See *Modern Artists on Art*, edited by Robert L. Herbert, Englewood Cliffs, New Jersey, 1965, p. 55.

39. "The first modern works that Modigliani must have seen and studied, those of Nadelman, Lehmbruck, and Brancusi . . ." From *Modigliani*, by Claude Roy, New York, 1958, p. 43.

40. See *Modigliani Drawings and Sketches*, by Franco Russoli, London, 1969, for comparison with Nadelman's drawings: plates facing p. vi, 19-22.

41. *Baudelaire: The Artist and His World*, by Robert Kopp, Geneva, 1969, p. 115.

"Schinkel (the great neo-classic architect of Berlin's museums, commenting on a collection which would form the basis for Prussian State collections) observed: 'Canova, coming from the sculptures of the Parthenon, expressed the following opinion under the effect of the art of van Eyck: "Every step taken further from the art of Raphael is a step down; on the foundation of van Eyck, however, there is an infinite structure to be erected." ' So speaks a classicist." From *Reminiscences and Reflections*, by Max J. Friedländer, New York, 1969, p. 26.

42. Paintings in the caves of Font de Gaume were uncovered beginning about 1901 by Abbé Henri Breuil. Engraved rock pictures and murals of the Dordogne confirmed valid dating of pre-historic art, in doubt since the discovery of Altamira in Spain, 1879. Nadelman kept post cards of the painted bisons at Les Eyzies.

43. *The Complete Poems of Cavafy*, translated and with notes by Rae Dalven; introduction by W. H. Auden; New York, 1961, p. 33.

Winston Guest, the most famous American polo-player of his generation, owned the first cast of two horses by Nadelman, the first and larger of which, bought by Madame Rubinstein in London, remained in plaster until the sale of her collections after her death.

A direct source of Nadelman's horses is the drawing by Jules Pascin (p. 40 of the 1920 reprint of the original de luxe 1910 edition) for *Aus den Memoiren des Herrn von Schnabelewopski* by Heinrich Heine. Included in this particular drawing is the profile of a jockey, the stance and silhouette of which Nadelman would recall when he came to carve his wooden figures. The linear quality, style of costume and the generalization in Pascin's forms in the Heine illustrations had a strong influence on Nadelman from 1914 through 1919.

44. For a fine study of problems involving marble portrait busts, see *Four Portrait Busts by Francesco Laurana*, photographs by Clarence Kennedy; essay by Ruth Kennedy; Northampton, Mass., 1962.

45. See *Florine Stettheimer: A Life in Art*, by Parker Tyler, New York, 1963.

46. See *Love Days* (with other writings, reissued), by Henrie Waste, New York, 1951.

47. In the winter of 1917-18, John Singer Sargent, the portraitist, was staying with James Deering, a childhood friend, at Villa Vizcaya: "It combines Venice and Frascati and Aranjuez, and all that one is likely never to see again." It is now superbly restored, serving as the Dade County Museum.

48. *The Education of Henry Adams*, Boston, 1918, p. 442.

49. *Dolls*, by John Noble, New York, 1967. See also *Dolls and Dollmakers*, by Mary Hillier, London, 1968.

50. Helleu was also a designer and muralist (vault of Grand Central Station), and partly responsible for revivals of Directory and Empire taste in fashion and house-furnishing which Nadelman preferred as his own décor.

51. When the Nadelmans lost their fortune, Brummer bought back antique marbles, later owned by Jacob Hirsch, now in Swiss national collections.

52. Nadelman's finest medieval forged iron was the dragon door-studs, now attached to doors of the Treasury at The Cloisters.

53. Nadelman was pleased to accept a commission to carve the figure-head of a private yacht. It is not known if he executed it.

54. Albert Weisgerber's portrait of Pascin with his derby (1906), in the Stadtisches von der Heydt Museum, Wupertal, is frontispiece to Gaston Diehl's monograph on Pascin; New York, 1969.

55. Nadelman made drawings from photographs of the vaudeville star, Eva Tanguay, whose theme-song, "I Don't Care," echoed through the 'Twenties.

56. *Bombes-funèbres* is a pun on *pompes-funèbres*, funeral ceremonies.

Some of Nadelman's pencil, pen-and-ink sketches and photographs, including nineteenth century *carte de visite* photographs of dancers and burlesque queens, are deposited in the Dance Collection, Library and Museum of the Performing Arts, Lincoln Center, New York City.

57. No poet, but the Comte de Salvandy, at a fête given by the Duc d'Orléans for the King of Naples, not far from Vesuvius, on the eve of insurrection, 1830.

58. See *The American Doll Artist*, by Helen Bullard, New York, 1965.

59. *Le Peintre de la Vie Moderne*, ix (the study of Constantin Guys), by Baudelaire.

60. See *Italian Mannerism*, by Giuliano Briganti, London, 1962, p. 14, *et seq*.

61. Nadelman was not the first impoverished sculptor who hoped to save himself through the U. S. Patent Office. Dr. William Rimmer experimented with automatic-rifle design.

62. See *On Neoclassicism* by Mario Praz, London, 1969, pp. 40-69.

63. *Satyricon*, by Petronius Arbiter, translated by William Arrowsmith, Ann Arbor, 1959.

64. For the first exhibition of American art sent to the Soviet Union after the Second World War, sponsored by the United States Department of State, a polished marble head by Nadelman (1922) was reproduced on the cover of the Russian-language catalogue.

65. Nadelman often served on New York Supreme Court juries, and was pleased to have helped poor claimants in insurance cases against large companies and their clever lawyers.

66. See *Out of Revolution*, by Eugen Rosenstock-Huessy, New York, 1938, p. 139, *et seq*.

67. *Meditations* of Marcus Aurelius Antoninus; Book v, 29. An excellent recent edition, translated and with an extended introduction by Maxwell Staniforth, is available as a Penguin paperback (1964).

68. See *Art Forms and Civic Life in the Late Roman Empire*, by H. P. L'Orange, Princeton, 1965, p. 25.

69. One of six divisions in Porphyry's collection of texts by Plotinus. Each contained nine books, a neo-platonic mystical category. For interesting parallels to Nadelman's general concepts see the analysis of Plotinus in *A History of Western Philosophy*, by Bertrand Russell, New York, 1967, p. 286, from which comes this quotation.

70. "The Artist of The Beautiful," from *Mosses From an Old Manse*, 1844, by Nathaniel Hawthorne.

71. See *Essays on a Science of Mythology: The Myth of the Divine Child and the Mysteries of Eleusis*, by C. G. Jung and C. Kerényi, New York, 1949.

72. See *Art and Geometry*, by William M. Ivins, Jr., Cambridge, Mass., 1946, p. 57.

73. See *Art and Anarchy*, by Edgar Wind, New York, 1969 (paperback), p. 182. This whole book in its facts and philosophy supports the author's claims for Nadelman.

74. *The Complete Poems of Cavafy* (see note 43), p. 15. Inspired by Suetonius, *Life of Nero*, XLVI.

REFERENCES

GENERAL CULTURAL HISTORY

Henry Adams. *The Education of Henry Adams*. Boston, 1918.
A. W. H. Adkins. *From the Many to the One: Human Nature in Greek Society*. London, 1970.
W. H. Auden (ed.). *The Portable Greek Reader*. New York, 1948.
Ernst Benz. *The Eastern Orthodox Church*. New York, 1963.
Peter Burke. *The Renaissance Sense of the Past*. London, 1969.
Ilya Ehrenburg. *Childhood and Youth: 1891-1917*. London, 1962.
David Hackett Fischer. *Historians' Fallacies*. New York, 1969.
Ernest H. Hutten. *The Origins of Science*. London, 1962.
Ruth Kennedy. *The Idea of Originality in the Italian Renaissance*. Northampton, Mass., 1938.
Eugen Rosenstock-Huessy. *Out of Revolution*. New York, 1938.

AESTHETICS AND PHILOSOPHY

Marcus Aurelius Antoninus. *Meditations*. Maxwell Staniforth (ed. & trans.). London, 1964.
Gérard de Chapeaux, Dom Sébastien Sterckx (eds.). *Introduction au Monde des Symboles*. Paris, 1966.
Jean Chevalier, Alain Gheerbrant. *Dictionnaire des Symboles*. Paris, 1969.
J. E. Cirlot (ed.). *A Dictionary of Symbols*. London, 1962.
Adolf von Hildebrand. *The Problem of Form in Painting and Sculpture*. New York, 1907.
William M. Ivins, Jr. *Art and Geometry*. Cambridge, Mass., 1946.
Jolande Jacobi. *Complex | Archetype | Symbol*. New York, 1959.
Carl Gustav Jung (ed.). *Man and His Symbols*. New York, 1964.
Hervé Masson. *Dictionnaire Initiatique*. Paris, 1970.
Gervase Mathew. *Byzantine Aesthetics*. New York, 1964.
Friedrich Nietzsche. *The Portable Nietzsche*. Walter Kaufmann (ed.). New York, 1954.
Richard A. Norris, Jr. *God & World in Early Christian Theology*. New York, 1965.
Blaise Pascal. *Pensées*. M. Brunschvicg (ed.). Paris, 1904.
Pythagoras. *Les Vers Dorés de Pythagore*. Fabre d'Olivet (ed. & trans.). Paris, 1813.
Arthur E. Waite (ed.). *The Hermetic and Alchemical Writings of Paracelsus*. London, 1894.

ARCHEOLOGY AND TECHNIQUES

Theodore Bowie (ed.). *The Sketchbook of Villard de Honnecourt*. Bloomington, Indiana, 1959.
James D. Breckenridge. *Likeness: A Conceptual History of Ancient Portraiture*. Evanston, Illinois, 1969.
Stanley Casson. *Techniques of Early Greek Sculpture*. Oxford, 1933.
C. W. Ceram. *A Picture History of Archeology*. London, 1958.
E. Guimet. *Les Portraits de Antinoé au Musée Guimet*. Paris, 1912.
Henry Hodges. *Technology in the Ancient World*. London, 1970.
Massimo Pallotino. *The Meaning of Archeology*. New York, 1968.
Carl Roebuck (ed.). *The Muses at Work: Arts, Crafts & Professions in Ancient Greece and Rome*. Cambridge, Mass., 1969.

MYTHOLOGY

Edward E. Barthell, Jr. *Gods and Goddesses of Ancient Greece*. Coral Gables, Florida, 1971.
Norman O. Brown. *Hermes the Thief*. Madison, Wisconsin, 1947.

Marie Delcourt. *Hermaphrodite: Myths and Rites of the Bisexual Figure in Classical Antiquity*. London, 1961.

Robert Flacelière. *Greek Oracles*. London, 1965.

Jane Harrison. *Prolegomena to the Study of the Greek Religion*. Cambridge, England, 1903.

Carl Gustav Jung & C. Kerényi. *Essays on a Science of Mythology*. New York, 1949.

R. M. Ogilvie. *The Romans and Their Gods in the Age of Augustus*. London, 1969.

Hazel Palmer (ed.). *Greek Gods & Heroes*. Boston, 1962.

H. J. Rose. *A Handbook of Greek Mythology*. New York, 1958.

Karl Schefold. *Myth & Legend in Early Greek Art*. London, 1966.

Oskar Seyffert. *Dictionary of Classical Antiquities*. New York, 1956.

GREECE, MAGNA GRAECIA, ASIA MINOR

Paolo Enrico Arias. *Policleto*. Milan, 1964.

John Barron. *Greek Sculpture*. London and New York, 1965.

John Boardman. *Greek Art*. London, 1964.

Jean Charbonneaux. *Les Terres Cuites Grecques*. Paris, 1936.

Jean Charbonneaux. *Greek Bronzes*. London, 1962.

Jean Charbonneaux. *Grèce Hellenistique*. Paris, 1970.

Kurt Emmrich [Peter Bamm, pseud.]. *Alexander the Great*. New York, 1968.

Adolf Furtwängler. *Masterpieces of Greek Sculpture*. Chicago, 1964.

Christine Mitchell Havelock. *Hellenistic Art*. Greenwich, Connecticut, 1970.

Ernst Langlotz, Max Hirmer. *The Art of Magna Graecia*. London, 1965.

Reinhard Lullies, Max Hirmer. *Greek Sculpture*. London, 1960.

D. G. Mitten, S. F. Doeringer. *Master Bronzes from the Classical World*. Cambridge, Mass., 1967.

J. J. Pollitt (ed.). *The Art of Greece 1400-31 B. C. Sources & Documents*. Englewood Cliffs, New Jersey, 1965.

Marjorie and C. H. B. Quennell. *Everyday Things in Ancient Greece*. London, 1954.

Gisela Richter. *A Handbook of Greek Art*. London, 1969.

Charles Seltman. *Approach to Greek Art*. New York, 1960.

Cornelius Vermeule. *Polykleitos*. Boston, 1969.

Umberto Zanotti-Bianco. *Magna Graecia*. New York, 1967.

ROME

J. P. V. D. Balsdon. *Life and Leisure in Ancient Rome*. London, 1969.

Jerome Carcopino. *Daily Life in Ancient Rome*. New Haven, 1940.

F. R. Cowell. *Everyday Life in Ancient Rome*. London, 1961.

Donald Earl. *The Art of Augustus*. New York, 1968.

Paul Friedländer. *Documents of Dying Paganism*. Los Angeles, 1945.

Otto Kiefer. *Sexual Life in Ancient Rome*. London, 1934.

R. M. Ogilvie. *The Romans and Their Gods in the Age of Augustus*. London, 1969.

H. P. L'Orange. *Art Forms and Civic Life in the Late Roman Empire*. Princeton, 1965.

Gilbert Picard. *Rome*. London, 1969.

E. Royston Pike. *Republican Rome*. London, 1966.

J. J. Pollitt (ed.). *The Art of Rome, c. 753 B. C. - 337 A. D. Sources & Documents*. Englewood Cliffs, New Jersey, 1966.

D. E. Strong. *Roman Imperial Sculpture*. London, 1961.

Cornelius C. Vermeule. *Roman Imperial Art in Greece and Asia Minor*. Cambridge, Mass., 1968.

MANNERISM & NEO-CLASSICISM

Giuliano Briganti. *Italian Mannerism*. London, 1962.
Walter Friedlaender. *David to Delacroix*. Cambridge, Mass., 1952.
Walter Friedlaender. *Mannerism and Anti-Mannerism in Italian Painting*. New York, 1957.
Henry Hawley. *Neo-Classicism: Style & Motif*. Cleveland, 1964.
Hugh Honour. *Neo-Classicism*. London, 1968.
John Pope-Hennessy. *Essays on Italian Sculpture*. London, 1968.
Mario Praz. *On Neoclassicism*. London, 1969.
Robert Rosenblum. *Transformations in Late Eighteenth Century Art*. Princeton, 1967.
John Shearman. *Mannerism*. London, 1967.
Cornelius Vermeule. *European Art & the Classical Past*. Cambridge, Mass., 1964.

NINETEENTH CENTURY SCULPTURE & PAINTING

Charles Baudelaire. *The Painter of Victorian Life* (Constantin Guys). P. G. Konody (trans.). London, 1930.
Alan Bowness. *Rodin*. London, 1970.
Bernard Champigneulle. *Rodin*. London, 1967.
Pierre Courthoin. *Seurat*. New York, 1969.
Moussa M. Domit. *The Sculpture of Thomas Eakins*. Washington, 1969.
John Dryfhout. *Augustus Saint-Gaudens: The Portrait Reliefs*. Washington, D. C., 1969.
Albert Elsen. *Rodin*. New York, 1963.
Albert Elsen (ed.). *Auguste Rodin*. Englewood Cliffs, New Jersey, 1965.
Roger Fry, Anthony Blunt. *Seurat*. London, 1965.
Lewis Hind. *Augustus Saint-Gaudens*. London, 1908.
Lincoln Kirstein. *William Rimmer: 1816-1879*. Whitney Museum of American Art, New York, 1946.
Corrado Maltese. *La Scultura dell'Ottocento in Europa*. Milan, 1966.
Mario di Micheli. *La Scultura Tedesca dell'800*. Milan, 1966.
Ruth Mirolli. *Nineteenth Century French Sculpture: Monuments for the Middle Class*. Louisville, Kentucky, 1971.
Henri Perruchot. *La Vie de Seurat*. Paris, 1966.
Auguste Rodin. *Cathedrals of France*. London, 1970.
Homer Saint-Gaudens. *Reminiscences of Augustus Saint-Gaudens*. New York, 1913.
Bernard Sattler. *Adolf von Hildebrand und seine Welt*. Munich, 1962.
Yvon Taillander. *Rodin*. Milan, 1965.

TWENTIETH CENTURY SCULPTURE

Jean Adhemar, Jean Vallery-Radot. *Paul Helleu*. Paris, 1957.
Adolphe Basler. *Henri Rousseau*. New York, 1927.
Horace Brodsky. *Pascin*. London, 1946.
Luigi Carluccio (ed.). *The Sacred and Profane in Symbolist Art*. Toronto, 1969.
Charles Chasse. *The Nabis and Their Period*. London, 1969.
Gaston Diehl. *Modigliani*. New York, 1969.
Gaston Diehl. *Pascin*. New York, 1969.
Robert L. Herbert (ed.). *Modern Artists on Art*. Englewood Cliffs, New Jersey, 1965.
Phillipe Julian. *Dreamers of Decadence*. London, 1971.
Katherine Kuh, William Lieberman. *Archipenko: The Paris Years*. Toronto, 1971.
Richard Ormond. *John Singer Sargent*. London, 1970.
Leoni Piccioni, Ambrogio Ceroni. *I dipinti di Modigliani*. Milan, 1970.
Margaret Potter (ed.). *The Collections of Gertrude Stein and Her Family*. New York, 1970.

Claude Roy. *Modigliani*. Lausanne, 1958.

John Russell. *Edouard Vuillard: 1886-1940*. New York, 1971.

Franco Russoli. *Modigliani Drawings and Sketches*. London, 1969.

Giulia Veronesi. *Style and Design: 1909-1929*. New York, 1966.

Alfred Werner. *Amedeo Modigliani*. New York, 1967.

DOLLS

Charles Baudelaire. *Morale de Joujou*. Crépet & Pichois (eds.). Paris, 1953.

Helen Bullard. *The American Doll Artist*. New York, 1965.

Catherine Christopher. *The Complete Book of Doll Making & Doll Collecting*. London, 1949.

Robert Culff. *The World of Toys*. London, 1970.

Lesley Gordon. *A Pageant of Dolls*. New York, 1949.

Oskar Grissemann. *Das Grosse Spielzeugbastelbuch*. Stuttgart, 1936.

Mary Hillier. *Dolls and Dollmakers*. London, 1968.

John Noble. *Dolls*. New York, 1967.

STATEMENTS BY NADELMAN

Notes for a Catalogue

The amount of material which The Secession had on hand last season made it impossible to show all of it. It is our regret that a collection of drawings by Elie Nadelman, of Paris, unexpectedly had to be returned to the artist for an exhibition in Europe without our having been able to place it before the New York public. We hope to get the collection back again at some future time. In the meantime we feel it may interest the readers of *Camera Work* to read what Mr. Nadelman had prepared for the catalogue which was to explain the character of his work when exhibited in the Little Gallery of the Photo-Secession. Mr. Nadelman wrote:

I am asked to explain my drawings. I will try to do so, although form cannot be described. Modern artists are ignorant of the *true forms of art*. They copy nature, try to imitate it by any possible means, and their works are *photographic reproductions*, not works of art. They are works without style and without unity.

It is form in itself, not resemblance to nature, which gives us pleasure in a work of art.

But what is this true form of art? It is significant and abstract, i. e., composed of geometrical elements.

Here is how I realize it. I employ no other line than the curve, which possesses freshness and force. I compose these curves so as to bring them in accord or in opposition to one another. In that way I obtain the life of form, i. e., harmony. In that way I intend that the life of the work should come from within itself. The subject of any work of art is for me nothing but a pretext for creating significant form, relations of forms which create a new life that has nothing to do with life in nature, a life from which art is born, and from which spring style and unity.

From significant form comes style, from relations of form, i. e., the necessity of playing one form against another, comes unity.

I leave it to others to judge of the importance of so radical a change in the means used to create a work of art.

(Signed) Elie Nadelman.

Published in Camera Work, *No. 32, October 1910. Alfred Stieglitz, editor.*

265

A Statement of Principles

It is precisely this *energy* in the materials *expressed in form and volume* which gives that *life* to the work of plastic art and architecture which is the aim of art.

This force, which obliges stone to prefer one position to another is not only found imprisoned within itself, but also exists outside itself; it exists in the universe and answers our own instinct. Hence, work created in this spirit reveals itself not only to our eyes, but also *corresponds* to our instinct. It is this correspondence, this harmony with ourselves which makes us feel the life in a work of art. How far does this concept of plastic life differ from that which pretends to render life by imitating the forms of living creatures without understanding them! It is this false concept of plasticity which prevents plastic art and architecture from raising themselves to their true greatness and beauty!

<p style="text-align:center">★</p>

There is a *plastic life* and a "life" of living beings which are completely different from each other.

I call *plastic life* the energy, the will which material itself possesses. A simple stone must already be considered a living body by the artist, since it indeed demonstrates its will by refusing all positions we might wish to afford it unless they are suitable, and it maintains that position which its weight, in accord with its shape, demands. I know this phenomenon is perfectly well recognized in science, but it is nevertheless true that in art it is not applied at all.

<p style="text-align:center">★</p>

Material has its proper will within itself which is its "life". A stone will refuse all the positions we might wish to give it; if these are not suitable and by its own will, it will resume the position which its shape in accordance with its volume demands.

What admirable strength have we here, a "life" which plastic art must express. Here is a life which, cultivated by art, will reach a staggering strength of expression to move us.

It is this will in material, expressed in form and volume, which I call *plasticity*.

It is only by plasticity that a true work of plastic art speaks to us: it possesses absolutely no other language.

This "will" in material is not found only imprisoned inside itself, it is a force of nature which corresponds to our own instincts. It is there where the contact between ourselves and the work of plastic art is born. It is there where plastic art begins.

<p style="text-align:center">★</p>

It is this will in the material expressed in form and volume which I call *plasticity*.

<p style="text-align:center">★</p>

266

Certainly, art must be free! But one must learn to *feel* that art is only free when it obeys the great natural laws (which are its life).

<div align="center">★</div>

What difference does our personal taste make to art! It imposes its taste on us! Genius discovers and represents the nature of art, while mediocrity expresses its own nature.

<div align="center">★</div>

Those artists who follow only their own passions without dependence upon the great natural laws produce only works without greatness or beauty. All artists tend towards perfection, but there are those who detest it since its laws make themselves felt. These laws annihilate mediocrity and reveal genius.

Art does not change. What changes is the distance between art and us. The further off one is from it, the more confusion complicates it and varies the dubious concepts which contradict themselves. The more one approaches it, the more the *unique truth* reappears and governs.

<div align="center">★</div>

The law of weight (gravity) is the soul of plastic art.

<div align="center">★</div>

To interpret the charm of life, often at its most fragile and shifting, – by inflexible and solid physical laws, – here is the definition of art.

<div align="center">★</div>

In nature, all elements coöperate.

<div align="center">★</div>

There is a holy mathematics and art in the will of the material which are the soul of plastic art.

<div align="center">★</div>

Art is free only when it obeys laws which man continually discovers in his own nature, as in the exterior world.

<div align="center">★</div>

A true work of art is created by space, by air and by light as much as by the human heart and soul. If the work of art is not in harmony with exterior elements it remains mediocre. And the function of art is to have the strength and taste to appropriate to itself elements of the exterior world, to bind them to its essence in order to allow them to reflect the grandeur of the world.

<div align="center">★</div>

267

Art, in its biggest sense, must convey a representation of objects from nature or from the imagination *by means proper to that art in which the objects are represented.*

<p style="text-align:center">★</p>

Plasticity is a quality of forms which we give to the material, thanks to which this material reveals itself and imposes itself on us.

Plasticity gives those qualities to material which correspond to our own instinct.

<p style="text-align:center">★</p>

Forms and volumes must be employed in a *plastic* sense.

<p style="text-align:center">★</p>

Beauty in plastic art is the sensation of plastic truth.

<p style="text-align:center">★</p>

Added at a later date (handwriting of 1915-16), in sequence with the above:

Works of plastic art create themselves in the manner of crystals; physical laws dominate their shapes.

<p style="text-align:center">★</p>

Enough of dilettantism! Art is not an amusement. Art is a truth which depends upon elements from the exterior world, as upon the emotions of the human heart.

<p style="text-align:right">*A proposed foreword by Nadelman, ca. 1912, for a publication to be called* Quarante Dessins, *or for another proposed portfolio,* Vers l'Unité Plastique, *Paris, 1914.*</p>

Notes from a Catalogue

We are flooded with pictures and sculpture, but are without plastic art. We seek, in painting and sculpture, all things save those which they could and should give to us. We have several ideals of art, but we lack the true one. At one time we imitate nature so closely that we make nothing but sterile copies of her. At another we separate ourselves from her completely and turn toward the abstract, where we float in the void and no longer find anything. We would like to possess a great art which, by its authority and clarity, would impose itself upon all; and we possess but vague attempts which change daily and fail to satisfy.

For a long while the true meanings of plastic art have escaped us. We do not recognize that essential quality which gives to this art its true value, and which permits it to develop in all its grandeur.

Neither an exact copy of nature, nor a geometrical abstract form, nor all the productions of painting and sculpture in our time that can be placed between these two extremes, possess that quality.

The ultimate quality of painting and sculpture is plasticity.

Matter has an individual will which is its *life*. A stone will refuse all the positions we may wish to give it if these are unsuited to it. By its own will it will fall back into the position that its shape in conjunction with its mass demands.

Here is a wonderful force, a life that plastic art should express. Here is a *life* which, cultivated, enriched by art, will reach a dazzling power of expression that will stir us.

It is this will of matter expressed in shapes and volume that I call plasticity. This power, this will, is not solely found imprisoned in matter itself. It is a natural force that corresponds to our own instinct. In looking at a tower whose height is too great a feeling of disquiet comes over us. We *feel* that the material labors under a strain and does not find itself normally conditioned. In the same way any object in which the needs of the material have been respected transmits to us a sense of satisfaction. It is from this that contact between us and a work of plastic art derives. It is, therefore, the plasticity of the image that awakes sensations in us; and the most indifferent object reveals itself to us with an unfamiliar force and charm if this object is interpreted by a *purely plastic* means, independently of what a work of plastic art represents, it is solely by its plasticity that it speaks to us. Plasticity is the poetry of plastic art. It is its essence. To seek its poetry elsewhere is to draw it toward error.

<div style="text-align:right">ELIE NADELMAN</div>

From the Eli (sic) Nadelman Exhibition at "291" (Gallery of the Photo-Secession), December 8, 1915, to January 19, 1916.

A Letter to the Press

At the Allies of Sculpture, in the Ritz-Carlton Hotel exhibition, the subject matter of almost all the works represent nude men – nude women – and nude men having the bodies of nude women.

I have exhibited some works whose subjects are dressed women, as one sees them in everyday life. Well! the majority of visitors – in seeing my dressed women – found them indecent, and were so shocked that they removed them from their original place to a remote corner from where they could not be seen.

This fact is significant.

It proves the tenacity of habit, and especially of bad habits. It proves that habit and not logic makes people accept or reject things.

When the public does not find nude women in sculpture they wonder whether the works are artistic or not. And when one represents women in dresses or men wearing hats, the public, not being accustomed to this, do not know whether there is art or solid insolence.

And instead of trying to decide about the question, the public revolts. It is easier for them. They revolt because they are disturbed in their habits. But I believe this revolt is always an evident proof that those who revolt are already half convinced.

This explains the attitude of the public.

But it does not explain my sculpture.

However, it is with respect to the meaning of my sculpture that I had the honor to be asked to say a few words.

I have 156 reasons for doing my sculpture as I do it. But even if I explained them all I wonder whether I would succeed in "arising" the sense of plasticity, which is to-day neglected, and without which no real sculpture can be understood.

This sense of plasticity will be cultivated, not by my words, but I hope that it will be cultivated by my sculptures.

After all, it is not the subject matter, it is the clearness of forms, that blinded the public long accustomed to confuse forms which are unable to impress themselves upon our imagination. It is a plastic language that my sculpture speaks. This language is not yet understood, but it is already heard.

Sent to the New York World, Sun, Herald, *and* Times, *December 19, 1917.*

Letter to an Editor

Editor of *The Forum:*

Your projected symposium, "Is Cubism Pure Art?", interests me exceedingly and for a special reason. Before Picasso ever thought of Cubism, I revealed in my work a new principle of Plastic Art, previously unrevealed. This principle discovered by me was that of *Abstract Form*, but I did not depart from nature, I merely interpreted Nature through Abstract Form, which introduced into my sculpture and drawings *Plastic Beauty* which before this discovery was entirely lacking in the plastic arts of our time.

Picasso is not the originator of Abstract Form, he merely exaggerated the abstract forms discovered by me, and not knowing their workings, piled up pell-mell abstract forms, abandoning nature more or less, and sometimes entirely, with a result which is meaningless and unsignificant from the point of view of plastic art and is merely a sensational novelty.

Of this assertion I am in a position to give convincing proof. It is manifest, however,

270

that I cannot do this in the form of a brief letter, nor even in the compass of a formal article. I must prove my point by divers illustrations interspersed with explanations. In view of this fact, I make the following proposal : – that you invite any representative exponents of Cubism whom you may choose to meet me at any time and place you may select, with the object of giving me an opportunity to answer your questions *à vive voix*.

Such an exposition by me, combined with the discussion to which it would give rise, could not fail to be constructively valuable in the clarification of what Cubism is, or rather is not, in relation to Pure Plastic Art.

Stenographic notes could be taken of this discussion and published in *The Forum*.

I believe the artistic world would be grateful to you for bringing this about, as it would bring a solution to a controversy which has lasted so many years. I most sincerely hope that you will take advantage of this offer.

<div align="right">

ELIE NADELMAN

</div>

NEW YORK CITY.

> *From* The Forum, *July, 1925, which published nine letters on* "Pure Art? Or Pure Nonsense?" *by Alexander Archipenko, Frank Jewett Mather, Eugene Speicher, Arnold Rönnebeck, Ivan Mestrovic, John Sloan, Alfred Bossom, Katherine S. Dreier, and Elie Nadelman.*

WRITINGS ON NADELMAN

Nadelman and Druet
by
ANDRÉ GIDE

From Gide's Journal, *Monday, 25 or 26 April, 1909*

Vernissage of the Nadelman Exhibition at Druet's. (Elie Nadelman is the young Jewish-Polish sculptor that Alexandre Natanson took me to visit in his lair [*tanière*] as I have already described that winter: December 24, 1908.)

But then I did not speak enough of the importance of Nadelman; Natanson eclipsed him. A Character decisive enough [*trempée*], nevertheless! Natanson held him back while waiting to "launch" him. In exchange for keeping him the while, Nadelman made him statues. They are those which are currently shown here, accompanied by numerous preparatory drawings. Nadelman draws with a compass and sculpts by assembling rhomboids. He has discovered that every curve of the human body accompanies itself with a reciprocal curve, which opposes and corresponds to it. The harmony which results from these balancings smacks of theorems. The most astonishing thing however is that he works from the live model. He is young and has time to recapture nature. But I fear for an artist who separates himself from simplicity; I'm afraid he will not achieve complexity but only complication.

Nadelman has known six years of misery; shut up in his dirty den, he seems to have nourished himself on plaster alone; Balzac could have invented him. I saw him again yesterday in a little blue suit which doubtless he was wearing for the first time, talking with a very ordinary and ugly lady to whom he introduced me: it was Madame X . . . She said, indicating the rhomboidal back of one of the statues:

"That one! At least it's alive! It's not like their Venus de Milo! What's it to me that she should be beautiful? That, at least, is a real woman! It's alive!" And precisely no qualification could apply worse to Nadelman's art, which as yet has only technique, and that rudimentary. Doubtless this pleases [Leo] Stein, because it can be assimilated without effort. Stein is the American collector who has bought a lot of Matisse. The Nadelman show had hardly opened when he had already bought up two-thirds or three-quarters of the drawings; at what price? I'll skip that, but in the back room of the gallery, I observed this little scene-from-life [between Nadelman and Druet]: Druet took out from under a table a head in plaster, or at least the plan for a head, with no eyes, no mouth, no nose, about as much formed as a duck of three days incubation. **[16?]**

— How much do you want for that?

273

— What! You're going to show *that*? (I understand such surprise; even in our time, such a shapelessness can hardly be shown.)

— No, said Druet; I'm holding it in reserve; I don't want to be caught short.

— Oh, well, I don't really know . . .

— Make up your own mind. I'll play the auctioneer . . . Come on: one! two! three! . . .

— Two hundred francs!

— Oh! That's too much, too much! said Druet, irritated that the other had gone a bit too well into the game. And Nadelman, in his turn:

— Very well, then. Name your own price: Come on, – one! two! . . .

— One hundred francs! That will do very well.

And Druet went off with the head.

Elie Nadelman
by
GERTRUDE STEIN

First published in larus, *Vol. 1, No. 4, July, 1927*

There was one who was a great man and his head showed this thing showed he did thinking. There was one who was a great man and his face showed this thing showed sensitive feeling. There was one who looked like the one the one who was a great one. This one looked like the other one the other one who was a great one. There was one who looked like both of them. He did look like that one the one who was a great one the one who did thinking. He did look like the other one the one who was a great one the one whose face showed this thing showed sensitive feeling. There was one and he looked like both of them, like both of the men who were great men. He did look like one. He did look like the other one. He did look like both of them.

He was one of a family in which there were seven children and he was the seventh one. He was one who had very much light coming out of him, it came out of him and it was a wonderful thing when he had been one working and then was one discovering himself being one being living.

He was one certainly doing thinking. He was one looking like one who was a great one and that one that great one had been one greatly thinking and his head did show that thing did show that he had been one greatly thinking.

The one looking like this one was one feeling light being something being existing. He was one looking like some one who was a great man and who had been one showing this thing in his face which was one showing sensitive feeling.

There was then one looking like one man who was a great man, and looking like another man who was a great man. He was one looking like both of them.

He was one feeling light being existing. He was one completely thinking about expressing light being existing. He was one completely working. He was one needing to be one completely loving women.

He was one feeling light being existing. He was completely thinking about expressing light being existing. He was one needing to be one completely loving women. He was one completely thinking about expressing loving women being completely in him. He was one who was working. He was one who was completely working when he was working. He was one looking like one man who had been a great man and greatly thinking. He was one looking like one man who had been a great man and greatly feeling light being existing. He was one looking like both of them.

Light was coming out of this one. This one was needing to be one completely loving women. This one was one who was completely working. This one was one who was completely thinking about expressing light being existing. This one was one who was completely thinking about expressing being one completely loving women.

This one was one being sometimes completely convincing as being one expressing light being existing, as expressing completely loving women, as expressing completely thinking about expressing something.

This one was one being sometime completely convincing as being one expressing light being existing, as expressing completely loving women, as expressing completely thinking about expressing something. This one was then completely convincing as one not being one realising light being existing, as completely loving women. This was one completely being convincing as being one not expressing light being existing, not expressing completely loving women.

This one was one having light coming out of him. This one was not expressing light being existing. This one was one loving women. This one was not expressing needing loving women. This one was not expressing completely loving women.

This one was one completely working. This one was one expressing thinking. This one was one completely working. This one was one completely expressing completely working. This one was one expressing thinking. This one was one having light coming out of him. This one was not one expressing light being existing. This one was one expressing thinking, this one was one expressing complete working. This one was one not expressing completely loving women. This one was one having some light coming out of him. This one was one not expressing light being existing.

At a Musical Tea with Nadelman
by
HENRY TYRRELL

From The World Magazine, *November 30, 1919*

Is Nadelman serious? Are these things art, or only insolence? Where does plastic beauty end, and decadence begin?

Difficult questions, in view even of the small group on this page. ["Hostess," "Host," "Cellist," "Singer," "Pianist"; Nadelman with bust of "Man in a Top Hat."] How much more complicated in a fashionable Fifth Avenue gallery, filled with a score or more of similar freakish presentments, and thronged with the very people supposed to be the originals of the types pilloried in plaster!

Views concerning Nadelman and his works are nothing if not contradictory. Such epithets as "outrageous", "degenerate", "neurotic", "unwholesome", "morbid", "effete", "gruesome", "sexless", and even "indecent", are freely bandied.

Elie Nadelman, Polish-Parisian and classically trained sculptor, who came to New York with something of a European reputation a little less than five years ago, is obviously a person possessing some virile qualities, personal, intellectual, and artistic. He also has an ironic wit and subtle humor. Doubtless this latter helps to account for his sculptures being "different" – shockingly different, in the instance of his latest New York exhibition. At the same time his admirable small bronzes of animals and mystically beautiful heads in marble have met with profitable appreciation by some of our most discriminating art collectors.

"How about it?" the World Magazine representative asked Mr. Nadelman in his Forty-Sixth street atelier. "Do you take New York criticism seriously?"

He leaned his blouse-clad elbow against the tall pedestal of a marble bust of "La Mysterieuse", and answered:

"Oh, it is a trifle – as though someone should throw charcoal dust on this marble. I blow it off. Pouf! It is gone. As for the New York public, it is the same as that of Paris, London or anywhere. They are all alike, and they all balk at any changed or novel viewpoint, in art especially. Now we have all been accustomed to shows, to figures of women represented nude, and to see portraits of men fully clothed, even to realistic buttons on their coats and creases in their trousers. For reasons of my own – and I have at least 156 of them – I show the ladies dressed as we always see them, and the men with their hats on. Consequently people jump at the idea that there must be something wrong."

"But the blue hair?"

"Ah, the blue hair! you, too, question that blue, though you never think of ques-

tioning the glaring white of plaster or marble, nor the metallic glitter of bronze, in a piece of portrait sculpture. The one is just as unlike as the other. Therefore, you are inconsistent. But I am perfectly consistent in thus defining the light-and-shade relation of hair or beard to the flesh quality of the face; because, remember, I am not making an image-copy of a man, but only expressing the essential proportions of a man's form, architecturally, you might say."

"Is it a man's form?" was the inevitable query, with a two-pronged radish staring one in the face.

"Surely it is a man's form – broad-shouldered, top-heavy, like the letter V. A woman's form is all curves and rotundity, say the letter O, or in profile S. And you see I have my top-heavy man leaning against a tree-trunk, which is the reverse of his, like the letter A. Thus a perfectly comfortable balance is established, and the law of gravity complied with, which is the first thing a sculptor has to look out for."

"You said it. But what a writer has to look out for is a story. Isn't there one among those 156 reasons of yours that would" – –

"Tell the story? Yes. In one word, it is Plasticity."

"Which means?"

"Taking liberties – moulding your material to express your idea, no matter what it is, and no matter how. And of course that involves" – –

It involved about a column and a half of perfectly good but unexacting artistic abstractions, such as geometrical simplification, physical laws of matter, perfect rhythm, Hellenistic harmony and repose, the mistakes of Rodin, musical melancholy, the emotionless calm of the true "*beauté plastique*".

Good-night to the story project, then, unless – – –

"Ah, oui, certainement! I will give you a story, if you so desire. Not of myself, but of the great impressionist painter Renoir, whom I know so well in Paris. He told it to me, I suppose, as a lesson.

"Many years ago, when Renoir was a young drifting artist, so unknown that nobody even made fun of his bizarre paintings, he and Monet and Sisley and Degas got together and formed a desperate plan. They would hire a vacant store and put up a joint exhibition of their pictures such as the public couldn't help but notice.

"Well, the exposition was installed, and it scored a success of notoriety and vituperation. The public did everything that could be done to or with pictures–except buy them. A month went by, and the rent fell due. It was not paid. There was not the faintest shadow of likelihood in all eternity that it would ever be paid. So the whole bunch of pictures were seized and sold – if you could call it selling, to scatter broadcast half a hundred serious paintings by these founders of a now fabulous-priced modern school, at a few francs apiece.

"Yet Renoir has told me more than once that the same farcical sheriff's sale was the

foundation of his subsequent success. It got his work talked about, looked at, and eventually compared with other artists' conventional work, to Renoir's material advantage. So the things that wouldn't sell, made a selling reputation for the painter's future product, and he had the game in his own hands."

Come to think of it, why should not the inscrutable Elie Nadelman profit in plutocratic New York by taking a leaf out of the book of Auguste Renoir of bohemian Paris?

Yes, he is a serious sculptor – decidedly.

Elie Nadelman Sculptures
by
HENRY McBRIDE

From "Modern Art" in The Dial, June, 1925

The Elie Nadelman sculptures in the Scott and Fowles Galleries might have aroused more excitement in another age than this. They seemed to point two ways at once, backward and forward, and when opposing points of view are endorsed with equal enthusiasm by a clever artist the public is apt to rebel at the enforced thinking that is necessary in order to come to a choice. There was no rebellion in this instance. We refused to stir from the apathy into which we have fallen of late, and did not think at all. We calmly divided into two ranks, the one half of us liking Mr. Nadelman's return to classicism and the other half preferring the caricatures in wood of modern society. The two factions ignored each other quite, and did not come into collision, which was a pity, for a clash of ideas, any ideas, might have wakened us up a bit. Neither side accused the artist of having off moments, or being partly woozy. There is, in reality, no ground for supposing Mr. Nadelman to be baiting his public. Both divisions of his art have been tormenting him for years, and both, apparently, must have expression. He was recognized from the first as being enormously proficient, and the necessity to carry his workmanship further and further has got him at last to the point where the glittering method absolutely distracts one from any thought of the theme. Even the marbles are carried beyond the sense of being marble, and as far as the eye can see, these figures might just as well be glossy porcelains. That may be the precise reason why those who loved them did so, for there are many who never relish porcelains, for instance, until a potter learns how to give them a semblance of linen; or ironwork unless it resembles silk; but be that as it may, the moneyed success of the show, I'm told, was with these shiny statues of far-away Greek goddesses. For my part, I preferred the caricatures in wood. As far as sheer

cleverness is concerned they topped anything shown this winter. They were so astonishingly skilful that an up-to-date sceptic who refuses to believe there is anything super-human save a machine had a moment's wild suspicion that some new kind of machinery must have carved out their perfections. But industrious investigation has not been rewarded as yet with a hint of the process, so at this writing, we must continue to assume that Mr. Nadelman relied upon knives and sandpaper for his jokes upon New York humanity. A few hardy collectors bought some of these carvings, which is greatly to our credit, though it would have been still more creditable, had all of them been hastily snatched up. I thought these effigies of plump hostesses and dancers and pianists – Mr. Nadelman seems to think us all plump without exception – could be immensely decorative in the right hands.

Elie Nadelman
by
MARTIN BIRNBAUM

From: Introductions: Painters,
Sculptors and Graphic Artists, *1919*

It is still too early to predict what effect the great War will have upon the development of Art in this country. Almost immediately after the conflict started, dealers who had made Paris and London their headquarters flocked to our shores, bringing with them their precious wares and treasures, and later, an exodus of artists started which, if it continues, may be compared to a similar flight from Byzantium to Florence, after the Turks occupied Constantinople in the fifteenth century. The present convulsion will undoubtedly scatter the artists and scholars and all the accumulation of learning in certain European centres, and these will gravitate to peaceful New York, where they are sure of a hospitable reception and where they may be expected to give an immense impetus to science and art.

Elie Nadelman, the Polish sculptor, was among the first of these men to come to America after the war began, and his presence here was immediately felt by his confrères. He was born in Warsaw in 1885, and studied for a time in the art schools there. It would seem that his early education conferred only irritation upon him and like so many other ambitious students, he finally drifted to Paris, where he remained twelve years. Nadelman had no teacher there, but his residence witnessed his rise from a sincere student into a self-taught man of original ideas, whose best works offer some of the most convincing arguments to those who are in search of propaganda in favor of the modern extremists.

Visitors to his studio are so astonished at the apparently conflicting works which

greet their eyes, that their critical faculties are at first in a maze. Beside a serenely calm mask, on the lips of which a strange smile lingers, there are distorted figures in impossible postures, and curious drawings which, when examined superficially, show no trace of obvious or delicate beauty. The average person will hesitate to laugh at these grotesque works, having recently heard of so many brilliant experimentalists whose creations should be approached with respect and even reverence, and if one understands Russian, Polish, French or German, Nadelman, who is always ready to flame up with enthusiasm, will soon convince you of the essential simplicity of his enigmatic designs. He has a charming way of modulating his causerie with expressive gestures, and you quickly see the logical relation of the geometrical forms to those beautiful sculptures, which in the first flush of unexpected pleasure are compared with Greek masterpieces and arouse the hope that here at last we have a man who has found at least a spark of the buried fire of the ancients. Nadelman's explanations are indeed so clear, that they serve not merely as a vindication of his theoretical drawings and sculptures, but he even enables a layman mentally to transform the intricate curves and shadows into the subtle play of light on his polished marble, bronze, or mahogany statuettes. One of his most interesting artistic doctrines deals with the respect which an artist owes to the peculiar nature of the material in which he works. "A rough stone," Nadelman says, "will refuse all the positions we may wish to give it, if these are unsuited to it. By its own will, it falls back into the position that its shape in conjunction with its mass demands. Here is a wonderful force, a life, that plastic art should express and if this life of the material is not destroyed, but is cultivated and enriched by the artist, it may acquire a wonderful power of expression that will stir the world." A piece of sculpture, therefore, should be created like a crystal, – physical laws should govern its fashioning, and the more of art there is discoverable in the work, the less the individuality of the artist becomes apparent. The curiously interwoven lines of these drawings which often suggest mineral crystallization, anticipate the beauty of the plastic form and its unbroken surface, the exquisite turn of the curves is merely accentuated by interfering lines, and the shaded portions represent the perfect rhythm of harmoniously balanced masses. The necessity and logic of every stage of work is cleverly explained by the artist in phrases like these, and when he transfers this harmonious play of line and surface from the drawings to his stone, wood, or metal, a satisfying tranquillity and a delicious serenity of soul result. Had he, however, shown only drawings or *recherches* in sculpture, Nadelman's name would doubtless be added to the vague group of artists known as post-impressionists, – a classification made hopelessly confusing in the presence of his extraordinary portraits and the beautiful heads, which for want of a better word we shall describe as Hellenistic. In this connection it is interesting to know that the Steins who were among the first to praise the work of Picasso and Matisse were also ad-

mirers of Nadelman, and Octave Mirbeau, protagonist of Van Gogh, was among the sculptor's first patrons. The connoisseurs just mentioned ardently admire his researches, but the artist himself has repeatedly told us that noble abstractions like "La Mysterieuse" are the flowers of his achievement. When he is more directly concerned with nature, as in his enchanting visions of fleeting childhood, his task is of course far simpler, and the result invariably convincing and superb. These delightful portraits arouse the greatest enthusiasm. Often the final touches are made directly on the marble from the living model and subtle shadows result from this handling of the stone. The vigorous yet refined head of Francis Neilson, the exquisite delicacy of the portrait of Mrs. Stevenson Scott, the highly original and sympathetic study of Miss Jane Barger Wallach, and the amazing, soft, all-embracing line, which begins on the chest of the bust of Mrs. Charles Templeton Crocker, and then goes on and on along the fine throat, over the pompadour and down the back, are only a few of his remarkable achievements in portraiture. These force one to wonder whether the gilded "Femme Nue," – fat and naïve, – the strange "Hermaphroditus," the scrutinizing head with slit eyes and blue hair, the delicious clowns and musicians, or the reclining wooden figure of a nude woman, are primarily intended not to amuse, but rather to crystallize the general public opinion about his work. Most people are unable to determine and they are merely exasperated by them. To us they seem like the vivid expression of the energies of a versatile artist, and in their most extravagant form they illustrate the subtle remark of some critic who said, that the peril of those who worship nature is eccentricity. As a matter of fact the enchanting heads of women are as purely theoretical as the abstruse problems, bearing the same relation to these, that Picasso's recent realistic works do to the earlier cubistic experiments. Models are rarely used directly and they are not more natural than Nadelman's "Horse," or his amusing garden piece "Le Promeneur." On the other hand they are not sterile imitations of Greek originals, for, although Nadelman's art undoubtedly has something of the clear ring of the genuine antique, something of its universal beauty and divine repose, the artist himself is not a neo-classicist. He is working as an ancient Greek must have done, with the inexhaustible universe, and not mere art, for an inspiration, and this distinguishes him from men like Thorwaldsen and Canova. Through his innate artistic feeling, incessant observation and unswerving continuity of studious effort, he has evolved rules and new ideals which compete with nature without copying her. Self-confidence and daring departures came only after many years of study, and therefore Nadelman's contention that his remotest abstractions are those closest to nature must be seriously weighed.

Nadelman's latest ambition seems to be to give artistic form and permanence to contemporary figures and costume. The gay maidens tripping like Greek nymphs along Fifth Avenue in their tight skirts, the lithe athletic woman dancing the tango

in her masculine tailor-made gown and high-heeled pumps, the overconfident violin virtuoso, the temperamental chamber musicians, the stout coloratura soprano bursting with song, – these are the types which impress him. He claims that if a sober appreciation of their qualities were possible, they would already be recognized as classics in their genre, for when analysed, they reveal plastic features essentially the same as his beautiful "Reverie" now in the Detroit Museum. Sobriety however is hardly possible in the presence of these figures, and on the occasion of their recent appearance in a miscellaneous exhibition of sculptures, society women are said to have broken some of them to pieces, so intense was the feeling aroused by these decently clad little people, among many pseudo-classical nudes. Visitors seemed surprised and shocked to see la mode treated plastically. Nadelman was laughed at when he insisted that these were par excellence the sculptures of our day and that the problems he attacked were just as serious as those handled by the Greeks. "One copies nature in vain," he cried. Divinity itself cannot create, let us say, a living hackney horse out of molten bronze, and it would be foolish for a mere artist to try. By carefully observing nature, however, a gifted mortal may produce a piece of sculpture which will suggest the sleekness, the almost idiotic pride, the nervous energy, the power and the absurdly high spirits of the living animal. A realistic bronze horse placed beside Nadelman's original creation will seem lifeless and dull. Men and women are studied and treated along the same lines. The laws of harmonious proportion in the construction of the draped human form, can of course be applied just as artistically to figures in skirts or trousers, as they once were to figures in togas. Certain lines of a tango dancer are just as beautifully balanced and as graceful in relation to each other, as the essential lines of a dancing faun or Apoxyomenos, and as soon as this is realized, the average amateur will be able to liberate his æsthetic faculties from old conventions. No one can quarrel with the soundness and logic of such theoretical arguments, but unfortunately the works which they are intended to justify seem conceived in the spirit of caricature and not with the earnestness which one associates with Nadelman's animal forms, portraits, and ideal heads.

It is almost inevitable to compare every modern sculptor to Rodin, but Nadelman is so directly his antithesis that it is more logical to contrast him with the great Frenchman. A mere glance at Nadelman's work will naturally disclose the fact, that his ability to handle such a vast arabesque of human forms as the "Porte de l'Enfer" or the solution of such a problem of complicated ensemble as the "Calais Bourgeois," has not yet been tested. Nor does the younger artist's work begin to display Rodin's wealth of imagination. In comparing the smaller sculptures, however, the higher praise does not always fall to the lot of the older artist. The obvious difference here is the romantic emotionalism of Rodin as contrasted with Nadelman's intellectual calm or his purely decorative quality, and it is regrettable that his mahogany decorations in

low relief, which adorn a New York residence, cannot be publicly shown. His work often suggests a mood of musical melancholy but we do not find here the quivering flesh, the ecstasy of desire, the grappling men and women, the insatiable longing and force of sex, which are always present in Rodin's palpitating figures. The creatures of Nadelman's fancy are indeed often strangely sexless. Beauté plastique, according to him, should not be a matter of emotion. A sculptor must never be sentimental or didactic. He may, indeed, arouse your feelings, – and Nadelman is often humorous and even witty on occasions, – but primarily, plastic art is not concerned with love or patriotism or kindred feelings, and you find accordingly that his loftiest conceptions are almost cold in their austerity and severe simplicity. Even some of the fine mahogany sculptures which have the advantage of rich color, lack the warmth of living flesh. Nadelman seems to put his keen intelligence and acquired Gallic taste, rather than native passion, into his work. His art savours at times of mathematical formulæ and, like the work of the great Belgian, George Minne, it is occasionally pure architecture in miniature. If, however, these are short-comings, it is nevertheless refreshing to find a comparatively young man with such strong convictions, taking his position, in spite of Rodin's supremacy in the popular mind. The intellectual note and aloofness are intensified by the extraordinary high polish which he gives to his surfaces, and which, he claims, enables his works to acquire tone without dirt, after the manner of antique marbles. Furthermore, some of these heads, fixed forever in marble meditation, display a rare delicacy, a kind of mysterious spirituality, which forever disposes of those detractors who say he is an apostle of ugliness. Such works stamp him as a seeker of the ideal, a speculative, artistic intellect, in quest of things immaterial, whereas his animal forms, like the "Young Deer," "The Bull," the "Stags," the "Horse" and the lovely "Swan Fountain," are notable for their great force, directness, and plastic qualities. Until, however, he gives us some single, supreme incarnation of all his powers, it will not be possible to develop his admirers into champions, and his opponents into that effective asset, a hostile literary body.

DRAFT CATALOGUE RAISONNÉ

The catalogue which follows is necessarily selective, partial, and is intended as a first draft, a listing of representative works in every medium to indicate the scope rather than the quantity of the artist's production. Though it does not include every work presently known to the author, it is a step towards a definitive listing which, due to many reasons, may take a number of years to complete. A final catalogue is being compiled under the direction of Athena Spear and the author. All persons who own or have knowledge of works are urged to send information to the author, in care of the publisher, in order to assure that they will be registered and included. Proper acknowledgment will be made, and in the case of errors corrections will be gratefully accepted.

Nadelman made no lists of his work, nor did he date drawings or sculptures. Many early records were lost in various studio moves. Exact dating is therefore impossible, though a knowledge of the development of his style and subjects makes possible some accuracy in terms of approximate periods.

Here are catalogued 190 sculptures out of an *oeuvre* that, when a complete inventory has been made, may total to between 500 and 1500 individual works, not including the artist's late experiments creating small terra cotta and papier-mâché figures in quantity. The present list of 162 drawings is out of an unknown total that may be more than 750. The listing of the prints is virtually complete; a master set is in the Metropolitan Museum of Art.

Included in the present draft are works in public collections as well as those in representative private collections, the greater part of which may eventually find their way into museums. There is no listing of foreign holdings (save for the portrait of Thadée Natanson), although work is known to exist in France, England and Poland.

Nadelman's marble heads were frequently unsigned: one was recently found at an antique dealer's in Washington; a bronze head of 1909 was discovered in an old-print shop on the rue du Bac a few years ago; others will doubtless surface when his work becomes better known again. It is impossible to date many of the late marbles and plasters with any precision, even to the decade, since his styles echoed and reechoed themselves continually. A drawing now in the Rhode Island School of Design, which looks exactly like those of 1909, was actually drawn at least a decade later. Several large caches of drawings have been discovered from sources outside the Nadelman Estate, and have been dispersed through private dealers, without recording. Others probably exist. A unique early pencil, pen-and-ink and charcoal sketch-book from about 1900 disappeared from his house in 1951 and may still be found. It was never photographed but contained beautiful very early drawings.

While much of Nadelman's output was sold and dispersed during his lifetime and by his widow, the Nadelman home in Alderbrook, Riverdale-on-Hudson, still contains, at this writing, a mass of original work from every period and in every material.

Pieces belonging to the Estate and itemized in this catalogue, some here annotated with the initial WH, have been chosen from among those considered by the sculptor or his widow to be complete. From 1930 through 1944 much of his labor was of an experimental nature. No total listing has yet been made of a large number of figures in terra cotta, glazed and unglazed ceramic, plaster, papier-mâché and plastic materials, some painted or gilded. Also to be inventoried are certain small bronzes, cast posthumously as experiments in reproduction and preservation, at a time when René d'Harnoncourt assisted Governor Nelson Rockefeller in the selection of pieces for his private collection. Experiments in reproducing some of the plasters in terra cotta were undertaken from 1950 by the Inwood Potteries and bear their mark. Further reproductions were attempted in Japan but were inconclusive: the figures are few and baked in black earth.

SCULPTURES. In the principal categories of sculpture below, works are listed chronologically. The following categories comprise all the artist's subject matter: 1. Female Heads; 2. Male Heads (both male and female are of an ideal nature as distinguished from actual portraits); 3. Standing Female Figures; 4. Seated, Kneeling, Reclining Female Figures; 5. Standing and Seated Male Figures (with one exception there are no seated male figures); 6. Combined Figures; 7. Architectural Sculpture; 8. Portraits; 9. Horses and Equestrian Figures; 10. Animals and Birds.

Works of sculpture considered lost or believed destroyed are not included in this Draft Catalogue, due to insufficient information as to size, material, date and provenance. However, a number of such works, especially plaster models later executed in permanent materials, are reproduced in the plate section because of their importance in the development of the final work. Many of the plates in this book are the only existing record of sculptures that no longer exist. Most of the photographs of finished sculptures before 1929 were, it is well to note, posed, lit, and photographed under the supervision of the sculptor.

DRAWINGS. Nadelman drew incessantly. Some five hundred separate sheets survive and there may be many more, sold or given away, of which no present record exists. There are few haphazard sketches to be found before 1914. A fine sketch book, full of careful student work done before 1902, disappeared from Mrs. Nadelman's home in the early 'Fifties, and may reappear from some illicit source. Abandonment of studios in Paris and London, the abrupt emigration of the sculptor to America in 1914, caused the loss of both ephemeral and important work. It has been impossible to trace material possibly existing in Poland, Paris or London. What remains from his Paris period are seldom sketches, but rather carefully conceived and finished demonstrations of theories, calculated for reproduction and publication. The two

most important repositories are the Metropolitan Museum and the Museum of Modern Art, both in New York City. A group of less important but fascinating studies related to theater are in the Dance Collection, The New York Public Library at Lincoln Center, Astor, Lenox, and Tilden Foundations. The Nadelman Estate holds a considerable number of fine drawings, often sketches for sculpture, though also many done simply for pleasure and unconnected with specific pieces in stone or bronze. The listing for this catalogue has been selected from the holdings of the three museums mentioned above, and from drawings known to be in other public or private collections. In addition, completed drawings that are now lost or destroyed, but that were reproduced in VUP, VBP, in Kirstein, *Drawings* or *Sculpture*, or that are in the present volume are included in this first Draft Catalogue as a matter of record. Many of those held in the Nadelman Estate are not recorded since they are presently unavailable.

L. K.

★

Abbreviations used:

Kirstein, *Drawings*: Lincoln Kirstein, *Elie Nadelman Drawings*, H. Bittner & Co., New York, 1949. Reprinted, 1970

Kirstein, *Sculpture*: Lincoln Kirstein, *The Sculpture of Elie Nadelman*, Museum of Modern Art, New York City, 1948

NDI: Lincoln Kirstein, "Elie Nadelman: Sculptor of the Dance," *Dance Index*, Vol. 7, No. 6, New York, 1948

NYA: William Murrell, ed., *Elie Nadelman* (Younger Artists Series), Woodstock, New York, 1923

Spear, "Early Heads": Athena T. Spear, "Elie Nadelman's Early Heads (1905-1911)," *Allen Memorial Art Museum Bulletin*, Vol. xxviii, No. 3, Spring, 1971, Oberlin College, Oberlin, Ohio

VBP: Elie Nadelman, *Vers la Beauté Plastique*, New York, 1921

VUP: Elie Nadelman, *Vers l'Unité Plastique*, Paris, 1914

WH: These letters stand for an inventory made for Wave Hill, an estate next to the Nadelman's land and left to the public as a Community Art Center. The inventory is useful for reference but is unpublished and incomplete.

An asterisk (★) preceding an entry indicates that a reproduction of the work appears in the plate section of this volume.

SCULPTURES

Female Heads

1. IDEAL HEAD, c. 1906 (?)-1908
Black bronze, 13"
Coll: Robert Schoelkopf Gallery, New York City
Prov: Madame Helena Rubinstein
Exh: Paterson's Gallery, London, April, 1911
Ref: Spear, "Early Heads," p. 210, fig. 8.
Other versions exist in green bronze and marble.

2. "EGYPTIAN" HEAD, c. 1906-1908
Wood, head and base in one piece, 8 3/4"
Coll: Nadelman Estate
Ref: WH 23.

3. IDEAL WOMAN'S HEAD, 1906-1908
Wood, 6 3/8" (excluding base)
Coll: Nadelman Estate
Ref: WH 22.

4. IDEAL WOMAN'S HEAD, c. 1906-1909
Wood, 12 3/4"
Coll: Nadelman Estate
Ref: WH 54.
Cracked. There are at least four and possibly more replicas or variants of this head, some unfinished and perhaps cut later than 1914.

5. IDEAL HEAD, c. 1907-1908
Marble, 14 1/2"
Coll: Museum of Art, Rhode Island School of Design, Providence, Rhode Island
Exh: Galerie Druet, Paris, April, 1909
This head is mounted on an onyx block. Nadelman preferred the light tone and jewel-like translucency of the glassy white stone, but rarely used it after 1915, as it became increasingly difficult to obtain. This may be a somewhat later replica of the "Ideal Head," entry 8, below.

6. IDEAL WOMAN'S HEAD, c. 1907-1908
Wood bas relief plaque, 14 1/8"
Coll: E. Jan Nadelman, Riverdale, New York

7. ★IDEAL HEAD, c. 1907-1908
Bronze, 14"
Coll: The Hirshhorn Museum and Sculpture Garden, Smithsonian Institution, Washington, D. C.
Prov: Madame Helena Rubinstein
Exh: Galerie Druet, Paris, April, 1909
Ref: Spear, "Early Heads," p. 210, fig. 9.
Plate 17

8. ★IDEAL HEAD, c. 1908
Marble, 12 3/4"
Coll: Zabriskie Gallery, New York City
Exh: Galerie Druet, Paris, April, 1909
Ref: Spear, "Early Heads," p. 214, fig. 12.
Plate 25

9. ★IDEAL HEAD, c. 1908
Bronze, 13"
Coll: Robert Schoelkopf Gallery, New York City
Exh: Galerie Druet, Paris, April, 1909
Ref: Spear, "Early Heads," p. 212, fig. 10.
Plate 18

10. IDEAL HEAD, c. 1908
Marble, 26 3/4"
Coll: E. J. Arnold, Boston, Massachusetts
Prov: Madame Helena Rubinstein
Exh: Galerie Druet, Paris, April, 1909
Ref: Spear, "Early Heads," p. 214.

11. IDEAL HEAD, c. 1908 (?)
Marble, 18"
Coll: Museum of Art, Rhode Island School of Design, Providence, Rhode Island, Gift of Mrs. Gustav Radeke
Exh: Galerie Druet, Paris, April, 1909
This piece, purchased in 1915, was the first sculpture by Nadelman to be acquired by an American museum.

12. IDEAL HEAD, c. 1908
Marble, 14"
Coll: Allen Memorial Art Museum, Oberlin, Ohio
Exh: Zabriskie Gallery, New York City, February 7 - March 4, 1967
Ref: Spear, "Early Heads," p. 216, fig. 13.
Entitled "Mercury" in Mrs. Spear's article, this is actually a female head.

13. IDEAL FEMALE HEAD, c. 1908 (?)
Marble, 14¹/₂"
Coll: Nadelman Estate
Ref: WH 109.
Unfinished, this piece is possibly the start of a recutting of an earlier model.

14. HEAD, c. 1908-1925
Marble, 13¹/₄"
Coll: Mr. and Mrs. William Feinberg, New York City
This seemingly unfinished head recalls Nadelman's early analytical drawings, but may have been a roughed-out demonstration for teaching purposes, executed at a time when he was briefly interested in teaching at the Beaux-Arts Institute of Design.

15. IDEAL HEAD, c. 1909
Wood, 15"
Coll: Dr. and Mrs. Samuel Karlan, Whitestone, New York
Prov: Madame Helena Rubinstein
Exh: Galerie Druet, Paris, April, 1909
Ref: Spear, "Early Heads," p. 216, fig. 15.

16. CLASSICAL HEAD, c. 1909
Marble, 14"
Coll: Allen Memorial Art Museum, Oberlin, Ohio
Prov: Madame Helena Rubinstein
Ref: Spear, "Early Heads," frontispiece.

17. CLASSICAL HEAD WITH HEADDRESS
c. 1909
Marble, 14"
Coll: Zabriskie Gallery, New York City
Prov: Madame Helena Rubinstein

18. CLASSICAL HEAD WITH HEADDRESS
c. 1909
White marble, with gray marble socle, 14"
Coll: Zabriskie Gallery, New York City
Prov: Madame Helena Rubinstein

19. CLASSICAL HEAD, c. 1909
White marble, with onyx base, 13"
Coll: Mr. and Mrs. Maurice Vanderwoude, Great Neck, New York
Prov: Madame Helena Rubinstein

20. IDEAL HEAD, c. 1909-1910
Marble, 12¹/₂"
Coll: The Hirshhorn Museum and Sculpture Garden, Smithsonian Institution, Washington, D. C.

Exh: Galerie Druet, Paris, April, 1909
Ref: Spear, "Early Heads," p. 216, fig. 16.

21. IDEAL HEAD, c. 1909-1910
Marble, 15¹/₂"
Coll: The Hirshhorn Museum and Sculpture Garden, Smithsonian Institution, Washington, D. C.
Exh: Paterson's Gallery, London, April, 1911
Ref: Spear, "Early Heads," p. 216, fig. 17.

22. ★FEMALE HEAD, c. 1909-1911
Marble, 16"
Coll: Unknown
Prov: Ex-coll. Madame Helena Rubinstein
Athena Spear believes this dates c. 1917.
Plate 24

23. ★FEMALE HEAD, c. 1909-1911
Marble, 12¹/₂"
Coll: Unknown
Exh: Paterson's Gallery, London, April, 1911; International Gallery, New York City, April 6-May 6, 1932
Prov: Ex-coll. Madame Helena Rubinstein
Plate 27

24. ★IDEAL HEAD, c. 1910
Marble, 16"
Coll: Unknown
Exh: Paterson's Gallery, London, April, 1911
Ref: Spear, "Early Heads," p. 216, fig. 18.
Plate 28

25. IDEAL HEAD, c. 1910
Marble, 13"
Coll: Mr. and Mrs. Maurice Vanderwoude, Great Neck, New York
Prov: Madame Helena Rubinstein
Exh: Paterson's Gallery, London, April, 1911
Ref: Spear, "Early Heads," p. 220, fig. 19.

26. *LA MYSTÉRIEUSE,* c. 1910 (?)
Marble, 15"
Signed: "Elie Nadelman"
Coll: The Brooklyn Museum, Brooklyn, New York, (R. B. Woodward Fund)
Ref: NYA, unpaginated; Spear, "Early Heads," p. 220, note 24.
Ms. Spear dates this head as of the mid-'Teens. It closely resembles the many marble heads known to have been carved before 1913, although a certain extreme refinement of the features and a subdued

formalization suggest Nadelman may have been repeating further his own refinements, which he often did.

27. HEROIC IDEAL FEMALE HEAD
c. 1910-1911 (?)
Marble, on circular two-tiered base, 16¹/₄"
Signed: "Elie Nadelman"
Coll: Nadelman Estate
Ref: WH 25.

28. IDEAL HEAD, c. 1910-1911
Marble, 13⁵/₈"
Coll: Nadelman Estate
Exh: Galerie Druet, Paris, April, 1909
Ref: WH 6.

29. IDEAL FEMALE HEAD, c. 1910-1912 (?)
Marble, 15"
Coll: Nadelman Estate
Ref: WH 47.
There is a crack at base of rear neck.

30. FEMALE HEAD, c. 1911-1914 (?)
Wood, 22"
Coll: Nadelman Estate
Ref: WH 50.
There are small splittings from chin to forehead.

31. IDEAL HEAD, c. 1913 (?)
Marble, 14¹/₄"
Coll: City Art Museum of St. Louis, St. Louis, Missouri, Gift of J. Lionberger Davis

32. IDEAL FEMALE HEAD, c. 1914-1917 (?)
Wood, 15⁷/₈"
Coll: Nadelman Estate
Ref: WH 46.

33. ★HEAD OF A GIRL WITH HIGH
HAIR-DO, 1915
Bronze, 13¹/₂"
Coll: Coe Kerr Gallery, New York City
A fine version in marble belongs to the sculptor's son, E. Jan Nadelman, somewhat larger than the bronze, which seems to be unique.
Plate 182

34. IDEAL HEAD OF A WOMAN WITH
SHUT EYES, c. 1915-1917 (?)
Marble, including white onyx plinth, 18⁷/₈"

Coll: Honolulu Academy of Arts, Honolulu, Hawaii, Gift of Mr. and Mrs. Walter F. Dillingham

35. *LA RÊVEUSE*, c. 1915-1917
Marble, 17¹/₂"
Signed: "Elie Nadelman"
Coll: Nadelman Estate
Ref: WH 2.

36. GIRL'S HEAD, c. 1915-1917
Marble, 16¹/₄"
Coll: Nadelman Estate
Ref: WH 44.

37. IDEAL GIRL'S HEAD, c. 1915-1920 (?)
Bronze, 14"
Coll: Nadelman Estate
Ref: WH 53.

38. IDEAL HEAD OF A GIRL WITH LONG
HAIR, c. 1916
Marble, on onyx plinth, 20"
Coll: The California Palace of the Legion of Honor, San Francisco, California, on loan from the Estate of Hélène Irwin Fagan

39. IDEAL HEAD OF A GIRL WITH LONG
HAIR, c. 1916
Marble, 14³/₄"
Coll: Paul Magriel, New York City
Prov: Edwin Hewitt Gallery, New York City; Nadelman Estate

40. FEMALE HEAD, c. 1916 (?)
Wood, with tapered base, 9"
Coll: Mr. Stephen Paine, Boston, Massachusetts
Prov: Madame Helena Rubinstein

41. *RÊVERIE*, c. 1916-1917
Marble, 17¹/₂" (excluding base)
Coll: Detroit Institute of Arts, Detroit, Michigan
Prov: Scott & Fowles, New York City
Ref: Bulletin of the Detroit Museum of Art, Vol. 12, May, 1918, no. 8; Bulletin of the Detroit Institute of Arts, Vol. 1, April, 1920, no. 55; Modern Sculpture, by Franklin Page, Detroit Institute of Arts, 1950, p. 30, (illus.).

42. HEAD OF A WOMAN, c. 1916-1918
Marble, 20"
Coll: The Newark Museum, Newark, New Jersey

43. WOMAN'S HEAD, c. 1916-1918
Bronze, on white onyx base, 12 ³/₄"
Signed: "Elie Nadelman," cast by "Griffoul, Newark, N.J."
Coll: Nadelman Estate
Ref: WH 1.

This is possibly a cast from a plaster, c. 1908.

44. GIRL'S HEAD, c. 1916-1918
Marble, 18 ¹/₂"
Coll: Nadelman Estate
Ref: WH 5.

45. GIRL'S HEAD, c. 1916-1920 (?)
Marble, on onyx block, 13 ¹/₂"
Coll: Nadelman Estate
Ref: WH 110.

Unfinished, this head was mounted on a block after Nadelman's death.

46. HEROIC IDEAL FEMALE HEAD
c. 1916-1922 (?)
Marble, 18 ⁵/₈"
Coll: Nadelman Estate
Ref: WH 49.

This piece was dropped during the forced studio move; Nadelman later repaired the damaged nose.

47. IDEAL GIRL'S HEAD, c. 1920-1935 (?)
Marble, 14 ³/₄"
Coll: Nadelman Estate
Ref: WH 108.

48. IDEAL WOMAN'S HEAD, c. 1923-1925 (?)
Marble, tinted hair, 15 ¹/₄" (including base)
Coll: Nadelman Estate
Ref: WH 98.

49. WOMAN'S HEAD AND TORSO, c. 1924
Galvano-plastique, 31 ³/₄"
Coll: Nadelman Estate
Ref: WH 38.

50. GIRL'S HEAD AND TORSO, c. 1924
Galvano-plastique, 25 ¹/₂"
Coll: Nadelman Estate
Ref: WH 39.

51. BUST OF A WOMAN, c. 1924-1925
Galvano-plastique, 21 ¹/₄"
Coll: Nadelman Estate
Ref: WH 33.

52. GIRL'S HEAD, c. 1924-1925
Galvano-plastique, painted, 15 ¹/₄"
Coll: Nadelman Estate
Ref: WH 36.

53. BUST OF A WOMAN, c. 1924-1925
Galvano-plastique, 25"
Coll: Nadelman Estate
Ref: WH 31.

54. WOMAN'S HEAD AND BUST, 1924-1925
Galvano-plastique, 25 ¹/₂"
Coll: Nadelman Estate
Ref: WH 40.

55. ★GIRL'S HALF-LENGTH TORSO
c. 1924-1925 (?)
Galvano-plastique, 30"
Coll: Nadelman Estate
Ref: WH 34.
Plate 135

56. GODDESS, c. 1926-1932 (?)
Marble, 23"
Coll: The Cleveland Museum of Art, Cleveland, Ohio, Bequest of James Parmalee
The Memorial Art Gallery of the University of Rochester, New York, owns a version in highly polished brass. The Nadelman Estate holds another marble version, unpolished.

57. BUST OF A WOMAN, c. 1927
Brass, painted with Prussian blue, 24 ³/₄"
Coll: Nadelman Estate
Ref: WH 30.

58. IDEAL WOMAN'S HEAD, c. 1930-1935 (?)
Marble, 14 ¹/₄"
Coll: Nadelman Estate
Ref: WH 52.

This head, left unfinished by the sculptor, seems to date from the period of the loss of his studio, after which he appears to have abandoned a number of unfinished pieces. George Baillie, a skilled stone-carver who had been employed by Nadelman, worked on this and other pieces from 1948 through 1950.

59. IDEAL WOMAN'S HEAD, c. 1935-1945 (?)
Marble, 15"
Coll: Nadelman Estate
Ref: WH 55.
Cracked and unfinished, this piece was worked on by George Baillie.

60. HEROIC IDEAL FEMALE HEAD
c. 1935-1945 (?)
Marble, 17 ¹/₈"
Coll: Nadelman Estate
Ref: WH 35.
The head is unfinished with indications of pointing-marks.

61. ★HEAD OF A WOMAN, c. 1942
Rose marble, 15 ⁵/₈"
Coll: Museum of Modern Art, New York City, Gift of William S. Paley, 1949
Prov: Nadelman Estate
Exh: Museum of Modern Art, New York City, 1948, cat. no. 40
Ref: Kirstein, Sculpture, p. 41 (illus.).
This head, perhaps not entirely finished, was in the sculptor's studio, unmounted on the present green marble base. It is a recapitulation of his early 'classic' heads, as projected from his style in the late 'Thirties.

Plate 181

Male Heads

62. MALE HEAD, c. 1906-1908
Bronze, 16 ¹/₈"
Coll: Nadelman Estate
Ref: WH 9.

63. HEAD OF A YOUTH, c. 1908 (?)
Patinated bronze, 16 ¹/₈"
Coll: Nadelman Estate
Ref: WH 24.
This head reflects Nadelman's admiration of Aubrey Beardsley. A variant exists, in a private collection, Weston, Connecticut, with the ropy locks in Prussian blue on a gold base.

64. ★MERCURY PETASSOS, c. 1911
Marble, 16"
Coll: Unknown
Prov: Ex-coll. Madame Helena Rubinstein
Plate 61

65. ★MALE HEAD, c. 1911-1913
Bronze, 15 ¹/₂"
Coll: The Hirshhorn Museum and Sculpture Garden, Smithsonian Institution, Washington, D. C.
Ref: Kirstein, Sculpture, p. 18 (illus.).

The foundry mark reads "Alexis Rudier, Fondeur, Paris."

Plate 16

66. MERCURY PETASSOS, c. 1913-1914
Bronze, 20 ¹/₂"
Coll: Nadelman Estate
Ref: Guillaume Apollinaire, review of Salon des Indépendants, March 5, 1914. Reprinted in Apollinaire on Art: Essays and Reviews, 1902-1918, edited by LeRoy C. Breunig, Viking Press, New York, 1972, p. 358; WH 8.

67. HEAD OF A MAN IN A TOP HAT, 1914
Bronze, 18 ¹/₂"
Coll: Allen Memorial Art Museum, Oberlin, Ohio
Ref: Guillaume Apollinaire, review of Salon des Indépendants, March 5, 1914. Reprinted in Apollinaire on Art: Essays and Reviews, 1902-1918, edited by LeRoy C. Breunig, Viking Press, New York, 1972, p. 358.

There are two posthumous casts; the plaster exists. Apollinaire wrote: "The Central Room: Nadelman's two plaster heads, representing two modern young men, one wearing a top hat, the other a bowler, are the first works in which a piece of modern clothing has been treated in an artistic manner." Nadelman seems to have brought the plaster with him from Paris in 1914, but he neither showed it, nor cast it in bronze. It serves as the prototype for the "Man In a Top Hat," painted brass, in the Museum of Modern Art, New York City.

68. IDEAL MALE HEAD, c. 1915-1917
Bronze, 14"
Coll: Nadelman Estate
Ref: Kirstein, Sculpture, p. 61 (illus.); WH 97.

This is the bronze version of the so-called "Ideal Self-Portrait" (plates 154, 155).

69. ★MALE HEAD (Ideal Self-Portrait), c. 1916
Marble, 14 ¹/₂"

Coll: *Private collection, New York City*
Ref: *Kirstein, Sculpture, p. 61 (illus.).*

This highly polished head, supported by a number of brush and ink drawings suggesting Nadelman drew somewhat on his own features, is his single male portrait in stone. A bronze version exists in the Nadelman Estate. Nadelman also drew on the Praxitelean head of a curly-haired boy in the Metropolitan Museum of Art, of which he kept photographs. The nose was broken when the marble was dropped at an exhibition at Scott & Fowles in 1916, and Nadelman refused to show this piece publicly afterwards.

Plates 154, 155

70. ⋆MAN'S HEAD IN TOP HAT, c. 1923-1924
Galvano-plastique, painted, 26^1/$_2$"
Coll: *Nadelman Estate*
Ref: *WH 7.*

The eyes, brows and moustache are laid in with oil paint, which with the passage of time has faded. Nadelman's own photographs of most of his galvano-plastique figures indicate painted accents placed on the finished photo.

Plate 141

71. MAN'S HEAD IN TOP HAT, c. 1924
Galvano-plastique, 27^1/$_2$"
Coll: *Nadelman Estate*
Ref: *WH 41.*

72. ⋆MAN IN TOP HAT, c. 1927
Painted bronze, 26" × 14^7/$_8$"
Coll: *Museum of Modern Art, New York City, (Abby Aldrich Rockefeller Fund, 1948)*
Prov: *Nadelman Estate*
Exh: *Museum of Modern Art, New York City, 1948, cat. no. 31; Museum of Modern Art, New York City, generally on exhibition; Zabriskie Gallery, New York City, February-March, 1967*
Ref: *Kirstein, Sculpture, p. 43 (illus.).*

A variant exists, not from Nadelman's hand, but done from photographs available to an unscrupulous artisan.

Plate 142

73. IDEAL MALE HEAD, 1945
Marble, 8"
Coll: *Private collection, New York City*

Unfinished, this delicate recapitulation of Nadelman's "Ideal Self-Portrait" (plates 154, 155) was the last stone the sculptor carved.

Standing Female Figures

74. STANDING FEMALE NUDE, c. 1906
Plaster, 20^1/$_2$"
Coll: *Nadelman Estate*
Ref: *WH 113.*

This is possibly the original model of the first variant of Nadelman's recension of the "Aphrodite of Knidos," which served as the concept of the standing nude, the so-called "Gertrude Stein" (plate 34). This plaster is damaged.

75. ⋆HERMAPHRODITE, c. 1906-1908
Bronze, 15"
Coll: *Robert Schoelkopf Gallery, New York City*
Exh: *Galerie Druet, Paris, April, 1909*

This piece was cast by Alexis Rudier, Rodin's preferred *fondeur*. Guillaume Apollinaire, in his *Chronique des Arts et de la Curiosité*, a supplement to *La Gazette des Beaux-Arts*, remarked May 1, 1909, p. 148 (and again in writing about the Salon d'Automne of 1913), that Nadelman's art was reminiscent of Primaticcio, the Fontainebleau mannerists and El Greco.

Plate 70

76. ⋆STANDING FEMALE NUDE, c. 1907
Bronze, 20"
Coll: *The Hirshhorn Museum and Sculpture Garden, Smithsonian Institution, Washington, D. C.*

Plate 33

77. ⋆STANDING NUDE FEMALE FIGURE
(Called "Gertrude Stein"), c. 1907 (?)
Bronze, 29^1/$_2$" (Cast, 1926)
Coll: *Nadelman Estate*
Exh: *Museum of Modern Art, New York City, 1948, cat. no. 4; "Four Americans in Paris," Museum of Modern Art, New York City, 1970, p. 164*
Ref: *Kirstein, Sculpture, p. 11 (illus.).*

There may be four or more casts of this figure. It is the final version from several earlier plasters, one of which may be seen in a photograph of a corner of the apartment of Leo and Gertrude Stein, Paris, rue de Fleurus, c. 1909, reproduced in Kir-

stein, *Sculpture*, p. 60; above it are the famous canvases of Matisse and Picasso.
Plate 34

78. STANDING FEMALE NUDE, c. 1907
Gilt bronze, 28 3/8"
Coll: Private collection, New York City
Exh: Galerie Druet, Paris, April, 1909

The extraordinary tubular attenuation of the forms anticipates the personal style of the American sculptor, Hugo Robus.

79. STANDING FEMALE FIGURE WITH CROSSED ARMS, c. 1907-1908 (?)
Bronze, 24 1/2" (including base). Foundry mark: "Bingen"
Coll: Robert Schoelkopf Gallery, New York City
Prov: Noah Goldowsky, New York City; Pace Gallery, New York City
Exh: Galerie Druet, Paris, April, 1909

80. STANDING FEMALE NUDE ON MODELED BASE, c. 1907-1908
Green bronze, 22 1/2"
Coll: Michael Hall, New York City
Exh: Galerie Druet, Paris, April, 1909

81. ∗DRAPED STANDING FEMALE FIGURE c. 1907-1908 (?)
Bronze, 23"
Signed: "Eli Nadelman"
Coll: Currently unknown
Prov: Ex-coll. Alerain Gartenberg, Paris
Exh: Galerie Druet, Paris, "Exposition Elie Nadelman," 1913, cat. no. 13 (illus.)
Ref: André Salmon, L'Art Décoratif, March, 1914, Vol. 31, pp. 107-114 (illus.); Adolphe Basler, La Sculpture Moderne en France, 1928, p. 39 (illus.); Sales Catalogue, Sculpture, Parke-Bernet Galleries, Sale 3322, March 1, 1972, pp. 6-7 (illus.).

This figure of which some six casts are known to exist, as well as a version in marble, was sold at the Parke-Bernet Galleries, New York City, March 1, 1972. The foundry mark reads "C. Bingen." Another cast with the foundry mark "F. Costenoble" is owned by Mr. and Mrs. Douglas J. Bennett, Jr., Washington, D. C. A cast in the Nadelman Estate is in highly polished brass. The spelling *Eli* was replaced by *Elie* after 1914. When the marble version was first photographed (1915?), Frank Crowninshield, editor of *Vanity Fair*, entitled it "Sappho." J. J. Klejman, New York City, who owned the version now owned by Mr. and Mrs. Bennett, called it "Andromeda."
Plate 38

82. STANDING FEMALE DRAPED FIGURE c. 1907-1908
Bronze, 22"
Lost.

83. STANDING FEMALE NUDE WITH EXTENDED ARMS, c. 1907-1908
Bronze, 16" (including base). Foundry mark: "Alexis Rudier, Paris"
Coll: The Hirshhorn Museum and Sculpture Garden, Smithsonian Institution, Washington, D. C.

Nadelman preferred the Rudier foundry, which had worked for Rodin, to other foundries.

84. STANDING FEMALE NUDE ON DECORATIVE BRONZE BASE, c. 1907-1909
Bronze, 23 1/2"
Signed, top right base: "Eli Nadelman"
Coll: Nadelman Estate
Ref: WH 100.

The foundry mark "F. Costenoble, Paris" is at the bottom of base. There are at least two, and possibly more, copies, probably of the same period. One, known as "Eve," belongs to the Hirshhorn Museum, Washington, D. C.

85. STANDING FEMALE NUDE, HAND RAISED TO HEAD, c. 1908 (?)
Wood, 11"
Coll: Nadelman Estate

This delicate figure exists in at least three copies, of which the first and finest was given by the sculptor to his future wife shortly after their first meeting. A replica, once owned by Martin Liefer, New York City, is the property of the Zabriskie Gallery, New York City.

86. STANDING FEMALE NUDE, c. 1908
Wood, 15"
Coll: Mr. and Mrs. Monte Getler
Prov: Kennedy Galleries, New York City; Martin Liefer, New York City

87. STANDING FEMALE NUDE WITH RAISED ARMS, c. 1908 (?)
Plaster, tinted hair, 42"
Coll: Nadelman Estate

Exh: Galerie Druet, Paris, April, 1909
A second copy of this plaster, owned by Alexandre Natanson, was sold in Paris at the Hôtel Drouot, May 16, 1929.

88. ★STANDING FEMALE NUDE, c. 1909
Bronze, 21 3/4" (including base)
Coll: Museum of Modern Art, New York City, (Aristide Maillol Fund, 1949)
Prov: Nadelman Estate
Exh: Galerie Druet, Paris, April, 1909; Museum of Modern Art, New York City, 1948, cat. no. 8
Ref: Kirstein, Sculpture, p. 13 (illus.).
Plate 37

89. ★STANDING FEMALE NUDE, c. 1909
Bronze, 24"
Lost.
Plate 36

90. WOMAN WASHING HER HAIR
c. 1909-1911 (?)
Wood, 18 1/4"
Coll: E. Jan Nadelman, Riverdale, New York
This unique carved oak plaque, unfinished only at the top and bottom frames, may have been an *essai* for the style and technique of the decorations undertaken for Madame Helena Rubinstein's billiard-room in London, c. 1912-1913.

91. STANDING FEMALE NUDE, c. 1911-1913
Bronze plaque, mounted on black-and-white onyx base, 13 7/8"
Coll: Nadelman Estate
Ref: WH 29.
Derived from pen-drawings (VBP) with rolls of clay replacing pen-strokes. There are probably other casts.

92. FOUR SEASONS: SPRING, c. 1912
Terra cotta, 31"
Coll: Unknown
Exh: Museum of Modern Art, New York City, 1948
Ref: Kirstein, Sculpture, p. 20 (illus.).
The figures of the "Four Seasons: Spring, Summer, Autumn, Winter" were made for the Fifth Avenue beauty salon of Madame Helena Rubinstein.

93. FOUR SEASONS: SUMMER, c. 1912
Terra cotta, 31"
Coll: Unknown
Exh: Museum of Modern Art, New York City, 1948

94. FOUR SEASONS: AUTUMN, c. 1912
Terra cotta, 31"
Coll: Unknown
Exh: Museum of Modern Art, New York City, 1948

95. FOUR SEASONS: WINTER, c. 1912
Terra cotta, 31"
Coll: Unknown
Exh: Museum of Modern Art, New York City, 1948
Ref: Kirstein, Sculpture, p. 21 (illus.).

96. ★FLUTE PLAYER, c. 1913
Bronze plaque, 9 1/2"
Coll: Unknown
Prov: Ex-coll. Mary Cass Canfield, New York City
Plate 44

97. STANDING FEMALE DANCER
c. 1916-1920 (?)
Bronze, 31 1/4"
Coll: Nadelman Estate
Ref: NDI Cover (illus.); WH 32.

98. FEMALE TORSO, c. 1916-1925 (?)
Marble, 42 1/4"
Coll: Nadelman Estate
Ref: Kirstein, Drawings, p. 23 (illus.); WH 48.
This magnificent carving, Nadelman's largest and finest portable stone figure, was offered by Mrs. Nadelman to Dag Hammarskjöld, Secretary of the United Nations, to adorn the Secretariat. The death of the Secretary-General prevented acceptance. The figure was originally highly polished; it had been placed in the garden of Alderbrook and weather removed the waxed surface.

99. STANDING GIRL, c. 1918-1920
Cherrywood, base included, 32"
Coll: Nadelman Estate
Ref: WH 99.

100. ★DANCER, c. 1918-1921
Cherrywood with mahogany base, 28 1/4" (without base)
Coll: Wadsworth Athenaeum, Hartford, Connecticut, The Philip L. Goodwin Collection, 1958
Prov: Mrs. Stevenson Scott; The Edwin Hewitt Gallery, New York City; Philip L. Goodwin
Exh: Museum of Modern Art, New York City, 1948, cat. no. 19; Wadsworth Athenaeum: "The Philip L.

Goodwin Collection," Hartford, Connecticut, October 3-
November 30, 1958; Library and Museum of the
Performing Arts, Lincoln Center, New York City: "The
Dance in Sculpture," February 1-April 30, 1971
Ref: Kirstein, Sculpture, p. 33 (illus.); Wadsworth
Athenaeum Bulletin, Winter, 1958, p. 7.

A painted plaster model existed which was de-
stroyed. (Illus. NDI, p. 144.) Nadelman had in his
files a photograph of the vaudeville dancer Eva
Tanguay in the identical position.

Plate 72

101. ★STANDING GIRL, c. 1918-1922
Cherrywood, 30"
Coll: Mr. and Mrs. C. H. Tinsman, Shawnee Mission,
Kansas

Plate 73

102. CIRCUS GIRL, c. 1919-1920
Cherrywood and gesso, 31"
Coll: The Hirshhorn Museum and Sculpture Garden,
Smithsonian Institution, Washington, D. C.
Prov: The Downtown Gallery, New York City
Exh: The Corcoran Gallery of Art, Washington, D. C.,
"The Edith Halpert Collection," January 16-February
28, 1960; The Downtown Gallery, New York City,
"Surveys of American Art," 1966, 1967, 1968

An identical copy exists, whereabouts presently
unknown.

103. ★STANDING FEMALE FIGURE, c. 1924
Galvano-plastique, 60¹/₄"
Coll: Nadelman Estate
Ref: Kirstein, Sculpture, p. 36 (illus.); WH 27.

A unique bronze cast exists in a private collection
in New York City.

Plate 129

104. ★STANDING FEMALE FIGURE, c. 1924
Galvano-plastique, 58³/₄"
Coll: Nadelman Estate
Ref: Kirstein, Sculpture, p. 37 (illus.).

Plate 128

105. ★FIGURE, c. 1925
Marble, 38" × 11" × 12"
Coll: Walker Art Center, Minneapolis, Minnesota
Ref: Kirstein, Drawings, p. 23 (illus.).

Plate 122

106. STANDING FEMALE FIGURE, c. 1925
Marble, 38"
Coll: Walker Art Center, Minneapolis, Minnesota,
Gift of Mrs. A. Stewart Walker
Prov: Ferargil Gallery, New York City; Edwin Hewitt
Gallery, New York City

107. ★FEMALE NUDE, c. 1930-1935
Marble, 52"
Coll: Nadelman Estate

Plate 178

108. ★STANDING FEMALE FIGURE, c. 1935
Plaster, 6¹/₂"
Coll: Nadelman Estate

Plate 194

109. ★STANDING FEMALE FIGURE, c. 1935
Plaster, 6¹/₂"
Coll: Nadelman Estate

Plate 195

110. ★STANDING FEMALE FIGURE, c. 1935
Plaster, 6¹/₂"
Coll: Nadelman Estate

Plate 196

111. ★STANDING FEMALE NUDE, c. 1940
Marble, 12"
Coll: Nadelman Estate

Plate 173

112. DRAPED STANDING FEMALE NUDE
c. 1940-1945 (?)
Bronze, 22"
Coll: Irving Drutman, New York City
Prov: Curt Valentin Gallery, New York City

This is a unique posthumous cast.

113. ★STANDING CHILD GODDESS, c. 1943
Penciled plaster, 9¹/₂"
Coll: Nadelman Estate

Plate 206

114. ★STANDING CHILD, c. 1943-1945
Plaster, 9"
Coll: Nadelman Estate

Plate 198

115. ★FIGURE, c. 1943-1945
Bronze, 10 ¹/₂"
Coll: Private collection, New York City
Plate 200

116. ★FIGURE, c. 1944-1945
Gilt bronze, 12"
Coll: Private collection, New York City
Plate 201

117. ★CHILD GODDESS, c. 1944-1945
Plaster, 10"
Coll: Nadelman Estate
Plate 207

Seated, Kneeling, Reclining Female Figures

118. SEATED FEMALE NUDE, 1908
Bronze, on onyx plinth, 16"
Coll: The Baltimore Museum of Art, Baltimore, Maryland, The Cone Collection
Ref: Kirstein, Drawings, p. 22 (illus.).

The Cones were introduced to Nadelman by Gertrude Stein. This figure also exists in a marble and a carved wood version. It is based on an earlier plaster model of a reclining figure (lost), which the sculptor simply up-ended as a seated figure. The marble version (lost) is seated on a green marble plinth. The wood version is seated on a rough-hewn support from the same block. The patina on the Baltimore figure is exceptionally carefully handled.

119. ★RECLINING NUDE, c. 1909-1910
Bronze, 18"
Coll: Mr. and Mrs. Constantin Sczaniecki, Paris
Exh: Paterson's Gallery, London, April, 1911

This figure, integrated with its drapery, is a recension of a well-known classical bronze, sometimes called "Cleopatra," in the Museo delle Terme, Rome. During the 19th century, a black basalt figure was made in England (Neale & Co.) which was widely popular. The original from which Nadelman possibly drew his own projection was made by Primaticcio for François Premier. Apollinaire noted Nadelman's resemblance to this artist. The painter Poussin also adapted the pose of this semi-reclining figure in a number of paintings. Drawings by Nadelman supporting this com-

position are reproduced, Kirstein, *Drawings*, nos. 24, 25.
Plate 20

120. ★DANCING FIGURE, c. 1916-1918 (?)
Bronze, 29 ³/₄" (excluding base)
Coll: The Brooklyn Museum of Art, Brooklyn, New York

This figure was carved in marble for the garden of William Goadby Loew's estate on Long Island. Some six bronze casts exist, one owned by The Cleveland Museum of Art, Cleveland, Ohio, Bequest of James Parmalee; another by Mrs. Henry T. Curtiss, Bethel, Connecticut; and a third, the property of Mrs. Edward F. Hutton, was sold at Parke-Bernet, Lot 39, cat. no. 3373, in May, 1972, New York City.
Plate 39

121. ★WOMAN AT THE PIANO (*Femme au Piano*), 1917
Wood, stained and painted, 35 ¹/₈" h., base including piano 21 ¹/₂" × 8 ¹/₂"
Coll: Museum of Modern Art, New York City, The Philip L. Goodwin Collection
Prov: Nadelman Estate
Ref: Kirstein, Sculpture, p. 30 (illus.); Art Quarterly, no. 3, Autumn, 1958, p. 328 (illus.); Museum of Modern Art Bulletin, New York City, Vol. 26, no. 1, Fall, 1958, p. 11.

A copy, identical except for the block of wood supporting the piano-lid, is in the collection of the Fogg Art Museum, Cambridge, Massachusetts, the gift of Dr. and Mrs. John P. Spiegel. When the plaster model (destroyed) was first reproduced in *Vanity Fair*, April, 1918, the editor Frank Crowninshield gave it the topical title of "*La Pianiste: La Marseillaise.*"
Plate 118

122. HOSTESS, c. 1918-1920
Cherrywood and gesso, 32 ¹/₂"
Coll: The Hirshhorn Museum and Sculpture Garden, Smithsonian Institution, Washington, D. C.
Rep: NYA (unpaginated, in color)

123. ★LA FEMME ASSISE, c. 1918-1921 (?)
Cherrywood and wrought-iron, 33"
Coll: Private collection, New York City
Prov: Nadelman Estate

Exh: Museum of Modern Art, 1948, cat. no. 17
Ref: Kirstein, Sculpture, Cover, p. 31 (illus.).

Nadelman worked from a plaster model, the hair of which was painted blue. This was destroyed, 1917. A marble version, the arms of which are destroyed, is in the Nadelman Estate.

Plate 99

124. *LA FEMME ASSISE*, c. 1923-1930
Marble, 34"
Coll: Nadelman Estate

The two arms of the seated woman were broken in the move due to the loss of Nadelman's large studio. It was proposed that they be restored by Nadelman's early friend and compatriot, the distinguished sculptor, Count Auguste Zamoyski, but he had to leave the United States in order to found his own sculpture school in Brazil. This powerful figure is a stronger extension of the cherrywood "Femme Assise" of 1917.

125. SEATED FEMALE FIGURE, c. 1924
Galvano-plastique, 43¹/₄"
Coll: Nadelman Estate
Ref: Kirstein, Sculpture, p. 39 (illus. right); WH 28.

Governor Nelson A. Rockefeller had a bronze cast made in order to preserve permanence of the image, since the galvano-plastique medium is very fragile.

126. ★SEATED CIRCUS LADY, c. 1924
Galvano-plastique, 49¹/₂"
Coll: Nadelman Estate
Ref: Kirstein, Sculpture, p. 38 (illus.).

Plate 132

127. GIRL HOLDING RIGHT FOOT
c. 1928-1930 (?)
Marble, 15"
Coll: Nadelman Estate
Ref: WH 45.

This is a recension of the Roman bronze *"Spinario,"* the boy extracting a thorn from his foot. The right foot was broken and is repaired. Extant are a number of smaller variations of this figure in marble, terra cotta, glazed ceramic and papier-mâché. The finest of the small versions, mounted on a shaped green marble base, is owned by E. Jan Nadelman, the sculptor's son.

128. NUDE SEATED GIRL, c. 1940-1945 (?)
Marble (unfinished), 14³/₄"
Coll: Nadelman Estate
Ref: WH 51.

129. SEATED FEMALE NUDE, c. 1940-1945 (?)
Marble, 12"
Coll: Nadelman Estate
Ref: WH 60.

This is one of a series of some dozen small marble standing and seated nudes, left nearly complete at the sculptor's death. Four of the best were sold by Mrs. Nadelman; their present whereabouts are unknown, but they were all complete or nearly so.

130. ★STANDING FEMALE FIGURE, c. 1941
Plaster, 9"
Coll: Nadelman Estate

Plate 185

131. SEATED FEMALE NUDE, c. 1943
Orange marble, 14¹/₂"
Coll: Mrs. John D. Rockefeller, 3rd
Prov: Mrs. Elie Nadelman
Exh: Museum of Modern Art, New York City, 1948

Standing and Seated Male Figures

132. STANDING MALE NUDE, c. 1907-1908
Bronze, 37¹/₂"
Coll: Nadelman Estate
Ref: Guillaume Apollinaire, reporting the Salon d'Automne, Oct. 2, 1912, "Nadelman's Juggler (sic), a bronze that recalls the work of the Renaissance." Reprinted in Apollinaire on Art: Essays and Reviews, 1902-1918, edited by LeRoy C. Breunig, Viking Press, New York, 1972, p. 250; WH 102.

The model is very early; however, this cast has the foundry mark "J. M. O. Williams, New York" on rear base. Nadelman unquestionably brought plasters with him from Paris in 1914, from which later casts were made as seemed desirable. In most cases, the French casts and patinas are superior to the American.

133. ★AESOP, c. 1914
Bronze plaque, 10"
Lost.

Plate 45

134. ★MAN IN THE OPEN AIR, c. 1914-1915
Bronze, including base, 54¹/₂"
Coll: Museum of Modern Art, New York City, Gift of William S. Paley, 1949
Prov: Mrs. Elie Nadelman
Exh: Stieglitz's Gallery "291," January, 1915; Museum of Modern Art: "Memorial Show," 1948, "American Art of the Twentieth Century," February 1955-September 1956, "Paintings and Sculpture from The Museum's Collections," June 1967-June 1968; University of Nebraska Art Galleries, Lincoln, Nebraska, 1952; University of Kansas Museum of Art, Lawrence, Kansas, 1958; Munson-Williams-Proctor Institute, Utica, New York, 1960; Joslyn Art Museum, Omaha, Nebraska, 1961; Philbrook Art Center, Tulsa, Oklahoma, 1962
Ref: Kirstein, Sculpture, p. 25 (illus.); Town & Country, January, 1958, p. 108 (illus.).

The original plaster was first shown at Stieglitz's Gallery "291," 1915. Subsequently at least two bronze casts were made, of which the first is now in the Sculpture Garden of the Museum of Modern Art, New York City. Mrs. Nadelman had at least six further casts made after 1950. Examples are in The Sheldon Memorial Art Gallery, University of Nebraska, F. M. Hall Collection, Lincoln, Nebraska; the collection of Austin Briggs, Connecticut; and the collection of Mrs. Donald B. Straus, New York City.

Plate 66

135. CIRCUS CLOWN, c. 1915-1917
Bronze, 8¹/₂"
Coll: E. Jan Nadelman, Riverdale, New York

Another copy exists in a private collection, New York City.

136. ACROBAT IN HANDSTAND, c. 1916
Bronze, on square green marble base, 10³/₄."
Coll: Nadelman Estate
Ref: Kirstein, Sculpture, p. 25 (illus.); WH 101.

There are two distinct versions, the original having a bow-tie on the acrobat's chest. Subsequent (and also posthumous) casts have omitted the bow-tie. Mrs. Nadelman said that the sculptor never decided which was preferable. Several copies were made, c. 1948, at the Modern Bronze Foundry.

137. ★CHEF D'ORCHESTRE, c. 1919-1921
Cherrywood and gesso, 37" (excluding 1¹/₄," base)
Coll: The Hirshhorn Museum and Sculpture Garden, Smithsonian Institution, Washington, D. C.

Exh: Museum of Modern Art, New York City, 1948, cat. no. 20
Ref: NDI, p. 148 (illus.); Kirstein, Sculpture, p. 32 (illus.).

Plaster models of the head (enlarged) and of the whole figure existed, which were destroyed. An identical replica exists in a New York private collection. A silk-screen painting of the figure was used as a poster for the Tenth Anniversary Celebration of The City Center of Music & Drama, Inc., New York City, in 1953. Martin Birnbaum reported that originally Nadelman had intended the figure to hold a violin but canceled the idea as unstructural.

Plate 79

138. ★ HOST, c. 1920-1923
Cherrywood, gesso and wrought-iron, 28¹/₂."
Coll: Private collection, New York City
Prov: Nadelman Estate
Exh: Museum of Modern Art, New York City, 1948, cat. no. 18
Ref: Kirstein, Sculpture, p. 29 (illus.); NYA (unpaginated, in color).

The painter, Jules Pascin, and the art critic, Adolphe Basler, have been suggested as possible models. A second copy, identical with the above, is in The Hirshhorn Museum and Sculpture Garden, Smithsonian Institution, Washington, D. C.

Plates 100, 101

139. ★STANDING MALE FIGURE, c. 1940
Plaster, 12"
Coll: Nadelman Estate
Plate 186

140. ★STANDING MALE FIGURE, c. 1940
Plaster, 10"
Coll: Nadelman Estate
Plate 187

141. EROS STANDING AND POINTING
c. 1940-1945 (?)
Bronze, 26" (including base)
Coll: Michael de Lisio, New York City
Prov: Robert Isaacson Gallery, New York City
Exh: Edwin Hewitt Gallery, New York City, April 7-30, 1958

Unique posthumous cast, a variant or prototype for a larger version of the same subject, also mounted on a decorated base.

142. ★CHILD GOD, c. 1943-1945
Penciled plaster, 9"
Coll: Nadelman Estate

Plate 204

143. ★CHILD GODS, c. 1943-1945
Plaster, 9" to 15"
Coll: Nadelman Estate

Plate 205

Combined Figures

144. TWO WOMEN, c. 1907-1908
Gilt bronze, 20¹/₂"
Signed, lower right on base: "E. Nadelman"
Coll: Joslyn Art Museum, Omaha, Nebraska, Gift of Martin Birnbaum
Exh: Sheldon Gallery, Lincoln, Nebraska, November, 1968
Ref: Sale Catalogue for Alexandre Natanson's collection, Paris, May 16, 1929, cat. no. 130 (illus.).

145. TWO NUDES: BAS RELIEF, c. 1911
Plaster, 47¹/₂" × 49¹/₂"
Coll: Zabriskie Gallery, New York City
Prov: Madame Helena Rubinstein

146. TWO NUDES: BAS RELIEF, c. 1911
Bronze, cast from plaster, 1966, ed. 5, 47¹/₂" × 49¹/₂"
Coll: Zabriskie Gallery, New York City
Prov: Madame Helena Rubinstein

The bronze cast was made subsequent to the Rubinstein Sale of 1966. Madame Helena Rubinstein owned the original plaster.

147. WOMAN WITH DOG, c. 1911
Wood relief, 11¹/₂" × 15"
Coll: Zabriskie Gallery, New York City
Prov: Higford Griffith

148. LE PRINTEMPS, c. 1912
Bronze, 44¹/₂"
Coll: Whitney Museum of American Art, New York City

This bronze cast from a plaster panel formerly in the collection of Madame Helena Rubinstein is either an original from one of the four plaster decorations for her billiard-room in London, or a related piece.

149. ★L'AUTOMNE, c. 1914
Bronze plaque, 7"
Coll: Nadelman Estate; W. McNeil Lowry, New York City

Plate 46

150. ★SUR LA PLAGE, 1916
Marble and bronze, 21"
Coll: Sara Roby Foundation, on loan to the Whitney Museum of American Art, New York City

The luxurious combination of marble and bronze, both highly finished and polished, is unique in Nadelman's work. The photographs here illustrating it give only an indication of the exquisite aptness with which the sculptor harmonized and joined the forms of maid, tree and bather.

Plates 145, 146

151. ★TANGO, c. 1923-1924 (?)
Cherrywood and gesso, 34"
Coll: Private collection, New York City
Prov: Nadelman Estate
Exh: Museum of Modern Art, New York City, 1948, cat. no. 15; Worcester Art Museum, "Dial Exhibition," April-September, 1959; Downtown Gallery, New York City, 36th Spring Exhibition, May-June, 1962; Corcoran Gallery of Art, Washington, D.C., April, 1963; Whitney Museum of American Art, New York City, August, 1966; Amon Carter Museum, Fort Worth, Texas, September, 1967; Library and Museum of the Performing Arts, Lincoln Center, New York City, "The Dance in Sculpture," February 1-April 30, 1971
Ref: NDI, p. 141 (illus.); Kirstein, Sculpture, p. 28, (illus.).

There is a second version, formerly owned by Mrs. Edith Halpert of the Downtown Gallery. She showed the two figures separated and apart in an attempt to sell them separately.

Plate 115

152. ★BURLESQUE GIRLS, c. 1925
Painted plaster, 6" and 8"
Coll: Nadelman Estate

Plate 126

153. ★TWO CIRCUS WOMEN, c. 1930
Plaster covered with paper, 61¹/₄"
Coll: Nadelman Estate
Ref: Kirstein, Sculpture (frontispiece).

The original model for one of the statues, cut in marble in 1965, Carrara, Italy, and installed in the

Promenade of the State Theater, Lincoln Center, New York City. A replica is in the home of the architect, Philip Johnson, New Canaan, Connecticut.

Plate 165

154. BOY WITH DOLPHIN, c. 1930-1935 (?)
Bronze, 34"
Coll: Nadelman Estate

Nadelman left a complete plaster which was posthumously cast in bronze, c.1950. A lead version also exists. The figure was conceived as a fountain-support for a sundial. The treatment of the water recalls his "Aquarius" (plate 151).

155. ★TWO FEMALE NUDES, c. 1931
Plaster covered with paper, 59"
Coll: Nadelman Estate
Ref: Kirstein, Sculpture, p. 44 (illus.).

The original model, of which there are two identical copies, for the paired seated and standing figures in the Promenade of the State Theater, Lincoln Center, New York City.

Plate 164

156. ★GIRL WITH POODLE, c. 1935
Papier-mâché, 10"
Coll: Nadelman Estate

Plate 171

157. ★GIRL WITH POODLE, c. 1935-1940
Plaster, 12"
Coll: Nadelman Estate

Plate 172

158. ★WOMAN DRESSING ANOTHER'S HAIR, c. 1935-1940
Papier-mâché, 14¹/₄"
Coll: Nadelman Estate

Plate 162

159. TWIN STANDING FEMALE NUDES c. 1935-1940 (?)
Terra cotta, 5¹/₄"
Coll: Private collection, New York City

Mrs. Nadelman considered this small double figure an initial idea for the standing women, first realized in plaster and paper, subsequently in marble, for the Promenade of the State Theater, Lincoln Center, New York City. The piece is unique; Nadelman fired it in his kiln. Its size and simplicity would hardly imply a need for permanence, unless he wished to retain the concept for further work.

160. ★STANDING AND SEATED FEMALE NUDES, c. 1935-1940
Terra cotta, 10"
Coll: Nadelman Estate

Plate 163

Architectural Sculpture

161. ★CONSTRUCTION WORKERS, 1930-1932
Limestone, 144"
Coll: Fuller Building, Fifty-Seventh Street at Madison Avenue, New York City

There is a small plaster preparatory sketch (plate 148) which anticipates the plump infants of Nadelman's final years.

Plate 149

162. ★AQUARIUS, 1933
Bronze, 112"
Coll: Bank of the Manhattan Company (now Chase Manhattan), 40 Wall Street, New York City, removed in the remodeling of the building
Lost or destroyed.

Plate 151

163. EAGLE, 1933
Bronze, 38"
Coll: First National Bank, Broadway at Wall Street, New York City

This stylized eagle supports the flagpole over the door of the bank building, designed by Stewart Walker.

Portraits

164. ★THADÉE NATANSON, 1909
Bronze, 22"
Coll: Unknown
Prov: Ex-coll. Thadée Natanson, Paris
Exh: Galerie Druet, Paris, April, 1909
Ref: Kirstein, Sculpture, p. 60 (illus.); Natanson, Peints à leur tour, Paris, 1948, p. 241.

This head, modeled in two sittings as a contrast to other more formally 'abstract' pieces in Nadelman's first one-man show, recalls Rodin's bust of Antonin Proust, c. 1883.

Plate 83

165. STEVENSON SCOTT, c. 1916
Marble, 21"
Coll: Joslyn Art Museum, Omaha, Nebraska, Gift of Mrs. Stevenson Scott, 1946

Scott of the firm of Scott & Fowles was Nadelman's dealer from 1915 through 1925.

166. ★PORTRAIT OF A LITTLE GIRL, 1916
Marble, 22"
Coll: Metropolitan Museum of Art, New York City
Ref: "American Sculpture: A Catalogue of the Metropolitan Museum of Art," illus. p. 145.

Marie Scott was the daughter of Stevenson Scott, of the firm of Scott & Fowles, Nadelman's dealer in New York from 1915 through 1925. A number of drawings from life exist in pen and ink.

Plates 84, 85

167. ★MRS. CHARLES TEMPLETON CROCKER ("Hélène Irwin Fagan"), 1917
Marble, 29"
Coll: California Palace of the Legion of Honor, San Francisco, California, lent by the William G. Irwin Charity Foundation
Ref: Kirstein, Sculpture, p. 61 (illus. but incorrectly dated 1922).

This portrait, perhaps Nadelman's finest, recalls Rodin's busts of Madame Vicuna (1888) and la Comtesse de Noailles (c. 1907).

Plate 87

168. ★PORTRAIT OF JANE WALLACH
c. 1917-1918
Marble, 26 3/4"
Signed on back, lower left: "Elie Nadelman"
Coll: The Brooklyn Museum of Art, Brooklyn, New York, Gift of Miss Edna Barger, 1954

Miss Wallach was a patron of young students of the performing arts. This bust recalls the marble and terra cotta portraits executed in Verrocchio's studio, c. 1475.

Plate 86

169. MABEL PRESTON, c. 1923
Marble, 48"
Coll: Mrs. L. B. Preston, Mount Kisco, New York

This splendid life-size figure in marble of a young girl with outstretched arms, mounted on a decorative pedestal, was commissioned for a rose garden.

170. FRANCIS NEILSON, 1923-1924
Marble, 16"
Signed: "Elie Nadelman"
Coll: Unknown

All attempts to trace the present location of this admirable portrait have failed. It was on loan at The Chicago Art Institute through May, 1924. Nadelman had a show at the progressive Arts Club of Chicago (at The Art Institute) in May, 1925 under the direction of Mrs. John Alden Carpenter. Neilson had married a member of the Swift family and was himself English, a nephew of W. E. Gladstone, and an ardent follower of the single-tax exponent Henry George.

171. MARIE SCOTT, 1925
Marble, 21 1/2" (with bronze base, 5")
Coll: Los Angeles County Museum of Art, Los Angeles, California, Gift of Mrs. Stevenson Scott, 1958
Ref: Los Angeles County Museum of Art Bulletin, no. 4, 1958

Nadelman had portrayed Marie Scott, the daughter of his dealer Stevenson Scott, ten years before. An early photograph shows this portrait (or possibly another version of it) on a plain onyx base without the bronze base in which a plaque has been inset of a small bas-relief resembling "L'Automne" (plates 43, 46), (c. 1913-14).

172. ★BUST OF A WOMAN (Henrietta Stettheimer?), c. 1926-1928 (?)
Brass, painted with Prussian blue, 23 5/8"
Coll: Private collection, New York City
Exh: Museum of Modern Art, New York City, 1948, cat. no. 32
Ref: Kirstein, Sculpture, p. 42 (illus.).

Plate 139

173. ROBERT S. CLARK, c. 1928
Marble, 15 1/2"
Coll: Sterling and Francine Clark Art Institute, Williamstown, Massachusetts

A bronze version, probably from the original clay study, was cast in the identical dimension and is in the Sterling and Francine Clark Museum.

174. MRS. ROBERT STERLING CLARK
c. 1928
Marble, 14 1/4"
Coll: Sterling and Francine Clark Art Institute, Williamstown, Massachusetts

A terra cotta version of Mrs. Clark's portrait exists in the Nadelman Estate, but it was not cast in bronze.

175. SENATOR CARTER GLASS, 1934
Marble, 14 ³/₄"
Signed: "Elie Nadelman"
Coll: Library Reading Room, The University of Virginia, Charlottesville, Virginia

Nadelman took particular pride in his portrait of this distinguished American publisher and statesman, and preserved the plaster original, which is in the Nadelman Estate.

176. GYMNAST, c. 1934
Bronze, 13 ³/₄"
Coll: Nadelman Estate

This miniature full-length portrait was refused by the parents of the model, after two versions in plaster were made. The original cast, mounted on a green marble base, is in the Nadelman Estate. Subsequently some four copies of the first version were cast in bronze. The refused original is in the collection of Martin Liefer, New York City.

177. ★CHARLES BAUDELAIRE, c. 1940-1945 (?)
Marble, 17"
Coll: The Hirshhorn Museum and Sculpture Garden, Smithsonian Institution, Washington, D. C.

Nadelman had in his files a photograph of the great French poet by Etienne Carjat (plate 156). Unfinished at the sculptor's death, the lump of stone on the forehead used to point the stone from the plaster was removed by George Baillie, a stonecarver often employed by Nadelman from 1928 to rough-out his work. Otherwise, the head was untouched.

Plates 158, 159

PORTRAITS (Supplementary)
Nadelman made some two dozen portraits between 1915 and 1935. The following are known to exist, or to have existed, but complete information is not currently available.
Mrs. (?) Blagdan, c. 1917, marble
Lady Vivian Gabriel, c. 1918, marble, (Mount Kisco?)
Francis P. Garvan, Jr., c. 1930, marble, (Mrs. Francis P. Garvan, New York City)
Patricia Garvan, c. 1930, marble, (Mrs. Francis P. Garvan, New York City)

Mrs. James Gardiner Gayley, (Mrs. Frances Montgomery, New York City)
Mrs. Clarence Hay, c. 1922, wood, (Mrs. Clarence Hay, New York City)
Ruth Maguire, c. 1918, marble
Gerrish H. Milliken, c. 1918, marble
Sandra Stralem, c. 1933, marble, (Mrs. Robert Alan Russell, New York City)
Frederick Crocker Whitman, c. 1917-18, (F. C. Whitman, San Francisco)
Mrs. Charles Romer Wilson, c. 1918, marble, (London?)
Grenville Lindall Winthrop, c. 1919, marble, (New York City?)

Horses and Equestrian Figures

178. ★WOMAN ON A HORSE, c. 1912
Bronze relief plaque, 7 ¹/₁₆" × 7 ⁷/₁₆" × ⁵/₁₆"
Coll: The Worcester Art Museum, Worcester, Massachusetts, on loan from The Dial Collection
Prov: Galerie Flechtheim, Berlin
Exh: Non-jury Salon, Berlin, 1913
Ref: "The Dial and The Dial Collection," Worcester Art Museum Bulletin, 1959, cat. no. 68.

Plate 50

179. HORSE, c. 1913-1914
Bronze, 36 ¹/₄"
Coll: Robert Schoelkopf Gallery, New York City
Prov: Madame Helena Rubinstein
Ref: Art Quarterly 31, no. 108, Spring, 1968; John I. H. Bauer, Revolution and Tradition in Modern American Art, Cambridge, Massachusetts, 1958: plate 70 reproduces the plaster.

This piece remained in plaster until the Rubinstein auction of 1966. Due to the delicacy of the attachment of the feet to the base, there was some damage. Casts in bronze were made, of which one was painted white in imitation of the plaster original, which it seems Nadelman wished to retain uncast. Of these, one is in the Nadelman Estate. Others are in the Amon Carter Museum, Fort Worth, Texas (1967). Another is in the Baltimore Museum of Art, Baltimore, Maryland, (Mabel Garrison Siemonn Fund, 1967).

180. ★HORSE, c. 1914
Bronze, 13 ¹/₂"
Signed on base: "Elie Nadelman"
Coll: The Worcester Art Museum, Worcester, Massachusetts, on loan from The Dial Collection

Prov: Galerie Flechtheim, Berlin
Ref: "The Dial and The Dial Collection," Worcester Art Museum Bulletin, *1959, cat. no. 70.*

In January, 1913, Nadelman exhibited in a non-jury exhibition in Berlin, where his work was noted by the distinguished dealer, Alfred Flechtheim. *The Dial* was the most distinguished literary magazine of the American 'Twenties, backed by Schofield Thayer and Dr. Sibley Watson who purchased a large number of outstanding examples of progressive art of the period for reproduction in an influential *Dial* portfolio.

Plate 51

181. ★HORSE, c. 1914
Bronze, 12 ³/₄"
Coll: The Hirshhorn Museum and Sculpture Garden, Smithsonian Institution, Washington, D. C.

This seems to be a first casting of the reduction of the large horse in plaster, owned by Madame Helena Rubinstein prior to 1914. There were two copies of the small horse in the Nadelman Estate. Subsequent to 1955, at least six more were cast by the Modern Art Foundry.

Plate 55

182. HORSE AND HOUNDS, c. 1914-1915 (?)
Bronze plaque, 12"
Coll: E. Jan Nadelman, Riverdale, New York

There are at least two copies of this plaque, possibly cast long after the first here noted.

Animals and Birds

183. ★STANDING BULL, c. 1915
Bronze, 6⁵/₈" × 11 ¹/₄"
Colls: Museum of Modern Art, New York City; Honolulu Academy of Arts, Honolulu, Hawaii, Gift of Mrs. Walter F. Dillingham; Nadelman Estate
Ref: Kirstein, Sculpture, *p. 23 (illus.); Fred Licht, A* History of Western Sculpture, *Vol. IV, 1967, pl. 238.*

There were probably some six casts in bronze, of which the earlier have onyx and the later green marble bases. There were further posthumous casts made, c. 1950.

Plate 54

184. ★WOUNDED BULL, 1915
Bronze, 5⁷/₈" × 11 ¹/₂"
Colls: Museum of Modern Art, New York City; Hono-

lulu Academy of Arts, Honolulu, Hawaii, Gift of Mrs. Walter F. Dillingham; Nadelman Estate*

Mr. Philip Sills, Riverdale-on-Hudson, New York, owns both "Wounded Bull" and "Standing Bull" in early castings.

Plate 58

185. ★DOE WITH LIFTED LEG, c. 1915
Bronze, 20 ¹/₂"
Coll: Museum of Art, Rhode Island School of Design, Providence, Rhode Island, Bequest of Miss Ellen Sharpe

Other casts are in the collections of The California Palace of The Legion of Honor, San Francisco, California, on loan from the Estate of Hélène Irwin Fagan; The Corcoran Gallery of Art, Washington, D. C., Gift of Mrs. John B. Hayward.

Plate 57

186. WOUNDED STAG, c. 1915
Bronze, 17¹/₂" (base length, 21")
Coll: Detroit Institute of Arts, Detroit, Michigan, (purchased from City Appropriation, 1919)
Prov: Scott & Fowles, New York City
Exh: Flint Institute of Art, Flint, Michigan, "American Sculpture 1900-1965," April 1-25, 1965, cat. no. 50; Smithsonian Institution, Washington, D. C., "Roots of Abstract Art in America: 1910-1930," December 2, 1965-January 9, 1966, cat. no. 131

There are at least six and possibly more copies of this "Wounded Stag," some of which have an arrow piercing the animal. This was cast in a separate piece; some collectors considered the presence of the arrow disturbingly cruel. A variety of patina exists, some with light gilding.

187. STANDING BUCK, c. 1915
Bronze, 29"
Coll: Museum of Art, Rhode Island School of Design, Providence, Rhode Island, Bequest of Miss Ellen Sharpe

Another cast is in the collection of The California Palace of The Legion of Honor, San Francisco, California, on loan from the Estate of Hélène Irwin Fagan.

188. ★RESTING STAG, c. 1915
Bronze, 17¹/₂" (excluding base)

Coll: Detroit Institute of Arts, Detroit, Michigan, (purchased from City Appropriation)
Prov: Scott & Fowles, New York City
Exh: Smithsonian Institution, Washington, D. C., "Roots of Abstract Art in America: 1910-1930," December 2, 1965-January 9, 1966
Ref: Detroit Institute of Arts Bulletin, Vol. 1, no. 5, February, 1920.

There are at least six and possibly more copies of this "Resting Stag," of which the antlers of several are gilded. Examples are owned by Henry Mc-Ilhenny, Philadelphia, and Mrs. Henry T. Curtiss, Bethel, Connecticut. The Brooklyn Museum has a copy which has been entitled "Gazelle" and is misdated (1930-1935). It was the bequest of Mrs. Margaret Lewisohn, 1954.

Plate 56

189. DUCK, c. 1932-1936 (?)
Marble, 11"
Coll: Nadelman Estate
Ref: WH 16.

Two marble versions exist, one possibly unfinished; there is a single bronze cast (private collection, New York City); drawings exist, the gift of Wright Ludington to the Santa Barbara Museum, Santa Barbara, California.

190. TWO RECLINING FAWNS, 1941
Bronze, 38"
Coll: Myron Taylor, Locust Valley, Long Island, New York

The stags face each other on brick posts, painted white, about twelve feet high, and were commissioned for Killingsworth, the Taylor Estate.

DRAWINGS

Female Heads

1. CONCEPTUAL HEAD AND NECK
c. 1904-1907
Pen and black ink, 7¹/₂" × 5¹/₂"
Initialed, lower right: "E N"
Coll: Unknown
Ref: Kirstein, Drawings, no. 2.

2. FEMALE HEAD AND NECK, c. 1904-1907
Pen and black ink, 12" × 6"
Signed, lower left: "Nadelman"
Coll: Unknown
Ref: Reproduced, VUP; Kirstein, Drawings, no. 9.

3. FEMALE HEAD, NECK, BUST AND DRAPERY, c. 1904-1907
Pen and ink, 12¹/₂" × 7¹/₂"
Initialed, lower right: "E N"
Coll: Unknown
Ref: Reproduced, VUP; Kirstein, Drawings, no. 10.

4. ★OVOID HEAD AND NECK, c. 1904-1907
Pen and black ink, 11¹/₂" × 6"
Signed, lower right: "E. Nadelman"
Coll: Unknown
Ref: Reproduced from VUP; VBP, p. 11; NYA, p. 38 (without signature); Kirstein, Sculpture, p. 14 (without signature); Kirstein, Drawings, no. 8.

Plate 29

5. WOMAN'S HEAD WITH TRESSES
c. 1904-1907
Pen and ink, 19⁵/₈" × 12³/₈"
Signed, lower right, in pencil and ink
Coll: Museum of Modern Art, New York City, Gift of Lincoln Kirstein in memory of René d'Harnoncourt
Ref: Kirstein, Drawings, no. 6.

6. OVOID HEAD AND NECK, c. 1904-1907
Pen and black ink on tan paper, 13³/₄" × 9"
Signed, lower left: "Elie Nadelman" (in pencil over effaced monogram)
Coll: Unknown
Ref: Kirstein, Drawings, no. 5.

7. CONCEPTUAL HEAD, NECK AND SHOULDERS, c. 1904-1907
Pen and black ink, 7¹/₄" × 4³/₄"
Initialed, lower right: "E N"
Coll: Unknown
Ref: Reproduced, VUP; VBP, pl. 4; NYA, p. 32; Kirstein, Drawings, no. 4.

This hasty sketch marks a development in the drawings as it is more calligraphic than an aid to plasticity. Increasingly, Nadelman's graphic idiom leads to an expression independent of individual sculptural works but reflecting them.

8. CONCEPTUAL HEAD AND NECK
c. 1904-1907
Pen, black and brown ink on beige paper, 11⁷/₈" × 7¹/₂"
Initialed, lower right: "E N" (in pencil, at a later date)
Coll: Metropolitan Museum of Art, New York City, Gift of Lincoln Kirstein, 1965
Ref: Kirstein, Drawings, no. 3

9. CONCEPTUAL HEAD AND NECK
c. 1904-1907
Pencil on lined note-paper, 6³/₈" × 5³/₈"
Initialed, lower right: "E N"
Coll: Museum of Modern Art, New York City

This very rough drawing, on poor paper, was carefully saved by Nadelman, as representing a very early analytical projection.

10. ★HEAD, c. 1906
Pen and ink, 7¹/₈" × 5¹/₂"
Initialed, lower right: "E N" (in pencil, at a later date)
Coll: Museum of Modern Art, New York City, Gift of Lincoln Kirstein in memory of René d'Harnoncourt, 1969
Ref: Reproduced, VUP; VBP; NYA, p. 30; Kirstein, Sculpture, p. 14; Kirstein, Drawings, no. 1.

This is possibly the earliest extant drawing of Nadelman's. He considered it of seminal importance for the initial analytical projection leading to his first Parisian heads and figures.

Plate 15

11. ★FEMALE HEAD, c. 1908
Pen and ink, 8¹/₂"
Coll: Unknown
Ref: VBP.

Plate 6

12. FEMALE HEAD WITH HANDS, c. 1909
Pencil and ink on tan paper, 8" × 5"
Signed, upper left corner: "Elie Nadelman"
Coll: Santa Barbara Museum of Art, Santa Barbara, California, Gift of Wright Ludington
Ref: Reproduced, VUP.

13. HEAD OF A GIRL, c. 1909-1911
Pen and ink, 8¹/₂" × 5³/₄"
Initialed lower right: "E N"
Coll: Museum of Modern Art, New York City
Prov: Ex-coll. Madame Helena Rubinstein

14. HEAD OF A WOMAN WITH BANGS
c. 1911 (?)
Brush and pale gray wash, 3³/₄" × 2³/₈"
Coll: Private collection, New York City
Prov: Mrs. Elie Nadelman

15. PROFILE FEMALE HEAD AND BUST
c. 1911
Pen and bistre ink on tan paper, 6¹/₄" × 3³/₄"
Signed, lower right: "Elie Nadelman"
Coll: Unknown
Ref: Kirstein, Drawings, no. 7.

16. WOMAN'S HEAD, c. 1912-1914 (?)
Pen, pencil, 13³/₄" × 16¹/₈"
Coll: E. Jan Nadelman, Riverdale, New York

17. WOMAN'S HEAD, BUST AND SHOULDERS, c. 1913 or later
Ink over pencil, 17¹/₂" × 13³/₄"
Initialed in pencil with monogram: "E N"
Coll: Lester Avnet, New York City
Prov: Edwin Hewitt Gallery, New York City; Nadelman Estate
Exh: "Modern Master Drawings and Watercolors," Felix Landau Gallery, Los Angeles, California, April 3-29, 1967, no. 36

18. ANDROGYNOUS HEAD WITH FILET AND BOW, c. 1915
Pencil on paper, 6⁵/₈" × 4³/₈"
Stamped: "E. N."
Coll: Martin Liefer, New York City
Prov: Mrs. Elie Nadelman

19. VEILED WOMAN'S HEAD, c. 1915-1916
Pen and ink, over pencil indications, 9¹/₂" × 7¹/₄"
Monogrammed, pencil, lower left: "E N"

Coll: Museum of Art, Rhode Island School of Design, Providence, Rhode Island
This extremely carefully drawn design, done in the precise cross-hatching of a steel engraving, is inscribed in pen to the "très honoré Madame E. G. Radeke, respectueusement, Eli Nadelman". Mrs. Radeke had bought the first piece by Nadelman to enter an American museum. This drawing is perhaps the source of the style of many of Nadelman's later dry-points and etchings.

20. WOMAN'S HEAD WITH COIFFURE
c. 1916-1917
Pencil, 9³/₄" × 13¹/₄"
Coll: E. Jan Nadelman, Riverdale, New York

21. FEMALE PROFILE HEAD WITH COIFFURE, c. 1917
Pencil and watercolor, 10¹/₄" × 7³/₈"
Stamped, lower right: "E N"
Coll: Robert Schoelkopf Gallery, New York City

22. ★WOMAN'S HEAD AND HAIR-DO
1917-1920
Pencil, 9"
Coll: Nadelman Estate
Plate 138

23. WOMAN'S HEAD, c. 1919-1922
Fine pen and India ink, 7" × 4"
Coll: Unknown
Ref: Kirstein, Drawings, no. 57.
This exquisite drawing relates to a marble head in the collection of the artist's son, Jan Nadelman, and also exists in bronze in the Coe Kerr Galleries, New York City.

24. WOMAN'S HEAD WITH HAIR IN THREE BUNS, c. 1920-1922
Soft lead pencil, deliberately rubbed, 9¹/₂" × 7¹/₂"
Coll: Unknown
Ref: Kirstein, Drawings, no. 52.

25. WOMAN'S HEAD WITH PETIT RUBAN
c. 1920-1922
Pen, brush and fountain pen ink, 10¹/₂" × 6¹/₂"
Coll: Museum of Modern Art, New York City, Gift of Lincoln Kirstein in memory of René d'Harnoncourt
Ref: Kirstein, Drawings, no. 53.
The treatment of eye and lips derives from Pennsylvania-German *fraktur* pictures and their calligraphic decoration.

26. WOMAN'S HEAD IN PROFILE, c. 1923
Pen, pencil, brush and blue ink, 8 3/4" × 7 3/4"
Signed in pencil: "E N"
Coll: Michael Hall, New York City
Ref: Kirstein, Drawings, no. 45.

27. WOMAN'S HEAD AND BUST, c. 1923-1925
India ink, pen, brush and rubbed pencil, 6" × 4 1/2"
Coll: Unknown
Ref: Kirstein, Drawings, no. 56.
This is a study for the disposition of color on the galvano-plastique heads, now almost entirely faded.

28. WOMAN'S HEAD WITH BEADED
NECKLACE, c. 1923-1925
Brown wax crayon, 8" × 6"
Coll: Unknown
Ref: Kirstein, Drawings, no. 54.
This and the following drawing are possibly portraits and relate to the painted brass heads, such as that in plate 139.

29. WOMAN'S HEAD IN PROFILE WITH
BEADED NECKLACE, c. 1923-1925
Brown wax crayon, 8" × 6"
Coll: Unknown
Ref: Kirstein, Drawings, no. 54.

30. PROFILE OF A WOMAN, c. 1925
Pencil, 9"
Coll: Nadelman Estate
Plate 179

31. ⋆WOMAN'S HEAD WITH HAIR-DO
c. 1926-1927
Pencil, 4 1/2"
Coll: Nadelman Estate
Plate 136

Male Heads

32. ⋆HEAD OF MERCURY, c. 1913
Crayon, 8"
Coll: Nadelman Estate
Plate 60

33. ⋆PROFILE OF MAN IN BOWLER HAT
c. 1914
Pen, brush and India ink, 7 1/2" × 4 1/2"
Signed in pencil: "E N"

Coll: Unknown
Ref: Kirstein, Drawings, no. 35.
Study for the head of "Man in the Open Air," (plates 62-66).
Plate 59

34. ⋆MALE HEAD IN PROFILE, c. 1915
Pen and brush, 7 1/2"
Coll: Nadelman Estate
Plate 153

35. IDEAL MALE PROFILE HEAD, c. 1916
Pen, brush and India ink, 3 1/4" × 2 1/2"
Coll: Unknown
Ref: Kirstein, Sculpture, p. 57; Drawings, no. 37.
This profile is related to the so-called "ideal self-portrait" (plates 154, 155).

36. IDEAL MALE PROFILE HEAD, c. 1916
Soft lead pencil, 9" × 7 3/4"
Coll: Private collection, New York City
Ref: Kirstein, Drawings, no. 36.
This profile and others related to it are studies for the so-called "ideal self-portrait" (plates 154, 155).

37. ⋆MAN IN A TOP HAT, c. 1918
Pen and ink, 6"
Coll: Nadelman Estate
Plate 140

38. ⋆PROFILE OF A MAN, c. 1925
Pencil, 9"
Coll: Nadelman Estate
Plate 180

Standing Female Figures

39. STANDING FEMALE NUDE, c. 1907
Pen and black ink, 8 1/2" × 3 3/4"
Signed, lower right: "Elie Nadelman"
Coll: Unknown
Ref: Reproduced, VUP; Kirstein, Drawings, no. 14.

40. STANDING FEMALE FIGURE, c. 1907
Pen and ink, 7 5/8" × 2 5/8"
Initialed with monogram, lower right: "E N"
Coll: Museum of Modern Art, New York City
Prov: Ex-coll. Madame Helena Rubinstein

41. ★STANDING FEMALE NUDE, c. 1907
Pen and ink, 10"
Coll: Unknown

Plate 32

42. STANDING FEMALE NUDE, c. 1907
Pen and black ink, 9$^1/_2$" × 4$^1/_2$"
Signed, lower right: "Eli Nadelman"
Coll: Unknown
Ref: Reproduced, VUP; Kirstein, Drawings, no. 15.

43. ★STANDING FEMALE NUDE, c. 1907-1909
Pen and black ink, 10$^3/_4$" × 2$^7/_{16}$"
Signed, lower right: "E Nadelman"
Coll: Unknown
Ref: Reproduced, VUP; VBP, pl. 13; NYA, p. 39; Kirstein, Drawings, no. 13.

Plate 31

44. STANDING FEMALE NUDE, LOOKING TO THE RIGHT, 1907-1909
Pen and ink on brownish paper, 19$^1/_4$" × 8$^1/_8$"
Signed in pencil, lower right (later?): "Elie Nadelman"
Coll: Private collection, New York City
Prov: Mrs. Elie Nadelman

45. STANDING FEMALE NUDE, c. 1907-1909
Pen on brownish paper, 19$^3/_4$" × 8$^3/_4$"
Signed in pencil, lower right (later?): "Elie Nadelman"
Coll: Private collection, New York City
Prov: Mrs. Elie Nadelman

46. STANDING FEMALE NUDE, c. 1907-1910
Pen, pencil and black ink on tan tracing-paper, 21$^3/_4$" × 8$^3/_4$"
Signed, lower right: "Elie Nadelman"
Coll: The Hirshhorn Museum and Sculpture Garden, Smithsonian Institution, Washington, D. C.
Prov: Mrs. Elie Nadelman
Ref: Reproduced, VUP; VBP, pl. 17; Kirstein, Drawings, no. 20.

47. STANDING FEMALE NUDE WITH RAISED ARM, c. 1907-1910
Pen and black ink, 11$^1/_2$" × 4$^3/_4$"
Signed, lower right: "Eli Nadelman"
Coll: Museum of Modern Art, New York City
Prov: Mrs. Elie Nadelman
Ref: Reproduced, VUP; VBP, pl. 27; NYA, p. 45; Kirstein, Drawings, no. 19.

48. TWO STANDING FEMALE NUDES, FRONTAL AND PROFILE, c. 1907-1910
Pen and ink, 14$^1/_4$" × 12$^1/_8$"
Initialed in pencil, lower center: "E N"
Coll: Museum of Modern Art, New York City
Exh: Museum of Modern Art, New York City: "The Sculpture of Elie Nadelman," 1948; "Made in New York State," June-December, 1960; "Paintings, Sculpture and Graphic Arts from the Museum Collections," October, 1962 - February, 1963. M. Knoedler & Co., New York City, April, 1951. Brooklyn Museum of Art, Brooklyn, New York: "American Drawings," January-March, 1957. Zabriskie Gallery, New York City, February-March, 1967
Ref: Reproduced (left figure only), Kirstein, Drawings, no. 27.

49. ★STANDING FEMALE NUDE, c. 1908
Pen and ink, 10"
Coll: Unknown
Ref: Reproduced, VUP.

Plate 119

50. ★STANDING FEMALE NUDE, c. 1908
Pen and ink, 9"
Coll: Unknown
Ref: VBP.

Plate 184

51. SUPPLIANT STANDING FEMALE NUDE
c. 1908
Pen and ink, 8$^3/_4$" × 3$^1/_2$"
Initialed, sideways, left: "E N"
Coll: Unknown
Ref: Reproduced, VUP; VBP, pl. 16; Kirstein, Drawings, no. 26.
This drawing relates to the *orans*-type bronzes of Nadelman's earliest standing figures.

52. STANDING FEMALE NUDE, c. 1908-1910
Drafting-pen and India ink, 10$^1/_2$" × 2$^3/_4$"
Signed, lower right: "Elie Nadelman"
Coll: Unknown
Ref: Reproduced, VUP; VBP, pl. 24; NYA, p. 24; Kirstein, Drawings, no. 18.

53. ★STANDING DRAPED FEMALE NUDE
c. 1910
Pen and ink, 10"
Coll: Unknown
Ref: VBP.

Plate 41

54. STANDING FEMALE NUDE, c. 1910-1911
Pen and ink, 11 $^3/_8$" × 5 $^1/_4$"
Signed, lower right: "Eli Nadelman"
Coll: The Baltimore Museum of Art, Baltimore, Maryland
Prov: Ex-coll. Madame Helena Rubinstein

55. STANDING FEMALE NUDE, c. 1910-1912
Pen and ink, 11" × 3 $^1/_2$"
Coll: Unknown
Ref: Reproduced, VUP; Kirstein, Drawings, no. 22.

56. DRAPED FEMALE STANDING FIGURE
c. 1910-1912
Pen and ink, 10 $^1/_2$" × 3"
Signed, lower right: "Elie Nadelman"
Coll: Unknown
Ref: Reproduced, VUP; Kirstein, Drawings, no. 23.

57. STANDING FEMALE NUDE, c. 1910-1912
Pen and ink, 18 $^1/_2$" × 8 $^1/_2$"
Signed, lower right: "Elie Nadelman"
Coll: Mr. and Mrs. Max Wasserman, Chestnut Hill, Massachusetts

58. STANDING FEMALE NUDE, c. 1910-1912
Pen and ink on brown paper, 19 $^3/_4$" × 8 $^1/_8$"
Signed, lower left in pencil: "Elie Nadelman"
Coll: Museum of Modern Art, New York City
Prov: Mrs. Elie Nadelman

59. STANDING FEMALE NUDE, c. 1911-1913
Pen and ink, 10" × 2 $^1/_2$"
Initialed, lower right: "E N"
Coll: Unknown
Ref: Reproduced, VUP; VBP, pl. 19; NYA, p. 43; Kirstein, Drawings, no. 28.

60. KNEELING FEMALE NUDE IN PROFILE
WITH DRAPERY, c. 1915-1916
Pencil on paper, 10 $^1/_4$" × 7 $^3/_8$"
Coll: Martin Liefer, New York City
Prov: Mrs. Elie Nadelman
A study for "Sur La Plage" (plates 145, 146).

61. STANDING WOMAN IN SKIRT, c. 1916
Pencil, pen and ink, 17 $^1/_2$" × 27"
Coll: E. Jan Nadelman, Riverdale, New York

62. ★FEMALE TORSO, c. 1916
Pen and brown ink, 8 $^7/_8$" × 4 $^5/_8$"

Coll: Metropolitan Museum of Art, New York City, Gift of Lincoln Kirstein, 1965
Ref: Kirstein, Drawings, no. 38.
This finished drawing supports the large marble nude in the Nadelman Estate.
Plate 120

63. STANDING FEMALE TORSO AND
HEAD, c. 1916-1918
Pencil, 8 $^1/_4$" × 5 $^1/_2$"
Coll: Private collection, New York City
Ref: Kirstein, Drawings, no. 41.

64. ★STANDING WOMAN, c. 1916-1919
Pen and ink, 9"
Coll: Nadelman Estate
Plate 88

65. ★STANDING WOMAN, c. 1916-1919
Pen and ink, 9"
Coll: Nadelman Estate
Plate 89

66. ★STANDING WOMAN, c. 1916-1919
Pen and ink, 9"
Coll: Nadelman Estate
Plate 90

67. DRAPED FEMALE STANDING FIGURE
WITH EXTENDED ARM, c. 1917
Pencil and watercolor, 9 $^1/_4$" × 7 $^1/_2$"
Stamped, lower right: "E N"
Coll: Felix Landau, Los Angeles, California

68. STANDING CIRCUS GIRL, c. 1922-1923
Pen and ink wash, 7" × 3 $^1/_2$"
Coll: Unknown
Ref: Kirstein, Drawings, no. 43.
A study for the galvano-plastique figure (plate 128).

69. ★STANDING BURLESQUE GIRL, c. 1925
Pen and brush, 8"
Coll: Nadelman Estate
Plate 124

70. ★STANDING BURLESQUE GIRL, c. 1925
Pen and brush, 8"
Coll: Nadelman Estate
Plate 125

71. ★STANDING FEMALE NUDE, c. 1925
Pen, ink and brush, 9"
Coll: Nadelman Estate

Plate 176

72. ★STANDING FEMALE ACROBAT, c. 1925
Pencil, 4¹/₂"
Coll: Nadelman Estate

Plate 188

73. ★STUDIES FOR STANDING FEMALE
FIGURES, c. 1925-1935
Pencil, 7"
Coll: Nadelman Estate

Plate 189

74. ★STANDING FEMALE FIGURE, c. 1930
Pencil, 7"
Coll: Nadelman Estate

Plate 190

75. ★STANDING FEMALE FIGURE, c. 1935
Pencil, 9"
Coll: Nadelman Estate

Plate 193

76. ★STANDING FEMALE FIGURE, c. 1940
Pencil, 7"
Coll: Nadelman Estate

Plate 199

Seated and Reclining Female Figures

77. SEATED NUDE FEMALE BATHER
c. 1906-1910 (?)
Pencil on brownish paper, reinforced with blue crayon,
15¹/₂" × 11"
Signed, lower left: "E Nadelman"
Coll: Private collection, New York City
Prov: Mrs. Elie Nadelman

Rather than a finished piece, independent in itself,
this and the next drawing seem to be early work-
ing-aids.

78. SEATED NUDE FEMALE BATHER
c. 1906-1910 (?)
Pencil on brownish paper, 14³/₄" × 10¹/₈"
Signed with monogram: "E N", over half-effaced "E.
Nadelman"

Coll: Private collection, New York City
Prov: Mrs. Elie Nadelman

This sheet, somewhat damaged by fungus, has
been laid down on a card, as if Nadelman consider-
ed it of some importance.

79. SEMI-RECLINING FEMALE NUDE
c. 1908-1910
Pen and black ink, 6¹/₂" × 9³/₄"
Initialed, lower left: "E N"
Coll: Unknown
Ref: Reproduced, VUP; Kirstein, Drawings, no. 24.

80. ★RECLINING NUDE, c. 1910
Pen and ink, 7"
Coll: Unknown
Ref: VBP.

Plate 19

81. SEATED DRAPED FEMALE NUDE
c. 1910-1912
Pen and ink, 6¹/₂" × 9³/₄"
Signed, upper right: "Elie Nadelman"
Coll: Unknown
Ref: Reproduced, VUP; Kirstein, Drawings, no. 25.

This drawing is preparatory for a bronze (plate
20).

82. SEATED FEMALE NUDE, c. 1916 (?)
Pencil, 9¹/₂" × 6¹/₄"
Coll: Private collection, New York City
Ref: Kirstein, Drawings, no. 40.

83. ★SEATED WOMAN, c. 1916
Ink, 7"
Coll: Nadelman Estate

Plate 97

84. WOMAN SEMI-RECLINING IN A CHAIR
c. 1916-1917
Pen, brown ink, white gouache and pencil, 9¹/₄" × 7"
Coll: Unknown
Ref: Kirstein, Drawings, no. 42.

One of the first proposals for *"La Femme Assise"*
(plate 99).

85. RECLINING ADOLESCENT GIRL, c. 1917
Pen and ink, 7⁷/₈" × 9⁷/₈"
Coll: Museum of Modern Art, New York City, Gift of
Lincoln Kirstein in memory of René d'Harnoncourt
Prov: Mrs. Elie Nadelman

86. FEMALE NUDE LYING EXTENDED IN PROFILE, c. 1918
Pencil, 7 1/4" × 4 1/2"
Coll: Mrs. Norman Lasalle, New York City

87. NUDE SEATED ON DRAPERY
c. 1918-1920 (?)
Pencil, 10 1/4" × 7 3/4"
Coll: Private collection, New York City
Prov: Mrs. Elie Nadelman

88. ★FEMME AU PIANO, c. 1920-1922
Pen and ink, 5 1/2"
Coll: Nadelman Estate
Plate 116

89. ★SEATED FEMALE FIGURE, c. 1930-1935
Pencil, 7"
Coll: Nadelman Estate
Plate 191

Standing Male Figures

90. STANDING MALE NUDE, c. 1906-1908
Pen and black ink, 5 1/4" × 2 3/16"
Initialed, lower right: "E N"
Coll: Unknown
Ref: Reproduced, VUP; Kirstein, Drawings, no. 12.

91. ★STANDING MALE NUDE, c. 1907-1908
Pen and ink, 10"
Coll: Unknown
Ref: Kirstein, Drawings, no. 21.
Plate 35

92. STANDING MALE NUDE, c. 1907-1909
Pen, pencil and black ink, 21" × 9 1/2"
Signed, lower right, in pencil: "Eli Nadelman"
Coll: Unknown
Ref: Reproduced, Kirstein, Drawings, no. 21.

93. ★ANDROGYNOUS FIGURE AGAINST A TREE TRUNK, c. 1909-1911
Pen and ink, 9"
Lost.
Plate 63

94. ★STUDY FOR MAN IN THE OPEN AIR
c. 1915
Watercolor, pen and ink, 10 7/8" × 7 1/8"

Monogrammed, lower right: "E N"
Coll: Museum of Modern Art, New York City, (Aristide Maillol Fund)
Ref: Kirstein, Drawings, no. 34.
This drawing, somewhat damaged by mold, was found in Nadelman's cellar; it had been framed and matted. It seems likely he preserved it as the first notion for his "Man in the Open Air" (plate 66).
Plate 65

95. ★MALE NUDE, c. 1915
Pencil, 9"
Coll: Nadelman Estate
Plate 68

96. ★ADOLESCENT BOY, c. 1915
Pencil, 9"
Coll: Nadelman Estate
Plate 69

97. STANDING MALE NUDE WITH DRA-PERY, c. 1917-1920
Soft pencil, 9 1/4" × 6 1/2"
Coll: Unknown
Ref: Kirstein, Drawings, no. 39.

98. MAN IN PROFILE, c. 1918
Pencil, 4 1/2" × 7 3/4"
Coll: Mrs. Norman Lasalle, New York City

99. ★CELLIST, c. 1918-1919
Pen and ink, 7"
Coll: Nadelman Estate
Plate 91

100. STANDING MOUSTACHIOED MAN
c. 1918-1922
Pencil, pen, fountain pen and ink, intentionally blotted, 9 1/2" × 3 1/2"
Coll: Unknown
Ref: Kirstein, Drawings, no. 50.
This archetype may be subsequently discovered in the paintings of Guy Pène du Bois, and in drawings by George Bellows and John Held, Jr. It is a study towards Nadelman's plaster figures, some of which were finally achieved in cherrywood.

101. ★CONSTRUCTION WORKER, 1929
Pencil, 4"
Coll: Nadelman Estate
Plate 147

Combined Figures

102. STANDING FEMALE AND MALE NUDES, c. 1905-1908
Pen and black ink, 8¹/₄" × 5"
Signed, lower right: "E Nadelman"
Coll: Unknown
Ref: Reproduced, VUP; VBP, pl. 15; NYA, p. 41; Kirstein, Drawings, no. 16.

103. STANDING FEMALE AND MALE NUDES, c. 1906-1910
Reed pen and brown ink, 17" × 10¹/₂"
Signed, lower right: "E Nadelman" in pencil, at a later date
Coll: Unknown
Ref: Reproduced, VUP; VBP, pl. 25; Kirstein, Drawings, no. 17.

104. ★STUDY FOR AUTUMN: FOUR FEMALE FIGURES WITH A HORSE, c. 1911-1913
Black chalk, 8¹/₄" × 18¹/₂"
Coll: Metropolitan Museum of Art, New York City, Gift of Lincoln Kirstein, 1965

This study of four female figures with a horse is preparatory to the bronze plaque (plate 46) in the style of Art Deco mural panels made for Helena Rubinstein's billiard-room in London.

Plate 43

105. ★SEATED WOMAN AND STANDING MAN (M. and Mme. Thadée Natanson?), c. 1913
Brush and ink, 9"
Coll: Nadelman Estate
Plate 96

106. FAMILY, c. 1913-1914
Pen, brush and maroon ink, 8¹/₄" × 7¹/₂"
Monogrammed, lower right, in pencil: "E N"
Coll: Unknown
Ref: Reproduced, Kirstein, Sculpture, p. 54; Kirstein, Drawings, no. 33.

The father in top hat, the mother, a type of *femme vase*, the monstrous doll-child: this drawing is one of the first instances of Nadelman's ultimate development: his abandonment of 'classic' models, his interest in 'primitive' doll-shapes and in contemporary costume.

107. FAMILY, c. 1914-1915
Reddish brush and ink wash over pencil, on card, 8¹/₄" × 8¹/₂"

Monogrammed, lower left: "E N"
Coll: Private collection, New York City
Prov: Mrs. Elie Nadelman

In this drawing, one of a series of parents with single children, the father-figure is about to strike the child, whose mother-figure protects it. It relates to a similar "family," Kirstein, *Drawings*, no. 33.

108. ★LADY AND MAID, c. 1915
Pen and ink, 5"
Coll: Nadelman Estate
Plate 143

109. ★WOMAN AND CHILD, c. 1915-1916
Brush and ink, 4"
Coll: Nadelman Estate
Plate 169

110. ★TOP-HATTED MAN WITH BORZOI DOG, c. 1916-1920
Pencil and ink, 8"
Coll: Nadelman Estate
Plate 75

111. ★TWO STANDING GIRLS, c. 1920
Pen and ink, 8"
Coll: Nadelman Estate
Plate 103

112. ★GIRL WITH POODLE, c. 1935
Pencil, 5"
Coll: Nadelman Estate
Plate 170

Dancers

113. SURPRISED LOVERS, c. 1915
Pen and ink, 6¹/₂" × 5¹/₈"
Coll: The New York Public Library at Lincoln Center, New York City, Gift of Lincoln Kirstein, 1970
Prov: Mrs. Elie Nadelman
Ref: Kirstein, "Elie Nadelman, Sculptor of the Dance," Dance Index, Vol. VII, no. 6, 1948, p. 132 (illus.).

This was among the first of several impromptu sketches, perhaps stemming from a personal incident at Ostende in the summer of 1914, which ultimately led to the sculpture of two matched dancing figures (plate 114).

114. ★KNEELING DANCER, c. 1915
Pencil, 5"
Coll: Nadelman Estate
This is a sketch for the Goadby Loew marble.
Plate 40

115. TWO COUPLES DANCING, c. 1915-1916
Pen and ink, 11¹/₄" × 8"
Coll: The New York Public Library at Lincoln Center,
New York City, Gift of Lincoln Kirstein, 1970
Prov: Mrs. Elie Nadelman

116. TWO COUPLES DANCING, c. 1915-1916
Pencil, 7" × 4³/₈"
Coll: The New York Public Library at Lincoln Center,
New York City, Gift of Lincoln Kirstein, 1970
Prov: Mrs. Elie Nadelman

117. TANGO DANCERS WITH TWO
FEMALE SPECTATORS, c. 1916
Pen, ink and wash, 9⁷/₈" × 8"
Coll: The New York Public Library at Lincoln Center,
New York City, Gift of Lincoln Kirstein, 1970
Prov: Mrs. Elie Nadelman

118. FEMALE DANCER, c. 1916 (?)
Pencil on lined note-paper, 10" × 7¹/₄"
Coll: The New York Public Library at Lincoln Center,
New York City, Gift of Lincoln Kirstein, 1970
Prov: Mrs. Elie Nadelman

119. TANGO, c. 1916
Pen and ink over pencil, on lined note-paper,
7⁵/₈" × 4⁷/₈"
Coll: The New York Public Library at Lincoln Center,
New York City, Gift of Lincoln Kirstein, 1970
Prov: Mrs. Elie Nadelman

120. ★TANGO, c. 1916
Pen, ink and brush, 9"
Lost.
Plate 110

121. ★TANGO, c. 1916-1917
Pen, ink and brush, 9"
Lost.
Plate 108

122. ★TANGO, c. 1917
Pen, ink and brownish watercolor, 10" × 7"
Monogrammed, lower right, in pencil: "E N"

Coll: Baltimore Museum of Art, Baltimore, Maryland
Ref: Kirstein, Sculpture, p. 55 (illus.); Kirstein, "Elie
Nadelman, Sculptor of the Dance," Dance Index, Vol.
VII, no. 6, 1948, p. 139 (illus.).
Plate 111

123. TANGO: *LUNDI,* c. 1917
Pen and ink on tan paper, 5⁵/₈" × 5"
Initialed, top right: "E N"
Coll: The New York Public Library at Lincoln Center,
New York City, Gift of Lincoln Kirstein, 1970
Prov: Mrs. Elie Nadelman
"Lundi" is presumably the first in a series of tango dancers culminating in "Dimanche," identified with the craze for the dance which Nadelman seems to have recalled rather than documented at the height of its popularity, c. 1913-1914.

124. TANGO: *MARDI, MERCREDI, JEUDI,*
VENDREDI, SAMEDI, c. 1917
Pen and ink on tan paper, 6¹/₂" × 5"
Initialed, lower right: "E. N."
Coll: The New York Public Library at Lincoln Center,
New York City, Gift of Lincoln Kirstein, 1970
Prov: Mrs. Elie Nadelman
Second in the "Tango" series.

125. TANGO: *DIMANCHE,* c. 1917
Pen, ink and wash on tan paper, 6¹/₂" × 5"
Initialed, upper left: "E N"
Coll: The New York Public Library at Lincoln Center,
New York City, Gift of Lincoln Kirstein, 1970
Prov: Mrs. Elie Nadelman
The climax of the "Tango" series, ultimately leading to the double figure in cherrywood (plate 115).

126. TANGO, c. 1917
Pen and ink, 10³/₄" × 15³/₄"
Coll: E. Jan Nadelman, Riverdale, New York

127. VAUDEVILLE HIGH KICKER
c. 1917-1918
Pen, ink and tinted wash, 10" × 6⁵/₈"
Coll: The New York Public Library at Lincoln Center,
New York City, Gift of Lincoln Kirstein, 1970
Prov: Mrs. Elie Nadelman
There are several studies related to high-kicking dancers in profile, inspired by a photograph of the vaudeville star, Eva Tanguay, whose theme song, "I Don't Care," was a hit of the early 'Twenties.

These drawings support the cherrywood figure (plate 72).

128. TANGO, c. 1917-1919
Blue ink and wash, 9 7/8" × 8"
*Coll: Metropolitan Museum of Art, New York City,
Gift of Lincoln Kirstein, 1965*
Prov: Mrs. Elie Nadelman

129. ★DANCING COUPLE, c. 1917-1919
Pen, brush and fountain pen ink, 8" × 3 1/2"
*Coll: Metropolitan Museum of Art, New York City,
Gift of Lincoln Kirstein, 1965*
Prov: Mrs. Elie Nadelman
Ref: Kirstein, Drawings, no. 46.
Plate 107

130. ★DANCING COUPLE, c. 1917-1919
Pen, ink and reddish wash, 9 1/2" × 6 3/8"
*Coll: Metropolitan Museum of Art, New York City,
Gift of Lincoln Kirstein, 1965*
Prov: Mrs. Elie Nadelman
Ref: Kirstein, Drawings, no. 47.
Plate 109

131. TANGO, c. 1918-1919
Pen and ink on lined note-paper, 7 3/16" × 4 1/4"
Initialed, upper right: "E N"
*Coll: The New York Public Library at Lincoln Center,
New York City, Gift of Lincoln Kirstein, 1970*
Prov: Mrs. Elie Nadelman

132. ★TANGO, c. 1922-1924
Pen and ink, 2"
Coll: Nadelman Estate
Plate 113

133. ★CAN-CAN DANCER, c. 1925
Pencil, 7"
*Coll: The New York Public Library at Lincoln Center,
New York City*
Plate 130

Portraits

134. CARICATURE OF A BEARDED MAN
c. 1908-1910 (?)
Black ink on brown paper, 15 1/2" × 12"
*Coll: Metropolitan Museum of Art, New York City,
Gift of Lincoln Kirstein, 1965*
Prov: Mrs. Elie Nadelman

This may be one of a series of drawings based on Thadée Natanson.

135. ★ART CRITIC (Thadée Natanson?), c. 1909
Pen and ink, 6"
Lost.
Plate 80

136. ★THADÉE NATANSON (?), c. 1909
Pen and ink, 6"
Lost.
Plate 81

137. FEMALE PORTRAIT HEAD, c. 1910
Pen and ink, 8 1/2" × 7 3/4"
Initialed at lower right: "E N"
Coll: Mrs. Norman Lasalle, New York City

This is one of a series of drawings of a Polish (?) woman who may have been Nadelman's companion and model.

138. ★MADAME HELENA RUBINSTEIN
c. 1911-1912
Pen and black ink, 9 1/4" × 6"
Initialed, lower right: "E N"
Coll: Unknown
Ref: Reproduced, VUP; Kirstein, Drawings, no. 11.
Plate 82

139. ★MARIE SCOTT, 1915
Pen and ink, 9"
Coll: Nadelman Estate
Plate 84

140. WOMAN'S HEAD AND BUST, c. 1919
Pen and ink, 8 3/4" × 5 3/4"
*Coll: Metropolitan Museum of Art, New York City,
Gift of Lincoln Kirstein, 1965*
Prov: Mrs. Elie Nadelman

This sketch is a summary portrait of the sculptor's wife and supported other studies for brass painted heads such as the one reproduced (plate 139).

141. WOMAN'S HEAD (*AVEC PETIT RUBAN*)
c. 1919-1920
Pen and ink wash, on card, 6" × 4"
Coll: Private collection, New York City
Prov: Mrs. Elie Nadelman

Mrs. Nadelman, from about 1918, was accustomed to wear a single loop of ribbon in her hair, which

became a feature of her husband's figures. However, the ribbon appears from about 1916, before he met her, and she perhaps appropriated his preference.

142. ⋆BAUDELAIRE, c. 1934-1936
Pen and ink, 4"
Coll: Nadelman Estate
Plate 157

Animals, Birds and Equestrian Figures

143. BIRD IN FLIGHT, c. 1904-1907
Pen and black ink, 8 3/16" × 12 5/16"
Coll: Metropolitan Museum of Art, New York City, Gift of Lincoln Kirstein, 1965
Prov: Mrs. Elie Nadelman
Ref: Kirstein, Drawings, p. 37 (illus.). (No formal catalogue entry.)

This drawing may have been intended as a *cul de lampe* or title-page decoration for a projected publication of Nadelman's drawings, since it was attached to an announcement for VUP.

144. ⋆HORSE, c. 1912-1914
Pen and ink, 9"
Lost.
Plate 52

145. POODLE, c. 1913-1914
Pen and blue ink wash, 5" × 6 7/16"
Coll: Metropolitan Museum of Art, New York City, Gift of Lincoln Kirstein, 1965
Ref: For a related but more highly finished drawing, see Kirstein, Drawings, no. 31.

146. POODLE, c. 1913-1914
Pen and black ink, 5" × 6 7/16"
Coll: Metropolitan Museum of Art, New York City, Gift of Lincoln Kirstein, 1965

147. HORSE AND ARMLESS RIDER IN A BOWLER HAT, c. 1913-1914
Pen, pencil, brush and maroon ink, 8" × 6 1/4"
Coll: Unknown
Ref: Kirstein, Drawings, no. 32.

148. ⋆COW, c. 1913-1915
Pen and brown ink, reddish brown wash over traces of pencil, 5 1/2" × 8"

Coll: Metropolitan Museum of Art, New York City, Gift of Lincoln Kirstein, 1965
Ref: Kirstein, Drawings, no. 30.
Plate 53

149. HORSE, c. 1913-1915 (?)
Pen and blue ink wash, 5" × 6 1/2"
Monogrammed in pencil, lower left: "E N"
Coll: Private collection, New York City
Prov: Mrs. Elie Nadelman

Since Nadelman kept this slight sketch, mounted it carefully and signed it with delicate precision, it may be the original idea for the Rubinstein plaster, posthumously cast in bronze (plate 55).

150. CONCIERGE AND POODLES, 1914
Pen and ink, 8 5/16" × 5 7/16"
Coll: Metropolitan Museum of Art, New York City, Gift of Lincoln Kirstein, 1965
Prov: Mrs. Elie Nadelman

This precise sketch was done on ordinary notepaper of the Shakespeare Hotel, Ostende, where Nadelman vacationed in the summer of 1914, and seems to be the source of the handling of hair in further poodles and people, ultimately leading to the two figures in the State Theater, Lincoln Center, New York City.

151. POODLE, c. 1914
Pen and brown ink, reddish wash over pencil on white paper, 7 15/17" × 10 1/4"
Coll: Metropolitan Museum of Art, New York City, Gift of Lincoln Kirstein, 1965
Prov: Mrs. Elie Nadelman
Ref: Kirstein, Sculpture, p. 59; Drawings, no. 31.

152. ⋆POODLE, c. 1914
Pen, brush and ink, 4"
Coll: Nadelman Estate
Plate 167

153. ⋆POODLE, c. 1914
Pen, brush and ink, 4"
Coll: Nadelman Estate
Ref: Kirstein, Drawings, no. 31.
Plate 168

154. COW, c. 1914
Brush, 17 1/2" × 21 1/4"
Signed: "Eli Nadelman"
Coll: Private collection, New York City

Prov: Mrs. Elie Nadelman
Ref: Kirstein, Sculpture, *p. 59 (illus.).*
This drawing, and related ones, derive from the Lascaux caves.

155. HORSE AND RIDER, c. 1914
Reddish brown ink, pen and wash, 12$^1/_2$" × 7$^3/_4$"
Coll: Metropolitan Museum of Art, New York City, (Rogers Fund)
Prov: Mrs. Elie Nadelman
Badly damaged from fungus, this drawing was repaired by Nadelman, c. 1935.

156. BULL, c. 1914-1915
Pen and blue wash, 5$^1/_2$" × 6$^1/_2$"
Signed in pencil, lower left: "E N"
Coll: Private collection, New York City
Prov: Mrs. Elie Nadelman
This drawing, on poor paper but carefully mounted, was preserved by the sculptor and is possibly the start of "Standing Bull" (plate 54).

157. ★EQUESTRIAN FIGURE, c. 1915
Pen and brush, 9"
Lost.
Plate 49

158. EQUESTRIENNE, c. 1918-1920
Pencil, 7" × 5$^1/_4$"
Coll: Private collection, New York City
Prov: Mrs. Elie Nadelman

159. HEN, c. 1919 (?)
Fountain pen, ink and brush wash, 4" × 3"
Coll: Unknown
Ref: Kirstein, Drawings, *no. 58; Kirstein*, Sculpture, *p. 57 (illus.).*

160. ★EQUESTRIENNE, c. 1923-1925
Fountain pen, pencil, brush and ink, 7" × 7$^3/_4$"
Coll: Unknown
Ref: Kirstein, Drawings, *no. 48.*
Plate 47

161. ★EQUESTRIENNE, c. 1923-1925
Fountain pen and blue ink, 5$^1/_4$" × 4"
Coll: Metropolitan Museum of Art, New York City, Gift of Lincoln Kirstein, 1965
Prov: Mrs. Elie Nadelman
Ref: Kirstein, Drawings, *no. 49.*
This is the finer of two closely related drawings in the Metropolitan Museum.
Plate 48

162. ROOSTER, c. 1930-1935
Pencil and brown chalk on gray paper, 13$^1/_8$" × 12$^1/_8$"
Coll: Metropolitan Museum of Art, New York City, Gift of Lincoln Kirstein, 1965
Prov: Mrs. Elie Nadelman
This is probably a study for a gate-post which was not carried out.

PRINTS

1. HEAD, c. 1906-1907 (?)
Linoleum cut, 3 ¹/₈″ × 3 ³/₈″
Coll: Print Room, Metropolitan Museum of Art, New
York City, (Whittelsey Fund, 1951)
Prov: Mrs. Elie Nadelman

This unique print was made from the plate by
A. Hyatt Mayor, Curator, in August, 1950. The
plate is extant.

2. HEAD, c. 1906-1908 (?)
Linoleum cut, brown ink, 6 ¹/₄″ × 5 ¹/₄″
Coll: Print Room, Metropolitan Museum of Art, New
York City, (Whittelsey Fund, 1951)
Prov: Mrs. Elie Nadelman

This unique proof was printed by A. Hyatt Mayor,
Curator, on antique paper, from the original lino-
leum cut, August, 1950.

3. RECLINING AND STANDING FEMALE
NUDES, c. 1906-1908 (?)
Linoleum cut, brown ink, 11 ⁵/₈″ × 8″
Coll: Print Room, Metropolitan Museum of Art, New
York City, (Whittelsey Fund, 1951)
Prov: Mrs. Elie Nadelman

This unique proof was printed on antique paper
by A. Hyatt Mayor, Curator, from the extant li-
noleum plate, at the Museum, in August, 1950.

4. HORSE, c. 1907-1909 (?)
Linoleum cut on brown paper, 6 ¹/₂″ × 10 ¹/₄″
Signed in pencil, upper right: "Elie Nadelman"
Coll: Print Room, Metropolitan Museum of Art, New
York City
Prov: Mrs. Elie Nadelman
Exh: Galerie Druet, Paris, April, 1909; Stieglitz's
"291" Gallery, New York City, 1915

The linoleum cut exists; Nadelman seems to have
printed this unique example himself.

5. SEATED GIRL WITH ANIMAL IN LAP
c. 1913-1915 (?)
Negative monotype, 13″ × 9″
Coll: Print Room, Metropolitan Museum of Art, New
York City, Gift of Mrs. Elie Nadelman, 1951
Prov: Mrs. Elie Nadelman

This print is unique.

6. WOMAN'S HEAD, 1920
Drypoint, 4 ¹/₈″ × 2 ³/₄″
Coll: Print Room, Metropolitan Museum of Art, New
York City, (Whittelsey Fund, 1951)
Prov: Mrs. Elie Nadelman

There are three states.

7. GIRL'S HEAD, 1920
Drypoint, 11 ³/₄″ × 8 ⁷/₈″
Coll: Print Room, Metropolitan Museum of Art, New
York City, (Whittelsey Fund, 1951)
Prov: Mrs. Elie Nadelman

A unique proof, with penciled correction or sug-
gestion of a neckline to be added.

8. GIRL'S HEAD IN PROFILE, 1920
Drypoint, 3 ⁵/₈″ × 2 ¹/₂″
Coll: Print Room, Metropolitan Museum of Art, New
York City, (Whittelsey Fund, 1951)
Prov: Mrs. Elie Nadelman

9. WOMAN'S HEAD, 1920
Drypoint, 6 ⁷/₈″ × 5 ⁷/₈″
Coll: Print Room, Metropolitan Museum of Art, New
York City, (Whittelsey Fund, 1951)
Prov: Mrs. Elie Nadelman

10. FEMALE NUDE, 1920
Drypoint, 8 ³/₈″ × 4″
Unsigned (except for the sixth state, in pencil: "Elie
Nadelman")
Coll: Print Room, Metropolitan Museum of Art, New
York City, (Whittelsey Fund, 1951)
Prov: Mrs. Elie Nadelman

There are six states in the Print Room.

11. HIGH KICKER IN PROFILE, 1920
Drypoint, 8 ⁵/₈″ × 4″
Coll: Print Room, Metropolitan Museum of Art, New
York City, (Whittelsey Fund, 1951)
Prov: Mrs. Elie Nadelman

There are two states of this plate which derives
from drawings and a sculpture in wood (plate 72),
based on the vaudeville dancer, Eva Tanguay.

12. IDEAL HEAD, 1920
Drypoint, 12 ³/₄″ × 8 ⁷/₈″

Signed in plate, lower right: "Elie Nadelman" (reversed)
Proof initialed, lower left: "E N"
Coll: Print Room, Metropolitan Museum of Art, New York City, (Whittelsey Fund, 1951)
Prov: Mrs. Elie Nadelman

13. MAN AND WOMAN IN PROFILE, 1920
Drypoint, 8 ³/₈" × 4"
Coll: Print Room, Metropolitan Museum of Art, New York City, (Whittelsey Fund, 1951)
Prov: Mrs. Elie Nadelman

This plate is related to studies for Nadelman's "Tango" (plate 114). There are two states in the Print Room.

14. WOMAN'S HEAD, 1920
Drypoint, 6 ⁷/₈" × 5 ⁷/₈"
Initialed on plate, lower right: "E N"
Coll: Print Room, Metropolitan Museum of Art, New York City, (Whittelsey Fund, 1951)
Prov: Mrs. Elie Nadelman

15. PROFILE BUST OF A GIRL, 1920
Drypoint, 3 ¹/₄" × 4 ³/₄"
Coll: Print Room, Metropolitan Museum of Art, New York City, (Whittelsey Fund, 1951)
Prov: Mrs. Elie Nadelman

There are examples of two states of this plate in the Print Room.

16. BUST OF WOMAN WITH RAISED ARM 1920
Drypoint, 4 ⁵/₈" × 3 ¹/₄"
Coll: Print Room, Metropolitan Museum of Art, New York City, (Whittelsey Fund, 1951)
Prov: Mrs. Elie Nadelman

There are examples of two states of this plate in the Print Room.

17. STANDING FEMALE FIGURE, 1920
Drypoint, 10 ¹/₈" × 3"
Coll: Print Room, Metropolitan Museum of Art, New York City, (Whittelsey Fund, 1951)
Prov: Mrs. Elie Nadelman

18. WOMAN'S HEAD, WITH RIBBON, 1920
Drypoint, 4 ¹/₈" × 2 ¹/₄"
Coll: Print Room, Metropolitan Museum of Art, New York City, (Whittelsey Fund, 1951)
Prov: Mrs. Elie Nadelman

19. WOMAN'S HEAD IN PROFILE, 1920
Drypoint, 6 ⁷/₈" × 5 ⁷/₈"
Coll: Print Room, Metropolitan Museum of Art, New York City, (Whittelsey Fund, 1951)
Prov: Mrs. Elie Nadelman

20. WOMAN'S HEAD, 1920
Drypoint, 6 ⁷/₈" × 4 ⁷/₈"
Proof, pencil-signed, lower right: "Elie Nadelman"
Coll: Print Room, Metropolitan Museum of Art, New York City, (Whittelsey Fund, 1951)
Prov: Mrs. Elie Nadelman

The Metropolitan Museum's Print Room owns the complete set of the very few proofs Nadelman pulled of his own copper-plates during his lifetime, posthumously published as a set of plates by Curt Valentin in a limited edition. It is not certain how many were available, but those remaining at the time of Mr. Valentin's death seem to have disappeared. The original plates exist in the Nadelman Estate.

21. DRAPED WOMAN'S HEAD, 1920
Drypoint, 4 ¹/₈" × 2 ³/₄"
Monogrammed, lower right: "E N" (reversed)
Coll: Print Room, Metropolitan Museum of Art, New York City, (Whittelsey Fund, 1951)
Prov: Mrs. Elie Nadelman

22. WOMAN'S HEAD IN PROFILE, 1920
Drypoint, 4 ¹/₈" × 2 ³/₄"
Coll: Print Room, Metropolitan Museum of Art, New York City, (Whittelsey Fund, 1951)
Prov: Mrs. Elie Nadelman

23. WOMAN'S HEAD IN SHAWL, 1920
Drypoint, 7" × 5"
Coll: Print Room, Metropolitan Museum of Art, New York City, (Whittelsey Fund, 1951)
Prov: Mrs. Elie Nadelman

This listing differs from that attached to Curt Valentin's publication of the drypoints and is at variance in some respects with that of the Metropolitan Museum Print Room catalogue. The discrepancy may be explained by the descriptions of progressive proofs, resulting from the cleaning and rehabilitation of the plates in 1950.

BIBLIOGRAPHY & EXHIBITIONS

Compiled by Ellen Grand

WORK BY NADELMAN

arranged chronologically

1 [Statement on his drawings] in "Photo-Secession Notes" *Camera Work*, No. 32, October 1910, p. 41.

> Preface for catalogue of an exhibition of drawings to be held at the Little Gallery of the Photo-Secession. Exhibition cancelled because works to be shown had to be sent abroad for a show.

2 *Quarante Dessins de Elie Nadelman*. Paris: La Belle Edition, 1913.

> A de luxe four-page folio announcement, with 3 illus., for limited edition publication of reproductions of drawings, with explanatory notes. Edition never issued.

3 *Vers l'Unité Plastique*. Paris, 1914.

> Fifty-one reproductions of drawings, in portfolio. No text. Originally announced as *Quarante Dessins*. (See bibl. no. 2)

4 [Statement concerning exhibition at the Photo-Secession Galleries, December 8, 1915 - January 19, 1916] *Camera Work*, No. 48, October 1916, p. 10.
> "The text of the leaflet which accompanied the Nadelman Exhibition." (See bibl. no. 113a)

5 [Statement issued by Nadelman concerning the "Allies of Sculpture" exhibition] Partially quoted in *New York World*, December 19, 1917. (See bibl. no. 146)

6 [Interview with Nadelman by Henry Tyrrell] "At a Musical Tea with Nadelman; the Witty Polish-Parisian Sculptor, Whose Satires in Plaster Made Fifth Avenue Gasp" [*New York*] *World Magazine*, November 30, 1919. (See bibl. no. 97)

7 *Vers la Beauté Plastique, Thirty-two Reproductions of Drawings*. New York: E. Weyhe, 1921. 2p. plus 32 plates.

> Introductory paragraph by Nadelman on the significance of the drawings "made 16 years ago," plus a note that "175 sets of these reproductions of the drawings were printed at Paris in 1912. The blocks have been destroyed." Weyhe edition reissued 32 of the 51 drawings reproduced in *Vers l'Unité Plastique*, using the original Paris zinc cuts.

8 [Letter to Kineton Parkes, 1922] Concerns Nadelman's feelings about sculpture and his own "cubist" discoveries. Manuscript in Special Collections, Museum of Modern Art Library.
> a. Also in Museum of Modern Art Library are albums of Nadelman clippings, articles and catalogues.

9 Murrell, William, ed. *Elie Nadelman*. Woodstock, N. Y.: William M. Fisher, 1923 (Younger Artists Series, No. 6). 6 reproductions in color, 40 in black and white.

No editorial contribution. Text is a reprint in miniature of Nadelman's introductory paragraph for *Vers la Beauté Plastique*; reproduced in the section "Drawings No. 30-46" are 16 of the 32 drawings issued in *Vers la Beauté Plastique*.

10 [Letter to the Editor (Henry Goddard Leach) on "Is Cubism Pure Art?"] *The Forum*, V. 74, No. 1, July 1925, p. 148.

Manuscript and typescript drafts for this letter to Mr. Leach concerning the origins of Cubism, dated April 28, 1925, in Special Collections, Museum of Modern Art Library.

MONOGRAPHS

11 Kirstein, Lincoln. *The Sculpture of Elie Nadelman*. New York: The Museum of Modern Art, 1948. [64 p., 57 illus.]

Issued in connection with Nadelman retrospective at the Museum of Modern Art, New York, October 5 - November 28. In collaboration with the Institute of Contemporary Art, Boston and the Baltimore Museum of Art. Bibliography by Bernard Karpel. (See bibl. no. 124)

12 Kirstein, Lincoln. *Elie Nadelman Drawings*. New York: H. Bittner, 1949. [53 p., 27 illus. in the text, 58 pl.] Reprint edition, New York: Hacker Art Books, 1970.

13 Kirstein, Lincoln. *The Dry Points of Elie Nadelman*. New York: Curt Valentin, 1952.

"Twenty-two unpublished prints by the sculptor, proofed from the original zinc and copper plates by the master-printer, Charles S. White . . . With an introduction and catalogue by Lincoln Kirstein." Edition of 50. In portfolio.

GENERAL WORKS

14 *America and Alfred Stieglitz, A Collective Portrait*. Ed. by Waldo Frank [et. al.]. Garden City, N. Y.: Doubleday, Doran, 1934, p. 110, 314 (2 illus.).

15 Apollinaire, Guillaume. *Anecdotiques* [Entry dated April 16, 1911]. Paris: Librairie Gallimard, 1955, p. 17.

16 Apollinaire, Guillaume. *Apollinaire on Art: Essays and Reviews, 1902-1918*. Ed. by LeRoy C. Breunig. New York: Viking, 1972 (Documents of 20th Century Art Series), p. 116, 250, 319, 329, 334, 358, 364, 411.

17 Arnason, H. H. *History of Modern Art*. New York: Harry N. Abrams, 1968, p. 410, 433-5 (1 illus.).

18 Ashton, Dore. *Modern American Sculpture*. New York: Harry N. Abrams, 1968, p. 12 (1 illus.).

19 Basler, Adolphe. *Modigliani*. Paris: G. Cres, 1931, p. 6.

 For additional material on relationship between Nadelman and Modigliani see:
 a. Basler, Adolphe. "Amedeo Modigliani" *Le Crapouillot*, August 1927; reprinted in *Paris-Montparnasse*,
 No. 13, February 1930, p. 9.
 b. Carli, Enzo. *Amedeo Modigliani*. Rome: De Luca Editore, 1952, p. 18.
 c. Jedlicka, Gotthard. *Modigliani: 1884-1920*. Erlenbach-Zürich: Eugen Rentsch, 1953, p. 18.
 d. Modigliani, Jeanne. *Modigliani: Man and Myth*. New York: Orion, 1958, p. 54, 55.
 e. Parronchi, Alessandro. "La lezione di Modigliani" *Illustrazione Italiana*. November 1955, p. 53.
 f. Roy, Claude. *Modigliani*. Lausanne: Albert Skira, 1958, p. 43.

20 Basler, Adolphe. *La Sculpture Moderne en France*. Paris: G. Cres, 1928, p. 36, 46, 48
 (2 illus.).

21 Baur, John I. H. *Revolution and Tradition in Modern Art*. Cambridge, Mass.: Harvard University Press, 1951, p. 55, 61, 125 (1 illus.).

22 Birnbaum, Martin. *Introductions: Painters, Sculptors and Graphic Artists*. New York: Frederic Fairchild Sherman, 1919, p. 59-68 (3 illus.).

 See also:
 a. Birnbaum, Martin. *The Last Romantic*. New York: Twayne, 1960, p. 85-93, 139 (1 illus.).

23 Brummé, C. Ludwig. *Contemporary American Sculpture*. New York: Crown, 1948, p. 93, 94 (2 illus. only).

 Foreword by William Zorach.

24 Cahill, Holger and Barr, Alfred H., Jr., eds. *Art in America in Modern Times*. New York: Reynal and Hitchcock, 1934, p. 56, 57, 61 (1 illus.).

 Also printed in *Art in America: A Complete Survey* edited by Cahill and Barr. New York: Reynal and Hitchcock, 1935, p. 114, 115, 119 (1 illus.).

25 Cheney, Sheldon. *Sculpture of the World: A History*. New York: Viking, 1968, p. 4.

26 Clapp, Jane. "Nadelman" in *Sculpture Index*. Metuchen, N. J.: Scarecrow Press, 1970, V. 2, Part II (H-Z), p. 807-8.

27 Craven, Wayne. *Sculpture in America*. New York: Thomas Y. Crowell, 1968, p. 555, 588-91, 592, 593, 594, 595, 610, 614, 615 (2 illus.).

28 Frank, Herbert. *Die das neue fürchten*. Düsseldorf-Wien: Econ Verlag, 1964, p. 282.

29 Gardner, Albert TenEyck. *American Sculpture: A Catalogue of the Collection of the Metropolitan Museum of Art*. New York: [The Museum], 1965, p. 144, 145 (1 illus.).

30 Geist, Sidney. *Brancusi: A Study of the Sculpture*. New York: Grossman, 1968, p. 35, 140, 148, 189 (1 illus.).

 See also:
 a. Neagoe, Peter. *The Saint of Montparnasse: A Novel Based on the Life of Constantin Brancusi*. Philadelphia: Chilton, 1965, p. 119, 120, 121, 122, 124, 127, 129.

31 Gide, André. *Journal 1889-1939*. [Entries for December 24, 1908 and April "25 or 26" 1909.] Paris: Librairie Gallimard, 1948, p. 270-3.

32 Goodrich, Lloyd. *Pioneers of Modern Art in America: The Decade of the Armory Show, 1910-1920*. New York: Frederick A. Praeger, 1963, p. 19, 64, 66, 72, 73, 91 (2 illus.).

33 Hammacher, A. M. *The Evolution of Modern Sculpture: Tradition and Innovation*. New York: Harry N. Abrams, 1969, p. 136-9, 144 (3 illus.).

34 Hellman, George S. "Nadelman" in *Universal Jewish Encyclopedia*, Isaac Landman, ed. New York: Universal Jewish Encyclopedia, 1942, V. 8. p. 81-2.

35 Hunter, Sam. *Modern American Painting and Sculpture*. New York: Dell, 1959, p. 48, 163-4.

36 Huyghe, René, ed. *Histoire de l'Art Contemporain: La Peinture*. Paris: Félix Alcan, 1934, p. 143, 146.
 Originally published in *L'Amour de l'Art*, V. 14, No. 6, June 1933, p. 143, 146.

37 *Index of Twentieth Century Artists* "Elie Nadelman – Sculptor" V. 3, No. 6, March 1936.
 Reprint edition in one volume, New York: Arno Press, 1970, p. 555-7, 561.

38 Kiesler, Frederick. *Contemporary Art Applied to the Store and its Display*. New York: Brentano's, 1930, p. 28, 32-3 (3 illus.).

39 Larkin, Oliver W. *Art and Life in America*. Rev. ed. New York: Holt, Rinehart and Winston, 1960, p. 374, 395 (1 illus.).

40 Levy, Florence N. *Art in New York: A Guide to Things Worth Seeing*. 4th ed. rev. by Jessie Rosenfeld. New York: N. Y. Regional Art Council of the Art Center, 1931, p. 91 (illus. only).

41 Licht, Fred. *Sculpture: 19th and 20th Centuries*. Greenwich, Conn.: New York Graphic Society, 1967, p. 334 (2 illus.).

42 M[ellquist], J[erome]. "Nadelman" in *Dictionnaire de la Sculpture Moderne*. Paris: Fernand Hazan, 1960, p. 219 (1 illus.).

43 Mellquist, Jerome. *The Emergence of an American Art*. New York: Charles Scribner's Sons, 1942, p. 371-2.

44 Mendelowitz, Daniel M. *A History of American Art*. New York: Holt, Rinehart and Winston, 1960, p. 629-630 (1 illus.).

45 "Nadelman" in *National Cyclopedia of American Biography*. New York: James T. White, 1938, Current Volume E, p. 282.

46 "Nadelman" by Erna Stein in Thieme-Becker. *Allgemeines Lexikon der Bildenden Künstler*. Leipzig: E. A. Seeman, 1931, V. 5, p. 323.

47 Natanson, Thadée. "Elie Nadelman" in his *Peints à leur Tour*. Paris: Albin Michel, 1948, p. 239-243 (1 illus.).

48 Neumann, J. B., ed. *Artlover: J. B. Neumann's Bilderhefte, Anthologie d'un Marchand d'Art*. New York: New Art Circle, 1936 (illus. only, p. 95).
Special number (V. 3, No. 6, Summer 1936) celebrating the 25th anniversary of J. B. Neumann as an art dealer. Foreword by Murdoc Pemberton, plus reprints of his articles originally published in *The New Yorker*.

49 Parke-Bernet Galleries. *The Collection of Helena Rubinstein. Modern Paintings and Sculpture: Part I*. New York: [Parke-Bernet] April 20, 1966 (Auction No. 2428), p. 24-37 (9 illus.).

50 Parke-Bernet Galleries. *The Collection of Helena Rubinstein. Modern Paintings and Sculptures: Part II*. New York: [Parke-Bernet] April 27, 1966 (Auction No. 2431), p. 22-31 (13 works, 9 illus.).

51 Parkes, Kineton. *Sculpture of Today*. New York: Charles Scribner's Sons, [1921] (Universal Art Series), V. 2, p. 237-9, 242.

52 Patai, Irene. *Encounters: The Life of Jacques Lipchitz*. New York: Funk and Wagnalls, 1961, p. 108.

53 Proske, Beatrice Gilman. *Brookgreen Gardens Sculpture*. Rev. ed. Brookgreen Gardens, S. C.: Printed by order of the Trustees, 1968, p. xxxii, 278-80, 420, 535 (Bibl.) (1 illus.).

54 Rose, Barbara. *American Art Since 1900*. New York: Frederick A. Praeger, 1967, p. 36, 40, 75, 239, 240, 241 (1 illus.).

55 Salmon, André. "Humanisme" in his *La Jeune Sculpture Française*. Paris: Société des Trente, 1919, p. 77-82.
Edited, modified version of article in *L'Art Décoratif*. (See bibl. no. 93)

56 Schifferli, Peter, ed. with Hans Arp, Richard Huelsenbeck, Tristan Tzara. "Tristan Tzara: Chronique Zürichoise 1915-1919" in *Dada: Dichtung und Chronik der Gründer*. Zurich: Arche, 1957, p. 169.

57 Schnier, Jacques. *Sculpture in Modern America*. Berkeley-Los Angeles: University of California Press, 1948, p. 7, 8.

58 Schwarz, Karl. *Jewish Sculptors*. Tel-Aviv: Jerusalem Art Publishers, [1954?], p. 18, 36 (1 illus.).

59 Schwarz, Karl. *Die Juden in der Kunst*. Berlin: Welt-Verlag, 1928, p. 197.

60 "Sculpture: Garden Sculpture" by E[dward] McC[arten] in *Encyclopaedia Britannica*, 14th edition, London & New York: [The Encyclopaedia], 1929, V. 20, opp. p. 205 (illus. only).

61 Stein, Gertrude. "Nadelman" in her *Portraits and Prayers*. New York: Random House, 1934, p. 51-3.
A prose poem dated 1911, originally published in *larus*, V. 1, No. 4, July 1927, p. 19-20.
For other references to Nadelman and the Steins consult the Gertrude Stein material, Collection of American Literature, Yale University Library.

62 Ulanov, Barry. *The Two Worlds of American Art: The Private and The Popular*. New York: Macmillan, 1965, p. 110-12, 491-2.

63 Verkauf, Willy, ed. with Marcel Janco, Hans Bolliger. "Dada chronologie: 1914-1925" in *Dada: Monographie einer Bewegung*. Teufen: Arthur Niggli, 1958, p. 91.

64 W[erner], A[lfred]. "Elie Nadelman" in *Encyclopaedia Judaica*, Jerusalem: Keter, 1972, V. 12, p. 753-4 (1 illus.).

ARTICLES

65 Baur, John I. H. "Portfolio of American Drawings" *Art in America*, V. 49, No. 4, 1961, p. 64 (illus. only).

66 Beaunom, André. "Ein Hellenist: Elie Nadelman" *Das Zelt* (Vienna), V. 1, No. 3, March 1924, p. 94-5, 97 (6 illus.).

67 Birnbaum, Martin. "Eli Nadelman" *International Studio*, V. 57, No. 226, December 1915, p. LIII-LV (4 illus.).
Revised versions later published in:
a. 1917 - Scott and Fowles catalogue (Bibl. no. 114).
b. 1919 - *Introductions* (Bibl. no. 22).
c. 1925 - *The Menorah Journal*, V. 11, No. 5, October 1925, p. 484-8, plus "Sculpture – Art Insert" with 8 illus.

68 [Blumenthal, Arthur] in "New Acquisitions Spanning Three Centuries" *Progress Report First Semester 1969-1970*. Elvehjem Art Center, University of Wisconsin, Madison (1 illus.).

69 "Breaking Loose from the Rodin Spell" *Current Opinion*, V. 62, No. 3, March 1917, p. 206-8 (3 illus.).
Includes quotations from previously published writings by Nadelman (text for Photo-Secession Gallery exhibition catalogue, 1915/16, Bibl. no. 113a); Birnbaum (essay for Scott and Fowles catalogue 1917 taken from *International Studio*, 1915, Bibl. no. 114); McBride (*New York Sun*); Watson (*New York Evening Post*).

70 B[urroughs], C[lyde H.]. "The Sculpture of Elie Nadelman" *Bulletin of the Detroit Institute of Arts*, V. 1, No. 5, February 1920, p. 73-5 (3 illus.).

71 Canaday, John. "Promenade Will be One of State Theater's Bright Stars: Nadelman Sculpture is a Deft Adjunct to Architecture" *New York Times*, March 23, 1964, p. 26 (1 illus.).

New York State Theater sculpture also mentioned in:
a. Huxtable, Ada Louise. "Glass-Fronted Room Glinting with Gold Lends Regal Air" *New York Times*, March 23, 1964, p. 26.
b. "Inside the New York State Theater" *Saturday Review*, V. 47, No. 17, April 25, 1964, p. 54 (1 illus.).

72 Carpenter, Gilbert F. "Elie Nadelman: Spring" *Weatherspoon Gallery Association Bulletin*. University of North Carolina, Greensboro, 1967-68, p. 16-7 (2 illus.).

73 *Contemporary Sculpture*. Introduction by William Seitz. Arts Yearbook 8. New York: The Art Digest, 1965; p. 126 in "William King" by Martica Sawin; p. 185, 187 in "Private but Public: The Joseph H. Hirshhorn Collection" by Annette Michelson.

74 Davis, Virginia H. "Heads by Elie Nadelman" *International Studio*, V. 80, No. 334, March 1925, p. 482-3.

Based on works in the Helena Rubinstein collection.

75 *The Dial*, V. 71, August 1921, p. opp. 127 (illus. only); V. 85, October 1928, p. opp. 271 (illus. only).

76 duPlessix, Francine. "Anatomy of a Collector: Nelson Rockefeller" *Art in America*, V. 53, No. 2, April 1965, p. 35, 36 (1 illus.).

77 "Dwie Grupy" *Sztuka*, No. 8-9, 1904 (2 illus. only).

78 "Eli Nadelman" *Tygodnik Polski* [The Polish Weekly, N. Y.], V. 4, No. 50, December 29, 1946.

79 Evans, Jean. "Sculptor Passes but his Marble Lives On" *New York Star* (Magazine Section), V. 1, No. 33, July 31, 1948, p. 4-5 (2 illus.).

80 Fornaro, Carlo de. "Elie Nadelman, Vers la Beauté Plastique" *Social* (Havana), July 1929, p. 37, 64-5 (1 illus.).

81 Fornaro, Carlo de. "In the Art World: Elie Nadelman" *The Tatler* (New York), December 1929, p. 52.

82 Harper, Mr. [Russell Lynes]. "After Hours" *Harper's Magazine*, V. 196, April 1948, p. 381-4.

83 [King, Frederick A.]. "A 'Hellenist' Sculptor Driven Here by the War" *Literary Digest*, V. 54, No. 9, March 3, 1917, p. 550-1, 553 (3 illus.).
 Includes quotations from Martin Birnbaum's *International Studio* article, 1915 (Bibl. no. 67).

84 Kirstein, Lincoln. "Elie Nadelman, 1882-1946" *Harper's Bazaar*, V. 82, No. 2840, August 1948, p. 132-5, 186 (10 illus.).

85 Kirstein, Lincoln. "Elie Nadelman: Sculptor of the Dance" *Dance Index*, V. 7, No. 6, November 6, 1948, p. 130-151, front and back covers (32 illus.).
 Special number devoted to Nadelman.

86 McBride, Henry. "Neglected Sculpture, the Odd Story of a Brilliant Artist who Escaped Critical Attention" *New York Sun*, February 28, 1947, p. 23.

87 *Montjoie!* (Paris). V. 1, No. 4, March 29, 1913, p. 4; No. 9-10, June 14-29, 1913, p. 7; No. 11-12, November-December 1913, p. 1, 11. (Illustrations only.)

88 Moore, Lamont. "Sculpture in New York" *Art in America*, V. 45, No. 2, Summer 1957, p. 28 (illus. only).

89 "Nadelman's Museum [of folk and peasant art] Riverdale, New York" *The Art Digest*, V. 6, No. 4, November 15, 1931, p. 8.
 For additional material on the Nadelman collection of folk art see:
 a. "A Current Version of Rural Early English" *Antiques*, V. 25, No. 6, June 1934, p. 222.
 b. Gould, Mr. and Mrs. Glen. "Dolls for the Antiquarian" *International Studio*, V. 91, No. 379, December 1928, p. 50-1.
 c. Gould, Mr. and Mrs. Glen. "Plaster Ornaments for Collectors" *House and Garden*, V. 56, No. 2, August 1929, p. 84-5, 122.
 d. Gould, Mr. and Mrs. Glen. "The Nadelman Ship Figureheads" *International Studio*, V. 94, No. 388, September 1929, p. 51-3.
 e. "Nadelman's Folk Art" *The Art Digest*, V. 12, No. 11, March 1, 1938, p. 15.
 f. "The Nadelman Folk Art Collection" *Antiques*, V. 33, No. 3, March 1938, p. 152.
 g. "New York: Folk Art Purchased by the New York Historical Society" *Art News*, V. 36, No. 19, February 5, 1938, p.17.
 h. "Riverdale Museum Opened to the Public" *Museum News*, V. 12, No. 20, April 15, 1935, p. 2.
 i. Watson, Forbes. "A Museum of the Folk Arts" *American Magazine of Art*, V. 28, No. 5, May 1935, p. 312.

90 Parkes, Kineton. "After Futurism Comes 'Significant' Form; A Polish Sculptor, Elie Nadelman, Introduces the Newest Phase in Sculptured Art" *The Sphere* (London), V. 107, No. 1393, October 2, 1926, p. 18 (3 illus.).

91 "Rediscovered Genius" *Life*, V. 24, No. 21, May 24, 1948, p. 119-120, 122 (6 illus.).

92 "*Reverie* by Elie Nadelman" *Bulletin of the Detroit Museum of Art*, V. 12, No. 8, May 1918, p. 54, 56-7 (2 illus.).

93 Salmon, André. "Eli Nadelman" *L'Art Décoratif*, V. 16, No. 201, March 1914, p. 107-14 (9 illus.). (See bibl. no. 55)

94 Salmon, André. "La Sculpture Vivante, II: Maillol et J. Bernard" *L'Art Vivant*, V. 2, No. 30, March 15, 1916, p. 209, 210.

95 Salmon, André. "La Sculpture Vivante, III: Bourdelle et Nadelman" *L'Art Vivant*, V. 2, No. 31, April 1, 1926, p. 259-60 (3 illus.).

96 Spear, Athena T. "Elie Nadelman's Early Heads, 1905-1911" *Allen Memorial Art Museum Bulletin, Oberlin College*, V. 28, No. 3, Spring 1971, p. 201-22 (19 illus.); also, "Accessions" p. 238.

97 Tyrrell, Henry. "At a Musical Tea with Nadelman" [*New York*] *World Magazine*, November 30, 1919 (6 illus.).
Interview. (See bibl. no. 6)

98 *Vanity Fair* (New York). "American Work of a Polish Sculptor" V. 8, No. 1, March 1917, p. 59 (3 illus. and port. of the artist).

99 *Vanity Fair* (New York). "Sculpture of Mystery by Elie Nadelman" V. 9, No. 1, September 1917, p. 58 (4 illus.).

100 *Vanity Fair* (New York). "Sculpture at a New York Salon" V. 9, No. 5, January 1918, p. 54 (2 illus.). (See bibl. no. 145)

101 *Vanity Fair* (New York). "Sappho – A Statue, in African Marble, by Elie Nadelman" V. 10, No. 2, April 1918, p. 64 (1 illus.).

102 *Vanity Fair* (New York). "Elie Nadelman, in a Modernist Mood" V. 10, No. 3, May 1918, p. 64 (4 illus.).

103 *Vanity Fair* (New York). "Playing the Marseillaise" V. 10, No. 7, September 1918, p. 55 (illus. only).

104 *Vanity Fair* (New York). "La Rêve" V. 11, No. 3, November 1918, p. 63 (illus. only).

105 *Vanity Fair* (New York). "A Venus of Today. A Marble by Elie Nadelman" V. 24, No. 5, July 1925, p. 26 (1 illus.).

106 Weichsel, John. "Eli Nadelman's Sculpture" *East and West*, V. 1, No. 5, August 1915, p. 144-8 (10 illus.).
First American notice on Nadelman.

107 Werner, Alfred. "Nadelman: Recluse of Riverdale" *Commentary*, V. 9, No. 6, June 1950, p. 545-550.

EXHIBITIONS

Exhibition catalogues arranged chronologically, with reviews and notices. An asterisk (*) preceding an entry indicates that the actual exhibition catalogue or announcement is unavailable or non-existent.

One-Man Exhibitions

108 *Paris. Galerie B. Weill, rue Victor Massé. Before 1909.

(Referred to in bibl. no. 12)

109 Paris. Galerie E. Druet. "Exposition Elie Nadelman" April 26 - May 8, 1909. 29 sculptures, 100 drawings (2 illus.).

First large-scale one-man show.

110 *Barcelona. [With sculptor Manuel Martinez Hugué, known as "Manolo."] 1911.

(Referred to in bibl. no. 11)

111 *London. Paterson's Gallery. 1911.

Related material:
a. Basler, Adolphe. "Eli Nadelman" *Sztuka* (Lwów), March-April 1912, p. 72-4 (5 illus.). In Polish. Statement by the artist for Paterson's Gallery catalogue with introductory paragraph by Basler.
b. "A New Sculptor: Two Examples of the Work of Elie Nadelman" *Black and White* (London), V. 42, April 1, 1911, p. 25 (2 illus.).

112 Paris. Galerie E. Druet. "Exposition d'Art Plastique de Eli Nadelman" May 26-June 7, 1913. 21 sculptures, 30 works on paper (1 illus.).

Review:
a. Jean, René. "Petites Expositions: Exposition Eli Nadelman" *La Chronique des Arts et de la Curiosité - Supplément à la Gazette des Beaux-Arts*, No. 23, June 7, 1913, p. 179.

113 New York. Photo-Secession Gallery ["291"]. "Eli Nadelman Exhibition" December 8, 1915 - January 19, 1916. 15 sculptures, 10 drawings (3 illus.).

First show of Nadelman's work in America. For material related to this exhibition see:
a. "Eli Nadelman, of Paris" *Camera Work*, No. 48, October 1916, p. 10.
 Text by Nadelman which allegedly accompanied illustrated leaflet for this exhibition; introductory paragraph by Alfred Stieglitz. Also in this number, p. 42-5, are reprints of press notices reviewing the show by: Charles Caffin (*New York American*), Henry McBride (*New York Sun*), Forbes Watson (*New York Evening Post*), Elizabeth Carey (*New York Times*).
b. Wright, Willard Huntington. "The Aesthetic Struggle in America" *The Forum*, V. 55, No. 2, February 1916, p. 214-7.

114 New York. Scott and Fowles Gallery. "Exhibition of Sculpture and Drawings by Elie Nadelman" 1917. 70 works (7 illus. and port. of the artist). Introduction by Martin Birnbaum.

"A portion of this essay is reprinted by permission from *The International Studio* for December 1915" (See bibl. no. 67)
Reviews:
a. Eddy, Frederick W. "Classic Sculpture by Elie Nadelman . . ." *New York World*, February 11, 1917.

b. McBride, Henry. "Exhibitions at the New York Galleries: Elie Nadelman's Sculptures" *Fine Art Journal* (Chicago), V. 35, No. 3, March 1917, p. 227-8.

c. McBride, Henry. *New York Sun*, February 4, 1917.

d. Watson, Forbes. "At the Art Galleries" *New York Evening Post Saturday Magazine*, February 3, 1917 (1 illus.).

115 New York. M. Knoedler. "Nadelman" October 27 - November 8, 1919. 16 sculptures, 41 drawings (6 illus.).

Reviews:

a. Field, Hamilton Easter. "Modern Art Shown at Knoedler Gallery" *Brooklyn Eagle*, November 2, 1919.

b. McBride, Henry. *New York Sun*, November 2 and 16, 1919.

116 ★New York. Marie Sterner Gallery. "Recent Sculpture and Drawings by Elie Nadelman" November 1919.

(Referred to in bibl. no. 37; possibly a continuation of exhibition referred to in bibl. no. 115)

117 Paris. Galerie Bernheim-Jeune. "Exposition Nadelman. Sculptures et Dessins" September 23 - October 13, 1920. 10 sculptures, 90 drawings (6 illus.).

Reviews:

a. "Petites Expositions" *La Chronique des Arts et de la Curiosité – Supplément à la Gazette des Beaux-Arts*, No. 17, October 31, 1920, p. 144.

b. Reviews and notices quoted from 11 French sources and a notice from the *Chicago Tribune*, 8 typed pages, in Special Collections, Museum of Modern Art Library.

118 ★Berlin. Galerie Flechtheim. March 1923.

(Referred to in bibl. no. 37)

119 ★New York. Scott and Fowles Gallery. March 1925.

Reviews:

a. Cortissoz, Royal. "A Spring Interlude in the World of Art Shows: Reversions – Henri Matisse and Elie Nadelman in Normal Mood" *New York Herald Tribune*, March 15, 1925, Section 4, p. 12 (2 illus.).

b. F[lint], R[alph]. "Nadelman Exhibits in Triple Capacity" *The Art News*, V. 23, No. 23, March 14, 1925, p. 1-2.

c. McBride, Henry. "Neo-Greek Sculptures Shown" *New York Sun*, March 14, 1925.

d. McBride, Henry. "Modern Art" *The Dial*, V. 78, June 1925, p. 528-9 (3 illus. on pages between 474 & 475).

e. "New York Gallery Findings" *Christian Science Monitor*, March 18, 1925.

f. Read, Helen Appleton. "New York Exhibitions: Eli Nadelman" *The Arts*, V. 7, No. 4, April 1925, p. 228-9 (2 illus.).

120 Chicago. Art Institute (Arts Club Exhibition). "Sculpture by Elie Nadelman" May 1 - June 4, 1925. 18 works (1 illus.).

121 New York. M. Knoedler. "Sculpture by Elie Nadelman" January 31 - February 12, 1927. 10 works.

Reviews:
a. Kalonyme, Louis. "Art's Spring Song: Modern and Ultra-Modern American Art in the New York Galleries" *Arts and Decoration*, V. 26, No. 6, April 1927, p. 67, 102 (1 illus.).
b. McBride, Henry. "Modern Art" *The Dial*, V. 82, April 1927, p. 353-4.
c. McBride, Henry. *New York Sun*, February 5, 1927.
 Reprinted in *Creative Art*, V. 10, No. 5, May 1932, p. 392-4 (2 illus.) on the occasion of Nadelman exhibition at Marie Sterner's International Gallery, N. Y. (See bibl. no. 123)

122 Paris. Galerie Bernheim-Jeune. "Exposition Elie Nadelman" May 23 - June 3, 1927. 9 sculptures.

123 New York. International Gallery. "Private Collection of Helena Rubinstein: Nadelman" April 16 - May 6, 1932. (5 illus.)

Text by Marie Sterner.
Reviews: (See also bibl. no. 121c)
a. "Around the Galleries" *Art News*, V. 30, No. 30, April 23, 1932, p. 10.
b. "Beauty Specialist Displays her Nadelmans" *The Art Digest*, V. 6, No. 14, April 15, 1932, p. 15 (1 illus.).
c. B[ois], G[uy] P[ène du]. "Eli Nadelman" *Arts Weekly* (New York), V. 1, No. 8, April 30, 1932, p. 169, 174, 175 (2 illus.).
d. N[irdlinger], V[irginia]. "Eli Nadelman – International Gallery" *Parnassus*, V. 4, No. 4, April 1932, p. 13, 22, opp. p. 1 (2 illus.).

124 New York. Museum of Modern Art. "The Sculpture of Elie Nadelman" October 5 - November 28, 1948 [Memorial retrospective]. 43 sculptures, plus a group of small plaster figures and a group of drawings (57 illus.).

Text by Lincoln Kirstein. Bibliography by Bernard Karpel. Exhibition also shown at the Baltimore Museum of Art (December 29, 1948 - February 27, 1949) and the Institute of Contemporary Art, Boston (March 11 - April 24, 1949).
Reviews of exhibition at MOMA:
a. Coates, Robert M. "The Art Galleries: East and West" *The New Yorker*, V. 24, No. 34, October 16, 1948, p. 89, 90-1.
b. Crawford, Peggy F. "Nadelman Revived" *The Art Digest*, V. 23, No. 2, October 15, 1948, p. 15, 35 (1 illus.).
c. "Monumental Dolls" *Time*, V. 52, No. 16, October 18, 1948, p. 46 (1 illus.).
d. "Nadelman Rediscovered" *Newsweek*, V. 32, No. 16, October 18, 1948, p. 105 (1 illus.).
e. Preston, Stuart. "The Nadelman Revival" *Art News*, V. 47, No. 6, October 1948, p. 22-4, 51 (6 illus. and port. of the artist).
Reviews of exhibition at Baltimore Museum:
f. B[reeskin], A[delyn] D. "Elie Nadelman" *The Baltimore Museum of Art News*, V. 12, No. 3, December 1948, p. 5-6; also, V. 12, No. 5, February 1949, p. 6-7 (1 illus.).
g. Cox, Shelby Shackelford. "Elie Nadelman: A Sculpture Review" *Right Angle* (Washington, D. C.), V. 2, No. 11, February-March 1949, n. p. (1 illus.).
Review of exhibition in Boston:
h. Dame, Lawrence. "Regarding Boston" *The Art Digest*, V. 23, No. 13, April 1, 1949, p. 34.

125 New York. Knoedler Galleries. "Elie Nadelman Drawings" November 29 - December 10, 1949.

Reviews:
 a. B[rian], D[oris]. "Howard and Nadelman" *The Art Digest*, V. 24, No. 6, December 15, 1949, p. 22 (1 illus.).
 b. C[ampbell], L[awrence]. "Elie Nadelman" *Art News*, V. 48, No. 9, January 1950, p. 45-6.

126 New York. Edwin Hewitt Gallery. "Small Sculpture by Elie Nadelman" November 28 - December 16, 1950. (1 illus.)
 Text by Lincoln Kirstein.
 Reviews:
 a. B[ird], P[aul]. "Elie Nadelman" *The Art Digest*, V. 25, No. 5, December 1, 1950, p. 17 (1 illus.).
 b. McBride, Henry. [Reviews] *Art News*, V. 49, No. 9, January 1951, p. 50.

127 New York. Edwin Hewitt Gallery. "Wood Sculpture by Elie Nadelman" November 28 - December 22, 1951. 18 works (1 illus.).
 Text by Lincoln Kirstein.
 Reviews:
 a. Fitzsimmons, James. "New York Gets a Spate of Sculpture Shows" *The Art Digest*, V. 26, No. 5, December 1, 1951, p. 34.
 b. P[orter], F[airfield]. "Elie Nadelman's . . ." *Art News*, V. 50, No. 8, December 1951, p. 46.

128 Boston. Swetzoff Gallery. "Sculpture-Nadelman" September 28 - October 17, 1953. 14 sculptures and a group of carved figures.

129 *New York. Edwin Hewitt Gallery. March 28 - April 16, 1955.
 Reviews:
 a. M[unro], E[leanor] C. "Elie Nadelman" *Art News*, V. 54, No. 2, April 1955, p. 47 (1 illus.).
 b. R[osenblum], R[obert]. "Elie Nadelman" *Arts Digest*, V. 29, No. 13, April 1, 1955, p. 20 (1 illus.).

130 New York. Edwin Hewitt Gallery. "Elie Nadelman, 1882-1946: Sculpture in Bronze, Stone, Wood, Galvano-plastique. Drawings in Various Media. Etchings and Dry-points" April 16 - May 18, 1957. (port. of the artist)
 Text by Lincoln Kirstein.
 Reviews:
 a. B[urckhardt], E[dith] B. "Elie Nadelman's Sculpture . . ." *Art News*, V. 56, No. 2, April 1957, p. 10.
 b. Y[oung], V[ernon]. "Elie Nadelman" *Arts*, V. 31, No. 7, April 1957, p. 56.

131 New York. Edwin Hewitt Gallery. "Elie Nadelman: 15 Small Bronzes and Drawings" April 7-30, 1958. (1 illus.)
 Reviews:
 a. C[ampbell], L[awrence]. "Elie Nadelman" *Art News*, V. 57, No. 3, May 1958, p. 13.
 b. S[awin], M[artica]. "Elie Nadelman" *Arts*, V. 32, No. 8, May 1958, p. 55.
 c. Schwartz, Marvin D. "News and Views from New York: Elie Nadelman at the Hewitt Gallery" *Apollo*, V. 67, No. 400, June 1958, p. 241 (1 illus.).

132 New York. The Hewitt Gallery (Robert Isaacson). "Elie Nadelman: Figures and Figurines, 1930-1940" December 5-31, 1958. 29 works and a selection of dry-points. (2 illus.)

Text by Lincoln Kirstein.

Reviews:

a. Grosser, Maurice. "Art: Elie Nadelman's Figurines" *The Nation*, V. 187, No. 22, December 27, 1958, p. 503.

b. M[ellow], J[ames] R. "Elie Nadelman" *Arts*, V. 33, No. 3, December 1958, p. 52-3.

c. P[orter], F[airfield]. "Elie Nadelman" *Art News*, V. 57, No. 8, December 1958, p. 15 (1 illus.).

133 New York. Robert Isaacson Gallery. "Elie Nadelman, 1882-1946" October 18 - November 19, 1960. 20 sculptures (2 illus.).

Reviews:

a. Preston, Stuart. "Current and Forthcoming Exhibitions: New York" *Burlington Magazine*, V. 102, No. 693, December 1960, p. 549.

b. R[oskill], M[ark]. "Elie Nadelman" *Art News*, V. 59, No. 8, December 1960, p. 15.

c. S[awin], M[artica]. "Elie Nadelman" *Arts*, V. 35, No. 3, December 1960, p. 53.

134 New York. Robert Isaacson Gallery. "Drawings by Elie Nadelman" November 8 - December 2, 1961. 38 works (1 illus.).

Reviews:

a. "Art: Relax and Enjoy" *Progressive Architecture*, V. 42, No. 12, December 1961, p. 71 (1 illus.).

b. C[ampbell], L[awrence]. "Elie Nadelman" *Art News*, V. 60, No. 8, December 1961, p. 57.

135 ★Los Angeles. Rex Evans Gallery. [Bronzes and Drawings by Elie Nadelman. February 1962.]

Review:

a. Langsner, Jules. "Los Angeles Letter, Part II: February 1962" *Art International*, V. 6, No. 2, March 1962, p. 49-50 (1 illus.).

136 New York. Zabriskie Gallery. "Elie Nadelman, 1882-1946" February 7 - March 4, 1967. 20 sculptures, 40 drawings (3 illus.). Chronology.

Text by Alfred Werner.

Reviews:

a. C[ampbell], L[awrence]. "Elie Nadelman" *Art News*, V. 65, No. 10, February 1967, p. 17, 18 (1 illus.).

b. J. B. "Elie Nadelman" *Arts*, V. 41, No. 4, February 1967, p. 61 (1 illus.).

c. Goldin, Amy. "New York: Elie Nadelman" *Artforum*, V. 5, No. 8, April 1967, p. 59-60 (1 illus.).

d. Kramer, Hilton. "Nadelman's Achievement" *New York Times*, February 11, 1967, p. 24.

e. "Welt der Kunst: Elie Nadelman" *Aufbau*, February 24, 1967.

f. Willard, Charlotte. ". . . Galleries: Really and Truly" *New York Post, Saturday Magazine*, February 11, 1967, p. 14 (1 illus.).

137 New York. Metropolitan Museum of Art. [Projected Elie Nadelman Exhibition. December 1973.]

138 Paris. Société du Salon d'Automne. "3ᵉ Exposition de Peinture, Dessin, Sculpture, Gravure, Architecture et Art décoratif" October 18 - November 25, 1905. 4 works.
Text by Elie Faure.

139 Paris. Société du Salon d'Automne. "4ᵐᵉ Exposition de Peinture, Sculpture, Dessin, Gravure, Architecture et Art décoratif" October 6 - November 15, 1906. 8 works.
Text by Roger Marx.
Also "[11ᵐᵉ] Exposition" November 15, 1913 - January 5, 1914. 2 works. Introduction by Marcel Sembat.

140 Paris. Société des Artistes Indépendants. "23ᵐᵉ Exposition" March 20 - April 30, 1907. 6 works.
Also "29ᵐᵉ Exposition" March 19 - May 18, 1913. 3 works.

141 *Berlin. [Juryfrei Kunstschau. 1913.]
Notice:
a. Bülow, J. v. "Paris auf der juryfreien Kunstschau in Berlin" *Kunstchronik-Kunstmarkt*, V. 24 (New Series), No. 18, January 31, 1913, p. 250-1.

142 New York. Association of American Painters and Sculptors. "International Exhibition of Modern Art" [The Armory Show] held at the 69th Infantry Regiment Armory February 17 - March 15, 1913. Catalogue nos. 380 (12 drawings), 634 (sculpture), 1099 (sculpture listed in Supplement to Catalogue).

143 *Zurich. Cabaret Voltaire. [On the walls for the opening, February 1916. 4 drawings.]
Also represented in group show, June 1916. (See bibl. nos. 57 & 63)

144 New York. Montross Gallery. "Contemporary Group Exhibition" December 12-30, 1916. 4 works.

145 *New York. Scott and Fowles. [Contemporary American Art. November 1917. 2 works.]
Reviews:
a. Eddy, Frederick W. "News of the Art World: American Contemporary Art at Its Best..." *New York World*, November 19, 1917.
b. McBride, Henry. "Exhibitions at New York Galleries: Nadelman, Demuth and Other Artists" *Fine Arts Journal*, V. 35, No. 12, December 1917, p. 46, 51-2 (1 illus.).
c. "Sculpture at a New York Salon" *Vanity Fair* (New York), V. 9, No. 5, January 1918, p. 54 (2 illus.). (See bibl. no. 100)

146 *New York. Ritz-Carlton Hotel. ["Allies of Sculpture" December 1917. 4 works.]
Review:
a. "His 'Modest' Art Offends... Nadelman Thinks His Figures at Ritz-Carlton Show Have Too Many Clothes on to Please Committee" *New York World*, December 19, 1917.

147 ⋆New York. The Whitney Studio. ["'Indigenous' Sculpture" March 1918. 1 work.]
Review:
a. *New York Sun*, March 10, 1918.

148 ⋆New York. Penguin Club Galleries. [Exhibition of Contemporary Art. March 1918. 1 work.]
Review:
a. McBride, Henry. *New York Sun*, March 24, 1918.

149 ⋆New York. Gimpel and Wildenstein. ["First Annual Exhibition of the New Society of American Artists" November 1919.]
Review:
a. McBride, Henry. *New York Sun*, October 26, 1919.

150 Dallas. Dallas Art Association. "First Annual Exhibition, Contemporary International Art" November 18-27, 1919. 1 work.
Foreword by Christian Brinton.

151 Buffalo. Albright Art Gallery. "Fourteenth Annual Exhibition of Selected Painting by American Artists and a Group of Small Selected Bronzes by American Sculptors" May 29 - September 7, 1920. 1 work.

152 New York. Gimpel and Wildenstein. "Second Annual Exhibition of the New Society of Artists" November 8-27, 1920. 4 works (1 illus.).

153 ⋆New York. National Sculpture Society. [Small group show of work by members. November 1920.]
Notice:
a. *American Art News*, V. 19, No. 5, November 13, 1920, p. 6.

154 ⋆New York. The Colony Club. [Contemporary Art Exhibition. April 1922.]
Review:
a. Lloyd, David. "Modernists of Various Kinds in Three Shows" *New York Evening Post*, April 8, 1922.

155 New York. Anderson Galleries. "The New Society of Artists Fourth Exhibition" January 2-27, 1923. 4 works.

156 ⋆Berlin. Galerie Flechtheim. [Group show. March 1923.]
Notice:
a. "Berliner Ausstellungen: Galerie Flechtheim" *Kunstchronik und Kunstmarkt*, V. 34 (New Series), No. 25, March 23, 1923, p. 497.

157 ⋆New York. Joseph Brummer Galleries. ["Second Annual Exhibition of the Modern Artists of America" May 1923.]
Notice:
a. *Brooklyn Eagle*, April 29, 1923.

158 New York. Anderson Galleries. "The New Society of Artists Fifth Exhibition" January 2-31, 1924. 1 work.

159 Buffalo. Albright Art Gallery. "Eighteenth Annual Exhibition of Selected Paintings and Small Bronzes by American Artists" April 20 - June 30, 1924. 2 works (1 illus.).

160 New York. Anderson Galleries. "The New Society of Artists Seventh Exhibition" January 6-30, 1926. 1 work.

161 New York. Grand Central Art Galleries. "Eighth Annual Exhibition of the New Society of Artists" November 15 - December 4, 1926. 3 works.

162 San Francisco. California Palace of the Legion of Honor, in cooperation with the National Sculpture Society of New York. "Contemporary American Sculpture" April-October, 1929. (1 illus.)

163 New York. Salons of America. "Spring Salon" April 20 - May 9, 1931. 1 work. [Exhibition held at the Anderson Galleries.]

164 ★New York. Averell House. [Sculpture for the Garden. November-December 1931.]
Review:
a. "Rare Sculpture for the Garden at Averell House" *The Art News*, V. 30, No. 10, December 5, 1931, p. 14 (1 illus.).

165 ★New York. Kraushaar Galleries. [Group sculpture show. May 18 - June 15, 1932. 1 work.]
Review:
a. Burrows, Carlyle. ". . . Ten Sculptors" *New York Herald Tribune*, May 29, 1932.

166 ★New York. Knoedler Galleries. [International Horse Show of Art. March 20 - April 1, 1933. 1 work.]
Notice:
a. "Big Entry List Being Filled for Art Horse Show" *New York American*, March [12?], 1933.

167 New York. Reinhardt Galleries. "Baby Show: Exhibition of Children's Portraits" [for the benefit of the Children's Welfare Federation] May 1-13, 1933. 2 works.

168 New York. Milch Galleries. "Special Exhibition of Contemporary American Sculpture" February, 1937. 1 work.

169 ★New York. Karl Freund Gallery. ["Ducks and Geese in the Art of the Ages" April 1937.]
Review:
a. Burrows, Carlyle. "Ducks and Geese in Art" *New York Herald Tribune*, May 2, 1937.

170 Pittsburgh. Carnegie Institute, Department of Fine Arts. "Exhibition of American Sculpture" May 5 - June 19, 1938. 3 works.

171 Paris. Musée du Jeu de Paume. "Trois siècles d'art aux États-Unis: Peinture, Sculpture, Architecture, Photographie, Cinema" May-June 1938. 1 work.
Exhibition organized in collaboration with the Museum of Modern Art, New York. Foreword by A. Conger Goodyear. "Painting and Sculpture in the United States" by Alfred H. Barr, Jr. (Mention of Nadelman p. 33.) Other contributors: John McAndrew, Beaumont Newhall, Iris Barry.

172 Philadelphia. Museum of Art. "History of an American – Alfred Stieglitz: '291' and After; Selections from the Stieglitz Collection" [1944]. 1 work.
Text by Henry Clifford and Carl Zigrosser.

173 New Haven. Yale University Art Gallery. "Sculpture Since Rodin" January 14 - February 13, 1949. 1 work.

174 New York. M. Knoedler Galleries. "To Honor Henry McBride" November 29 - December 17, 1949. 1 work.
Essay by Lincoln Kirstein. Catalogue entry on Nadelman by Henry McBride.

175 New York. Edwin Hewitt Gallery. "Symbolic Realism" April 3-22, 1950. 2 works.
Text by Lincoln Kirstein.

176 Minneapolis. Walker Art Center. "Reality and Fantasy, 1900-1954" May 23 - July 2, 1954. 1 work.
Introduction by H. H. Arnason.

177 Paris. Musée National d'Art Moderne. "50 ans d'art aux États-Unis: Collections du Museum of Modern Art de New York" April-May 1955. 5 works (1 illus.).
Introduction to "Peinture et Sculpture" by Holger Cahill. (Mention of Nadelman p. 31.)

178 London. Tate Gallery. "Modern Art in the United States, A Selection from the Collection of the Museum of Modern Art, New York" January 5 - February 12, 1956. 5 works (1 illus.).
Foreword by John Rothenstein and Philip James. Introduction by René d'Harnoncourt. "American Painting and Sculpture in the Twentieth Century" by Holger Cahill. (Mention of Nadelman p. 26.)

179 Brooklyn, N. Y. The Brooklyn Museum. "Golden Years of American Drawings: 1905-1956" January 22 - March 17, 1957. 2 works (1 illus.).
Text and catalogue by Una E. Johnson. (Mention of Nadelman p. 7, 31.)

180. New York. Whitney Museum of American Art. "The Collection of the Sara Roby Foundation" April 29 - June 14, 1959. 2 works (1 illus.).

181 Worcester, Mass. Worcester Art Museum. "The Dial and The Dial Collection" April 30 - September 8, 1959. 4 works (1 illus.).

Catalogue of painting and sculpture for the exhibition by Louisa Dresser.

182 Detroit. Institute of Arts. "Sculpture in Our Time – Collected by Joseph H. Hirshhorn" May 5 - August 23, 1959. 3 works (1 illus.).

Foreword by E. P. Richardson. Text by Abram Lerner. "Sculpture in Our Time" [an essay] by Addison Franklin Page. An abbreviated version of the exhibition travelled across the U. S.: Milwaukee Art Center, Walker Art Center (Minneapolis), William Rockhill Nelson Gallery of Art (Kansas City, Mo.), Museum of Fine Arts (Houston), Los Angeles County Museum, De Young Memorial Museum (S. F.), Colorado Springs Fine Arts Center, Art Gallery of Toronto (Ontario).

183 Moscow. "American Painting and Sculpture" July 25 - September 5, 1959. 1 work (illus.).

First cultural exchange exhibition prepared by Fine Arts Section, U.S.I.A., as part of American National Exhibition. Text by Lloyd Goodrich. (In Russian)

184 New York. Museum of Modern Art. "100 Drawings from the Museum Collection" [checklist] October 12 - January 2, 1960. 1 work.

185 Utica, N. Y. Munson-Williams-Proctor Institute. "Art Across America" October 15 - December 31, 1960. 1 work.

Introduction by Howard Mumford Jones. Text by Richard B. K. McLanathan.

186 Newark, N. J. The Newark Museum. "Survey of American Sculpture: Late 18th Century to 1962" May 10 - October 20, 1962. 1 work (illus.).

Text by William H. Gerdts. (Mention of Nadelman p. 21.) Part of this essay (including the paragraphs on Nadelman) was reprinted in *American Artist*, V. 26, No. 7, September 1962, p. 44, 71 (1 illus.).

187 New York. Downtown Gallery. "36th Spring Annual: The Figure" [announcement] May 22 - June 15, [1962].

188 New York. Forum Gallery. "Sculptors' Drawings from the Joseph H. Hirshhorn Collection" October 1-20, 1962. 3 works (1 illus.).

Foreword by Abram Lerner.

189 New York. Solomon R. Guggenheim Museum. "Modern Sculpture from the Joseph H. Hirshhorn Collection" October 3, 1962 - January 6, 1963. 7 works (3 illus.).

Foreword by Abram Lerner. Commentary by H. H. Arnason.

190 New York. Whitney Museum of American Art. "The Decade of the Armory Show: New Directions in American Art, 1910-1920" February 27 - April 14, 1963. 3 works.

Text by Lloyd Goodrich. Exhibition also shown at: City Art Museum, St. Louis (June 1 - July 14, 1963); Cleveland Museum of Art (August 6 - September 15, 1963); Pennsylvania Academy of Fine

Arts, Phila. (September 30 - October 30, 1963); Chicago Art Institute (December 15-29, 1963); Albright-Knox Art Gallery, Buffalo (January 20 - February 23, 1964).

191 New York. The American Federation of Arts Gallery. "The Educational Alliance Art School: Retrospective Art Exhibit" April 29 - May 18, 1963. 2 works (2 illus.).
Preface by John I. H. Baur. "The History of the Art School" by Alexander Dobkin. "Recollections of a Student" by Moses Soyer.

192 Lincoln, Nebraska. Sheldon Art Gallery. "A Selection of Works from the Art Collections at the University of Nebraska" May 1963. 1 work (illus.).
Handbook published on the occasion of the inauguration of the Sheldon Art Gallery.

193 Waltham, Mass. The Rose Art Museum, Brandeis University. "Boston Collects Modern Art – A Loan Exhibition of the Poses Institute of Fine Arts" May 24 - June 14, 1964. 1 work.
Introduction by Sam Hunter.

194 Baltimore. Museum of Art. "1914: An Exhibition of Paintings, Drawings and Sculpture" October 6 - November 15, 1964. 1 work (illus.).
An exhibition in celebration of the 50th anniversary of the Baltimore Museum of Art. Foreword by Charles Parkhurst. Contributions to the text by George Boas, Henri Peyre, Lincoln Johnson, Jr., Gertrude Rosenthal.

195 New York. Zabriskie Gallery. "The American Sculptor, 1900-1930" [announcement] April 5-30, 1966.
Review:
a. Kramer, Hilton. "The American Sculptor, 1900-1930" New York Times, April 23, 1966 (1 illus.).

196 New York. Public Education Association. "Seven Decades, 1895-1965: Crosscurrents in Modern Art" April 26 - May 21, 1966. 1 work (illus.).
Text by Peter Selz. Nadelman shown at Perls Gallery.

197 Buffalo. Albright-Knox Art Gallery. "Drawings and Watercolors from the Albright-Knox Art Gallery" December 18, 1967 - January 31, 1968. 1 work (illus.).

198 Los Angeles. Felix Landau Gallery. "Modern Master Watercolors and Drawings" March 30 - April 25, 1970. 3 works (illus.).

199 Lincoln, Nebraska. Nebraska Art Association. "American Sculpture" September 11 - November 15, 1970. 4 works (1 illus.).
An exhibition organized to inaugurate the Sheldon Sculpture Garden at the University of Nebraska, Lincoln.

200 New York. Museum of Modern Art. "Four Americans in Paris: The Collections of Gertrude Stein and her Family" December 19, 1970 - March 1, 1971. 1 work.
Foreword by John B. Hightower. Introduction by Margaret Potter. With contributions by: Irene Gordon, Lucile M. Golson, Leon Katz, Douglas Cooper, Ellen B. Hirschland; and reprints of writings by Leo and Gertrude Stein.

201 New York. Library and Museum of the Performing Arts, Lincoln Center. "Dance in Sculpture" February 1 - April 30, 1971. 2 works (1 illus.).

202 Providence, Rhode Island Museum of Art, Rhode Island School of Design. "Selection I: American Watercolors and Drawings" December 30, 1971 - January 23, 1972. 1 work (illus.).
Bulletin of Rhode Island School of Design: Museum Notes, V. 58, No. 4, January 1972, issued as exhibition catalogue. Preface by Stephen E. Ostrow. Note on the catalogue by Susan P. Carmalt. (Discussion of Nadelman p. 47-9.)

While this exhibition list includes almost all major exhibitions in which works of Nadelman were represented, a number of existing records of group exhibitions, illustrations and other bibliographical material has been omitted, as being primarily of interest to research specialists. This additional information is available on request from either the compiler or the publisher.

ACKNOWLEDGEMENTS

This study owes all to Mrs. Elie Nadelman, whom I first met in the week following her husband's death, and with whom I became increasingly close until her own. For a time, my wife and I lived in her attic, and Alderbrook became our second home. I never knew the sculptor in person, but I had the run of his studio, sketches, photographs, letters and books, so that I came to believe I understood him. Except for time spent abroad, I spoke to Mrs. Nadelman almost daily and, more often than not, saw her several times a week. Many things she told me did not come within the scope of this book; files for future reference are kept by her son, Jan. A survey covering the Nadelman Folk Art Museum would be of value to show the Nadelmans' capital responsibility for the collection and display of European and American primitive painting and sculpture; textiles, glass and metal-work.

Going through files, I found a letter of mine from 1930, written from Harvard on behalf of its Society of Contemporary Art, in a small but significant way a prototype of the Museum of Modern Art in Manhattan. I requested examples of Nadelman's work for an exhibition of progressive sculpture, but he refused. In 1948, under the elegant and masterful supervision of René d'Harnoncourt, a memorial exhibition was held at the Museum of Modern Art, for which I wrote a catalogue. In 1952, Curt Valentin published a very limited edition of Nadelman's complete graphic work in a characteristically splendid format. A great dealer made available work which Nadelman had never issued. His own trial proofs on various papers and in several states are deposited in the Print Room of the Metropolitan Museum of Art. In 1949, Herbert Bittner published a selection of Nadelman's drawings, for which I wrote an introduction. Out of print since its first publication, it has been reprinted by Hacker Books, New York, 1970.

For twenty-five years I've been involved in salvaging, studying and promulgating Nadelman's work. In this I have had enormous aid from Governor Nelson A. Rockefeller, whose mother early encouraged me, and whose taste, generosity and compassion were extraordinary. Only second to this was the support of Philip Johnson, a great neo-classic architect. His New York State Theater, the home of the New York City Ballet, enshrines Nadelman's two principal statues, given by Johnson. They can be seen as the muses of two other neo-classicists whose repertory fills that opera-house: George Balanchine and Igor Stravinsky. Johnson's magnificent promenade is the finest contemporary honorific space in America.

Following the retrospective show of 1948, several smaller exhibitions were held at the galleries of Edwin Hewitt and Robert Isaacson, New York City. I had first met Mrs. Nadelman through Hewitt, a friend of Mrs. Stewart Walker, wife of the architect

342

who had given Nadelman important outdoor commissions. Each show turned up new work, although a great deal more than half of his whole *oeuvre* has not yet been shown, is lost, or unaccounted for. The records of his life before he came to the United States are far from complete. Archives in Paris, London, Munich and Warsaw must be searched for a full biography. A start has been made here for a final *catalogue raisonné*. This will not be easy to accomplish as examples known to be in French and Polish collections are unavailable to scholars and are never shown in public. Thanks to Mrs. Nadelman's circumstances following her husband's death, casts were made posthumously while original works were repaired and refinished. Few records had been kept of sales; thus the whereabouts of many privately owned pieces are presently unknown.

Since 1947 I have corresponded with many people, particularly in Paris, who knew him between 1905 and 1914. Many are no longer here to thank, notably Gertrude Stein, Alice B. Toklas, and Constance Lloyd, who shared his studio from 1907 until she went to South Africa in 1914. It has been impossible to locate letters (if such existed) between Nadelman and Jules Pascin, who was the sculptor's favorite contemporary artist and a close friend. Recent biographies of Constantin Brancusi, Amedeo Modigliani, and Jacques Lipchitz have references concerning Nadelman's effect on them.

I am greatly indebted to the many people who interested themselves in problems attendant upon the rediscovery of Nadelman's work, notably Alfred H. Barr, Jr. and Professor Meyer Schapiro, who curbed my enthusiastic ignorance on several points. Count Auguste Zamoyski, a greatly gifted sculptor, who knew Nadelman early, helped in every way, including the restoration of damaged marbles and wooden figures. Excellent pictures of Alderbrook, house, studio and garden, were taken by Henri Cartier-Bresson and W. Eugene Smith, from February, 1947. Robert Ganley photographed almost all the late plasters here illustrated. Madame Olivier Ziegel searched Parisian sources for five years and spoke with people who had known Nadelman before 1914.

Letters from, or conversations with, the following, living and dead, served my text: Alexander Archipenko, George Baillie, Adolphe Basler, Clive Bell, Bernard Berenson, Edward L. Bernays, Aline Bernstein, Martin Birnbaum, Ernest Brummer, Mrs. Joseph Brummer, Dr. Ruth Cohn, e. e. cummings, Professor Szczesny Detlov, Muriel Draper, Donald C. Gallup (and The Collection of American Literature, Yale University Library), Philip Goodwin, Princess Gourielli-Tchkonia (Madame Helena Rubinstein), Michael Hall, Daniel H. Kahnweiler, Gaston Lachaise, Oliver Larkin, Henry McBride, A. Hyatt Mayor, Thadée Natanson, John Rewald, David Rosen, Mrs. Marie Sterner, Florine Stettheimer, Gilbert Seldes, Marek Swarcz, Pavel Tchelitchew, Virgil Thomson, Edward and Roy Titus, Carl van Vechten, Glenway Wescott, Monroe Wheeler, Dr. Edgar Wind and A. J. Yow.

The most important scholarly writing about Nadelman, "Elie Nadelman's Early Heads: 1905-1911," by Athena T. Spear, was published by the Allen Memorial Art Museum, Oberlin College, Spring, 1971. This brilliant essay by a gifted specialist in the work of Rodin and Brancusi made me see new aspects of the early sculpture. I hope Ms. Spear will follow it with a survey of the standing figures, an even more fascinating and complex subject. For her comments and suggestions on this book while in manuscript, and for her contributions to the Draft Catalogue Raisonné, I am especially indebted to Ms. Spear, and to her husband, Professor Richard E. Spear.

I also wish to thank Evelyn B. Harrison, Professor of Art and Archeology, Princeton University, for reading and corroborating information relating to Greek and ancient art referred to in the text.

The Draft Catalogue Raisonné was compiled by Elizabeth Broad, who realizes only too well that her listings are incomplete and often inconclusive. The Bibliography & Exhibitions listing has been prepared by Ellen Grand, and is based on that of Bernard Karpel. Mr. Karpel, Librarian, Museum of Modern Art, New York, made his original bibliography for the catalogue of the 1948 exhibition of Nadelman's work at that museum.

For the careful attention that has seen the manuscript into printed form I wish to thank especially Elizabeth Pollet and Harvey Simmonds; also, Linae Frei, Francis Kloeppel and Margaret Sheffield. The Index was prepared by Elenor Fardig.

I am indebted to the following individuals and institutions for permission to reproduce original works of art in their collections: The Baltimore Museum of Art, Maryland; The Brooklyn Museum, New York; California Palace of the Legion of Honor, San Francisco; Coe Kerr Gallery, New York City; Mrs. Henry Curtiss, Bethel, Connecticut; The Detroit Institute of Arts, Michigan; The Dial Collection: The Art Museum of Worcester, Massachusetts; The Hirshhorn Museum and Sculpture Garden, Smithsonian Institution, Washington, D. C.; Los Angeles County Museum of Art, California; The Metropolitan Museum of Art, New York City; The Museum of Modern Art, New York City; The New York Public Library at Lincoln Center, Astor, Lenox and Tilden Foundations, New York City; The Museum of Art: Rhode Island School of Design, Providence; The Sara Roby Foundation, Nantucket, Massachusetts; Robert Schoelkopf Gallery, New York City; Mr. and Mrs. Constantin Sczaniecki, Paris; Mr. and Mrs. C. Humbert Tinsman, Shawnee Mission, Kansas; Wadsworth Athenaeum, Hartford, Connecticut; Walker Art Center, Minneapolis, Minnesota; Mrs. George Henry Warren, New York City; Zabriskie Gallery, New York City.

I also wish to thank the publishers for permission to quote from the following copyrighted material: Gertrude Stein, *Portraits and Prayers*, New York: Random House, 1934; Rainer Maria Rilke, *Briefe aus den Jahren 1907 bis 1914*, Leipzig: Insel Verlag, 1933; Henry McBride, "Modern Art," *Dial*, Vol. LXXVIII, January-June, Chi-

344

cago: The Dial Publishing Co., 1925; André Gide, *The Journals of André Gide*, Vol. I. 1889-1913, New York: Alfred A. Knopf, Inc., 1947; T. S. Eliot, *Collected Poems 1909-1962*, New York: Harcourt, Brace and World, Inc., 1963; *The Complete Poems of Cavafy*, translated by Rae Dalven, New York: Harcourt, Brace and World, Inc., 1961.

Michael Hoffman, editor of *Aperture*, the most distinguished magazine of photography following Stieglitz's *Camera Work*, managed to place my manuscript with Leslie Katz of The Eakins Press. The book had been refused by half a dozen publishers since its coverage of an artist so obscure hardly justified the cost of printing. However, I have finally found a publisher who feels the sculpture important enough to be printed by the great Stamperia Valdonega of Verona. Joseph Del Valle designed the placement of the plates. The photographs of the sculptures, except for the late plasters, were in every case those posed and lit by the sculptor, and were taken by either Rudolph Smutny or Jessie Hewitt. Photographs of some of the drawings were taken by Malcolm Varon.

As an amateur I have benefited by the method and knowledge of many professionals, notably Stanley Casson, Gisela Richter, Cornelius C. Vermeule, III, and Sir Mortimer Wheeler.

Finally, this book owes much to Jan Nadelman who became my friend through his father's sculpture. His permission to use family documents was unstinting. He has let me say what I wished, although perhaps the portrait I have sketched does not coincide with his own ideas. The memory of Viola Nadelman is vividly alive in the minds of my wife and myself.

<div align="right">L. K.</div>

INDEX

The References, Draft Catalogue Raisonné, Bibliography & Exhibitions, and Acknowledgements are not covered in the Index. Plate numbers appear in brackets.

DESIGNED BY MARTINO MARDERSTEIG
AND PRINTED AT THE STAMPERIA VALDONEGA
VERONA · ITALY

OF THIS FIRST EDITION OF 3075 COPIES SEVENTY-FIVE
ARE SPECIALLY BOUND WITH AN ORIGINAL
DRY POINT BY ELIE NADELMAN, AND
ARE SIGNED BY THE AUTHOR